DANGEROUS AND DIVINE

Sahmaran is the Queen of Serpents in Turkish tradition. She has healing powers and helps a young boy in his struggle against an evil sultan. Images of her are often hung in houses and shops to bring luck and protection against evil.

Painting, around 1950, Istanbul/Turkey, glass, paint, 43 x 58 cm. Collection: Tropenmuseum, Amsterdam. 6058-3

DANGEROUS AND DIVINE

the secret of the serpent

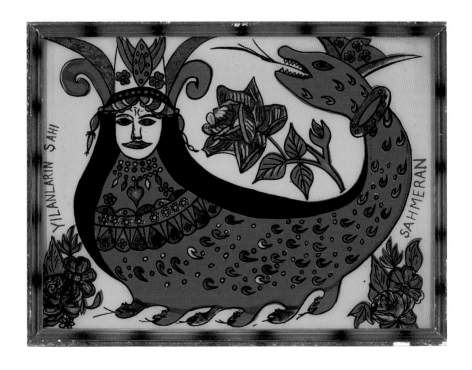

Wouter Welling (ed.)

KIT Publishers / Afrika Museum

Santiago Rodríguez Olazábal, *La dualidad*, 1993. Collection of Peter and Irene Ludwig, Aachen, Germany

Contents

Foreword

Statuette, Mende/Sierra Leone, wood, 60 x 24 cm. Trustees of the British Museum, Af1938,0216.5

Ever since the 1990s, the collection and presentation of contemporary art from Africa and the African 'diaspora' have been a key part of the Afrika Museum's policy. Contemporary works of art do much to illustrate not just the major changes that African cultures undergo in interaction with the world around them, but also local responses to these changes. This process is particularly evident in the diaspora. Of the works in the museum's collection and exhibitions by artists of African origin living and working in the Americas, the Caribbean and Europe, most draw inspiration from Africa's cultural heritage or use it to comment on the confrontation of cultures that is now taking place around the world. African and diaspora artists are thus contributing to the emergence of what is becoming known as 'transcultural' or, increasingly often, 'global' art. Such art forms, and their roots, are part of a new area of research: global art history, or World Art Studies.

The Afrika Museum's most recent exhibitions have presented contemporary art in its own right, rather than for purely illustrative or documentary purposes. The museum endeavours to display works of art in precisely the same way as art museums. In combination with 'traditional' African art, this helps visitors grasp the present-day meaning of culturally specific elements that inspire contemporary artists to interpret ancient spiritual traditions in highly personal, individual-istic ways.

Dangerous and Divine: the Secret of the Serpent is the latest in this series of exhibitions focusing on contemporary and diaspora art and highlighting its African roots. The concept of the exhibition and the accompanying catalogue was devised by the Afrika Museum's curator of contemporary art, Wouter Welling. First 'tempted' by the snake just over two years ago, he set out to discover

the 'secret' of a creature that is seemingly a constant in human history, cropping up in myths and folk tales all over the world. The snake intrigues us, stimulates our minds and challenges scholars to find possible explanations for our fascination with this smooth, slippery creature. The articles in this catalogue will guide you on this mysterious journey. The authors, who come from a broad range of disciplines, describe both hard facts and ancient myths, and advance hypotheses and speculations. It is up to you, the reader, to draw your own conclusions.

Let me take this opportunity to thank all the contributing authors: Wouter Bleijenberg, Edward de Bock, Sheila Coulson, Wilfried van Damme, David van Duuren, Frans Ellenbroek, Ben Meulenbeld, Georges Petitjean, Maarten J. Raven, Siebe Rossel, Mineke Schipper, Jacob Slavenburg, Marinus van der Sluijs and Wouter Welling. Without their joint expertise this catalogue could never have come to fruition. I am particularly grateful to Wilfried van Damme for the many hours he spent assisting me in his capacity as research consultant at the editorial stage. Translator Kevin Cook subsequently worked with similar attention to detail. My compliments to them both for their commitment and professionalism.

Just as the catalogue was the work of many hands, the exhibition itself could never have taken shape without the help of its lenders and sponsors, and of course the efforts of our own staff. In organising *Dangerous and Divine: the Secret of the Serpent*, the Afrika Museum benefited from museum and gallery collections and private collections in the Netherlands and elsewhere. The works they so generously lent us have resulted in an exhibition that will take our visitors on a journey through time and all round the world. I hereby express my sincere thanks to

the Metropolitan Museum of Art in New York, the British Museum in London, Musée Barbier-Mueller in Geneva, Museum Rietberg in Zurich, the State Museum of Ethnology in Munich, Sefton Museums & Galleries, Sefton MBC in Southport, England, the Murray White Room in Melbourne, the Herzog Anton Ulrich Museum in Braunschweig, the Pro Arte Ulmer Kunststiftung in Ulm, the Morat-Institut für Kunst und Kunstwissenschaft in Freiburg im Breisgau, the Tropical Museum and the Allard Pierson Museum in Amsterdam, the Museum of Contemporary Aboriginal Art (AAMU) in Utrecht, the National Museum of Ethnology and the National Museum of Antiquities in Leiden, the Wereldmuseum and the Museum Boijmans van Beuningen in Rotterdam, the ING Bank's Netherlands Collection, the Frisian Maritime Museum in Sneek, the University Museum in Groningen, the Natuurmuseum and the Museumwinkel in Nijmegen, Mr and Mrs Durand-Dessert in Paris, and Mr Gerard Lentink, Henk and Leonie Pijnenburg and Mr Maarten van Straaten in the Netherlands, as well as the many other lenders who have chosen to remain anonymous. Artists John Breed, Jan van Munster and Juul Kraijer have lent us their own work, and the Haitian-American artist Edouard Duval Carrié and Gérard Quenum from Benin have produced new works specially for this exhibition.

The task of putting all these works together was entrusted to designers Roel Schneemann and Ehud Neuhaus. As usual they did not let us down, and they have presented 'the snake and its secrets' in an utterly fascinating manner. Each in their various ways, our museum staff have worked to complete this project with great flexibility and professionalism. I specifically want to thank a number of people who went out of their way to meet seemingly impossible deadlines: exhibition coordinator Maaike Kool, who spent two years arranging the loan of works of art and was a mine of information for her colleagues at every stage of the project; our ever-reliable technician Cor Felten, who worked on a final exhibition for us before leaving to enjoy his well-earned retirement; restorer Lucas de Roeper, who installed the exhibits; our matchless exhibition builder Frans Verbiesen; and of course curator Wouter Welling, whose persuasive skills were regularly put to the test as he shared his ideas with us.

Finally, my heartfelt thanks are due to the Mondriaan Fund, the VSB Fund, the Prince Bernhard Cultural Fund, the Turing Foundation, the SNS REAAL Fund and the Janivo Foundation, whose faith in the Afrika Museum is reflected in their substantial financial contributions. In these times of swingeing cutbacks in the cultural sector, they are havens of generosity for institutions such as ours. Had it not been for them, a project of this size could never have seen the light of day.

IRENE HÜBNER
Director

Snake Art Studies: representations of the snake worldwide, and World Art Studies

WILFRIED VAN DAMME

The exhibition *Dangerous and divine: the secret of the serpent* (and the accompanying catalogue) have always been seen by its initiator Wouter Welling as a fruitful testing ground for the new area of artistic research known as World Art Studies, or WAS. So what is WAS, and why should Welling's project be considered part of it?

Promising and controversial

After a hesitant start around the turn of the millennium, WAS has now seized the imagination of art scholars. Whatever we may think about it, the idea of approaching art studies in global terms can no longer be ignored in today's world.

There are those – such as Whitney Davis, Professor of Art History at the University of California, Berkeley – who are sure that this is where the future lies. Davis believes that for the next fifteen years or so his area of endeavour will be unable to manage without WAS, which he sees as the only relevant framework for a globally operative history of art.[1] He says so in a review of one of the first comprehensive theoretical works on the subject, *World Art Studies: Exploring Concepts and Approaches*, in which fifteen authors from various academic backgrounds (not just art history, but also cultural anthropology, philosophy and even behavioural biology) examine the study of art as a phenomenon in human history.[2] The new academic journal *World Art*, the first issue of which was produced by a leading international publisher in 2011, likewise points to a growing interest in global approaches to the study of art.

Others are sceptical. However, anyone who jumps to the conclusion that the sceptics are grumpy old Eurocentric art historians convinced that only the West has produced art worth studying is mistaken – or at least has an incomplete picture of the situation. In fact, it is above all critics (both Western and non-Western) of Western culture and science that tend to be averse, if not downright hostile, to the global broadening of horizons implicit in WAS. In some circles, the mere fact that this global approach to the study of art was first proposed by Western researchers is apparently reason enough to steer well clear of it.[3]

Global questions

WAS has developed out of a realisation that twentieth-century Western art historians focused entirely on the production of art in one small part of the world. Just as, say, linguistics is not confined to European languages but treats all the world's languages as part of its field, so art history – or rather art studies – should surely consider manifestations of visual art from all times and places. It goes without saying that researchers from the most varied cultural backgrounds can contribute to the study of art as a global phenomenon.

This worldwide perspective on visual art raises new issues and provides a broader, intercultural framework for the exploration of more classical topics. There are three major research themes in WAS, and Welling's project sheds light on all three.

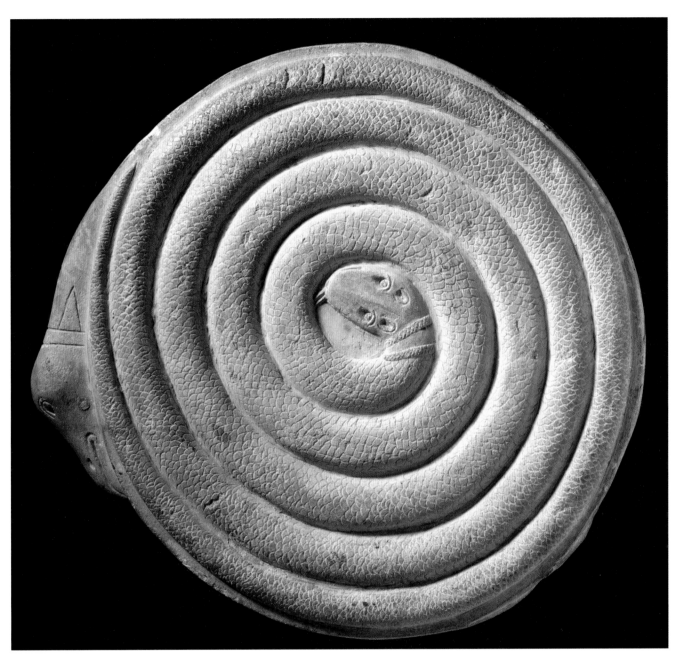

Board game, Egypt, limestone, 35 cm. Collection: Dutch National Museum of Antiquities, Leiden, F1968/3.1

The first theme is the origin of visual art – the emergence of such phenomena as body ornamentation, sculpture and painting during the evolution of *Homo sapiens*. When did humans start producing and using art, what were the conditions that made this possible, and why is it still with us?

Over the past ten years our picture of the origins of art has changed radically. Whereas we used to think that visual art emerged in Europe some 30,000 years ago, we now believe that it may first have been produced in Africa as early as 65,000 years ago – before anatomically modern humans left the continent to populate the rest of the world.

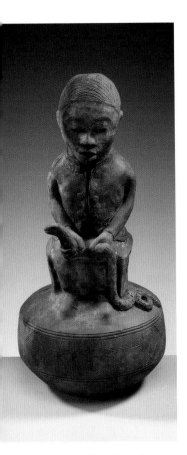

Jar, Woyo/Dem. Rep. Congo, pottery, 41.5 cm. Collection: Afrika Museum, Berg en Dal, 41-16

One of the recent archaeological finds that have played a part in current discussions on the African origins of art is described in this catalogue by Sheila Coulson. Whatever the outcome of the debate on the possible depiction of a snake in Botswana's Tsodilo Hills, the attention paid to that find in this book illustrates Welling's keenness, as part of his wide-ranging project, to discover the oldest material evidence of our fascination with snakes.

The second major theme in WAS is intercultural comparison of visual art and its context. What differences and similarities are revealed by a global comparison of a given art form or artistic theme, what do they tell us, and how can we account for them?

This book contains a series of brief articles on the concept and meaning of snakes in various cultures and eras, written by experts who have spent many years closely studying the relevant cultural areas and historical periods. Welling's comprehensive introductory text provides an intercultural comparison of this information, focusing on some recurrent themes and placing them in a broader context.

A third major theme in WAS is 'intercultural-isation' in art, i.e. the artistic interactions between various cultural traditions. Under what conditions and in what ways do works of art and ideas from one culture influence art forms in another (in both directions), and what part do artists, their patrons and the public play in this process of artistic cross-fertilisation?

The work of contemporary artists such as José Bedia and Edouard Duval Carrié, which is represented in this project, illustrates the syncretic form and content that can arise in art when visual idioms, myths and religious practices from different cultural traditions come into contact. Both artists' output is rooted in the Caribbean African 'diaspora' and blends elements and iconographies from African religions with ingredients from Catholicism and, in Bedia's case, the original Indian culture. The snake plays an important part in each of the traditions that merged in such places as Cuba and Haiti (the Indian tradition of the indigenous population, the Christian tradition of the European colonisers and the various traditions of the Africans who were imported as slaves); its present-day representation emerges from, and resonates with, ideas about the snake that have developed in these various traditions over time.

A multidisciplinary perspective

WAS is not just global but also multidisciplinary in outlook, and makes use of input from any scientific discipline that can shed light on the phenomenon of visual art. Davis's aforementioned review hails this multidisciplinary approach as something new in the study of art.

Besides the more conventional, tried-and-tested approaches to art history, such as stylistic study and iconography, WAS offers perspectives and insights from such areas as evolutionary biology, neurosciences, cultural anthropology and philosophy.

A topic such as the representation of snakes in various cultures around the world is eminently suited to such a multidisciplinary approach. Indeed, this topic cannot be properly studied without reference to religious studies, anthropology and related disciplines. Evolutionary biology can also help by describing the evolutionary background to our fear response when we are confronted with potentially threatening creatures such as snakes. Psychology can attempt to explain why something that causes fear can also be the object of such profound interest, as reflected in the phrase that the religious researcher Rudolf Otto used to describe our experience of 'the sacred': *tremendum et*

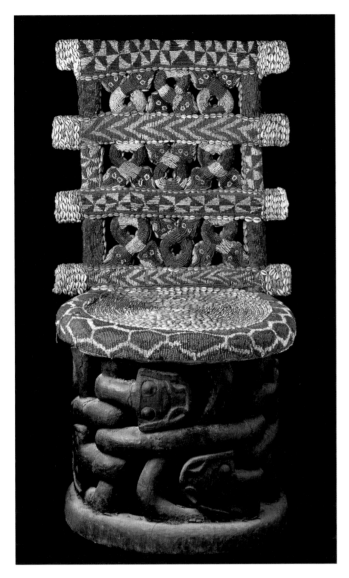

Chair, Bamum/
Cameroon, wood, beads,
cowrie shells, 119 x 65
cm. Collection: Musée
Barbier-Mueller, Geneva,
1018-21. Photo: Studio
Ferrazzini Bouchet

can in turn improve our understanding of
humanity in general. WAS is thus the branch of
anthropology – in its literal meaning 'the study
of humans' – that deals with the visual, artistic
dimension of being human. Further study of how
people convey the world around them in images
and then respond to them can provide a clearer
picture of what it actually means to be human.
The visual representation of snakes around the
world in Wouter Welling's project is above all his
own starting point for a personal exploration of
human imagination.

fascinans, terrifying and fascinating. Input from
various scientific disciplines is bound to increase
our understanding of the snake's evident
influence on our imagination.

Art and human experience

The purpose of the global, multidisciplinary
approach in WAS is to gain insight into the
various aspects of visual art as a phenomenon in
human history. Such comprehensive knowledge

The secret of the serpent

WOUTER WELLING

Dedicated to Petra Welling (1959-2010), an art historian who was my guide on the path to interdisciplinary art studies

Nothing keeps its own shape, and Nature renews
By recycling one form into another.
Nothing dies, believe me, in the world as a whole,
But only changes its looks. What we call birth
Is a new beginning of what was before,
As death is an ending of a former state.
Although that over there may be transferred here,
And this over there, the sum remains constant.

OVID[1]

Something was wrong.

The story began in a *hortus conclusus*, an enclosed garden – a safe, idyllic place with the loveliest trees and plants, flowers and butterflies, and with animals that were not trying to kill one another. Time did not exist, so there was no threat of things coming to an end. Diseases and other suffering were unknown. Two people in perfect harmony with nature – a man and a woman, unaware of their sex. In fact, they were living in a blissful childlike world, a state of unawareness. Nothing would ever change. There was the occasional gust of wind announcing the coming of the creator. And he was kind to his children, just as long as … as long as they kept away from those two trees. The fruit of those trees was taboo. The only taboo.

And then you *know*. Of course you're completely focused on the forbidden fruit – the Tree of Knowledge, and the Tree of Eternal Life. Once you have eaten of the fruit of the former, you desire the fruit of the latter. Knowledge spoils things, destroys the perfect world. Knowledge implies awareness of the end; and everyone wants to escape death. Then the one creature that makes sure that what has to happen *does*

happen appears on the scene – for the bible is marked by *fatum*, fate. Events have what you might call an 'inner necessity', just as in the myths of classical antiquity: once the gods have decided, even they can no longer unpick the threads of fate. The Moirae, the goddesses of destiny, have already woven the pattern of the story into their web. What we are dealing with here is the 'gerundive of obligation': something *having to happen*. If something 'is written' in the bible, a story unfolds that is, so to speak, present in the genes of creation. So how can you blame the snake?

The snake is sometimes depicted as a half-woman, as the mysterious Lilith, Adam's first wife, originally a Sumerian queen of heaven who did not know her place and was therefore demonised, a dreaded, winged queen of the night – a darkly seductive figure that was associated with the primal snake Leviathan and was depicted 'wound about with snakes' like a temptress (we will come back to this later). Like Lilith, Eve (originally Chawwâh, Hebrew for *life* in the sense of *the life-giving one*) does not keep to the rules, for she accepts the knowledge she is offered – the knowledge of good and evil, but also the knowledge of the beginning and the

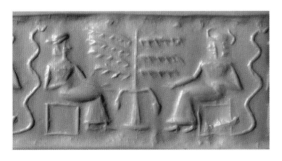

Arie van Geest, *Adam*, 1996, work on paper. Private collection, Netherlands

Adam & Eve seal, 2200-2100 BCE, Middle East (Mesopotamia), 2.7 x 1.6 cm, Trustees of the British Museum, 00861135001

end. The idyll of the children's garden is over; the way has begun. And this, the human condition, is perceived as punishment. The creator is wrathful, an angel with a fiery sword appears and the two main characters in the story, like their offspring, will always have to work hard, suffer pain and then die, for violating a taboo that *had to be* violated in order to enter

time, complete the separation, become aware of their own identity – in short, become human.

The snake is also punished. It will have to crawl in the dust of the earth till the end of its days.

Religious education teachers who told this story in primary schools without any critical commentary instructed their pupils to draw it in an exercise book. The story of the Garden of Eden must have been drawn by countless children – the scene of Adam and Eve, the tree and the snake is a primal image. The tree, the snake and the human couple: a combination that dates back to well before the period in which the biblical stories emerged. Arie van Geest has shown the connection very clearly: Adam is

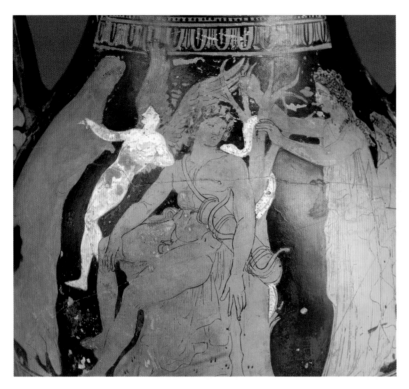

Amphora, *Hesperides*, 4th century BCE, Athens/ Greece, pottery, 29.5 cm. Collection: Allard Pierson Museum, Amsterdam, APM03505

Vase, Etruscan, pottery, 44.5 x 23.5 cm. Collection: Allard Pierson Museum, Amsterdam, APM10188

linked to the tree, just as Eve is linked to Adam and the snake to the labyrinth of branches. Another depiction of paradise is the earth goddess Gaia's garden of the Hesperides, with the golden apples. The garden was guarded by nymphs (Hesperides, daughters of Atlas and Hesperis) with assistance from Ladon, a hundred-headed dragon that never slept. The titan Atlas, whose task (supporting the pillars of heaven) was briefly taken over by the hero Hercules, steals three of the apples for Hercules, who later returns them. Greek influence on Christian art can be seen in the depiction of the snake in combination with the tree and its unusual fruit.[2]

The theme of gods dying in connection with a tree precedes the New Testament crucifixion. Wounded by a spear, Odin (the supreme god in Norse mythology) was hung on the world tree for nine days and nights. Attis, the beloved of the Anatolian mother goddess Cybele, died at the foot of a pine tree. Angered by his relationship with an earthly girl, Cybele had driven him mad; Attis castrated himself and died of his injuries. The evergreen conifer sprang forth from his blood. Cybele laid her beloved in a rocky tomb. Like Odin, he rose from the dead. On 25 March there was light in his grave – the beginning of spring. The cult of Attis flourished in Rome during the reign of Emperor Claudius (41-54 CE). Attis was worshipped there as a sun god; the festivals of Attis included the carrying of a conifer to a cave dedicated to the goddess, the womb, the 'other world'. The vegetation symbolism clearly refers to regeneration, and the Attis tree can be seen as a prefiguration of our Christmas tree. Cybele and Attis were also known as a complementary pair in alchemy.[3] The tree is the primal principle of life and order, an *axis mundi*, an organising axis of the world.

In my school exercise book I drew a golden snake slithering along in solitude. I felt that the creature had been treated unfairly. The gnostics would have agreed with me. They did not think

of the snake as a diabolical tempter. 'For the serpent was wiser than all the animals that were in Paradise ... But the creator cursed the serpent, and called him devil. And he said "Behold, Adam has become like one of us, knowing good and evil".'[4] Here we are basically talking about a jealous god, a demiurge (known as Demogorgon): a god that does not produce a *creatio ex nihilo*, creation out of nothing, but starts out from primal chaos. The gnostic demiurge is the lesser creator of the imperfect, material world.[5] He wants to keep knowledge from humans, for they must not become 'like one of us' (i.e. part of the divine world). But the snake does the opposite – it offers knowledge. The snake as a teacher of wisdom is a well-known phenomenon. The Ophites, a gnostic sect from the second and third centuries CE in Rome, worshipped snakes, which they saw as 'a revelation of the unknown God', the *nous* (divine spirit, consciousness) in snake form.[6] Elsewhere in this book, Jacob Slavenburg discusses the gnostic snake in more detail. Around the world, the snake appears in myths as a creature that possesses special knowledge; it has access to the 'other world' and is the guardian of great treasures. It is also an unparalleled healer, with extensive knowledge of plants which it can use to bring the dead back to life. It appears to shamans in their visions, and explains to them how plants can be used. The special status of snakes dates back to the most ancient religions. Worldwide it has been depicted in the visual arts more often than any other creature, from at least 40,000 years ago to the present day, usually in a positive sense, but also as a symbol of the dark and menacing: the snake is both dangerous and divine. Although in ancient cultures the snake had high status as an attribute of the great goddess, in orthodox Christianity it was considered diabolical and was trampled on by Mary – a remarkable reversal, for Mary is a belated version of the great goddess, the mother goddess, the power of nature, of the life-giving principle: Gaia, Ishtar, Astarte, Inanna (she had many different names). The male god cast her down from her throne, and her sacred animal was degraded to a symbol of the darkness that had to be controlled. Reviled, feared, worshipped: the snake is the embodiment of a reverse side, a repressed story. Perhaps this is why humans have always found snakes so fascinating. If we were to look for a key in religion, mythology, literature and the visual arts that would open the door to a constant in the human psyche, a highest common denominator, we might well end up with the symbol of the snake. Why? What is its secret?

The adventure of the explanatory hypotheses

These questions occurred to me when I was working on *Roots & More: the Journey of the Spirits*, an exhibition on contemporary African diaspora art with roots in African spiritual traditions. In Brazil the snake appeared to me in

Mestre Zé Lopes, Medusa figure, Brazil, wood, 60 x 29 cm. Private collection, Netherlands

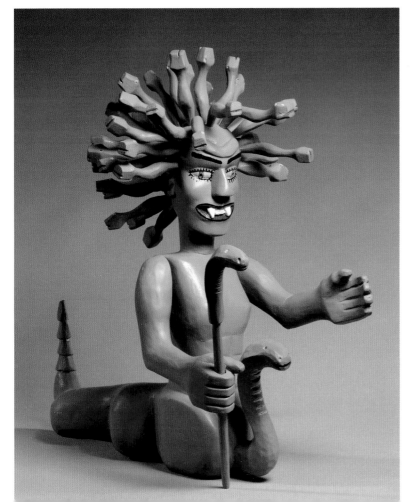

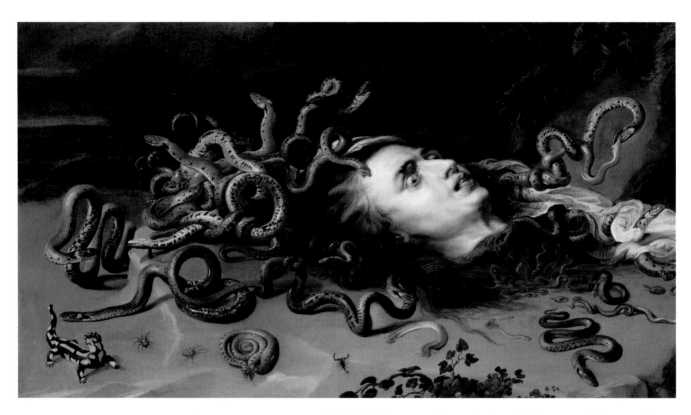

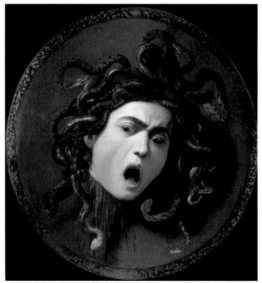

Peter Paul Rubens,
Medusa's head, 1617-
1618, 68.5 x 118 cm.
Collection:
Kunsthistorisches
Museum, Vienna

Michelangelo Merisi da
Caravaggio, *Medusa*,
1598, 60 x 55 cm. Uffizi
Gallery, Florence

the form of Medusa: a remarkable puppet made
by the Brazilian master puppeteer Mestre Zé
Lopes (b. 1950). In a gallery of outsider art I saw
two Medusas standing side by side; one of them
appeared to be the male version, with a cobra

rearing up before him like a penis. He was also
holding a cobra sceptre. Medusa is one of the
three Gorgon sisters, the daughters of the sea
gods Phorcys and Ceto. They are depicted as
winged monsters with snakes for hair. Medusa is
the victim of the wrathful goddess Pallas Athena,
having been raped before her statue by
Poseidon-Neptune when a young girl. Athena,
perhaps jealous of her beauty, punishes her by
turning her curly locks into snakes. She will
eventually be killed by the hero Perseus, who
makes a gift of her severed head to Athena. The
goddess then wears this on her armour to inspire
terror. Medusa's fate is as undeserved and
unfortunate as Lilith's.

Since the female Medusa had already been sold,
it was the male one ('Meduso') that travelled on
with me. The puppeteer had adapted the myth
by giving the terrifying element both female and
male manifestations. In Haiti I found the snake
everywhere, on *vodou drapo* (flags for the *lwa*,

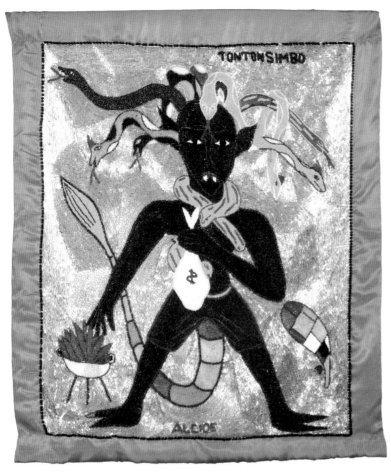

Alcide, *Drapo* (*vodou* flag) for Ton Ton Sombo, spangles, beads, fabric, 90 x 82 cm. Collection: Afrika Museum, Berg en Dal, 681-10

Anonymous, Haïti, wood, fabric, paint, 46 x 34 cm. Collection: Gerald Pinedo

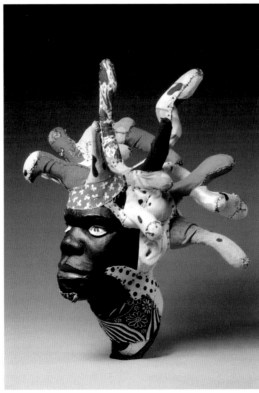

Vodou bottle for Dambala, spangles, beads, fabric, 34.5 x 9 cm. Collection: Afrika Museum, Berg en Dal, 670-8

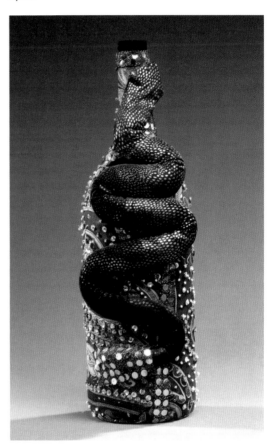

the spirit beings of the *vodou* pantheon), on a magnificent bottle dedicated to the snake god Dambala and in the paintings of such artists as Frantz Zéphirin (b. 1968) and Préfète Duffaut (b. 1923). On returning to the Afrika Museum I went looking for snakes, and found them throughout the collection – on ceramics, doors, jewellery and amulets. From then on I could not stop thinking about them. I explored their mythology and psychological meaning. Various studies turned out to have drawn intercultural parallels on the subject. Anyone who studies snakes sets

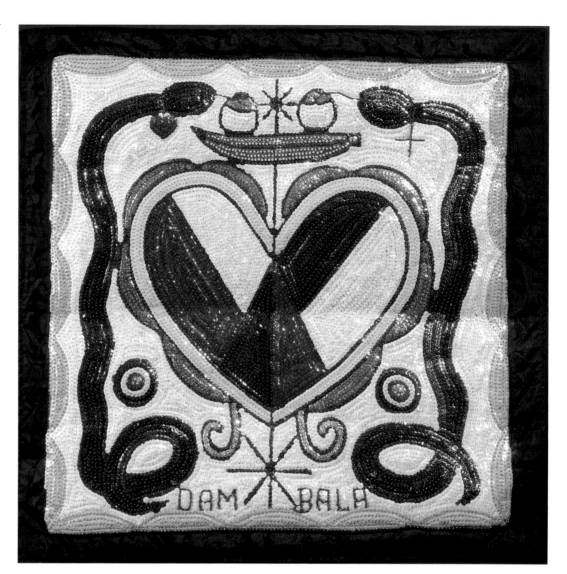

Dambala, *drapo (vodou* flag), spangles, beads, fabric, 74 x 77 cm. Collection: Afrika Museum, Berg en Dal, 670-9

Vévé (graphic *vodou* symbol) for Dambala, metal, 51 x 78 cm. Private collection, Netherlands

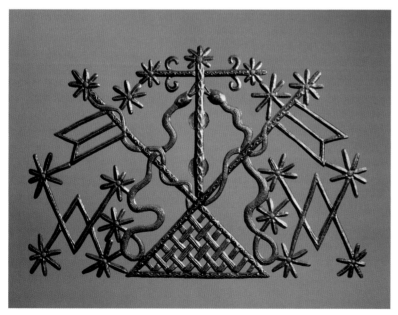

out on a journey through the human psyche, from the walls of prehistoric caves to recent developments in quantum physics. This catalogue can give only a brief review of possible explanations for our fascination with snakes – a voyage of adventure in the company of renowned scholars and fascinating writers who create room for all manner of associations and speculations.

Snakes make their appearance in myths whenever dramatic changes are about to occur. They are classic symbols of liminality – signs marking the transition between this world and the next, the metaphysical domain. People have always sought answers to the major existential questions about the meaning of birth, life,

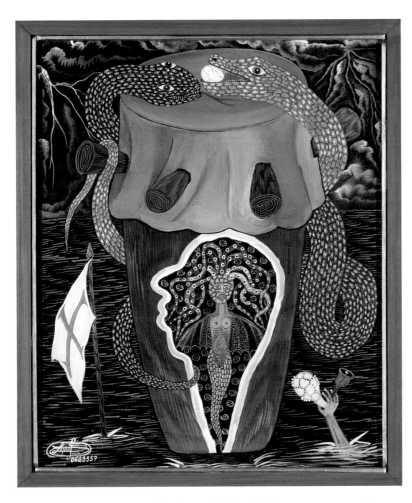

Franz Augustin Zéphirin, *Interpellation, Dambala & Aido Wedo*, 2007, acrylic paint on canvas, 50 x 40 cm. Private collection, Netherlands

all these are archetypes that can be observed in the outside world, from cornfields to starry skies.

The Swiss founder of analytical psychology, Carl Gustav Jung (1875-1961), introduced the hypothesis of the collective unconscious and the archetypes that operate within it. 'I have chosen the term "collective" because this part of the unconscious is not individual but universal; in contrast to the personal psyche, it has contents and modes of behaviour that are more or less the same everywhere and in all individuals. It is, in other words, identical in all men and thus constitutes a common psychic substrate of a suprapersonal nature which is present in every one of us.'[7] An archetype is an inherited image that can emerge from the collective unconscious and then 'is altered by becoming conscious and by being perceived.'[8] The psyche of what Jung, in the terminology of the time, still called 'primitive man' has 'an irresistible urge to assimilate - all outer experiences to inner mental events ... All the mythologised processes of nature, such as summer and winter, the phases of the moon, the rainy seasons and so forth, are in no sense allegories of these objective occurrences; rather they are symbolic expressions of the inner, unconscious drama of the psyche which becomes accessible to man's consciousness by way of projection – that is, mirrored in the events of nature.'[9] The hypothesis (advanced by Marinus Anthony van der Sluijs in this book) that the Ouroboros as a mythical figure is derived from observations of the firmament is entirely in keeping with this description of mental processes.

The Ouroboros is a familiar image in alchemical illustrations, the symbol of 'the eternal, cyclic nature of the universe.'[10] It resolves contrasts, thereby symbolising the interconnectedness of all that is, of the beginning and completion of the *opus* (the work of the alchemist). In the privacy of his laboratory, the alchemist worked

suffering and dying. If the answers cannot be couched in words, images – symbols, from the Greek verb *symballein*, to coincide – speak in their stead. Inner processes are projected outwards; thinking in analogies is based on this. What we perceive is what we recognise, or rather what appeals to us. An image only acquires meaning when it connects with our inner world, in other words when it strikes a chord with us. When images become iconic in art, it is always for a reason. A cosmogony that organises, that gives the world a fixed place, a tree as the *axis mundi*, the relationship between opposites, sacrifice, death and regeneration/rebirth (recalling the cycle of the seasons), the link between the human world and the 'other world', to mention just a few *topoi* (recurring themes) –

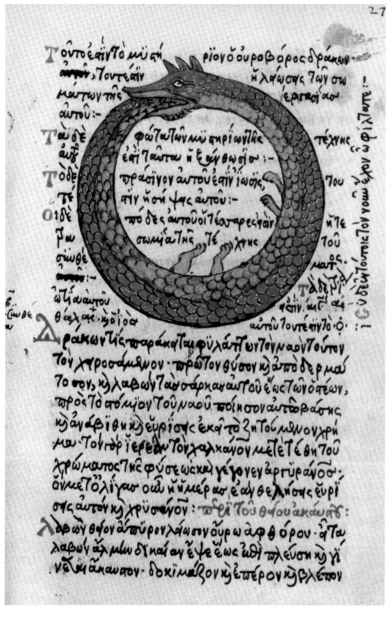

developments, phases, that are recognised by the psyche (the aforementioned projection). It is in this interaction between the conscious and the unconscious, the inner and outer worlds, that mythology, literature and visual arts emerge. In a sense they are the reflection of the psyche. Some of these reflected images are archetypes, primal patterns that we share just as we share our DNA structure. Mental content recognises a corresponding form, for example in the snake – which, as we will see, may symbolise many different things.

The snake has a special position in psychoanalysis. As Adler writes, it is 'one of the most pregnant symbols of the unconscious, so much so that it often stands for the unconscious itself … it is the personification of the earthly unconscious, of the instinctual layer, with all its secret, mantic and curative powers as well as its inherent dangers which must be overcome. It is precisely this which explains the venerations and fear inspired by the serpent.'[11] Not everyone finds the psychoanalytical perspective equally convincing. The biologist Balaji Mundkur, author of *The Cult of the Serpent: an Interdisciplinary Survey of its Manifestations and Origins*, a standard work on snake symbolism, advocates a practical explanation for it: the impact of the natural environment and the climate in which people had to survive. 'It is hardly surprising that sun, rain, and serpents are recurring subjects in the religious and cosmogonic beliefs of the most diverse aboriginal peoples, even in the colder zones.'[12] Mundkur offers many examples from world mythology. 'The Fon of Dahomey, the Bambuti and Baluba of the Congo, the Makara of the Sudan, the Tswana of Botswana, and the Bushmen of South Africa directly equate serpents with rain and myths and rainmaking rites that reflect a common African sentiment. Rain appears early in Baluba creation myth; "its greatest desire was to fall down and inundate the earth." The Baluba believe that the world's

on a transformation of matter that probably paralleled inner changes. In the Jungian interpretation, alchemy is a secret code for the process of individuation, mental maturity. It is a path from the inner to the outer, as well as a recognition of the inner in the outer. The psyche can find the images in nature that suit it; the outer image helps articulate the inner one. Nature – flora and fauna, the seasons – displays

first human inhabitant had two wives – one human, the other, her senior, a serpent named Kizimu. The Rainbow Serpent myth of the Australian Aborigines is a product of the violent rains and thunderclouds of the northern Australian monsoon. The details vary, but in essence this immensely powerful and important monster spends the dry season resting in a deep waterhole and emerges as a rainbow in the wet season.' Snakes and rain are almost inseparable in mythology.

One of the best-known examples is the snake ritual of the Hopi Indians in Arizona, including a snake dance in which snakes symbolising light-ning, the bringer of rain, are held in the hand. The art historian Aby Warburg visited the Hopi during his journey in 1895-96. He was too early in the year to see the snake dance, but he did study its symbolism. A lecture he gave on the subject at the Bellevue sanatorium in Kreuzlingen in 1923 has assumed great importance in art history. Warburg, who graduated with a thesis on Botticelli and specialised in Italian Renaissance painters, introduced iconology (analysis of the meaning of visual art in a broad cultural/ historical context) into art history, focusing on the similarity in the religious thought of, for example, ancient Athens and modern Oraibi, the Hopi village that he visited in Arizona. His favourite motto was a quote from Goethe's *Faust Part II*: 'There's an old book for browsing in; from Harz to Hellas all are kin.' He detected continuous line 'from the Harz to ancient Greece', and developed a comparative concep-tion of art history in which survivals of the ancient could be identified in the contemporary. Warburg had a broad range of interests: among the topics he explored were history of religion and what in his day were the still young disci-plines of cultural anthropology and psychology.

In Mundkur's view, the approach taken by psychologists such as Freud, Jung, Adler and their followers, who relate the snake to the unconscious, is 'intuitive speculation'. 'As a mechanistically inclined biologist, I regard their methodology and inferences ... as questionable ...'[13] Opinions differ even among psychologists. In various publications and interviews, the clinical psychologist Professor Jan Derksen has expressed concern at the strong tendency within psychology to exchange the field of psycho-therapy for that of cognitive science. Derksen disagrees with the researcher Dick Swaab, author of the Dutch bestseller *Wij zijn ons brein* ('We are our brain'), who entirely reduces the psyche to processes in the brain. According to the 'ruthlessly reductionist'[14] Swaab, it is nonsense to think of the body (brain) and the mind as separate – there is only the body, only matter. But, says Derksen, 'you cannot slice into the psyche or take pictures of it; you do have to draw up theories about it.'[15]

Like processes in the brain, which will be discussed in more detail later, Mundkur's environmental factors clearly have an influence; but of course mythical thinking cannot be seen in isolation from mental reality, for it is an expression of it. The myths that will find resonance and survive in the psyche are those that have the power of the archetype (just as the crucifixion is a late version of the sacrifice of the mother goddess's son or beloved). Archetypes could thus be said to contribute to mental development, to individuation – they are *active*. The sandplay therapy referred to by Wouter Bleijenberg involves 'playing' with archetypes, *active imagination*, which gives the therapist a key to his client's mental situation.

If we consider the visual arts from an intercultural perspective, we need to be very open to the impact of images. An object from an unfamiliar cultural background is much easier to understand if we approach it 'from within', i.e. allow it to act upon us. The most important thing is the image's inner message. This is a subjective approach that can be complemented by

contextual information. Traditional art historians tend to work the other way round. Confronted with work from an unfamiliar cultural environment, they immediately go looking for explanatory texts. The premise that such art is different and can therefore be understood and appreciated only with the help of contextual knowledge – in an ethnographic museum – ignores the fact that 'inner perception' has long since recognised an image and that further study will show it is by no means as 'remote and strange' as we first thought. The theme of the snake, seen as a journey through cultural history and the human psyche, shows just how meaningless it is to think in terms of cultural pigeonholes. Yet art historians, critics and curators still cling to their own frames of reference so that that they can continue to classify 'different' art as different. Fear of recognition may be an unconscious motive here. In this age of interculturality and globalisation, a blend of intuition and knowledge is more necessary than ever. Mindful of the tale of Minos's labyrinth, we have to realise that Theseus (the male principle, consciousness) needs Ariadne (the female principle, intuition) in order to accomplish his task – reach the heart of the labyrinth and return safely.[16] That is why Wilfried van Damme's article in this book presents the exhibition *Dangerous and Divine: the Secret of the Serpent* as a case study in World Art Studies – a broader approach to art that includes rather than excludes.

'Archetypes form [the] centres and fields of force [of the unconscious].'[17] The step from Jung's theory and research (not just on archetypes but also on synchronicity) to the hypothesis of morphogenetic fields, formative causality and the field of zero-point energy (the all-connecting network of vibrations), which a number of scholars have been exploring for some time now, seems an obvious one. If we are inextricably linked to an ocean of energy, a giant quantum field[18] that connects all that is and all experience from all ages, this may explain both

the existence of primal images and the fact that ideas are 'in the air' – such as the idea of holding an exhibition on the symbolism of snakes.[19] As the church father St Irenaeus put it, 'the creator of the world did not fashion these things directly from himself, but copied them from archetypes outside himself.'[20]

Anyone who finds such fascinating speculation exaggerated could adopt an alternative approach that may seem different but is not necessarily incompatible with it – at least when linked to the daring ideas of such an adventurous anthropologist as Jeremy Narby. The South African archaeologist and anthropologist David Lewis-Williams, a renowned expert on San rock paintings, has written pioneering studies on the neurological origins of the earliest manifestations of art. According to him (and David Pearce, co-author of their 2005 book *Inside the Neolithic Mind*), the basic patterns that we find everywhere can be traced back to the workings of the human brain: '... the neurology and functioning of the brain create a mercurial type of human consciousness that is universal.'[21] 'Altering human consciousness to some extent by prayer, meditation, chanting and many other techniques'[22] is a phenomenon found in all ages and religions. Such other techniques include the use by shamans of drugs such as iboga and ayahuasca. The sense of unity that users can experience has been termed 'absolute unitary being'. It is a sensation of union with an all-embracing vital energy, called 'the Holy Spirit' in Christian contexts. This overwhelming experience of unity and of being outside the space-time dimension is a worldwide constant in both shamanistic experiences and the work of mystics. 'Somewhere between supernatural and aesthetic experiences is the sense of being one with the universe,' write Lewis-Williams and Pearce; and the experience can be accounted for neurologically. Dick Swaab would undoubtedly agree. The neurological causes of mystical experiences, say Lewis-Williams and Pearce, can

be extremely varied; among other things, the authors mention the use of hallucinogenic substances, near-death experiences, intense concentration and sensory deprivation, as well as hunger, headache and pathological conditions. Alterations in consciousness take place in distinct stages, with geometric patterns and spirals initially appearing in the mind's eye and then, as the trance deepens, animals and objects that are assigned an emotional or religious meaning. This is followed by the 'vortex phase', in which a tunnel appears with a bright light at the end of it. The last stage of the journey is

Jeremy Narby, *The Cosmic Serpent*

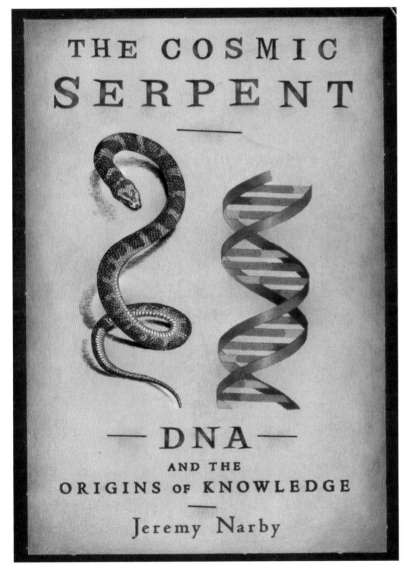

marked by a sensation of having extra limbs; animals are observed and the person may turn into an animal.[23] Experiences by shamans from various cultures reflect this pattern, although the description varies according to context. In short, it's all in the brain.

Cardiologist Pim van Lommel, who has published a much-discussed study on near-death experiences, argues that these cannot simply be reduced to processes in the brain resulting from oxygen starvation. He uses numerous examples and studies by fellow scholars to substantiate his view that consciousness can also be perceived in isolation from the brain and the body. 'It is hard to avoid the conclusion that the essence of our endless consciousness predates our birth and our body and will survive death independently of our body in a non-local space where time and distance play no role. There is no beginning and there will never be an end to our consciousness. In view of this, we should seriously consider the possibility that death, like birth, may be a mere passing from one state of consciousness into another.'[24] Van Lommel sees the body as a temporary place of resonance, and DNA as an interface between non-local consciousness and the body. In other words, what Lewis-Williams describes are in Van Lommel's view simply the workings of the radio, the instrument that enables programmes to be received.

Anthropologist Jeremy Narby has studied Peruvian Amazonian Indians' profound knowledge of two plants that are needed in order to prepare a particular psychedelic substance (the second ingredient is needed to deactivate a stomach enzyme that would otherwise neutralise the hallucinogenic effects of the first one). Narby wondered how the Indians could acquire such highly specific knowledge without the help of modern laboratories. Of the eighty thousand plant species in Amazonia, they knew exactly which two to pick. It was the plants themselves that

conveyed the knowledge, Narby was told. The effect of a less strong tobacco and the very strong ayahuasca puts the shaman in touch with the *maninkari*, the souls that are present in animals, plants, mountains and rivers, even crystals.[25] The *maninkari* are suggestive of the archetypes that, as in crystals, are referred to by Jolande Jacobi as a pre-existent, immanent 'axial system'.[26] She extends this to what Plato called the 'Idea', but in this case one in which both light and dark sides are present. Ayahuasca is the substance that helps the user switch to another wavelength and get in touch with a (literally meta-physical) kind of super-reality. As one *ayahuasquero* told Narby, 'I know that any living soul, or any dead one, is like those radio waves flying around in the air.' 'Where?' 'In the air. That means that you cannot see them, but they are there, like radio waves. Once you turn on the radio, you can pick them up. It's like that with souls; with ayahuasca and tobacco, you can see them and hear them.'[27] And he added 'The owner of these plants, in truth, is like God; it is the maninkari. They are the ones who help us. Their existence knows neither end nor illness.'[28]

This description matches what Van Lommel calls 'endless consciousness' and others 'the zero-point energy field', 'the akashic field' (*akasha* is Sanskrit for 'space') or 'absolute unitary being'. Deciding to conduct participatory research, Narby took ayahuasca under the supervision of an *ayahuasquero*. 'I suddenly found myself surrounded by two gigantic boa constrictors that seemed fifty feet long. I was terrified. These enormous snakes are there, my eyes are closed and I see a spectacular world of brilliant lights, and in the middle of these hazy thoughts, the snakes start talking to me without words. They explain that I am just a human being. I feel my mind crack, and in the fissures, I see the bottomless arrogance of my presuppositions. It is profoundly true that I am just a human being, and, most of the time, I have an impression of understanding everything, whereas here I find

myself in a more powerful reality that I do not understand at all and that, in my arrogance, I did not even suspect existed.'[29] That Narby saw snakes did not come as a surprise to the *ayahuasquero*: the mother of ayahuasca is a snake. As a young anthropologist and, as he himself put it, 'a materialistic humanist',[30] Narby experienced this as an important lesson in humility. He saw and felt himself to be part of a huge network of life, of vibrating energy. His holistic experience recalls life on the moon Pandora as portrayed in the 2009 film *Avatar* (written and directed by James Cameron). There is a conflict between people from Earth, with a cold, materialistic attitude that is entirely geared to exploitation of nature and shareholder profit, and the native population, who live in complete harmony with the mother goddess Eywa. Communication takes place as though all life on Pandora were one great energy field, a bio-botanical neurological network. The film's great success and the public's appreciation of life on Pandora indicate how unhappy people are with consumer society, and how they long to return to a – fictitious – primal state. Their great interest in theories about the 'network', 'field' or whatever one wants to call it may perhaps be seen as an example of present-day 'longing for paradise'.

Of course, the most obvious explanation is that ayahuasca creates the images in the brain and not, as the shamans claimed, makes outside information available through the plant world. Yet it did not seem plausible to Narby that the images he was confronted with, and their speed and coherence, were products of his own brain. 'Maybe I would find the answer by looking at both perspectives simultaneously, with one eye on science and the other on shamanism. The solution would therefore consist in posing the question differently: it was not a matter of asking whether the source of hallucinations is internal or external, but of considering that it might be both at the same time.'[31] Narby also

wondered whether the use of ayahuasca might be as effective a way to acquire biomolecular knowledge as microscope research in laboratories. That would bridge the gap between reasoning based entirely on processes in the brain and the possible existence of external information. Via intercultural parallels in mythology and art, Narby saw a link with molecular biology. He feels that the appearance of images such as the two snakes (sometimes entwined like the snakes on the caduceus, Hermes's rod), entwined lianas and spiralling ladders in shamanistic visions, or the *axis mundi* (the axis of the world that frequently occurs as an organising principle in mythology and rituals), is strongly reminiscent of the double-helix structure of DNA. Perhaps hallucinations and dreams put us on the wavelength of DNA and so enable us to receive information that would pass us by in a normal state of being.[32] In that case the snake could be the real interface between two worlds, the messenger, just as Hermes is the messenger of the gods – the snake as a liminal phenomenon, in accordance with the qualities ascribed to it in art and mythology. Narby emphasises that the shaman can decide how to use his newly acquired knowledge – for good or evil. This would integrate the shadow side that Jung saw in archetypes.

The question of why the same symbols recur in different cultures and ages has not yet been answered. As already mentioned, the supply of signs and themes provided by mythology, religion, folk tales and visual arts is by no means endless. The experiences of shamans and mystics, certain images in the work of artists and poets are closely related, even though their design, formulation and conception may differ. The cultural context plays a key role in this, as does the time when the manifestation occurred. In their book *The Serpent Grail* – as exciting a read as a Dan Brown novel – authors Philip Gardiner and Gary Osborn suggest that world religions were essentially the same and only differed in their outward appearance, their

cultural veneer, and that the origin of all religions was the snake, the giver of immortality.[33] This sounds an attractive idea, but a convincing timeline based on snake-oriented religious ideas cannot be constructed. The great temptation is to go back to the cradle of humanity, Africa; and indeed, in 2006, archaeologist Sheila Dawn Coulson found a remarkably ancient work of art in a cave in Botswana – a snake-like rock formation that was decorated with scales at least forty thousand years ago, using tools found at the site. A giant snake and the origins of humanity – surely as close to the Garden of Eden as you can get?

This 'snake cave' is located exactly where you might expect to find a depiction of a giant snake. The cosmogony of the Venda people of southern Africa includes a giant python that carried human beings and the rest of creation in its belly and regurgitated them. Although southern African figurative rock paintings may be just two to four thousand years old, a notched piece of ochre on which geometric patterns were marked some sixty-five thousand years ago has also been found.[34] Giant snakes, horned snakes, snakes with antelopes' heads and plumed snakes are common in southern African mythology, so it is no surprise to find giant snakes in rock paintings.[35]

Reconstruction of migration flows from Africa on the basis of snake symbols still requires a great deal of speculation, etymological pole-vaulting and extremely free association (to which this topic lends itself particularly well). However, one very plausible explanation for the exceptionally common occurrence of snake symbolism can be found in the workings of the psyche, namely the analogue thinking whereby the stages of life and the longings and dangers that confront us all are projected onto the continually 'self-rejuvenating' snake. Combining several disciplines may eventually bring us closer to a possible explanation of what may be called 'the collective

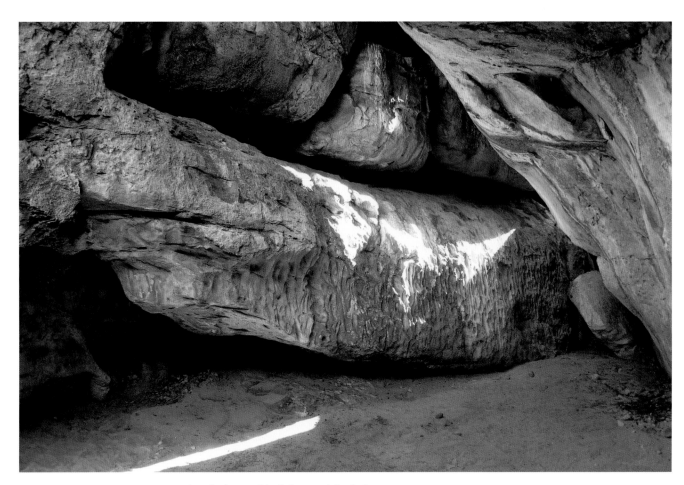

Rhino Cave, the carved south wall shown in the mid-winter late afternoon light. Photo by Sheila Coulson

unconscious', the world of the *maninkari*, the 'field' or the *reason* for the workings of the brain (rather than simply their cause). The snake is a vital archetype that will always be the subject of debate. 'Not for a moment dare we succumb to the illusion that an archetype can be finally explained and disposed of.'[36]

Act One

Expulsion from the Garden of Eden

So, if a timeline of snake religion or mythology cannot be constructed, the story of an exhibition about snakes will require a different structure, and one that is provided by the topic itself: the life of the snake in parallel with the manifestations of the snake in mythology and visual arts, in other words with the lives of human beings – the dramatic libretto of an opera in three acts.

The snake breaks out of its egg in order to be born. Its life on and under the ground is one of struggle with animals that threaten it, and also with its prey. It can use poison as a weapon. It will eventually die, but only after having suggested that it possesses the secret of everlasting life by repeatedly shedding its hardened skin. This strange cold-blooded creature has no arms, legs or wings, but is capable of moving very swiftly on both land and water. It makes a chillingly hissing or rattling sound, has no eyelids, and hence sleeps with its eyes open.

It is thus physically quite different from human beings. Yet humans must also leave a safe, protected environment: the womb. Their lives are also accompanied by struggle, and may or may not end with the idea of transition to another world. Just as the snake sheds its skin, we leave our bodies behind. Myths, from the Garden of Eden story to the tale of Percival, clearly refer to these three stages: expulsion from the safe initial state; the way of good and evil; and return (or at least a longing to return) to the lost paradise or the Grail. Metamorphosis is a constant. The myth implies a cyclical consciousness: the Ouroboros biting its own tail. In the following mosaic I will present the image of the snake as a metaphor for human life.

An early work by the eminent Dutch sculptor Cornelius Rogge (b. 1932) shows the primal origins of life: a bubbling surface with emerging life forms. In the late 1960s Rogge produced four unique small aluminium tableaux displaying the start of life. His primal forms included the snake, which appears outstretched and coiled as the first sign of life.

The typical feature of Rogge's work is metamorphosis. He constantly confronts us with contrasting pairs, such as material/immaterial and closed/open. Like a true alchemist, he shows

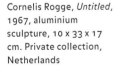

Cornelis Rogge, *Untitled*, 1967, aluminium sculpture, 10 x 33 x 17 cm. Private collection, Netherlands

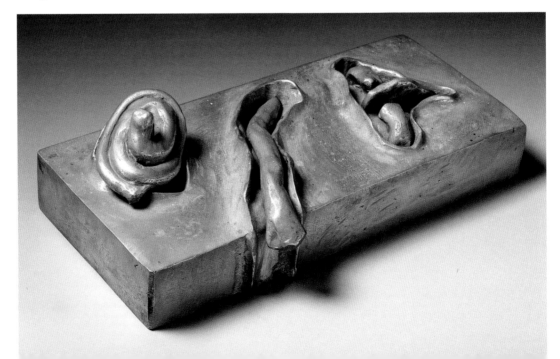

Luiz Figueiredo, *Adam & Eve*, acrylic paint on canvas, 68.6 x 78.6 cm. Collection: Stichting de Stadshof. Dr. Guislain Museum, Ghent

Moke, *Adam & Eve*, 1975, acrylic paint on flour sack, 100 x 89.5 cm, 609-48. Loan collection Dutch Cultural Heritage Agency

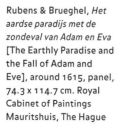

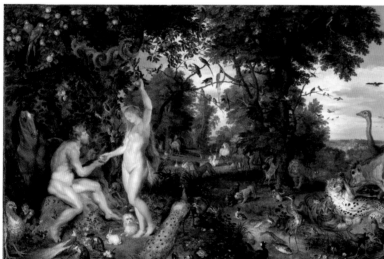

Rubens & Brueghel, *Het aardse paradijs met de zondeval van Adam en Eva* [The Earthly Paradise and the Fall of Adam and Eve], around 1615, panel, 74.3 x 114.7 cm. Royal Cabinet of Paintings Mauritshuis, The Hague

Lucas Cranach the Elder, *Adam & Eve*, 1526, oil paint on panel, 117 x 80 cm. Collection: Courtauld Institute of Art Gallery, London

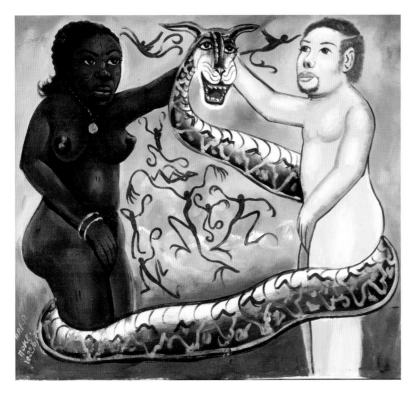

the workings of the spiritual as manifested in matter. He shows the transformation, the process whereby the spirit seeks to break free from matter. This transformation is also reflected in his actual work when he includes images from earlier work in a new constellation. The motto that applies to his work is Heraclitus's famous adage 'everything changes and nothing remains still.'

No stage is permanent; even the protection of the Garden of Eden is temporary. The Adam-and-Eve story is one of the everlasting themes in art history. It has been used both by great masters such as Lucas Cranach the Elder (1472-1553), Jan Brueghel the Elder (1568-1625) and Peter Paul Rubens (1577-1640), as well as by numerous unknown artists and advertising designers. It is not a theme that can easily be approached from a new angle. Yet John Breed (b. 1969) managed it: for the first time, the Garden of Eden scene was depicted as a direct confrontation with death. Adam, Eve, two (!) snakes, a heron, a peacock, a wallaby, a beaver and a pig are silver-plated skeletons – in the case of the animals he used, real skeletons: a python for the snake in the tree, and a highly poisonous Chinese pit viper for the one crawling downwards. Artificial skeletons were used for Adam and Eve. Whereas John Milton (1608-1674) followed up his epic poem *Paradise Lost* with *Paradise Regained*, John Breed left things in no doubt: his Adam-and-Eve tableau is called *Goodbye Paradise*. Yielding to temptation was the main feature of Milton's first poem, but in the second one Jesus resists Satan's temptations, thereby restoring the link with God and regaining paradise for mankind. In Milton there is thus still hope; but, in Breed's spectacular work, temptation results in a permanent farewell to the innocent primal state. There is no way back. His composition was inspired by Brueghel's and Rubens's depictions of paradise; Adam's and Eve's poses and above all the way in which she is reaching out to the tree are based on Bernini's sculpture of Apollo,

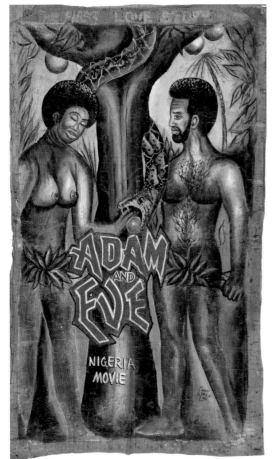

Moke, *Adam & Eve*, 1975, acrylic paint on flour sack, 91 x 100 cm. Collection: Afrika Museum, Berg en Dal, 567-4

Movie poster, *Adam and Eve, subtitle: The First Love Story*, Nigeria 2003, Mr. Brew Art, 189 x 111 cm. Collection: Mandy Elsas

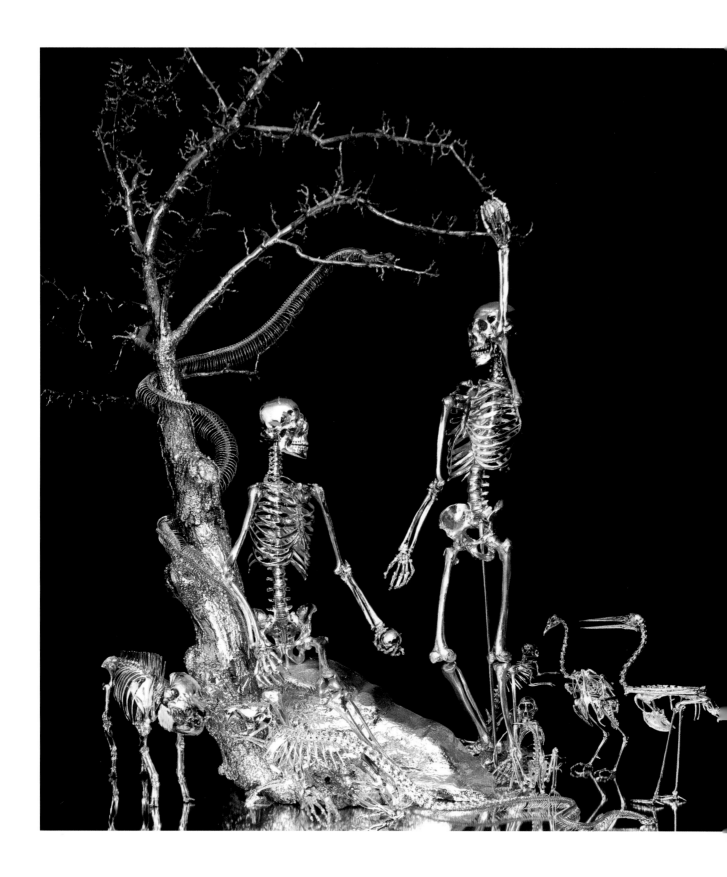

John Breed, *Goodbye Paradise*, 2010, bone, silver alloy, glass, 220 x 110 x 350 cm. Artist's own collection

with one arm round Daphne and the other pointing downwards, while Daphne's raised arms are already starting to turn into a tree. The picture is shiny, glittering glamour, but, as Breed emphasises, 'it only reflects the here and now – paradise no longer exists.' It thus expresses a contemporary awareness of life; in the material world of outward appearances everything is transient, and there is no room for a numinous experience of existence. The two snakes symbolise farewell: the way to temptation and the knowledge of good and evil, and then crawling in the dust of the earth forever after. Breed has always shown a great interest in classic techniques, studying the painting of frescoes in Rome, calligraphy in Japan, graffiti in New York, icon painting in Russia and landscape painting in China. As a decorator he has designed clubs and hotels from New York to Kazakhstan. He is sufficiently familiar with outward appearance to render its relativity with technical perfection.

Creation stories involve separation – separation from the primal, divine world of paradise. Expulsion from paradise implies an eternal

longing to return there, the end of the separation. Awareness of the male/female and divine/human duality immediately results in a longing to be reunited, to become whole once more.

In mythology the perception of harmony between heaven and earth is as important as the harmonious fusion and cooperation of the male (*animus*) and female (*anima*) in people and society. 'From Sumeria and Egypt to the beginning of the Christian era, the ritual of the sacred marriage between the Virgin Mother Goddess and her son-lover, the god, gave the psyche an image of wholeness and relationship, uniting the two dimensions of heaven and earth, spirit and nature, which language separates.'[37] In Mesopotamia a new king was expected to contract a *hieros gamos* (sacred marriage) with the mother goddess, or specifically her high priestess. Their union made the kingdom prosper. Eliade states that this connection is a repetition of a divine example, the primal connection of heaven and earth, which resulted in the creation of the cosmos. The repetition leads to cosmic rebirth, i.e. the fertility of the

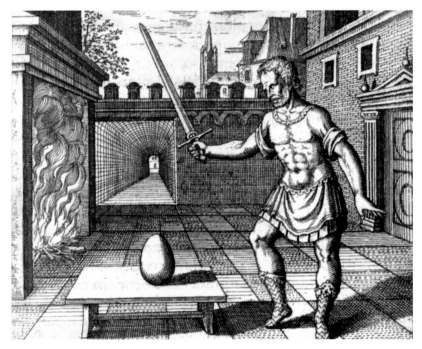

Michael Maier, *Atalanta Fugiens*, Oppenheim 1617. The sword symbolises inner fire, while the egg symbolises (primal) matter that is destroyed to make way for new life

Print of snake couple,
Naga Pachami,
illustration on cardboard,
Nepal, 44.7 x 27.9 cm.
Collection:
Tropenmuseum,
Amsterdam, 4368-2

land.[38] Later – some say during the Iron Age – the goddess's role was taken over by the god,[39] and the goddess was degraded to the consort or mother of the dying and resurrected god.[40]

This process was already heralded in the Gilgamesh epic, which was recorded in cuneiform on clay tablets around the late third and early second millennium BCE. The hero Gilgamesh, king of the city of Uruk around 2620 BCE, refuses to marry the great mother goddess Ishtar, to whom a temple in his city is dedicated. Refusing the *hieros gamos* with the goddess – a marriage that would bring great prosperity to the city – is something that cannot go unpunished. Ishtar asks her father Anu to set the celestial bull on Gilgamesh. Together with his friend Enkidu, Gilgamesh conquers the bull, whereupon the gods decide that Enkidu must die by way of punishment. This confrontation with death makes Gilgamesh go looking for the life plant in order to attain everlasting life. With great courage and effort he finds the plant, but when he goes bathing in a pool it is taken from him – by a snake.

'A snake smelled the fragrance of the plant, silently came up and carried off the plant. While going back it sloughed off its casing.'[41]

The link between the snake and the life-giving plant is a theme that recurs in other cultures. In myths from classical antiquity, a snake is killed and then revived by another snake with a life plant.[42] The snake is often familiar with medicinal plants. It is no accident that the divine healer Asclepius and his daughter Hygieia are depicted with a caduceus and a snake respectively. However, in the case of the unfortunate Gilgamesh, the snake takes from humans the knowledge they would so dearly like to possess.

Failure to resolve contradictions, to unite the male and female principle, leads to calamity, whereas their union leads to prosperity and fertility, in other words regeneration. In alchemy, as we will see, *coincidentia oppositorum* is an equally important theme, and results in spiritual rebirth. Primal couples, the primal father and mother, are shown entwined.

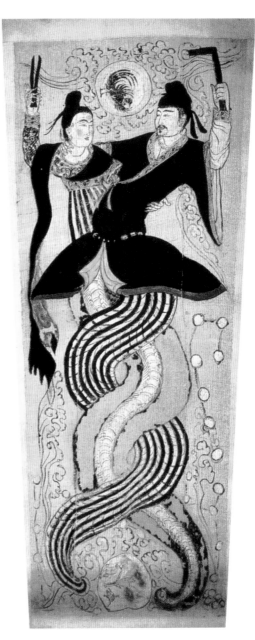

Benoit Rigaud, Dambala and his consort, acrylic paint on canvas, 45 x 65 cm. Private collection, USA

Chinese Adam and Eve: Fu Hsi and Nu Kua

The Chinese Adam and Eve, Fu Hsi and Nu Kua, are depicted as half-snakes whose tails are entwined like the double helix we know from both the structure of DNA and Indian depictions of *kundalini* energy[43] (this will be discussed in more detail later). An unusual depiction of the union of two *Iwa* (spirit beings) from the Haitian *vodou* pantheon is the union of Dambala and Ayido Wedo by the painter Benoît Rigaud (1911-1986). Rigaud married the daughter of Hector Hyppolite (1894-1948), undoubtedly the most famous of Haiti's first generation of artists around the *Centre d'Art* set up by the American

conscientious objector Dewitt Peters.[44] Hyppolite was embraced in Europe as the new Henri Rousseau, as the painter of an unspoiled paradise filled with natural forces. On visits to the *Centre d'Art* in 1945 and 1948, the grand master of Surrealism André Breton bought many of Hyppolite's paintings. From another private collection comes Hyppolite's painting of Dambala, the patriarchal snake god who is associated with both rain and fire (wisdom and creative force).[45] Hyppolite shows him in profile as a young man with a snake's body and with wings such as the messenger of the gods,

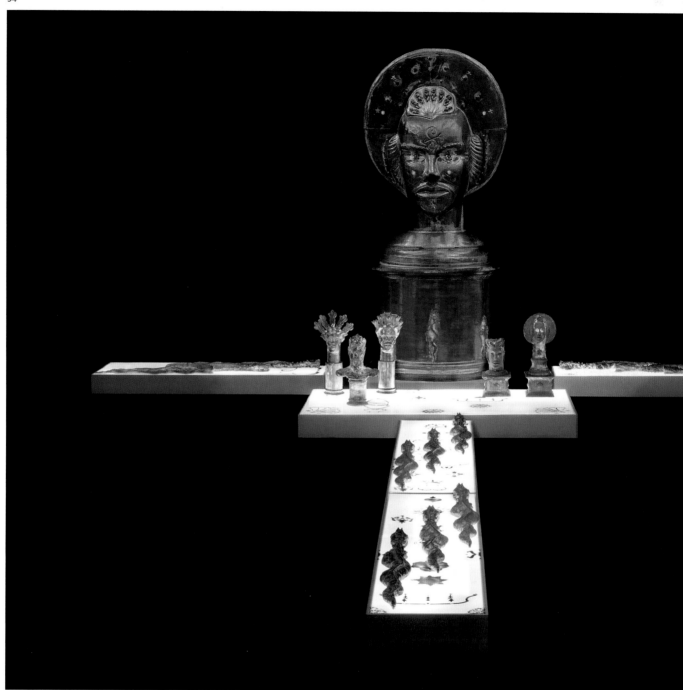

Edouard Duval Carrié, *Apotheosis Altar,* 2004, polyester, various materials, 350 x 800 x 800 cm. Collection: Afrika Museum, Berg en Dal

Hermes, wears on his helmet in classical Greek depictions. Hermes's fixed attribute is the caduceus, the rod with two snakes entwined into a single figure. Presenting Dambala as a winged snake symbolises the resolution of the contradictions between earth and heaven. Rigaud's highly sophisticated painting also reconciles contrasting elements, a god and a goddess that are entwined like the snakes on the caduceus.

Another striking example of the *mariage mystique* ('mystical wedding') is the installation *Apotheosis Altar* (2011) by Edouard Duval Carrié, a Miami-based Haitian artist who combines Haitian sources of inspiration with his international outlook and design. *Vodou* merges Catholic symbols and saints with the symbols and spirit beings of West Africa, from where many people were taken to the Caribbean island as slaves. At

the time, the plantation owners must sometimes have thought that Catholicism had successfully supplanted the forbidden African religion. But nothing was further from the truth, for the slaves managed to preserve their spiritual world intact in Catholic disguise. The Africans recognised the spiritual power of their own pantheon in the powers that were attributed to the saints. Thus an uninitiated observer could easily see Mary and her baby Jesus where Erzulie and her daughter Anaïs were intended. Erzulie ('Ezili' in Haitian Creole) is the matriarch, the great goddess. She is manifested in three forms: Erzulie Freda, a young woman, seductive and dangerous, a beautiful goddess of revenge,[46] Erzulie Dantor, the goddess as mother, and Gran Ezili, the grandmother, the wise old woman.

It is tempting to draw a comparison to Hecate, referred to in Greek as *trimorphos*, a goddess with three forms.[47] An early triple depiction of Hecate shows her riding on two lions, just like

Lilith. The creatures that are always dedicated to Hecate include the snake. Like Lilith, Hecate is associated with natural forces and the dark aspects (magic, the other world) of the great goddess. There is still no satisfactory explanation for the three forms; but they have been associated with the three fates,[48] so that the past, the present and the future can be related to Hecate just as youth, adulthood and old age are related to Erzulie. In Mithraea – places of worship for followers of the mystery god Mithras, in caves or subterranean spaces – three-headed sculptures of Hecate have been found, which in this context could represent three essential human motives,[49] in the manifestations Minerva-Athena, Diana-Artemis and Venus-Aphrodite, respectively symbolising pride and passion, the spirit and the heart, and libido energy. The purpose of the fascinating mystery religion Mithraism, in which there were seven degrees of initiation (we will return to these later), was to learn how to control passions and achieve balance.

Mother goddesses are always associated with the crucial features of life: birth, life itself and death. The Eleusinian mysteries, in which the initiate stroked the goddess's snake, were dedicated to the great goddess of vegetation Demeter, who conceived her daughter Persephone by her brother Zeus in the form of a snake. The snake was in a basket or box, the *cista mystica*. 'Divine life withdrew into the basket, died and reappeared over and over again.'[50] This process of appearance and disappearance corresponds to the seasons and hence the fate of Persephone, who was abducted by Hades and taken away to the underworld; Persephone was allowed to return to her desperate mother, but, because she had eaten the seeds of a pomegranate, creating a link with the other world, only for half of the year, in the spring and summer; she had to spend the other half with Hades. The pomegranate, which we will come back to shortly, is said to

Hecate, 200-300 CE, 2.85 x 2.35 cm. Collection: Herzog Anton Ulrich Museum, Braunschweig, Germany, Kunstmuseum des Landes Niedersachsen (museum photographer), Gem 155

have been the apple that Eve offered Adam. It symbolises the productive, fertile nature of life and the dodecahedron, in which the golden section is present;[51] twelve months divided into two parts, one part for light and fertility and another, equally large part in which crops are harvested, also a period of autumn, decay, death and impetus for regeneration – two inextricably connected parts, like the two snakes in alchemy that together form an Ouroboros, the top one with wings and the bottom one with none. As Persephone is being abducted, she is seen and heard by two opposing gods: Helios, who as the sun god in the sky witnesses everything that takes place on earth and hence observes the scene; and Hecate, who at that moment is in a cave (a reference to the entrance to the underworld)[52] and hears her cries for help. Hecate helps Demeter search for her daughter. The three figures Demeter, Hecate and Persephone may perhaps account for the triple nature of Hecate,[53] providing the link between the goddess of land and fertility and Persephone, who is now connected to the

underworld. Hecate is a 'guardian of the threshold.'[54] Her position in between this world and the next is similar to that of the snake that is dedicated to her, which also appears from and disappears into the 'underworld'. The three aspects of Erzulie are reminiscent of Hecate *trimorphos*.

Duval Carrié has cast the *mariage mystique* of Dambala and Erzulie Dantor in a form that enhances the fusion of contrasts: a united cross and circle. The matriarch is the central figure, snakes wind their way along a path of light that is painted with mysterious figures, *vévé* signs (signs of the spirit beings), blue on white.[55] Around Erzulie are busts of other *lwa*. She is accompanied by a silver-coloured Agowe, Aizan is a powerful natural force, and we see a young Erzulie with flowers: Erzulie Freda and General Sobo, the thunder that announces Erzulie's appearance and, like Agowe, seeks her favours. Dambala is present in the form of snakes, referred to by Duval Carrié as 'cosmic sperm' – 'the perfect symbols of time (as in Dahomey where the circular snake is eating its tail in an unending cycle!).'[56] The great goddess's head is surrounded by a halo full of babies. The marriage can take place and will be fruitful! Traditionally Ayida Wedo (also spelled Aida Wedo), the rainbow snake that surrounds the earth, is seen as Dambala's wife; but, as Duval Carrié explains, 'When I went to Benin I found out that there is a gender issue, for over there she is a he: Ai Do Dan Wedo, same rainbow concept (the firmament or the cosmos superstructure which envelops us). How he became a she in Haiti is a puzzle to me but the Haitian scheme fits better the concept of a universe maintained and fuelled by time (Dambala) in this cosmic wedding *pas de deux*. So as not to lose myself in a gender issue that is as futile as incongruous I decided to bring the whole concept one notch down and speak solely on the "survival of the species": ours and not of the universe. Thus the archetypal mother Erzulie

Temple in Haiti, Jacmel 1993. Photo: Marilyn Houlberg

Dantor, the genitrix, fierce protector of women and their reproductive cycle, becomes the consort of the male/time representative who is Dambala (snakes) in order to maintain the balance of life!!!'[57]

A remarkable reference to Dambala was found in a Haitian *hounfour* (temple) in 1993: Richard Avedon's 1984 photograph of a naked Nastassja Kinski with a snake coiled round her. To the *houngan* (priest), the snake was the logical connection with Dambala.[58] A manufacturer of pomegranate juice recently produced a promotional film in which Nastassja Kinski's daughter was shown in the same pose as her mother all those years ago, with a snake coiled caressingly round her.

The god with snake's legs and the winged snake: the great desire for spiritual regeneration

'The way is within us, but not in gods, nor in teachings, nor in laws. Within us is the way, the truth and the life … The signposts have fallen, unblazed trails lie before us,'[59] wrote Carl Gustav Jung in his famous *Das Rote Buch* ('*The Red Book*'), named after the red leather cover of the tome full of his paintings and calligraphy. In 1913 he began an awe-inspiring descent into the unconscious, based on 'active imagination', a kind of sleepless dreaming in which he opened up to images and ideas that were slumbering deep within him. Initially he drew and wrote this 'travel report' on his intimate journey through the soul in black notebooks, but later he worked the material out in greater detail in *The Red Book*. The universal is attained from the personal through confrontation with the unconscious; the search reflects the desire for a new image of god.

Whereas God had been declared dead by Nietzsche, Jung proclaimed the rebirth of God in the soul.[60] This period was marked by his break with Freud. The First World War was looming. *The Red Book* describes a sense of imminent calamity, but also spiritual development (to which Wouter Bleijenberg returns in his article). Jung worked on the book for sixteen years and ended the experiment in 1930.

In the early twentieth century, especially the inter-war period, with the horrors of the First World War still fresh in people's minds, there was a strong desire for a new outlook on life. The old patriarchal world order, and the accompanying authority of the church, were crumbling. In Paris, the Surrealists, led by André Breton (1896-1966), were fascinated by whatever took place in the twilight zone between the conscious and the unconscious; they studied the work of Freud, but also hallucination and the products of 'mental illness'.[61] Breton wanted to link up the outer and inner worlds, the rational and the irrational, in an unusual realism called Surrealism – a world beyond everyday consciousness, beyond

Erotic obsessions

An example of an 'outsider artist' who was obsessed with women and snakes was Friedrich Schröder Sonnenstern (1892-1982). In the years after the First World War, Sonnenstern worked in Berlin as a self-styled esoteric natural healer under the flamboyant name Professor Dr. Eliot Gnass van Sonnenstern. He shared his income from these dubious practices with the poor. After the Second World War, at his wife's urging, he began to draw, and the resulting fantasies earned him the admiration of such artists as Jean Dubuffet, Hans Bellmer and the Surrealists, who included his work in exhibitions in Paris, New York and Milan. His struggle with sexuality in combination with his visionary imagery yielded fascinating drawings with all the mystical-erotic charge and glowing colours found in tantric paintings.

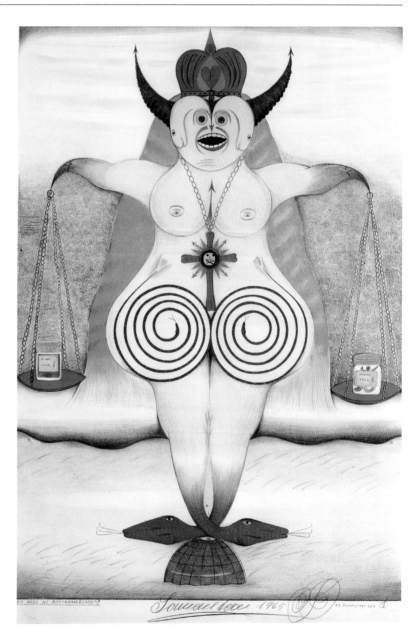

Friedrich Schröder Sonnenstern, *Die Wabe*, 1954, lithograph. Private collection, Netherlands

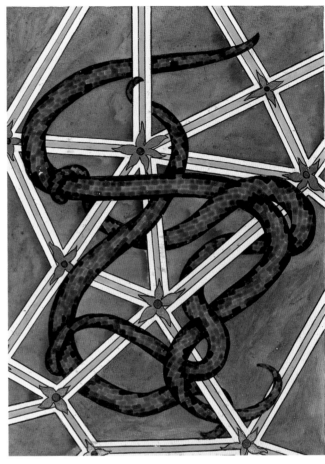

Meret Oppenheim, *Spiral, Snake in Rectangle*, 1973, pastel and ink, 68 x 49.5 cm. Collection: Kunstmuseum Bern, Switzerland, artist's legacy. Copyright Pictoright Amsterdam 2011

C.G. Jung, *Das Rote Buch*, Copyright 2009 Foundation of the Works of C.G. Jung, Zurich. First published by W.W. Norton & Company, Book 2-071b

the range of reason. The snake is a recurrent feature in the work of Surrealists such as Meret Oppenheim (1913-1985) and Leonora Carrington (1917-2011).

Jung's work certainly influenced Oppenheim: 'Many of her motifs and figures – among them the snake, the spiral, the eye, and mandalas – are borrowings from Jung. The snake, in particular, which for Jung is "a most fitting symbol of the unconscious", crops up in dreams and works from almost all her creative periods. And even if it appears in a wide variety of forms and materials, it is still clear that the serpent, like the spiral, is a recurrent leitmotif for the same theme – the return and regenerative power of nature – throughout Oppenheim's oeuvre.'[62] In the rich illustrations contained in *The Red Book*,

reminiscent of medieval illuminations, the snake regularly appears as a symbol of the transforming journey of the soul through life, the process of individuation. The snake appears with remarkable frequency in Oppenheim's work, from a mysterious wooden box with a snake on it (*The Black Snake knows the Path of the Islands*) or a Hermes-Mercury fountain with a winged caduceus and a large painting on the power of vegetation that would serve well as an illustration of an ayahuasca vision, to the remarkable picture *Spiral: Snake in Rectangle*, which shows horizontally and vertically woven snake patterns that recall Nasca cloth. Placed next to an illustration from *The Red Book*, both pictures suggest a snake labyrinth, a depiction of the quest that is the process of individuation – with the snake as guide.

Meret Oppenheim, *De zwarte slang kent de weg van de Eilanden (The Black Snake Knows the Path of the Islands)*, 1963, wood, glass, 30 x 30 x 8.5 cm. Collection: Galerie de France, Paris

Meret Oppenheim, *Mercury's Fountain*, 1966/2000, bronze, 220 x 180 x 180 cm, photo: Roman März in *Il Giardino di Daniel Spoerri*

In 1936, when Leonora Carrington broke away from her respectable English family at the tender age of nineteen to join her lover Max Ernst (1891-1976), she and her writings were instantly accepted by André Breton and the circle of

Surrealists. Her paintings, which have a clearly alchemical signature, also include snakes. This is particularly true of *Forbidden Fruit* (1969), in which we see a snake entering a closed space via a small opening in a wall and circling round

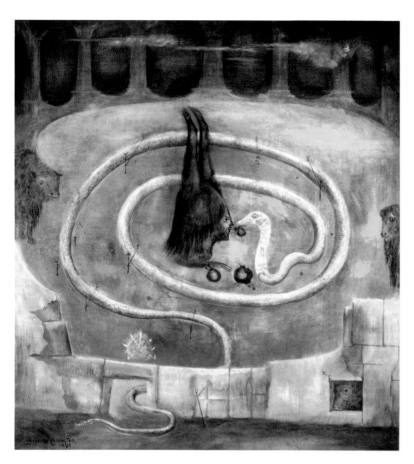

Leonora Carrington, *Forbidden Fruit*, 1969, oil paint on canvas, 49 x 46 cm. Private collection, France

beautiful snake Serpentina describes to her lover Anselmus in E. T. A. Hofmann's novel *The Golden Pot* as 'a childlike poetic nature',[63] an openness to other worlds that allows the 'golden pot' – alchemical, i.e. not real, gold – to be attained. In *The Red Book* Jung comments 'Scholarliness alone is not enough; there is knowledge of the heart that gives deeper insight.'[64]

Hermann Hesse's coming-of-age novel *Demian: the Story of Emil Sinclair's Youth* (1919) is more than just the story of an individual process of maturation in an oversensitive young man who sets out to find himself and a spirituality that deviates from the socially established religion. 'The bird fights its way out of the egg. The egg is the world. Who would be born must first destroy a world. The bird flies to God. That God's name is Abraxas.'[65] Thomas Mann felt that the story struck a precise chord with the times and expressed exactly what the younger generation was looking for. The recovery of a lost unity, the elimination of Christian duality, in essence the pursuit of a holistic consciousness, is what Emil Sinclair, the same kind of protagonist as Anselmus in Hoffmann's tale, longs for. In his vulnerability and uncertainty he is assisted by his mysterious friend and spiritual guide Demian, who sends him the above text. Demian is what Philemon was to Jung. In Jung's visionary work *The Red Book*, Philemon appears as a teacher of wisdom, and the same mysterious god is called Abraxas. Hesse was treated by Jung for a while, and *Demian* can be read as the report on a Jungian individuation process.

The Herzog Anton Ulrich Museum's collection in Braunschweig includes an Abraxas-Hecate gem that was made in Alexandria in the second to third century CE and was later framed with a snake-like coil that forms a circle, so that it can be worn as an ornament. Such gems, which serve as amulets or talismans, are not unique, but this is an unusually fine gnostic depiction of *coincidentia oppositorum*, the mystical resolution

a strange creature that appears to rise up out of the earth. The snake is offering the creature a pomegranate. Lying on the ground between them are two pomegranates, one of which is broken open, releasing its red seeds. The association with Persephone is inescapable. Two bulls are looking on, and a third is gazing with one eye through an opening in the wall. The bulls enhance the chthonic nature of the scene and recall the image of both the Minotaur and the Mithraic bull, which we will return to later. The snake seems to be offering both food and knowledge (the aforementioned meaning of the pomegranate).

The search for renewal implies a struggle with traditional values – it is by definition an individualistic, difficult way that can lead to a conflict with society. This requires what the

of contrasts. On one side we see the year and sun god Abrasax/Abraxas in Roman armour, with a whip in his right hand and a shield in his left. Abraxas has a man's torso and a cockerel's head, and snakes for legs.[66] The background is sky-blue. The Greek letters in the name of the god have the numerical value 365 – Abraxas is the ruler of the 365 heavens and the 365 days of the year cover the entire seasonal cycle, an endless repetition of emergence, decay, death and regeneration. The whip is an attribute of the sun god Sol; the snakes' heads carry a solar disc.[67] The cockerel refers to dawn. Although the cockerel, solar disc and whip refer to all the aspects of light and day, the snakes naturally also have a chthonic side. It is no accident that they are the deity's legs – he is not detached from the earth. Abraxas resolves contrasts; the coin cannot exist without its reverse side. As mentioned, the number 365 refers to the revolution of the sun, but is also associated with the 'cavern of death and rebirth'.[68] It was necessary to descend a 365-step staircase to see the cave mysteries of Hecate, the goddess of night and the other world, whose attributes were a key, a whip, a dagger and a torch. Hecate lights the way, and bears the key to the underworld.

On the reverse side of the gem we find Hecate *trimorphos*, the three forms of the goddess in a single image. The background is as black as night. The gem links day and night, the upper world and the underworld. Abraxas is described as *agathos daimon*, a good, protective force. Like Emil Sinclair, Jung was confronted with Abraxas on his journey through the soul, and he emphasises that he does *not only* represent the good: 'Hard to know is the deity of Abraxas. Its power is the greatest, because man perceiveth it not. From the sun he draweth the SUMMUM BONUM; from the devil the INFINUM MALUM; but from Abraxas life, altogether indefinite, the mother of good and evil.'[69] – the contrasts resolved in a single divine image, just as in the Abraxas-Hecate gem.

The same collection as this gem includes a remarkable drawing of a cockerel with a snake's tail, a reptilian ribcage and outspread wings, produced by an anonymous Dutch artist, perhaps in the eighteenth century. The creature is nothing less than the basilisk, the king of serpents, part-snake, part-cockerel, and apparently also hatched from a cockerel's egg by a snake. According to the poet Lucan (39-65 CE) it sprang forth from Medusa's blood, hence its ability to kill with a glance.[70] It was so poisonous that its mere breath was deadly. This basilisk is an insignificant cockerel compared with the blood-curdling monster that confronts Harry Potter in *The Chamber of Secrets*. Yet, unlike in that Hollywood version, this basilisk is true to life, for the artist added the words 'drawn after a dead basilisk.'

Just as Hesse expressed the sense of a new spirituality that harked back to the gnostic Abraxas, D. H. Lawrence's *The Plumed Serpent* (first published in 1926) sought a primal religion in Mexico. 'We must take up the old, broken impulse that will connect us with the mystery of the cosmos again, now we are at the end of our own tether,'[71] thinks Kate, the Irish protagonist

Abraxas, 200-300 CE 2.85 x 2.35 cm. Collection: Herzog Anton Ulrich Museum, Braunschweig, Germany, Kunstmuseum des Landes Niedersachsen (museum photographer), Gem 155

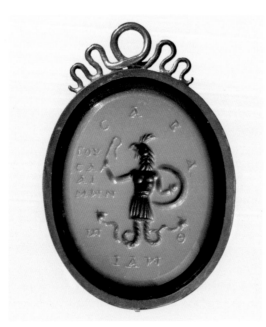

43

of the Aztecs, saw Hernán Cortés as the incarnation of Quetzalcóatl – a fateful error, as the conquistadors' thirst for gold would prove. Don Ramón wants to restore the primal force of pre-Columbian religion to Mexico and drive out the conquerors' Christianity that destroyed Moctezuma's empire. Kate becomes obsessed with him and his friend, General Cipriano Viedma, the self-appointed incarnation of Quetzalcóatl's opposite, the war and sun god Huitzilopochtli, the son of Coatlicue, the earth goddess who wears a skirt made of snakes. Kate finds Mexico and Indian spirituality as horrifying as they are attractive. She finally lets herself be overwhelmed by the primal earth religion; in this dark cult of blood and regeneration she discovers what she finds lacking in rational, industrialised Europe. She finally 'goes native' and abandons her Western individualism by deciding to marry her virile general rather than return home. Don Ramón expresses Lawrence's ideas on the return of pre-Christian religions in the following terms: 'So if I want the Mexicans to learn the name of Quetzalcoatl, it is because I want them to speak with the tongues of their own blood. I wish the Teutonic World would once more think in terms of Thor and Wotan, and the tree Iggdrasil. And I wish the Druidic world would see, honestly, that in the mistletoe is their mystery, and that they themselves are the Tuatha

Watercolour, 36.2 x 25.8 cm. Collection: Herzog Anton Ulrich Museum, Braunschweig, Germany, Kunstmuseum des Landes Niedersachsen, photo: museum photographer, H 27, No. 28, Bl 113

Statuette, *Quetzalcóatl*, Toltec/ Mexico, 30 x 20 x 20 cm. Collection: Tropenmuseum, Amsterdam 3502

in the novel, who admires the Mexican Don Ramón. Don Ramón sees himself as an incarnation of the god of wind, wisdom and life, Quetzalcóatl, the Plumed Serpent, 'lord of two ways' and 'master of up and down'. Quetzalcóatl belongs to the earthly and heavenly domains; he is the transcendent deity, lord of the transitional stages between day and night, between death and rebirth, and has been associated with the moon.[72] In one Quetzalcóatl myth, the god sacrifices himself and his heart very aptly becomes the morning star, the twilight star that stands between darkness and light.[73] In another myth he departs on a raft made of intertwined snakes, and will return one day. Moctezuma, king

De Danaan, alive, submerged. And a new Hermes should come back to the Mediterranean, and a new Ashtaroth to Tunis; and Mithras again to Persia, and Brahma unbroken to India, and the oldest of dragons to China … Ah, the earth has Valleys of the Soul, that are not cities of commerce and industry. And the mystery is one mystery, but men must see it differently.'[74]

Some years after *The Plumed Serpent* was published, a *Blut und Boden* spirituality that would have made Lawrence (who died in 1930) shudder surfaced in old Europe; but he had in any case sensed the *Zeitgeist* and the slumbering desire for a new religiosity every bit as well as Hesse.

Act Two

Duality: the way of good and evil, disease and cure

Help! help! or else I am lost,
Chosen victim of the cunning serpent.[75]

We have already seen that the snake is a liminal symbol – a creature on the threshold between two worlds. It is also a symbol of duality. Duality also typifies life: the struggle between good and evil, the confrontation with disease, the hope of cure. In the sixteenth and seventeenth centuries, snakes appeared in allegorical prints of virtues and sins. *Prudentia*, shrewdness, can be associated with a piece of advice from St Matthew 10:16: 'Be as shrewd as snakes.'[76] Snakes were equally suitable as symbols for negative qualities such as cruelty and envy: they were depicted writhing horridly and with vicious-looking heads, 'for instruction and delight'.

In mythology the path of life is depicted by the way of the hero, who not infrequently has to vanquish a snake or dragon. Mozart's opera *The Magic Flute*, an alchemical allegory of initiation,

begins with the hero, Prince Tamino, being threatened by a large poisonous snake – a seemingly overwhelming danger, the announcement of the start of the alchemical 'great work' (the black or *nigredo* stage). Tamino is rescued by three women, servants of the Queen of the Night, who vanquish the snake. After many trials the opera ends with a *hieros gamos*, the sacred marriage or *coincidentia oppositorum* that we have encountered before.[77] Mythological and alchemical themes match up closely.

The snake as the symbol of the struggle with evil is a well-known motif. The hero Hercules, whom we encountered when he outwitted a hundred-headed snake monster, had already engaged in a struggle with what was if possible an even more horrific monster: the Hydra, a many-headed water snake with poisonous breath. The problem when fighting the Hydra was that, whenever one

Sculpture, Classical Antiquity, early Imperial period, 0-100, marble, 23.5 cm. Collection: Dutch National Museum of Antiquities, Leiden, F1951/8.4

Jacques de Gheyn (II), *Prudentia*, around 1600-1625, engraving, 14.8 cm. Collection: Museum Boijmans van Beuningen, Rotterdam, BdH 9758 (PK)

Hieronymus Wierix, *Crudelitas*, around 1580-1585, engraving, 20.8 x 13.3 cm. Collection: Museum Boijmans van Beuningen, Rotterdam, BdH 9829 (PK)

INVIDIA.

Inuidia, *alterius macrescens rebus opimis,*
Lites, *diſſidia, et* Bella *cruenta parit.*

Karel de Mallery, *Invidia*,
around 1590-1610,
engraving, approx. 16 x
22.7 cm. Collection:
Museum Boijmans van
Beuningen, Rotterdam,
BdH13274 (PK)

C.G. Jung, *Das Rote Buch*,
Copyright 2009
Foundation of the Works
of C.G. Jung, Zurich. First
published by W.W.
Norton & Company, Book
2-109b

of its heads was struck off, it grew two more.
With the help of his nephew, who cauterised
each wound after Hercules had struck off a head,
the hero managed to kill the creature. He then
used the poisonous blood as venom for his
arrows – a fateful error, for he himself would
later die of it. So in the end Hercules did not
escape his punishment, for his heroic feats were
always atonement for earlier acts of violence.

The hero Cadmus also had to vanquish a dragon
or snake, which was guarding a spring near the
place where Cadmus wanted to found the city of
Thebes. Cadmus sent his companions to the
spring to fetch water for a libation; but they
failed to return, having been killed by the giant
snake living by the spring. The hero then did
battle with the monster, and managed to pierce
it with his lance and pin it to an oak tree, which
was sacred to both the Greeks and the Germans.
This combination of elements – a spring, a snake-
like monster, a hero, a lance, a sacrificial death
and a tree – could almost be considered
archetypical.[78] The image of Christ on the cross,

said to have been made from the wood of the tree in the Garden of Eden, and of Odin nailed to the world tree Yggdrasil after being wounded by a spear, evokes the idea of regeneration – the sacrifice provides nourishment, and creates new life. The tree of life and the source of life are 'tapped' by Cadmus; the hero's sacrifice of the snake pinned to the tree gives the people the vital force they need in order to found the city. Pallas Athena advises him to sow the monster's teeth, causing warriors to rise up from the ground and then fight and kill each other. Only five survive; they make peace and become Cadmus's new comrades. The vanquished snake or dragon is an animal belonging to the god of war Ares, and the warlike deity seeks revenge. In gratitude for his services to Zeus, Cadmus has earlier been given Harmonia, the daughter of Ares and Aphrodite (hence a fusion of 'war' and 'love'), as his wife. Their life together is long, but not without its sufferings or setbacks. Cadmus will later lament that the gods' anger at him for killing the snake or dragon has lasted so long.

'If that is what the gods have been avenging
In their terrible anger, may I lay out my length
As a long-bellied snake.' And as he spoke, he did
Lay out his length as a long-bellied snake
And felt his skin turn into hard black scales
Chequered with blue. As he lay on his stomach
His legs fused together and tapered to a point.
What was left of his arms he stretched out to his wife,
And with tears running down his still-human cheeks,
'Come here,' he said, 'my poor, ill-starred wife,
While there is still something left of me. Come here
And touch me, hold my hand while it is still a hand,
While the serpent has not yet usurped me completely.'
He wanted to say much more, but suddenly
His tongue was forked and words wouldn't come,
And even plaintive sounds came out as a hiss.'[79]

Harmonia now also wants to become a snake, and shortly afterwards they crawl away into the woods, 'their coils intertwined' – as Ovid adds, 'they neither avoid people nor try to harm them', but remain peaceful creatures.

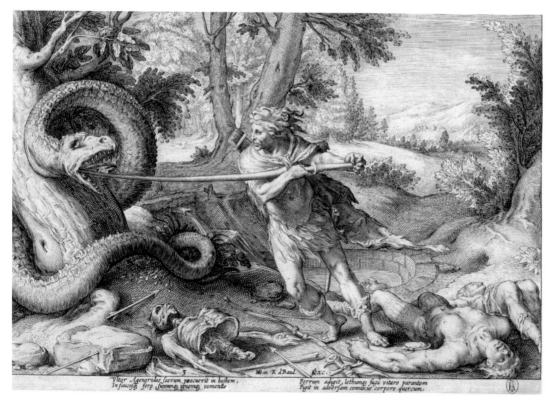

Hendrick Goltzius, *Cadmus doodt de draak bij de fontein van Mars* [Cadmus slays the dragon by the fountain of Mars], 1615, engraving, 16.5 x 25 cm. Collection: Museum Boijmans van Beuningen, Rotterdam, BdH 17698 (PK)

In 1994, at the age of sixty-four, Niki de Saint Phalle (1930-2002) wrote her autobiographical book *Mon Secret*. In a text addressed to her daughter Laura she describes what happened to her as an eleven-year-old girl – a devastating event that brought her to the verge of collapse, but she survived it thanks to her mental fortitude and her art. Before telling how she was sexually abused by her ultra-Catholic father, she takes us back to the New England countryside where she spent her summer holidays in 1942. The eleven-year-old girl was walking through the fields and enjoying the scenery.

'A heavy grey rock was blocking my way, too big to just walk past. Entwined on top of it were two snakes, thick and black (copperheads), with deadly poison, moving slowly. I stood there in terror, no longer daring to move or breathe.

Niki de St. Phalle, *Fauteuil Serpent*, 1994, polyester, 180 x 85 x75 cm. Private collection, Netherlands

Niki de St. Phalle, *Chair with Crossing Snakes*, polyester, 150 x 80 x 93 cm. Collection: Pro arte Ulmer Kunststiftung, Neu-Ulm, photo: Maria Strilic

Fascinated, I was seeing death at close quarters for the very first time.

'Was this death, or the dance of life? For an endless moment I stood facing the snakes in fascination.

'I had turned into a snake.

'The very next week the grass was mown, and poison was put down in the fields all round the house to get rid of the snakes. Was I exterminated along with the snakes back then?'[80]

Deadly poison, terror, death... there is a strong emphasis on menace and calamity, but also a reference to 'the dance of life'. On the cover of the book is a typical Saint Phalle drawing, a black skull with colourful flowers growing out of it – death and life in a single image. The text that follows links the father's – the procreator's – penis to rape and death.

The snake is a frequently recurring creature in Saint Phalle's extremely vital work, for instance in snake trees (one of them five-and-a-half metres tall) and snake furniture. In her work the tree and snakes are pure vital force, freed from a Catholic doom scenario. In the early 1960s, as one of the most striking *Nouveaux Réalistes*, she attacked stifling, patriarchal Catholicism and its implicit subordination of women in performances in which she fired a rifle at altar-like assemblies with bags of paint attached to them. The female figures she produced at the time had a dual aspect: life-giving and threatening, devouring. 'I think I was trying to discover the essence of womanhood, of my own self, in the various roles we have to play – the bride, the whore, the witch,' she told me in 1990.[81] Much later she created the Tarot garden mega-project in Tuscany, where she reproduced the twenty-two figures from the Major Arcana as large sculptures. Having rejected religious dogmatism,

she developed her own personally experienced spirituality. 'My new work, after the Tarot garden, is about gods, about various gods in various societies. I used to fire bullets at religion in its rigid form, but now, thirty years on, I'm paying homage to the spirit of religion.'[82].

Snake love and snake punishment

The snake is clearly not just any creature; it belongs to the domain of the gods, and should preferably be left in peace. The mythical seer Tiresias discovered this when he saw two large snakes copulating. He hit them with a stick, and was instantly changed into a woman. Seven years later he again saw the same snakes and again hit them with a stick, whereupon he turned back into a man. He was to suffer for this unique knowledge of both sexes when called upon to

arbitrate in a dispute between Zeus and his wife Hera. The god claimed that women enjoyed lovemaking more than men did, and the goddess disagreed. Asked for his opinion, since he was familiar with both, Tiresias said that Zeus was right, whereupon Hera punished him by striking him blind. Because of the aforementioned *fatum*, Zeus could not reverse another deity's action; but he could mitigate it. From then on Tiresias was blind but clairvoyant.

Yet another man, Laocoon, discovered that goddesses were not to be trifled with. Snakes once again play a leading role in this story, which inspired one of the most famous sculptures in classical antiquity. They were sent by the goddess Athena, who, after the Greeks' long siege of the city of Troy, wanted the trick with the wooden horse to succeed. The horse was standing in the Greeks' abandoned encampment; the Trojans rushed out and were told by a Greek who was pretending to be a deserter that the horse was a gift to Pallas Athena, in hopes of a safe return home. It had been made that size so that the Trojans could not take it into the city. If they did, Troy would become impregnable; but if they destroyed it, they would incur divine wrath. Delirious with joy, they decided to drag the horse into the city, but Laocoon, their priest of Apollo and Poseidon, warned them not to. In Virgil's *Aeneid*, Laocoon uttered the immortal words 'Whatever it is, I fear the Greeks, even those bearing gifts!' He flung a spear into the horse's belly, wounding one of the men hidden inside it. Together with his two sons, Laocoon sacrificed a bull to Poseidon on the beach – whereupon two giant sea snakes, sent by Athena, came out of the sea and attacked the three men. The death of Laocoon and his sons convinced the Trojans that this was a punishment for his warning about the horse that was dedicated to the goddess. They dragged the horse into the city, widening a passageway so that it could enter, and indulged in wild celebrations. What happened then is well known. Much later, in the

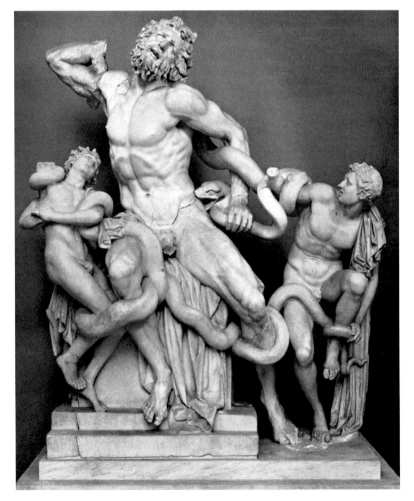

Statue, *Laocoon,* 20-40 BCE, Rhodes/Greece, 2.4 m. Collection: Vatican Museums, Museo Pio-Clemento, Octagon

first century BCE, three men on the island of
Rhodes (Agesandros, Polydoros and
Athenodoros) together produced a sculpture
of the three Trojans struggling with the snakes
that was to acquire iconic status. When Pliny
the Elder (c. 23-79 CE) saw it in the palace of
Emperor Titus, he praised it as a work that
outshone all other paintings and sculptures.
The sculpture was only rediscovered in 1506,
when a winegrower who was ploughing up his
land came upon it in a room that had been part
of the palace of Nero and Titus. Pope Julius II
purchased it for the Vatican museums. Since
then it has led a life of its own in art history, and
numerous artists, from the sixteenth century to
Zadkine and even more recent artists, have
drawn inspiration from it. Laocoon and his sons
struggling with the merciless snakes coiling
around them symbolise humans' despair,
struggle with fate and inevitable death.

Sanctuary, Egypt,
terracotta, 9.7 x 22.5 x
14 cm. Collection: Allard
Pierson Museum,
Amsterdam, APM1630-
1650

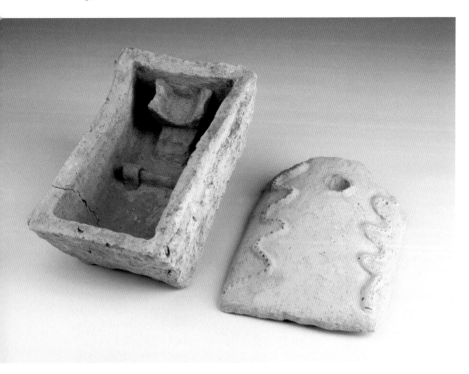

Snakes and women: of demons and feminists

Snakes and women are a topic in their own right.
Classical authors made much mention of
Alexander the Great's hot-blooded mother,
Olympias. She participated with great fervour in
the Orphic mysteries and Dionysian festivals, to
which she took snakes that reared up from their
sacred baskets (the aforementioned *cista mystica*,
often depicted on coins). Olympias was alleged
to have had an intimate relationship with a god in
the form of a huge snake. Her husband, King
Philip II of Macedon, had only one eye; he is said
to have lost the other one when spying on his
wife through a keyhole while she was entwined
with the snake. Cicero relates that Alexander the
Great fell asleep when sitting at the bedside of
his general (and perhaps half-brother) Ptolemy,
who had been struck by a poisoned arrow. He
then dreamed of a snake that told him where to
find medicinal herbs, and that Cicero said was
the snake kept by his mother. We know that
Ptolemy (Ptolemy I Soter, 367-283 BCE) survived,
and indeed reached a very respectable age for
the time. He was the founder of the Ptolemaic
dynasty, whose last representative, perhaps the
most famous queen in world history and
certainly the one that appeals most to the
imagination, was 'freed' at the end of the
text – by a snake.

The divine procreator disguised as a snake is a
frequently recurring motif.[83] For example, the
mother of Emperor Augustus, Atia, supposedly
fell asleep in a temple to Apollo and was then
impregnated by the god in the form of a snake.
The mother of the popular hero of Messenia,
Aristomenes, was also said to have been born
from the union of a woman and a snake. The
Roman king Faunus was rejected by his daughter
Bona Dea, despite all his efforts to commit
incest with her. 'Only when he had assumed
the form of a snake did she consent to his
advances.'[84] Living in the cave of Artemis was

a huge divine snake that seduced the girl Halia; their offspring were known as the Ophiogenis.[85]

The snake is evidently a royal animal, is immortal (for it leaves its own skin just as a baby leaves the womb) and has medicinal knowledge. The union between such a creature and a human being is bound to result in an extraordinary personality! Nor are snake marriages merely mythical. Even in the twenty-first century, weddings to snakes still take place in India and Thailand. Such weddings are greatly valued for the good fortune they will bring to the village.

As this whole 'snake story' makes clear, the union of snakes and women is a common theme in the visual arts. One of the most famous Symbolist paintings is *The Sin* (1893) by Franz von Stuck (1863-1928). A naked woman with a sultry gaze is wearing a huge snake as though it were a stole; the head is looking demonically over her right shoulder. It is clear that little good can be expected of this otherwise unfrightening woman – the snake is the symbol of her wicked influence. Earlier, John Collier (1850-1934) also painted a naked woman with a snake coiled round her: *Lilith* (1897).

Statuette, 'Serpent Goddess', around 1600 BCE, originates from the palace of Knossos. Collection: Heraklion Archaeological Museum

Snake goddesses or snake priestesses in Crete

The Cretan ceramic snake goddesses or snake priestesses of the Great Goddess in a fertility or regeneration cult are world-famous. Countless illustrations, souvenirs, T-shirts and ornaments displaying the sculptures can be found on the Internet. The excavation of the palace of Knossos, where they were found, was to bring the tenacious archaeologist Sir Arthur John Evans (1851-1941) lasting fame. He worked at the 'Palace of Minos' site from 1900 to 1931. Evans was the Indiana Jones of his day; he had a highly nonchalant attitude to 'collecting', purchased illegally excavated objects and sometimes carried out digs of his own without permission from the authorities. The popularity of the 'snake goddesses' inevitably led to forgeries, such as the 'Boston Snake Goddess' acquired by the Boston Museum of Fine Arts in 1914 – a fine ivory-and-gold sculpture with a face that was bound to appeal to the early twentieth-century public. The history of this forgery is related in *Mysteries of the Snake Goddess* by Kenneth Lapatin, president of the Boston Society of the Archaeological Institute of America.

John Collier, *Lilith*, 1887,
oil paint on linen, 199 x
107.9 cm. Collection:
Sefton Museums &
Galleries, Sefton MBC,
Southport, UK

Franz von Stuck, *The Sin,*
1893, oil paint on linen,
95 x 59.7 cm. Collection:
Neue Pinakothek, Munich

'If Eve was charged with the bringing of death,
sin and sorrow into the world, Lilith was demonic
from the moment of her creation.'[86] Thousands
of years before our era, Lilith appears as a
powerful winged goddess, a 'queen of the
night'. She dwells in a tree that the goddess
Inanna planted in order to use its timber for her
throne. When the time came to fell the tree, a
snake turned out to have settled in its roots, a
bird in its crown and Lilith halfway down. The
hero Gilgamesh killed the snake, whereupon the
tree was felled and Lilith flew away. In the
Sumero-Akkadian language, Lilith's name is
associated with dust clouds and the night, and
with properties of a nocturnal demon. In Hebrew
mythology her children are similar demons.
Yahweh made her at Adam's request, but used
inferior, impure clay. However, Lilith did not
consider herself inferior to Adam (as she was
expected to). She uttered an unheard-of wish to
sometimes take the 'top' position during
lovemaking. She left the dominant Adam,
whereupon he asked God to bring her back to
him. Three angels were sent to see her, but their
coercive words made no impression on the
resolute Lilith. The demon-bearing Lilith
threatened to kill children – as a punishment for
their fathers' sins – unless they wore an amulet
bearing the pictures or names of the three
angels. She became not only a threat to newborn
children, but also a dangerous seductress who
could visit men in their sleep – the classic image
of the *femme fatale* onto whom repressed sexual
desire was projected.[87] Lilith was demonised to
such an extent that in illustrations of the Adam-
and-Eve story it is she, in the form of a winged
snake, that offers the forbidden fruit. She was
thus the start of a long history of misogyny in
which women were branded as witches –
copulating with demons, killing newborn
children and seducing men – and persecuted
accordingly.[88]

Lilith became a heroine among feminists. Collier
was also clearly well-disposed towards his
subject – quite something in Victorian Britain.
Far from being a dark witch, his *Lilith* is an
attractive Pre-Raphaelite woman who, even
though seductive, is toying innocently with her
long blonde hair. Nor is there anything demonic
about the snake that is coiled round her, its head
resting on her right shoulder. Definitely not
imbued with a Christian sense of sin, Lilith is
depicted here in her full purity and beauty, amid
lush green vegetation, as a natural force *par
excellence*. The Pre-Raphaelites – Collier is
considered one of the later exponents of the
movement – broke with the prevailing academic
style and instead sought a romantic purity that
they found in painters before Raphael (1483-
1520). Collier was a humanist and an advocate of
secular morality. 'I am looking forward to a time
when ethics will have taken the place of religion,'
he confessed in his book *The religion of an artist*
(1926). 'People may claim without much
exaggeration that the belief in God is universal.
They omit to add that superstition, often of the
most degraded kind, is just as universal.'

The catalogue for Iris van Dongen's exhibition at
the Stedelijk Museum in Schiedam refers to her
as a 'snake charmer in art. Her work evokes soft
sounds, but also a suspicion of furtive danger.'[89]
The women that Van Dongen draws with chalk
and charcoal on a brightly-coloured pastel
background have the same dark, sultry aura as
Von Stuck's snake-entwined *The Sin*. Just as the
Pre-Raphaelites were opposed to the academic
art prescribed by the Royal Academy of Arts, Iris
van Dongen was opposed to the doctrine of
conceptually moulded social commitment that
prevailed when she graduated from the art
academy in the Dutch city of 's-Hertogenbosch in
the mid-1990s.[90] Bucking the trend, she explored
the work of such artists as Félicien Rops,
Holbein, Dürer, Goya and the Pre-Raphaelites.
'Beauty felt like a taboo.'[91] Gothic girls, the
femme fatale, a world of sultry seduction: it is no

accident that the word 'suspicious' recurs in her titles. '... and it immediately sounds as if the snake himself is speaking. His hissing ensures us that we cannot mock these heroines, alert and self-conscious as they are. They are the high-priestesses of women's power.'[92] Iris van Dongen's women, often combined with snakes, are a contemporary version of Collier's *Lilith* – not so sweet, but just as independent. 'That

snake, which has been transformed from a symbol of evil to a pet or a piece of jewellery, has been absolved of all original sin. Even as the woman lies in the arms of the devil, she is there willingly. These women no longer allow themselves to be talked into feeling guilty.'[93]

As with Rogge, metamorphosis is a constant in the work of Juul Kraijer (b. 1970). Her drawings of refined, ethereal female figures could be illustrations for the work of a contemporary Ovid. Animal figures appear within the outlines of a woman, transcending them and extending beyond them as though the woman were merely the cocoon in which change gradually takes place. 'The change, either mutation or mutilation, continues to come into being at the most vulnerable place, there where the form of the body is most advantageous or where resistance is the least,' Kraijer writes about the strange girlish figures that she describes as 'embodied frames of mind'.[94] The unexpected frame of mind that she depicts in Medusa is serene calm. Instead of the snake hair being terrifyingly directed outwards, the reptiles' heads point towards the face and the face is depicted almost ethereally, with closed eyes. The figure is deeply absorbed in itself and is really an 'inverted Medusa', a heroine that dares to confront herself in contemplation. The serene facial expression makes clear that she will not be literally petrified with fear, as happened to anyone that looked at Medusa in classical mythology. Perseus managed to kill Medusa by looking at her in the shiny reflection of his shield, rather than directly. He gave Medusa's head to Pallas Athena, who henceforth wore it on her breastplate (*aegis*) in order to vanquish her enemies. Medusa is frequently found as an antefix, a decorative feature that masks the lower edge of roof tiles. Such appropriation of what is dreaded is effectively an inversion of fear, becoming an image that wards off evil. Amulets, too, often display the thing that is to be kept at bay.

Iris van Dongen, *Suspicious VI*, work on paper, 245 x 150 cm. ING collection, Netherlands

Identification with a snake can be seen in Kraijer's remarkable portrait of a woman – it could be a self-portrait – whose ribcage contains a snake from which her head appears to emerge. The Afro-American artist Renée Stout (b. 1958) has also produced a work in which a woman and a snake become one: her portrait of the famous *mambo* (*vodou* priestess) Marie Laveau from New Orleans shows an African woman with a bright-green snake in her curly hair. There are portraits of Marie Laveau (1794-1881) that show her instead as a white woman; she was the daughter of a white plantation owner and a free coloured Creole woman. She married a Haitian, a free coloured man, by whom she had a daughter who was to support her in her activities. She is said to have kept a snake called Zombi. In Stout's work the historical Marie Laveau would seem to matter less than her interpretation of the African identity that marks *vodou* – a blend of the African

vodun world view (in which natural forces are perceived as spirit beings) and Catholic saints – as a product of the period of slavery. Stout's Laveau is a self-confident woman with mysterious knowledge – the snake is in her hair with its head pointing to her ear, ready to whisper secrets into it.

The concept of metamorphosis was incorporated into a sculpture of Medusa by the Dutch artist Gerhard Lentink. In 1983-84 he produced his *Medusa Table*, a glass table supported by three giant snakes that are biting each other, and surmounted by Medusa's head with rigidly erect snake hair. Despite her snake's eyes, Medusa is not so much frightening as vulnerable, 'a head staring vacantly'.[95] A vandal hurled a brick through one of the windows of the room where the sculpture stood. The brick hit Medusa, shattering the sculpture. 'That might have been

Renée Stout, *Marie Laveau,* 2009, work on paper, 59 x 28 cm. Collection: Afrika Museum, Berg en Dal

with her pieces, her face protected by a gate-like construction which can be opened.' [96] The fragments of the broken snakes have been incorporated into the Medusa cart. *Iconomneme* is the 'memory of an image' and, at the same time, a new image that shows the inherent vulnerability of the Medusa figure, the unfairly punished woman whose power was appropriated by a goddess. Something good came of her downfall, just as in mythology the winged horse Pegasus sprang forth from her blood.

It is the life-giving power of Medusa's primal femininity (the femininity of the snake goddesses), perceived as darkly menacing, that is emphasised by the Australian artist Sangeeta Sandrasegar (b. 1977, lives and works in London) in her installation *Take away that monster / That face that makes men stone, whoever she is*: 'Sentenced to isolation on a stony island outcrop and with her once lustrous hair turned to snakes, the Gorgon Medusa's will to beauty and to make life (thus also take it away) is imbued in her power to turn men to stone. When eventually beheaded by Perseus, even in death Medusa gives life: from her neck springs forth the fully formed giant Chrysaor, and from her blood the winged Pegasus. In depicting the slaying of a mother and her incarceration, the story puts forth a re-presentation of this wily mother. The giant marked out in the manner of police outlines

Antefix Medusa, 450 BCE, Greek (site: Taranto/Italy), pottery, 16.5 cm. Collection: Allard Pierson Museum, Amsterdam, APM1122

Antefix Medusa, 350-300 BCE, Greek (site: Taranto/Italy), pottery, 18 cm. Collection: Allard Pierson Museum, Amsterdam, APM1136

the end of her story had not Lentink interpreted this destructive deed as a constructive contribution to the creative process. The broken pieces of the sculpture were transformed into the *Iconomneme*, in which Medusa became a literally dynamic figure. She is in a wooden cart

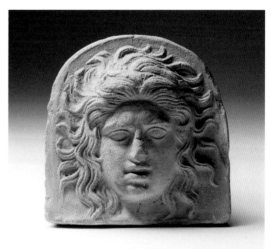

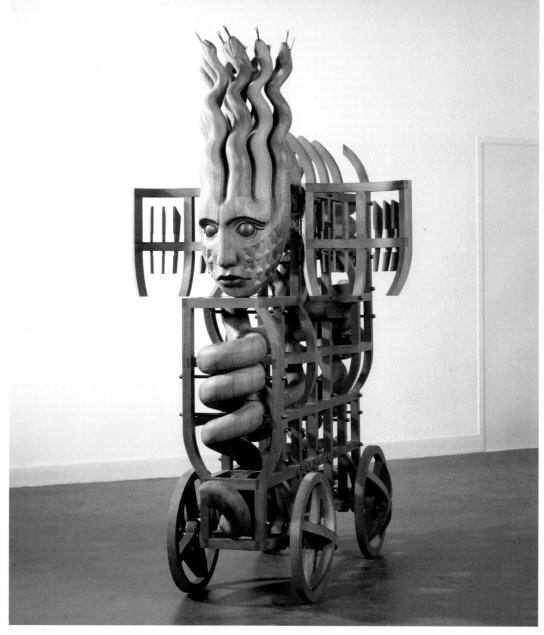

Gerhard Lentink, *Opus 14: Iconomneme*, 1983-1991, wood, steel, aluminium, glass, partial polychromy, 202 x 161 x 114 cm. Artist's own collection

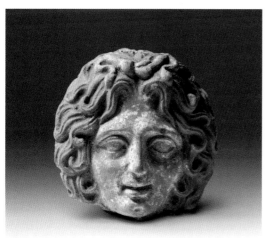

Figure, Medusa, pottery, 8.6 cm. Collection: Allard Pierson Museum, Amsterdam, APM8078

for dead bodies is already a victim. Already a target of the state, without mother, protection and home. His sentence is fully formed at his birth. The work posits a re-socialisation of women, who don't fit into the roles designated normal by a society, and asks where and what is home for their children.'[97]

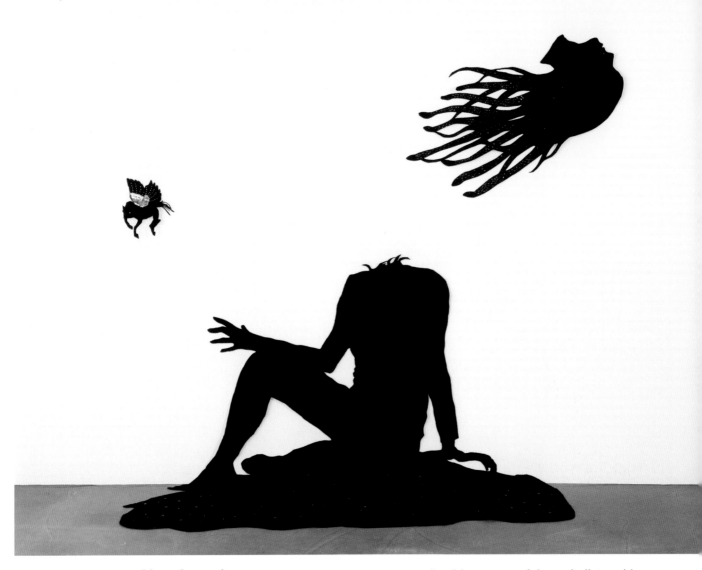

Sangeeta Sandrasegar,
*Take away that monster/
That face that makes men
stone, Whoever she is*,
2009, felt, cotton, wire,
beads, spangles, variable
dimensions. Artist's
collection represented
by Murray White Room,
Melbourne/Australia

Menacing snakes

Women that give birth to snakes are a theme
found not only in the aforementioned classical
mythology and in the myths and art of the
ancient Djenné of Mali (discussed by Siebe
Rossel later in this book) but also in Ghana,
where the snake occurs in the contemporary
mythology of films. Until recently, advertise-
ments for Ghanaian cinemas were hand-painted.
They displayed a predilection for creepy horror,
such as a snake emerging from a woman's
abdomen. To Ghanaian Christians the snake is the
symbol of Satan. Especially under the influence
of the Pentecostal movement, traditional African
religion and ritual specialists are demonised, as

well as 'the aspects of the capitalist world
economy that are perceived as negative.'[98]
Ghanaians, most of whom are poor, are
suspicious of rapidly acquired wealth. Public
confessions, as well as the horror films shown in
cheap cinemas, tell of a deceitful Satan who
grants wealth to those who make a pact with
him, but only if they do terrible things that
destroy their humanity. Their sole salvation is
the way of Christ – not as ordinary churchgoers,
but as 'born-again' Christians. Traditional
experts on magical practices play a major part in
such tales of a pact with the devil – they provide
'dark knowledge' that is not infrequently
associated with snakes. Thus a man who
poisoned his brother and mother had to wear a

rattlesnake round his own waist. One day he left the creature behind and it bit his daughter, who subsequently died in hospital. The snake was killed. A preacher told him that all his children would die if he did not burn all his magic substances and turn to God. In the popular film *Diabolo* a man is turned into a snake so that he can enter a prostitute's vagina. The woman then vomits banknotes. Birgit Meyer's description of this theme points out that the snake has traditionally been considered beneficial; a woman who dreams of being bitten by a snake will quickly become pregnant.[99] Under the influence of Christianity, however, the meaning

of the snake has shifted towards evil. 'There is a common story about the wealth of market women which I did not hear in the form of a confession, but often as gossip … Several people I spoke to in Ghana knew someone that had once seen a snake emerging between a rich market woman's legs. Some of these women supposedly had a snake in their belly that fed on sperm left there by unsuspecting men. Since her belly is already occupied by the snake, such a woman cannot become pregnant with a human baby. The creature emerges at regular intervals, eats an egg and then vomits money. In this case, in accordance with the principle that wealth is of

Movie poster, *Jason to Hell: The Final Friday*, USA 1993, Leonardo, Accra 2000, 164 x 105 cm. Collection: Mandy Elsas

Movie poster, *Prince Doom*, Ghana 1996, Mr. Brew Art, 116 x 146 cm. Collection: Mandy Elsas

Movie poster, *The Judgement Day. Subtitle: Prince of Doom 2*, Ghana 1997, King Art, Fosu, 156 x 101 cm. Collection: Mandy Elsas

Of course, snakes really can be dangerous. Each year about half a million people are bitten by snakes worldwide.[101] The good news is that only 212 of the 2,700 species of snake are poisonous enough to be life-threatening.[102] Nevertheless, fifteen out of every 100,000 inhabitants of Myanmar alone die of snakebite each year.[103]. Then there are the non-poisonous but still man-eating pythons, which can grow to over seven metres in length. In the Philippines there are documented cases of people being devoured by pythons. Incidentally, according to recent research, blood from pythons that have just eaten contains substances that protect the heart and increase its size. This is necessary, for pythons can manage without food for up to a year, and if prey then suddenly arrives in their stomachs the quantity of triglycerides, the main components of natural fats and oils, increases enormously – but without adverse consequences such as fat deposits in the heart. Python plasma has already produced positive results in mice, and heart patients may eventually also benefit from it.[104] Processed snake venom and snake blood may also have positive effects on humans.

Protective snakes

In the storeroom of a museum that I visited to select objects for the exhibition, the staff member who received me said 'Ugh, snakes, how horrid!' I pointed to the ornament she was wearing round her neck – a subtly designed snake. 'Oh, but that's for protection', she replied. Another colleague was immediately enthusiastic about the theme: she had had two Naga goddesses (discussed in more detail in Ben Meulenbeld's article) tattooed on her back, and it turned out that her husband also had a protective snake tattoo on his arm. When Buddha was achieving enlightenment while sitting under the *ficus religiosa* or peepal tree, a cobra sheltered him under its hood. The Hindu

the devil, the woman swaps her ability to bear children for money.'[100]

The terrifying snake is also a popular feature of Western films and comics, from the *Anaconda* films to superhero Spiderman's enemy Venom. From Adam and Eve to modern advertisements for pomegranate juice and the shapely Selma Hayek performing a snake dance in *From Dusk till Dawn* before turning into a vampire, the snake continues to be divine (in the pre-biblical and gnostic sense), creepy and fascinating.

god Shiva is likewise often depicted in the company of protective cobras. Although snakes usually trigger an innate fear response, they can certainly also be associated with protection. During a session of sandplay therapy, the aforementioned Jungian therapy in which the client chooses from thousands of small sculptures (a wide range of figures that can appeal to unconscious elements in the mind) and places them associatively in a small sandbox to create an 'inner landscape', psychologist Wouter Bleijenberg saw a boy from an unsafe home environment take a snake that was just hatching from an egg and place it in the middle of a circle he had formed using the largest snake in the collection. However, this seemingly safe place was threatened by a dinosaur. As a result, the therapist decided to talk to the parents about their aggression (the father) and passiveness (the mother). Protective objects in the form of snakes, objects bearing depictions of snakes,

Frank Zwartjes, Liquid
Sky Tattoos, Nijmegen
Photo: Ferry Herrebrugh

Protective statuette,
Nagaraja, China, wood,
54 x 32 x 12 cm.
Collection:
Wereldmuseum,
Rotterdam, 29260

Protective statuette,
Nagaraja, China, wood,
56 x 32 x 10 cm.
Collection:
Wereldmuseum,
Rotterdam, 29259

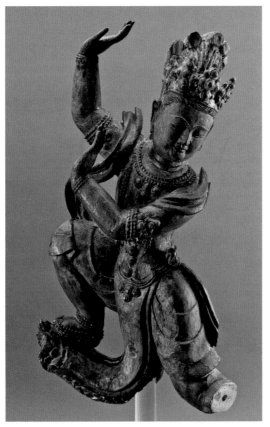

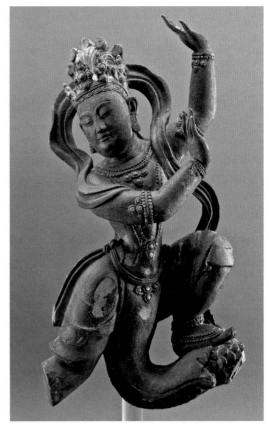

Snake amulets, various materials. Collection: Afrika Museum, Berg en Dal

Amulet in the shape of a snake couple, Bali, rattan, 26 x 14.5 cm. Collection: Tropenmuseum, Amsterdam, 1330-182

Ring, *Ali ali,* Lombok/ Indonesia, red copper alloy, 1.8 x 1.8 cm. Collection: Tropenmuseum, Amsterdam, 1330-291

Ring, Madurai, Tamil Nadu/ India, silver alloy, 3 x 2.5 cm. Collection: Tropenmuseum, Amsterdam, 6226-40

snakeskin, snakes' heads or snake bones are found all over the world. Angelina Jolie and her husband Brad Pitt have designed a range of snake jewellery for Asprey, called *The Protector Collection*. During Jolie's first pregnancy Pitt gave her a ring in the form of a snake, and ever since the successful delivery of her baby she has considered the snake as her family's protector (it should be noted that proceeds from the sale of the highly expensive jewellery are donated to a foundation that supports the education of child victims of wars and natural disasters).

Although the snake may have been demonised among Ghanaian Christians, in older, pre-Christian traditions it has a much more positive role. Figurative goldweights depicted proverbs and sayings. They were used not only in commercial transactions, but also to cure diseases or as talismans or amulets (in which case they included rings so that they could be worn on the body). The Gan and the Lobi used iron snakes on altars

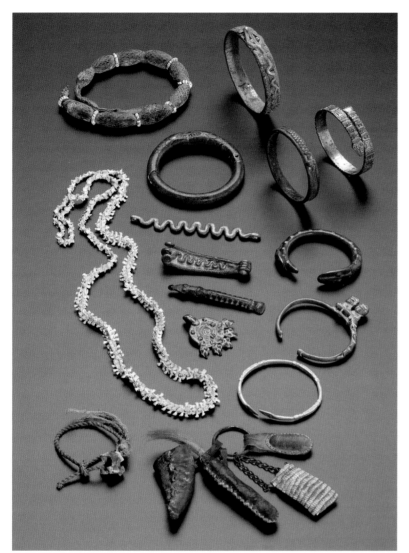

Snake amulets, various
materials. Collection:
Afrika Museum, Berg en
Dal, and private
collection, Netherlands

Bracelet, Toba, Sumatra/
Indonesia, brass, 3.5 x 9.5
cm. Collection:
Tropenmuseum,
Amsterdam, 137-506

for protective purposes or in initiations,[105] and as
protection against snakebite.[106] Lobi protective
jewellery, sometimes worn at knee or ankle
height, often depicted the highly poisonous bitis
snake.[107] The goldweights used by the Akan
peoples of Ghana and Ivory Coast could be used
not only to weigh gold but also as a means of
communication, similar to the use of proverb lids

Bracelet, Bobo/Burkina Faso,
wood, 28 x 28 cm. Collection:
Tropenmuseum, Amsterdam,
3981-407

Amulet, Toba,
Sumatra/Indonesia, wood, 13
cm. Collection:Tropenmuseum,
Amsterdam, 2761-817

Charinda, *Untitled*, bicycle paint on hardboard, 61.5 x 60 cm, 609-69. Loan collection Dutch Cultural Heritage Agency

Dish, *Agwa,* Marron/ Suriname, pottery, 34 x 50 cm. Collection: Tropenmuseum, Amsterdam, 6395-18

among the Fiote people of Cabinda (an Angolan enclave in the Democratic Republic of Congo). Knowledge of proverbs and sayings was valued, for only 'when a proverb is told to a fool does its meaning have to be explained to him'. Some images were instantly recognisable; others could be interpreted in various ways. Goldweights depicting snakes are common. A snake may refer to the proverb 'The cobra that blocks the path is going its own way, yet people run away when they see him.' In other words, once you have a bad reputation no-one will ever trust you again, even if you have no evil intentions. A man

holding a snake behind its head refers to the proverb 'If you hold a snake by the head, what is left is only string', i.e. once you have the enemy's leader in your power his followers will be helpless. The Afrika Museum collection includes a number of goldweights that show a snake gripping a bird in its fangs. This is a reference to the well-known proverb 'The puff adder on the ground has caught the hornbill', which is associated with a folk tale that has two meanings: 'a man should not despair of getting anything, however difficult it may seem', and 'behave well and be kind to others, for one day you may need to depend on their kindness.' The story on which this is based tells of a hornbill who complained that his mother-in-law was always pestering him for money. He therefore borrowed money from the puff adder. On the

day he was supposed to pay the money back, he was unable to do so. The snake asked other birds to tell the hornbill to pay off his debt. The hornbill sent the contemptuous reply that if the snake was brave enough he should fly up into a tree to collect his money. The snake calmly sent a reply via the other birds that you only need one day to catch a thief; and the day came. In the dry season the hornbill could only find one stream to drink from – right by the place where the puff adder lived. The snake suddenly appeared and seized him by the foot. 'You said I should fly up into a tree to get my money, and I didn't ask you to come down. Now here we are together on the ground, and I will have my money.' The hornbill began to beg and whimper, and called on other animals to help him; but however hard they tried to persuade the snake he would not let the hornbill go. Only after a long time did the bird finally manage to escape. And that is why he always flies so high – he is afraid of the puff adder.[108]

The snake's protective aspect includes its willingness to share its knowledge of medicinal herbs with humans. We have already seen the snake as a teacher of wisdom among the gnostics and the Amazonian shamans. The Huichol Indians of Mexico are known for their brightly coloured yarn paintings of trance experiences. In the yarn painting illustrated here, shamans are making sacrifices to acquire knowledge of medicinal herbs. A clearly marked segment at the bottom of the picture shows a snake near water, which it is tempting to interpret as a symbol of unconscious knowledge. The relationship between a snake and a *nganga* (ritual specialist) is

Power artefact, Banki/Cameroon, terracotta, 19 x 16 cm. Collection: Afrika Museum, Berg en Dal, 307-2

Goldweight, *Ashanti*, Ghana, copper alloy, 2.5 x 7.3 cm. Collection: Afrika Museum, Berg en Dal, 544-86

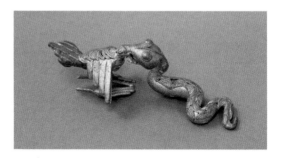

Yarn painting by
Cristobal Gonzales,
Untitled. Private
collection, Netherlands

very evident in a painting by José Bedia (b. 1950 in Cuba). 'Both in my Afro-Cuban and in Indian traditions I find parallels that once again confirm that I am in touch with an ancient heritage of humanity.' Bedia is a transcultural artist if ever there was one. In 1983 he was initiated in Cuba into the highest degree of the *palo monte* religion, which has deep roots in Congo. He has also been initiated into the religion of the Sioux people. Bedia is an avid collector of ethnographic objects, and is particularly drawn to objects with a magico-religious meaning. His spiritual quest results in installations and paintings marked by cultural cross-fertilisation and a mystical-poetic visual idiom. The snake in *Ndoki Noka de la Noche (The Doomed Snake of the Night)* is moving towards the ritual specialist, who is lying on his back in a nocturnal mountain landscape and receiving knowledge from a spirit being that occupies the entire firmament. The messenger is the snake, who conveys the knowledge.

Snake rods: healing and power

Our discussion of the positive power of the snake continues with a subject that is inextricably bound up with the snake theme, namely rods. Moses had already experienced the relationship between snakes and rods when he appeared before the pharaoh to appeal for the release of his people. Yahweh had instructed him how to impress the pharaoh when asked to prove the strength of his faith. He cast his rod upon the ground, and it instantly turned into a snake. The Egyptian court magicians were not impressed, for they had no difficulty in doing the same thing with their own rods. This probably has little to do with magic. Snake charmers have a trick that enables them to put a Uraeus snake into a cataleptic state. Eye witnesses have reported that tapping the snake on the mouth and then squeezing its head can cause it to become rigid; vigorously rolling the end of its tail between the hands makes the creature move again.[109] Unfortunately for the pharaoh's magicians,

José Braulio Bedia Valdes,
Ndoki Noka de la Noche
(The Doomed Snake of the
Night), acrylic paint on
linen, 242 x 186 cm.
Collection: Afrika
Museum, Berg en Dal,
685-2

Moses's snake devoured all their snakes. When the Israelites were attacked by a plague of snakes, Yahweh told Moses to make a bronze snake on a rod, called the Nehustan. Anyone who was bitten by a poisonous snake and looked at the snake rod recovered.

'From of old the staff had been the symbol of vegetation and, since it represented the unchanging life of the earth in all its various forms, also represented the recovery from illness or, in other words, rescue from death.'[110] In tarot, the wand (or rod) is a symbol of potency,

Maerten van Heemskerck, *Mozes en de koperen slang* [Moses and the copper snake], 1551. Stedelijk Museum Het Prinsenhof, loan collection Frans Hals Museum

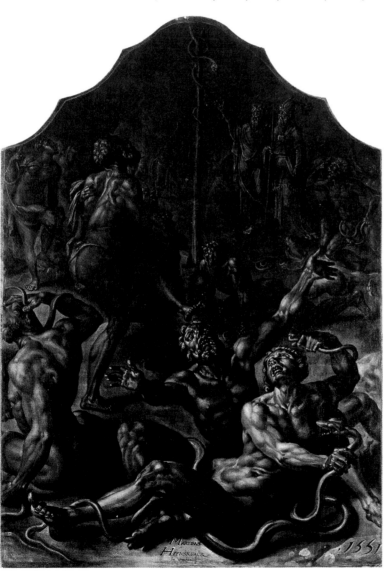

fertility, growth and flowering.[111] Of course it is a phallic symbol, but it is more than just that. 'It is the branch of a tree, the magical tree of life, and it can symbolise the whole tree as pars pro toto. It thus has the same power as the tree. The snake dwells in the tree of life, and hence also in the rod. Not only do rods and snakes belong together, but so do rods, snakes and words. All three have procreative power. Ever since ancient times (and to some extent even in our own time) spokesmen have borne rods, often with snakes on them. Anyone who utters suprapersonal words on behalf of a god or master bears a rod, or a snake rod. Messengers, heralds, envoys, generals (marshals' rods), judges, priests (bishops' staffs), seers, magicians (magic wands) and physicians (the Aesculapian rod) utter magic words thanks to their rods. Kings also bear rods, known as sceptres, for they utter the word of God on earth.

In many religions there is a herald-god, divine messenger or Lord of the Word who bears a special rod. The Greeks called him Hermes, and the Romans Mercury. His rod was known in Greek as rabdos (twig), *skeptron* (rod, from the verb *skeptomai*, to support oneself) or *kerykeion* (herald's rod, from *keryx*, herald); the latter became caduceus in Latin.

The caduceus is a snake rod. It ends in two snakes that together form a figure of eight, usually open at the top. Originally it was a forked branch. Among other peoples the forked branch also had magic powers. The words twig and two [in the original Dutch, *twijg* and *twee*] are etymologically related; the branch par excellence is forked'[112]

In the caduceus the 'two' element is emphasised by the combination of a snake (= underground, earth) and wings (= heaven). The rod thus unites heaven and earth. 'As a magical rod [the rod of Asclepius] is similar to that carried by Hermes

Statue of Mercury, wood, 120 x 60 cm. Collection: Frisian Maritime Museum, Sneek 1988-663

Dervish staff, Iran, wood, 124 x 20 cm. Collection: Wereldmuseum, Rotterdam, 73859

Print of Dervish with snake staff, around 1570, India, Mughal Dynasty, 55.3 x 40 cm. Trustees of the British Museum, 00037841001

who, by means of it, rescued the dead from the grave and awakened the sleepers.'[113]

Hermes's rod, and witches' and magicians' wands, all connect *two* worlds: this one and the metaphysical one. The association with the snake's forked tongue is obvious: its words have two sides to them, namely wisdom and expulsion from the Garden of Eden.

Snake rods are often found as shamans' instruments, from Siberia to the northwest coast of America (the Kwakiutl and Haida Indians). The most famous and beautiful 'magic wands' are those belonging to the ritual specialists (*datu* or *guru*) of the Batak on the island of Sumatra. Some of them have a *singa*, a mythical snake-like creature that wards off evil. Some of the rods in

this exhibition have a scaly 'backbone' over their entire length. There are two kinds of rod: the *tunggal panaluan*, with carved figures over its entire length, and the *tongkat malehat*, in which a simple rod is associated with a figure, or combination of figures, riding on a *singa*. The meaning of the succession of figures on the *tunggal panaluan* is associated with a myth in which the incest taboo is broken by a set of twins. As a punishment, first the boy (who climbs a *piupiu-tangguhan* tree at the girl's request to pick the *ruham* fruit for her) and then the girl are turned into wood that becomes part of the tree. Their father summons a succession of great 'magicians' to free them, but they too become part of the tree. The last 'magician' that he summons tells him to have the tree felled and rods bearing likenesses of those who have died carved from it. Since they died suddenly, the rods will have great power, warding off enemies and bringing rain in times of drought. It is

COUR DES GRANDS

Chéri Cherin, *Cour des Grands*, 2004, oil paint on linen, 85.5 x 125 cm. Collection: Afrika Museum, Berg en Dal, 648-6

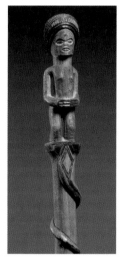

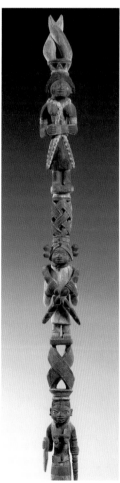

Staff, detail, Luena/ Angola, wood, 84.5 x 4.5 cm. Collection: Afrika Museum, Berg en Dal, 686-1

Staff, Yoruba, Nigeria, wood, 152 cm. Collection: Afrika Museum, Berg en Dal, 160-22

Staff, Nguni/ South Africa, wood, 100 x 6.5 cm. Collection: Afrika Museum, Berg en Dal, 686-2

uncertain whether the myth arose as an explanation for the figures on the rod or the rod is a depiction of the myth.[114] The rods often have a metal tip on the underside, while the figurative images at the top include a turban, feathers or hair-like material. Just as snakes are 'feared and worshipped', so are the owners of the magic wands. The *datu* had special knowledge: he could read the magic books (*pustaha*), knew white and black magic, and could identify favourable or unfavourable days, cure diseases and make contact with the spirit world.[115] His wand, which was sometimes taller than a man, was indispensable when performing rituals before, say, a house was built or a wedding took place. A magical sign was scattered on the ground using white lime, charcoal and red powder; the *datu* followed these lines during his dance, and finally stabbed the tip of his rod into a frog and/or an egg – evidently an act that brought good fortune. Beforehand he had rubbed his rod with sacrificial matter, and during the dance he spat betel-nut juice onto it and rubbed it with well-chewed rice. He also dripped blood from sacrificial animals onto it – the rod had to be fed.[116] In any case it had already been charged with power by the owner, who had carved it

Staff, Niger, wood,
109.6 x 5.4 cm.
Collection:
Wereldmuseum,
Rotterdam, 10624

Staff, Halmahera, wood,
95 x 5.1 cm. Collection:
Wereldmuseum,
Rotterdam, 24364

Staff, Tanzania, wood,
117 x 5 cm. Collection:
Wereldmuseum,
Rotterdam, 154831

Staff, Batak, Sumatra/
Indonesia, wood,
170.5 x 6.3 cm.
Collection:
Wereldmuseum,
Rotterdam, 32727

Staff, Karo, Sumatra/
Indonesia, wood,
174 x 5 cm. Collection:
Wereldmuseum,
Rotterdam, 20019

Staff, Batak/ Indonesia,
wood. Private collection,
Netherlands

himself (styles and depictions varied greatly).
At chest, abdomen or liver height there were
small holes that were filled with a magic
substance called *pupuk* and then sealed with
resin or a wooden peg. This 'magic pulp' was said
to have been made from the body of a child that
had been stolen and buried in the ground up to
its neck and, after promising to defend the
interests of the village forever, had had molten
lead poured into its mouth. This supposedly
ensured that the child's *tendi* (life soul) would
remained tied to its body and that its power
would be transferred to the magic wand.[117] Not
surprisingly, the wand was so feared that it was
never simply kept in a dwelling, but was either
hung under the eaves or kept in a separate small
house along with the *datu*'s other magical
attributes.[118]

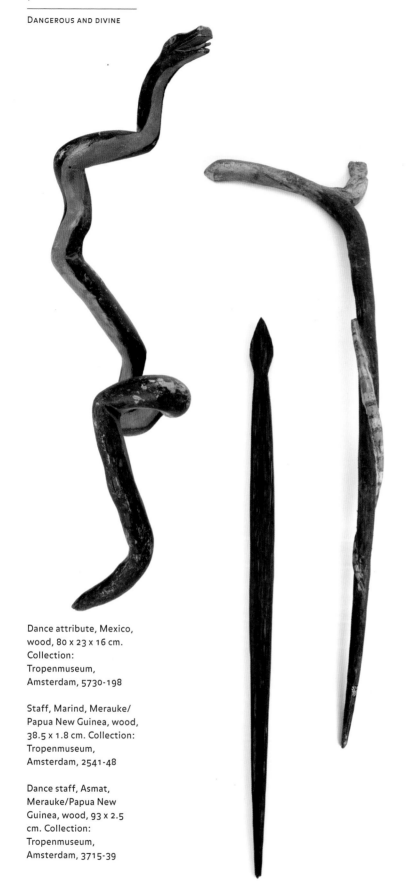

Dance attribute, Mexico, wood, 80 x 23 x 16 cm. Collection: Tropenmuseum, Amsterdam, 5730-198

Staff, Marind, Merauke/ Papua New Guinea, wood, 38.5 x 1.8 cm. Collection: Tropenmuseum, Amsterdam, 2541-48

Dance staff, Asmat, Merauke/Papua New Guinea, wood, 93 x 2.5 cm. Collection: Tropenmuseum, Amsterdam, 3715-39

Nowadays Batak dances are a tourist attraction, and the wands are made so that they can be taken apart and will fit easily into a backpack. The once-dreaded wands with their scaly *singa* that could bring rain and fertility have become inanimate souvenirs.

A painter who longed for a paradise in the late nineteenth century and would become world-famous after dying in misery on one of the Marquesas islands had a snake rod that he had carved himself for use as a walking stick. Paul Gauguin (1848-1903) was not only a pioneer of Modernism, but also one of the first artists to seek vitality and inspiration in art from non-Western cultures. He wanted to break free from Western civilisation and return to an Eden-like state of purity in which he could draw directly on the power of nature – the same kind of longing for the primal source that would later take D. H. Lawrence to Mexico. It was in all likelihood the 1889 World's Fair in Paris – for which the Eiffel Tower was built – that drew Gauguin to Tahiti. During the exhibition Gauguin enjoyed Buffalo Bill's Wild West Show, admired casts of models of the Borobudur temple and was above all interested in the *Exposition coloniale*, where people from France's African and South Pacific colonies were displayed amid their own traditional architecture, in stark contrast to that new monument to progress the Eiffel Tower. Whereas modern life depended on steam power, steel and electricity, the non-Western world was still living in 'prehistory'. Gauguin painted Javanese dancers and collected photographs of Cambodia. Two years later he arrived in Tahiti, which according to letters he wrote to his wife had become much too French for his taste and was already ridden with Christian hypocrisy. Within two years he returned to Paris, where he lived as a flamboyant bohemian, with a blue coat, an astrakhan fez and a walking stick he had carved himself. He was accompanied in the streets of Paris by the young mistress he had at the time, a Javanese woman called Anna, and her

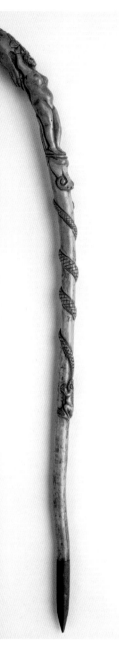

'Paul Gauguin's walking stick, 1880-1890, wood, 93.3 cm. Collection: The Metro-politan Museum of Art, Bequest of Adelaide Milton de Groot, 67.187. 45a,b. Image copyright The Metropolitan Museum of Art/ Art Resource/ Scala, Florence

monkey. Gauguin knew how to present himself, as well as how to shock the bourgeoisie. Carving his walking stick was not some incidental excursion into woodworking; apart from the paintings that would make him posthumously famous, he also produced wooden and ceramic sculptures that bore an emotional rather than stylistic resemblance to the popular art and ethnographic objects he studied. Eventually he withdrew to Hiva Oa in the Marquesas, a group of Pacific islands that were part of French Polynesia. There he carved door panels that must have greatly upset his neighbour the bishop: naked women, as well as texts such as *Maison du jouir* ('House of Pleasure'), *Soyez mystérieuses* ('Women, be mysterious') or *Soyez amoureuses, vous serez heureuses* ('Women, be loving and you will be happy'), made it abundantly clear that the artist's views were far from bourgeois. The mystery of life and love was celebrated here without moral value judgements. Gauguin was anti-clerical, and as he studied world religions his view of religion became increasingly syncretic.[119] A self-portrait painted in 1889 showed Gauguin with a halo above his head, a branch bearing apples and an elegant snake. The reference to the Garden of Eden story is evident, but this self-sanctified ultimate seeker of paradise is holding the snake in two fingers as though it were some perfectly innocent creature. Nor does the coiled snake that he carved on his walking stick seem in any way malevolent. Its tail begins at the mouth of a frog (an animal equally associated with water and fertility in ethnographic objects), and its head is next to a naked woman – the by now familiar combination of snakes and women. Produced by an artist such as Gauguin, who enjoyed native women in every sense, this was a celebration of beauty and vital energy. But impoverished, at loggerheads with the colonial authorities and debilitated by alcohol and syphilis as he was, that energy would abandon him all too soon, and he died at the age of fifty-four. He was swiftly buried by the bishop in the Catholic cemetery, and his goods were auctioned off by court order. And so all his belongings – his clothes, his bottles of wine, his brushes and palette, his paintings and sculptures, the door panels of the 'House of Pleasure' and the walking stick – changed hands for a song.

Act Three

The secret of the serpent

One becomes two, two becomes three, and out of the third comes the One as the fourth.

MARIA PROPHETISSA

Duality is a precondition for activity. The separation that took place in Act One was followed by the way of contrasts, the quest in Act Two. The resolution of contrasts in a *hieros gamos* brought good fortune – it was a productive union. The connection between the goddess and the king is the outward sign of an inner process. The psyche needs wholeness – union – in order to grow. Yet danger lurks in the achievement of wholeness. Jung points out that all energy then ceases, for there is no longer any decay. A river can only flow thanks to differences of height and depth. Union includes a moment of stagnation – in alchemy this is depicted by the

Michael Maier: *Atalanta Fugiens*, Oppenheim, 1617. Depiction of the stage of *putrefactio*, i.e. decay, which precedes rebirth.

grave in which the united King and Queen lie. This is a stage that is necessary in order to achieve sublimation: *putrefactio* (decay) is followed by elevation and transformation. Nothing in this image remains similar to itself, nor can anything ever disappear. Sublimation is the goal of the *opus*, the work of the alchemist, just as the goal of the journey of life is the actual process of individuation, spiritual transformation, growth. The whole thing can be summed up in the above axiom formulated by Maria Prophetissa, a Jewish Alexandrian neo-Platonic philosopher and alchemist, who lived between the first and third centuries CE. This mysterious statement can be seen as a metaphor for individuation: from unconscious wholeness (one) through the clash between contrasts (two) to their potential resolution, the process of change that is individuation (three). Four is the transformed situation after synthesis has taken place.[120]

In Egyptian mythology, this path is reflected in the story of Isis and Osiris. It is no accident that Sarastro in *The Magic Flute* is a priest in the temple that is dedicated to them. Isis and Osiris are children of the gods Geb (earth) and Nut (heaven). The killing of Osiris by his jealous brother Seth, followed by Isis's recuperation of his chopped-up body and the conception of the child Horus, symbolises the cycle of life, death and regeneration that can be observed in the seasons and crops. Horus must fight the power of darkness, and vanquishes Seth. Isis, a mother goddess, is a healer and bringer of fertility. She gives her brother knowledge of agriculture and grants him eternal life in the next world. Osiris is thus associated with regeneration (the annual flooding of the Nile). The Seth-Isis-Osiris-Horus quaternity is an image of completeness or infinity, the cycle of emergence, decay, catharsis and rebirth. In one illustration in the alchemist

Hendrick Goltzius, *Demogorgon in de grot van de eeuwigheid* [Demogorgon in the cave of eternity], 1588, chiaroscuro woodcut, 35 x 26.5 cm. Collection: Museum Boijmans van Beuningen, Rotterdam, L 1954/7 (PK)

Nilton Moreira da Silva, *Oxumare*, wood, metal, paint, 110 cm. Collection: Afrika Museum, Berg en Dal, 622-9

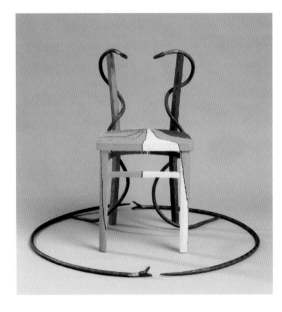

Athanasius Kircher's book *Obeliscus aegyptiacus* (1666), the four Egyptians gods are linked by the snake of eternity, which is biting its own tail.[121]

The snake is a recurring motif in alchemical illustrations. Two battling snakes that are united in the Ouroboros symbolise the contrasting pairs sun and moon, male and female, *nous* (mind) and *physis* (matter) that are united in the *opus* after lengthy transformation – in order to move on to a new stage.

In the second half of the sixteenth century, graphic art flourished in the Netherlands, with Haarlem as its second centre after Antwerp.[122] The Haarlem graphic artist and painter Hendrick Goltzius (1558-1617) was an international celebrity in his own lifetime. His chiaroscuro woodcut *Demogorgon in the Cave of Eternity* (c. 1588-90) shows the ancient creator-god Demogorgon writing with his right hand, and with his left hand raising a rod that he uses to govern the heavens. Demogorgon's pose recalls the figure of Adam in Lucas van Leyden's woodcut *The Fall of Man*, which also inspired the dense cross-hatching technique, resulting in a dark print.[123] This 'hidden' link with the Adam-and-Eve story is as remarkable as it is apt in the depiction of a demiurge, for he is a creator who wishes to withhold 'excess' knowledge from what he has created. There are two spherical forms in the picture: on the left the Ouroboros, the symbol of eternity, and on the right 'the form of Terra or Mother Nature, that sprays the land with plants and animals.'[124] Like the sculpture of Artemis of Ephesus, Terra has several breasts.[125] The relationship with Artemis-Diana, in turn derived from the Anatolian mother goddess Cybele, is evident in the figure of Terra: both are fertility goddesses. During the same period Goltzius produced two similar works depicting Proserpina and Pluto (Persephone and Hades), who can be seen as possible symbols of life and death. The Ouroboros may be seen as the linking element in this theme: the endless cycle of

emergence, death (Pluto) and rebirth (Proserpina-Terra or Demeter). The National Gallery collection in London includes a painting by Luca Giordano (1634-1705) that dealt with the same subject over thirty years after Goltzius's print. Here we see a Demogorgon with milk flowing from his breast (the feeding principle is thus transferred from a goddess to a god), the three Norns or fates spinning the thread of destiny and a winged Chronos referring, like the Ouroboros surrounding the group of figures, to time.

The Ouroboros is *the* symbol of that return and the infinity of the cycle of birth, life, death and

Emblem on the palace wall of Abomey. Piqué en Rainer, *Wall Sculptures of Abomey*, 1999, p 75

Romuald Hazoumè, *Dan-Ayido-Houedo*, *Rainbow Serpent*, 2007, jerry cans, metal, 400 cm. Courtesy October Gallery, London. Photo: artist

Tokoudagba, *Dan*, 1998, paint on linen, 145 x 245 cm. 609-82, Loan collection Dutch Cultural Heritage Agency, Amsterdam

Eugène Brands, *Cobraslang* [Cobra snake], 1958, oil paint on paper, 49.5 x 49.5 cm. Collection: Cobra Museum of Modern Art, Amstelveen, donated by Jan and Jet Brummelhuis

Cobra

Like the Surrealists, the artists of the Cobra movement (1948-1951) were interested in non-academic art. Asger Jorn studied pre-Christian signs such as the (snake) spiral, and Eugène Brands explored the music and art of non-Western cultures. Brands presents his version of the symbol of the movement, the Cobra (the name comes from the first letters of the cities where the members worked: Copenhagen, Brussels and Amsterdam), as the Ouroboros. This work reveals his affinity with esotericism: in alchemical illustrations the combination of the sun and the moon is a well-known symbol of the resolution of contrasts. Brands's Cobra can be interpreted as a depiction of cosmic unity.

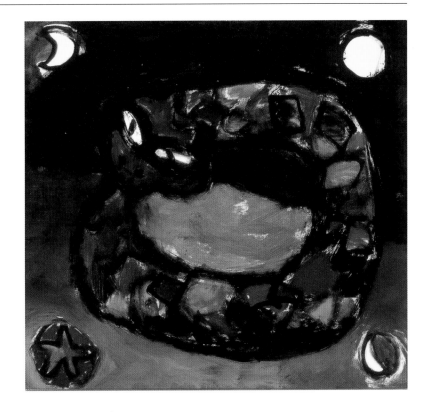

Gérard Quenum, *Untitled*,
2011, metal, paint,
mirror

Gérard Quenum during
his time as artist in
residence at the Afrika
Museum, December
2011. Photo: Wouter
Welling

rebirth. As a symbol of eternity it is of course a
highly appropriate emblem for a king, and in
Benin it was therefore used for one of the most
renowned kings of Abomey, Guezo, who ruled
from 1818 to 1858 and brought unity to the
kingdom. On the palace walls the Ouroboros
is found as Dan Ayido Houédo, the horned
rainbow snake,[126] executed in red, yellow and
blue. During his time as artist in residence at
the Afrika Museum, visual artist Gérard Quenum
(b. 1971) told me that in Benin the Ouroboros
symbolises not only infinity but also wealth. It
is a rainbow snake whose droppings are cowrie
shells, a traditional means of payment in Africa.
There is a striking similarity to the European
tale that the patient seeker will find a crock of
gold at the end of the rainbow. Quenum's
Ouroboros is reflected, as if in water, by a
reflecting soil on which there is a tiny figure
surrounded by strings of cowrie shells once
used by a *féticheur*.

The alchemical adage *aurum nostrum non est
aurum vulgi* ('our gold is not the common gold',

the gold of this world) applies to the gold
'provided' by the rainbow. The treasure sought
here is mental 'gilding': transformation of the
Self.
But what is this Self? What is the essence of
being human – 'simply' the brain, or is there
more? Is the essence energy? Is that energy
consciousness, and is that consciousness

infinite? After that energy has left our body, is it transferred to the field of consciousness that we encountered at the beginning of this story? Mystics and shamans believe so. If we compare their experiences, we see a holistic universe in which everything is interrelated. Quantum physics yields information that points in the same direction – at least, if we are to believe those who philosophise about the results of the research. And this is an appealing notion, like the application of ancient methods of association that link external images to inner assumptions and desires. Take, for example, the particle accelerators at the European Organization for Nuclear Research (CERN) in Geneva, where the

tiniest particles are made to collide so that they disintegrate into elementary particles. The purpose is to identify the elementary primal force that is the basis for the universe. It is hoped that the largest particle accelerator in the world, the Large Hadron Collider (LHC), will find the mysterious Higgs boson particle, which gives other particles mass. The collisions that take place in the LHC release incredible amounts of energy. With a circumference of 27 kilometres, the LHC is the world's largest, subterranean Ouroboros! The world snake, which according to worldwide mythical traditions will be present at the beginning and end of time, provides ultimate knowledge on the primal force of the universe.

'As it is above, so it is below' is (in a nutshell) the famous saying by the mythical philosopher Hermes Trismegistos. From the macrocosm let us now return to the microcosm of our human existence. The combination of snakes and energy is well known in India: *kundalini* energy is represented as a snake, crawling from the bottom to the top of the backbone. An etching by Jyotindra Manshankar Bhatt (b. 1934) reduces the body to the Devi *kundalini* energy which, once aroused or awakened, moves upwards like a snake from the lower back (the Muladhara) via various chakras to the head, where Shiva dwells. Transferring the energy there by means of meditation or tantric ritual sex can result in ultimate bliss, an experience of release from earthly form, and union with the divine. The lemniscate form in the centre of Bhatt's etching – like the Ouroboros, a sign of infinity – seems to emphasise this union. Since 1967 Jyoti Bhatt

Detail of CERN particle accelerator

Etching, *Devi*, India, ink on paper, 58.5 x 43.2 cm. Collection: Tropenmuseum, Amsterdam, 4850-5

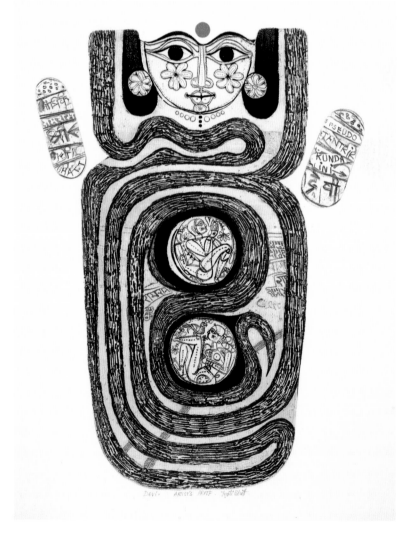

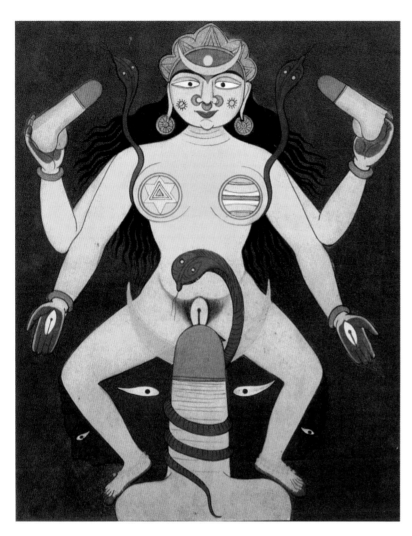

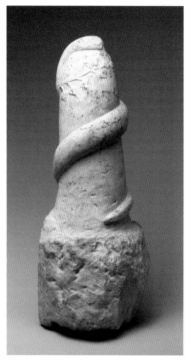

Tantric painting, the serpent as symbol of *kundalini* energy, 18th century

Pillar, Roman, 1st-2nd century BCE, marble, 37.2 cm. Collection: Metropolitan Museum of Art, Rogers Fund, New York, 12.229.2. Image copyright The Metropolitan Museum of Art/Art Resource/Scala, Florence

has photographed traditional life in villages and Indian folk art, which also provides inspiration for his graphic works and paintings.

In the Hindu tantra tradition, sexual energy is a means to an end: an experience of union, the link between Shakti (the great goddess in all her aspects, from life-giving to destroying, from Parvati to Kali) and Shiva, who represents the elimination of all contrasts as ascetic and lover, god and beggar, sober and drunk – identical to the female numinous force that likewise links up a long series of contrasts in the Nag Hammadi texts.[127]

In tantrism and gnosticism, the focus is on the inner experience of the numinous and the transcendent. The union of the all-embracing female principle with the active male one (active because it is made up of contrasts) is expressed by the *lingam* (penis) standing erect in the *yoni* (vagina).

The *lingam* is sometimes depicted with a snake coiled round it – Shakti energy, an image remarkably similar to an unusual Roman marble phallic column with a snake and a wreath, from the Metropolitan Museum collection in New York. This sculpture can be interpreted in one of two ways. The snake as the attribute of Asclepius

may indicate that it was a gift to the god of medicine in gratitude for curing a disease; but as a symbol of the underworld, and in combination with ivy round the top, it could equally well have a funerary meaning. Dionysos, god of wine, intoxication and ecstasy, was the son of Zeus and Semele (daughter of Cadmus). The ever-jealous Hera encouraged Semele to ask her lover to appear to her in his true, divine form. When he appeared to her in a blaze of fire, she was consumed by the flames. Zeus rescued the baby in her womb, and ivy burst forth from the columns of the palace to protect it. Zeus hid the child in his thigh until it had grown to maturity. Dionysos was thus born twice – a deity that overcame death and hence is associated with the transition to the underworld, and with rebirth. Ivy is a symbol of immortality.

Indra Sinha's *Tantra: the cult of ecstasy* traces tantrism back to the worship of the mother goddess and points to the etymological and cultic association between tantrism and the aforementioned great goddesses in Mesopotamia and the Mediterranean region. In both religious settings the bull plays a key role in relation to the goddess. Dionysos was sometimes referred to as *taurokeros* (bull-horned) and *tauroprosopos* (bull-faced). The white bull Nandi guards the door of the bedchamber where Shiva – originally depicted with horns and later with curly hair and entwined snakes – makes love to the great goddess Parvati. The *hieros gamos*, the Dionysian festivals, the mystery cults of the Roman era and later gnosticism share with tantra their focus on the elimination of duality, on union. In gnosticism this leads to an experience of enlightenment (*sophia* = knowledge, insight), and in tantra to liberation. Both the bacchanalia of classical antiquity (with their focus on intoxication) and tantric ritual gatherings where *kundalini* energy is activated by means of sex involve the crossing of boundaries. In India this is the point at which taboos are broken – high and low castes no longer exist. The elimination of

duality, the experience of union, the ecstatic moment transcends all. Sinha's study refers to parapsychologist Serena Roney-Dougal's work *Where Magic and Science Meet*, which states that the pineal gland produces certain hallucinogens similar to the Amazonian shamans' aforementioned ayahuasca. There is another path to this experience that does not involve the use of either hallucinogenic drugs or tantric sex. It is the path of meditation. The description of what is experienced by a deeply meditating woman who concentrates on a lotus and eventually perceives *kundalini* energy flowing out into the sahasrara chakra recalls Jeremy Narby's aforementioned holistic experience after he had taken ayahuasca, or the near-death experiences described by Van Lommel. 'It is impossible to describe the experience accurately. I felt the point of consciousness that was myself growing wider, surrounded by waves of light. It grew wider and wider, spreading outward while the body, normally the immediate object of its perception, appeared to have receded into the distance until I became entirely unconscious of it. I was now all conscious without any outline, without any idea of a corporeal appendage, without any feeling or sensation coming from the senses, immersed in a sea of light simultaneously conscious and aware of every point, spread out, as it were, in all directions without any barrier or material obstruction.
'I was no longer myself, or, to be more accurate, no longer as I knew myself to be, a small point of light and in a state of awareness confined in a body, but instead was a vast circle of consciousness in which the body was but a point, bathed in light and in a state of exaltation and happiness impossible to describe.'[128]

Not religious dogmatism, but inner experience: the body but a point bathed in light. 'Whether we attribute it to mystical or endocrinological causes, it remains the blissful end of the gnostic road, the return journey of matter into spirit ... '[129]

Jan van Munster, *Clone*, 2010, glass, argon, 160 x 50 cm. Artist's own collection

An artist who, more than any other in the Netherlands, has long been associated with the theme of energy is Jan van Munster (b. 1939). Ever since the 1960s electric plugs have been a standard feature of his work. One of his trademarks is neon tubes; he was the first to use 'black light' by painting them black. His work focuses on the clash between contrasts: hot/cold, light/dark, light/heavy, solid/liquid, plus/minus. Such contrasts are characteristic of life; as we saw earlier with *coincidentia oppositorum*, their elimination implies temporary non-existence. 'To me, light is not just about visual impression, but above all about energetic charge, which is invisible. This has to do with the mystical side of the object, that is typified by a kind of closedness. But what is inside is brought outside by a particular way of placing the elements. The result is tension, radiation into space, in which, as it were, light splits open.'[130] Van Munster starts out from what is most personal, himself – in light sculptures and architecture in the form of his design for the letters IK (the Dutch word for 'I', and 'ego'), as well as in his *Brainwaves* series, based on registration of his own brain activity. He arrives at the universal via what is most personal, for, as he himself puts it, 'the EGO is generous – every individual can identify with it.'[131] The intertwined vertical black and white neon tubes are reminiscent of the aforementioned double helix that is experienced after taking ayahuasca and found in the structure of DNA. The artist's brain activity brings us back to the initial question: is it 'all in the brain', or is there also some kind of elusive energy?

The Persian-Roman Mithraic mystery religion, which was practised in caves, focused on the starry sky. Mithras was born from a rock on 25 December, and various depictions show the god emerging from a rock with a snake (symbolising the second degree of initiation) coiled round it.[132] Initiates had to pass through a total of seven degrees of initiation, corresponding to the seven planetary spheres. The purpose was to achieve enlightenment and insight (release from the imprisonment of Plato's cave). The snake symbolises both transformation (its ability to shed its skin) and the link with the earth. The main focus of the cult is the sacrifice of a bull by Mithras, *Sol Invictus*, the unconquered god of light (a quality that made him highly popular among Roman soldiers). The sacrificial blood is drunk by creatures including a snake. The sacrifice regenerates life, nourishes the earth and makes corn, trees and plants grow.[133] The flowing of the sacrificial blood symbolises the recreation of the world. The sacrifice of the bull

A snake's embrace

Gods are regularly depicted with snakes coiled round them. The meanings of this embrace vary considerably. The winged lion-headed man represents the fourth degree of initiation in the Mithraic cult, and the snake's three coils around his body may symbolise the equinox (middle), the summer solstice (top) and the winter solstice (bottom) (sculpture from Sidon, 389 CE, Louvre collection, Paris). In the sculpture of Chronos-Saturn, likewise associated with the cult of Mithras, the spiralling path of the sun from one solstice to the other is depicted by a snake coiled six times round the figure (the sculpture, which stands at the entrance to the Vatican Library, dates from 190 CE). This bronze sculpture of the Syrian goddess Dea Syria or Atargatis, which was discovered on one of Rome's hills and can now be found in the collection of the National Museum of Rome, was made around the third century CE, perhaps under the influence of such sculptures and Egyptian depictions of Isis. The coiled snake is a well-known attribute of goddesses associated with fertility and regeneration. The *candomblé orixa* or spirit being (*candomblé* is a religion with African roots) Becem is depicted as a Christ figure who appears to be overcoming the snake as a symbol of baser urges – at least, this struck me as an appealing interpretation when the sculpture was sold to me in a *botanica* in Salvador da Bahia as the *orixa* corresponding to my date of birth. But Becem (also spelled Bessem) is often compared to Dan, the *vodun* spirit being depicted in West Africa as a rainbow. Dan provides the link between heaven and earth, and in that sense resolves contrasts, something also expressed in the sculpture. In the famous emblem book *Atalanta Fugiens* (1617) by the German physician and alchemist Michael Maier (1568-1622), the snake's embrace has yet another meaning. The snake coiled round a human being in a grave refers to the *putrefactio* stage that precedes spiritual cleansing or rebirth (see p. 74).

Becem figure, Brazil, terracotta, 19 cm. Private collection, Netherlands

Lion man, Sidon, 389 CE Collection: Louvre, Paris

Chronos/Saturn, 190 CE Collection: Vatican Library, Rome

Dea Syria/Atargatis, c. third century CE. Collection: National Museum of Rome

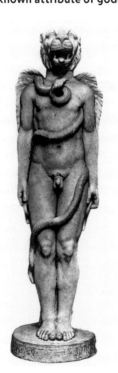

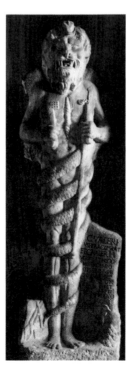

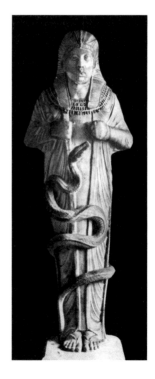

Snake bracelet, Egypt,
silver alloy, 11.6 cm.
Collection: Allard Pierson
Museum, Amsterdam,
APM7029

Mummy mask of Aphrodite,
daughter of Dides, 20 years
of age, 50-70 CE, Hawara,
Egypt, plaster cast, linen, 54
x 30 cm. Trustees of the
British Museum, 1979.1017.7

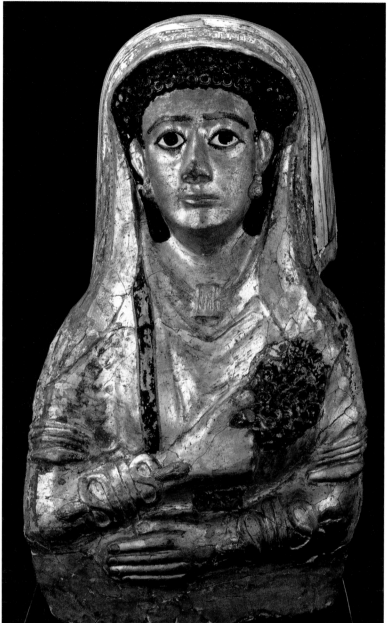

is related to the moon; the sun god Mithras seizes the bull by the horns (the lunar crescent – the moon was a symbol of death and rebirth).[134] The seventh and highest degree of initiation corresponds to the planet Saturn. Mithras is a manifestation of Saturn-Chronos, and hence time,[135] depicted as a lion-headed man with a snake spiralling round him. The snake refers to time, i.e. the passing of the year, the spiralling path of the sun.[136] Saturn is essentially the same unpopular demiurge that we encountered earlier: he devours his own children (the passage of time). The various degrees of initiation and the animal symbolism correspond to the celestial bodies. The purpose of initiation was to live rightly and so return after death to the star from which the soul had descended. During its descent, the soul had acquired qualities that would be of use to it during its life on earth. 'After death, the soul casts off the qualities it has acquired at each of the gates of the seven spheres in order to enjoy bliss in the highest heaven.'[137]

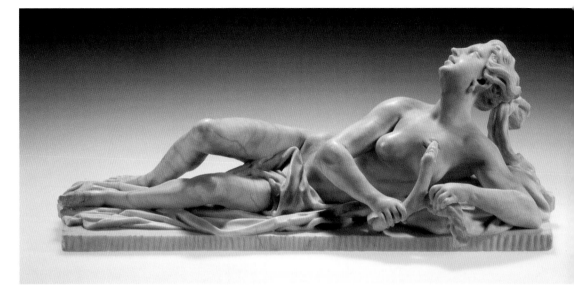

Statuette, Cleopatra,
1700, alabaster, 46 cm.
Collection: Herzog
Anton Ulrich Museum,
Braunschweig, Germany,
Kunstmuseum des
Landes Niedersachsen,
Ste 67. Photo: museum
photographer

Back to the origin. A historical heroine and a fictional hero both used a snake to return to their distant places of origin beyond the earth. Cleopatra chose to be bitten not just by any snake, but by the sacred creature of the sun god Amon Ra, the *uraeus* snake depicted on the diadems of Egyptian pharaohs. The bite of the sacred snake took her back to the celestial world not just as the final member of the Ptolemaic dynasty, but above all as a pharaoh. As for the Little Prince, he travelled from his star via other planets to the seventh (!) planet, Earth. He landed in the midst of an African desert. The first living creature he encountered was a snake,

'Calendar worms'

Toothed snakes on shrouds from the Paracas culture (900-300 BCE) and on pottery from the burial chambers of the Nasca culture (see the article by Edward de Bock) – a most unusual type of snake, a small creature with rows of 'teeth' on either side of its body and an unforked tongue. Whereas archaeologists believed it was a mythical creature, biologists Wolfgang Wickler and Uta Seibt, authors of the book *Kalenderwurm und Perlenpost* ('Calendar Worm and Bead Mail'), discovered that it really does exist – only it is a polychaete marine worm rather than a snake. At a given point in the lunar cycle these 'bristle worms' spawn *en masse* and shed their reproductive parts (known as epitokes), which rise to the surface and are much savoured by fish and fishermen alike. The peoples of ancient America may also have eaten the epitokes, and since the worms always

spawned at a particular phase of the moon they probably played a part in lunar calendars – so that in fact they were 'calendar worms'. Both the phases of the moon and the possibility that the worms were a source of food – not only weapons, tools and ornaments were wrapped up in shrouds along with the dead, but also maize, beans, groundnuts, yucca and sweet potatoes – are in keeping with the notion of life after death.

Fabric, Paracas/Peru,
wool, 9.3 x 9.5 cm.
Collection:
Tropenmuseum,
Amsterdam, 3842-880

which he thought was a 'strange animal', as thin as a finger.

'But I am more powerful than a king's finger,' said the snake.

'You do not look very powerful … You don't even have paws … You cannot even travel.'

'I can carry you farther than a ship,' said the snake.

He twined himself around the little prince's ankle, like a golden bracelet.

'Whomever I touch I send back to the earth from which they came,' the snake added. 'But you are pure and innocent, and you come from a star …'

The little prince said nothing.

'I feel sorry for you, so weak on this Earth of granite. I may be able to help you one day, if you become too homesick for your own planet. I can …'

'Oh! I understand you perfectly,' said the little prince. 'But why do you talk in riddles all the time?'

'I solve them all,' said the snake.[138]

And of course there comes a time when the little prince grows homesick for his planet, where a flower is waiting for him. He asks the snake for help, for he cannot take his body with him – it is much too heavy.

'Is your poison good? Are you sure it will not make me suffer for too long?' he asks the snake below the wall he is sitting on. The snake does its work quickly. And so the little prince returns to where he came from.

The end is the beginning of the same story – only different.

Antoine de Saint-Exupéry, illustration from: Le Petit Prince, 1943

Roundabout ways:
serpent symbolism in West Africa

SIEBE ROSSEL

Humans are incapable of living in chaos. Since time immemorial, humans have always had a need for an ordered world view. Humans classify things in their environment by grouping them in a range of juxtapositions: culture and nature, village and forest, heaven and earth, water and land, human and animal, us and them, masculine and feminine, good and evil, life and death. This order is captured in a cosmology that is reflected in ritual artefacts, performances, and mythological tales. These mythological tales explain how and why man's environment has been classified the way it has. They tell the story of the origins of the world, of life, of man, or of culture, and

they describe drastic changes, such as migration. Myths convey where humans stand in relation to nature, who they are in relation to each other, which standards and values they adhere to, and which duties and power relations are to be respected. Any human being or animal that displays deviant behaviour or qualities that defy categorisation can count on special treatment. After all, such a human or animal is a threat to the order, and the resulting power of the transgressor must be neutralised. The feared outsider is therefore harnessed and declared a revered 'witch' or 'wizard', i.e. a ritual specialist, who establishes contact with the realm of the spirits on behalf of the community, and conveys messages from the great beyond. Serpents too have this kind of special status, they are intermediaries that feature heavily in ritual artefacts and performances.

Its atypical appearance has led to many different cultures considering the serpent an animal that defies the order within which humans understand their world. A serpent lives on land, but has no paws, it sometimes swims in water and has scales, but not the fins fish use to propel themselves through the water. Serpents lay eggs and sleep in the treetops, but they lack the wings of a bird to get there. Heaven and water are also often the domains where spirits and ancestors are thought to abide. These supernatural beings possess invisible powers that can bring life, fertility, and success, but also cause disease, death, and other misfortune. Such powers are also attributed to the serpent. The ability to move without limbs makes it seem as if the serpent is propelled by, and somehow allied to, the invisible powers that also make rivers and rain flow and create life. But this animal can also dish out a deadly bite. The duality of life and

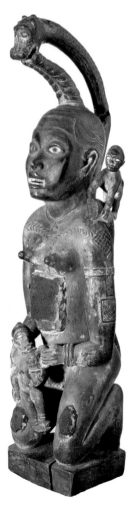

Power statue, *Nkisi*, Vili/Cabinda, wood, pigment, glass, fabric, 44 x 11.2 cm. Collection: National Museum of Ethnology, Leiden, RMV 1354-47

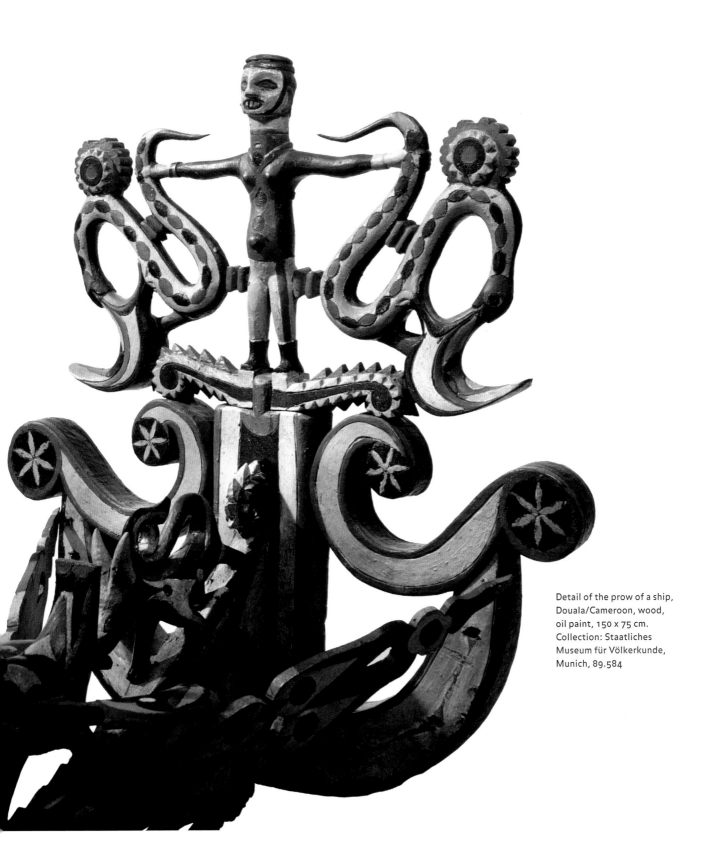

Detail of the prow of a ship,
Douala/Cameroon, wood,
oil paint, 150 x 75 cm.
Collection: Staatliches
Museum für Völkerkunde,
Munich, 89.584

Initiation panel, Eton/Cameroon, wood, 460 x 65 cm. Collection: Staatliches Museum für Völkerkunde, Munich, 22-30-3

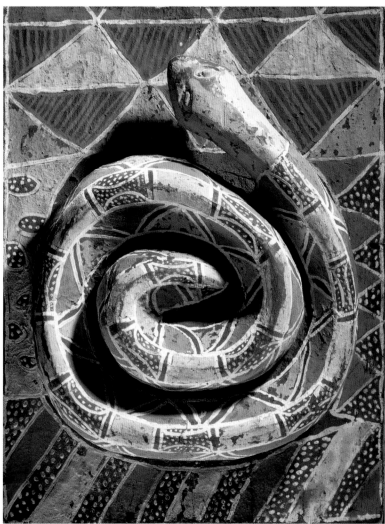

Initiation panel, Nkanu/Dem. Rep. Congo, wood, 58 cm. Collection: Afrika Museum, Berg en Dal, 17-849

spirits and ancestors for favours.

As a liminal being that exists on the boundary of opposite domains, the serpent guides boys and girls who are leaving their childhood behind them and are initiated into the secrets of adulthood and sexuality. It can also bring fertility at the start of a new agricultural season. The serpent is also seen as a guardian of people who leave the village to go out into nature and hence enter the domain of the supernatural forces. Another role ascribed to serpents is that of a messenger conveying prophecies from the gods, spirits, and ancestors. Serpents also protect ritual specialists or monarchs who are in contact with this divine domain.

Of the many roles attributed to serpents and the many forms of worship that befall serpents in Africa, this chapter focuses only on those from West Africa, as most artefacts on display are from that part of Africa. Since limiting the scope to this geographical area still leaves a selection of cultures that is far too large to cover here, three cultures where serpents are considered important spiritual media have been singled out for closer scrutiny. These are the cultures of the Dan people in Liberia and Ivory Coast, the former Wagadou Empire in Mali, among other countries, and the Baga people in Guinea. The meaning of the serpent in several other cultures is further examined by adding two large geographical areas to the scope. These are the savannah covering Mali, Burkina Faso, and northern parts of Ivory Coast on the one hand, which is home to ethnic groups such as the Dogon, Senufo, Lobi, and Bwa, and the coastal area around the Bight of Benin on the other, where the Fon and Yoruba people live, among others. This yields a varied picture of serpent worship, past and present, covering a large part of West Africa.

death is also expressed in the serpent's shedding of its skin, which marks its 'rebirth'. The serpent's defiance of the categories humans use to interpret their world makes this animal ideally suited to the role of intermediary in rituals that people use to make contact with the invisible forces influencing their lives. In a range of (mainly West) African cultures, people rely on serpents as conduits through which they ask

The cultures described here are not isolated units, but rather often share more than just their serpent worship traditions, and also have a common history. Since their contributions to this history vary, sharing a common history can have amplified both the similarities and the differences between the various ethnic groups. Whenever relevant in describing the significance of the serpent, this essay also covers the history of the respective cultures. The decision to split West Africa up into a coastal and an inland area was also based on historical reasons. Large parts of West Africa were governed by Sahelian rulers for many centuries. These empires traded with North Africa and encompassed several cultures that maintained mutual relations. These Sahelian

empires also spawned a diaspora of ethnic groups and cultural elements. As the Sahelian empires in the West African interior weakened and the flow of goods, people, and ideas moved south with the arrival of European colonists, coastal and inland areas reconnected and similarities and differences between cultures were reinforced.

This chapter about serpent worship in West Africa will first look at the Dan people, who left the interior to settle on the coast. Their approach to the serpent addresses cultural elements that will be covered later in this essay, followed by a section about the serpent in the former Soninke Empire, and a section about current forms of serpent worship in the Sahel. The Baga people, who swapped their inland villages for coastal settlements many centuries ago, take us back to the coast for the final part of this chapter. Given the impossibility of making a full reconstruction of historic lines and their interconnections without any gaps, this chapter takes a roundabout path that writhes its way through history to provide an introduction to the various forms of serpent worship in West Africa, drawing examples from the cultures encountered along the way.

Children of the serpent

Contrary to most animals, it is rare for a female human being to give birth to several young at once. Twins therefore occupy a special position in many West African cultures. Until well into the twentieth century,[1] Dan people in Ivory Coast and Liberia used to equate women who gave birth to twins with animals, while the twins themselves were seen as snakes more than as human beings. Twins were thought to be closer to the spirits and ancestors, whose souls were believed to live on in these children. This bestows upon twins a divine power, which depending on the nature of these children could bring either prosperity or death and destruction. When a pregnant woman has visions of snakes

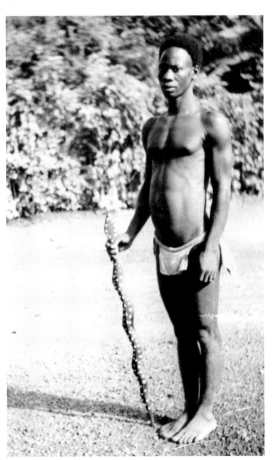

Copyright Pieter-Jan Vandenhoute Foundation, no. 152a,152b, 153b

surrounding her, feels them in her belly, or has dreams of snakes, such sensations are considered harbingers of the divine powers of the twins she is carrying. After a ritual healer has examined the woman's body and confirmed her suspicions, snakes are strictly taboo for the woman and her family, and she is made to eat 'snake food' (goat meat with palm oil). Even during pregnancy, the twins can kill each other or their parents, and also after their birth, twins can immerse their parents and village in good or evil, and will rule over life and death. The pending arrival of twins therefore steeps the village in fear and insecurity.[2] Shortly after their birth, a ritual is held to confirm whether the twins are bringers of good or of evil. In an attempt to ward off any impending doom, villagers organise a large party, complete with music, dancing, palm wine and food in palm oil, which is intended to goad the snake babies into choosing the side of the people. The traditional healer will then rub some of the food on the babies' mouths and leave them be. By eating the food or not, each twin baby reveals its intention to become one of the people or to spread evil. Depending on how this test plays out, which may even be with one or both babies dying, the party goes on or ends. Since this test is far from foolproof, people always remain wary of twins, and use special rules and precautions in dealing with them. Twins are never punished and only given food that has been soaked in palm oil. If they are ever refused something, or if someone were to renege on their obligations towards twins, or if the twins were not to be treated equally, the

disadvantaged child would mutate into a snake crossing the sinner's path, enter his home, and give him 'diarrhoea in the form of running palm oil'. Even though twins grow up amidst other children, people tend to steer clear of them. When one of a set of twins dies, many of the rules become defunct, and the other child goes on to live a normal life.[3]

Twins always have a snake as their totem animal,[4] are not allowed to chase, hit, kill, or eat snakes, and must marry outside the group symbolised by the snake. A totem animal is a mythical ancestor of a group of kindred people. Although Dan people believe in an actual connection between twins and snakes, the association with totem animals also serves to distinguish groups such as those formed by twins from other groups in society. Apart from the snake, other totem animals used by the Dan are the goat, sheep, dog, or antelope. These animals represent groups of people that are classified based on analogies with the animal kingdom. The Dan traditionally had a competitive society where a link with the divine powers of a totem animal was an important boost for people's social standing. Marrying outside the group symbolised by the totem, and the ban on eating, killing, touching the totem may be considered as a ban on incest, because people inside the group are considered relatives. People's kinship with their totem animal is expressed, among other ways, by sharing a meal with the totem animal as part of special rituals.[5]

 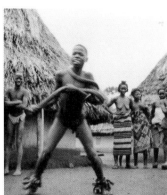

Making snakes taboo is also an avoidance tactic that is applied to elements that unsettle the way people classify their environment, and therefore form a threat to the relationship between man and the invisible powers that control his life. That is also why the Dan shun twins in social circles. Aside from avoidance, removing or killing unsettling elements is another way of neutralising their threat. In Dan culture, this happens by subjecting twins to a test soon after their birth. A third tactic is to incorporate anomalies into rituals with a view to harnessing the powers of that which transcends categorisation in a positive way. The Dan also use this third tactic with twins.[6]

Such rituals see twins taken into the woods together with other teenagers to be initiated into adulthood and the secrets of the realm of the spirits. But on such occasions, only twins are also initiated into the society of the serpent. Once initiated, their bond with the serpent gives twins the power to heal and create life. Women who are part of the society of the serpent are therefore always midwives and healers, while the society's men are snake dancers and snake charmers. They are all immune to poisonous snake bites after having eaten snake medicine, and they have the ability to keep snakes, scorpions, and spiders at bay and heal people who were bitten by a snake or suffer disease. As they perform acts of healing or rituals, members of the society of the serpent dance with live snakes or a snake-shaped staff to invoke their powers. That allows twins to re-establish their

relationship with nature when the powers of evil manifest themselves in day-to-day life. The Dan consider culture and nature to be at odds with each other, and that antithesis is reflected in the contrast between the village controlled by man and the woods where spirits and souls rule.[7]

Snake charmers have their own snakes, but also go looking for them in the woods. That is where snakes point them towards herbs and treatments for healing, as well as towards means of exposing and neutralising powers of evil. Aside from boa constrictors and vipers, the woods are also home to the mythical snake, which seems allied to thunderbolts and rainbows, and which is not visible to the regular human eye. Whenever humans need the help of serpents, twins with white rings painted around their eyes and black charcoal rubbed onto their chests head into the woods. Those medicinal colours help snakes track them down and make them immune to the forces of spirits that mean harm. The negative effects of these forces for man, agricultural land, and cattle can be cancelled out by the twins.[8]

Belief in the bond between twins and snakes is interlaced with the mutual competition among Dan people and the support from their totem animal that individuals and groups need. In Dan cosmology, man and animal are connected in a special way. Besides an inaccessible creator deity that is not worshipped, the Dan also have the important and ubiquitous force called Du. Du is present in spirits, humans, and animals, as well as in the masks and power artefacts that people use

Statuette of a kneeling figure with tongue extended, Djenné/Mali, 14th – 16th century, terracotta, 42.5 cm. Collection: Musée Barbier-Mueller, 1004-78, photo: Studio Ferrazzini Bouchet

to invoke spirits. When Du manifests itself in the form of an animal, this will be as the soul of a deceased person. Souls of the deceased were mostly thought to return in another human body after some time, but sometimes one soul would return in two children, or in an animal and a human being. In the latter case, a person and an animal would share qualities, meaning that a person can be as strong as an elephant or as industrious as a wild boar, and can even transform into that animal. A soul that is still lacking a material body will appear in dreams to express how it wants to return, for example in the form of an antelope horn filled with medicine. By making an offering to this object, the dreamer will then enter into contact with this soul. If the soul in question is particularly strong, several people will want a part of that strength. That is how secret societies are formed around a power artefact, which are led by the person who initially dreamt it, and whose members share the divine powers.[9]

The Dan used to greatly value the power to predict the future, expose witches, garner fame and fortune, be a successful hunter and warrior, or the ability to transform into an animal. Their society required individuals to perform and be indispensable as the best farmer, cattle breeder, potter, healer or leader of a secret society. The Dan traditionally lacked central government, and whenever they waged war to establish new settlements, village chiefs and rulers would forge alliances. This was the modus operandi for many centuries following the Dan's ousting from the Sahel around 1300 until they reached Liberia and Ivory Coast via Guinea in the seventeenth century after constant warfare. In these circumstances, people who could not hold their own would be gifted to other village chiefs as slaves. Being able to perform was literally of vital importance, and a connection with divine powers such as those of the serpent was crucial.[10] Allied to the serpent, twins can boast more powers than humans with other totems, and they therefore carried a lot more weight when it came to manipulating the precarious relationship with nature and in competitive relations between humans.

Snake brides

Also in days long gone, snakes were considered animals with special powers in West Africa, animals who influence everyday life from the invisible world of the gods, spirits, and ancestors. This certainly goes for Mali, which produced enormous empires that ruled large parts of West Africa, and whose leaders, in the case of the Wagadou Empire, were connected to the cult of the serpent. Archaeological digs around the towns of Djenné and Mopti have unearthed terracotta figurines depicting curled-up snakes, as well as human figurines covered in snakes, with snakes even coming out of these figures' ears, eyes, and mouths. These statuettes date back to a period that runs from the seventh – ninth century up to the seventeenth century.[11] Little is known about the function, meaning, and makers of the Djenné figures. Some insight can be derived from the figurines themselves, from old tales, and from more recent snake-based rituals in Djenné and its surrounding area, as well as from the historical context of the great Sahelian empires.

The human figurines that were dug up are often male and female figures that are sitting up

Statuette, Djenné/Mali, terracotta, 23 cm. Collection: Durand-Dessert, Paris, photo: Hugh Dubois

Statuette, Djenné/Mali, 1187-1287, terracotta, 22 cm. Collection: Durand-Dessert, Paris, photo: Hugh Dubois

Statuette of a woman giving birth to a snake, Djenné/Mali, 12th – 14th century, terracotta, 36 cm. Collection: Musée Barbier-Mueller, 1004-95, photo: Studio Ferrazzini Bouchet

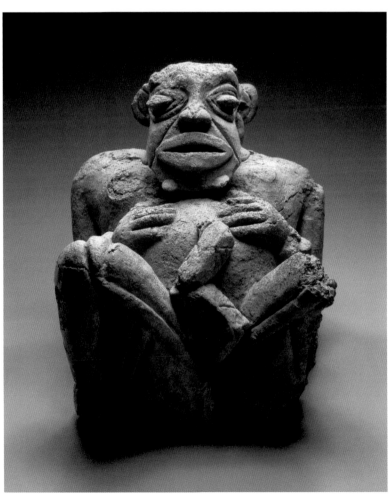

straight and seem unfazed to have snakes writhing all over their bodies. The female figurines are snake-covered mothers with one or several children, which seems to allude to fertility. Some of the male figurines, on the other hand, are stooped forward and seem to be seriously ill. When a snake is depicted on its own, the artefacts are mostly amulets or small freestanding sculptures, and there is also one snake's head that seems to originate from a much larger figure. Sometimes the boundary between human and snake has faded, such as in one sculpture of a woman giving birth to a snake, and in the figurines depicting people morphing into snakes. Other finds include spherical urns with snakes depicted on them, and sometimes with a human head sticking out of them. Snakeless human and animal figures also exist. These tend to be depictions of archers and horsemen, who are, however, adorned with circled dots or zigzagging lines that seem to allude to snakes. Dromedaries, oxen, and birds are also depicted.

Most of the Djenné sculptures were made between the eleventh and fifteenth century, but the figures with snakes only date back to the sixteenth and seventeenth century, while the

abovementioned snake's head was made as far back as in the seventh – ninth century. Snakes seem to be absent during intermediate centuries, but the snake-related myth was still passed on orally and eventually captured in script in the nineteenth century.[12] All in all, the terracotta figures cover a time frame during which Djenné and its surrounding area were part of the Wagadou Empire of the Soninke people (approx. 400 – 1235), the Mali Empire of the Malinke people (approx. 1230 – 1600), and the Songhay Empire (approx. 1340 – 1591).[13] These three Sahelian empires stretched out across the savannah and were wedged in between the Sahara desert to the north and the forests along the West African coast to the south. Around the year 1000, the Wagadou Empire covered the southern parts of present-day Mali and Mauritania. The Mali Empire covered roughly the same area around 1350, but also extended further east into present-day Niger, while to the west Senegal, Gambia, Guinea-Bissau and Guinea to the north were also part of the empire, as were northern parts of Ivory Coast, Burkina Faso, and Ghana to the south. The Songhay Empire included the same areas, while also covering the whole of Mauritania, as well as a much bigger part of Niger and the north west of Nigeria. Within these immense empires, the Djenné figures come from a small, but highly important, area: the interior delta of the Niger River.

Cities like Djenné were popular waypoints for Muslim traders who were transporting salt southward and gold and cola nuts northward through the Sahara desert. The Sahelian empires boomed on the back of the trade that passed through them on dromedaries, animals that were also depicted in Djenné figures. Traders would pay tax on the gold dust they traded and had to hand over the nuggets of gold they mined. This brought huge wealth to Sahelian leaders, who would reflect that wealth by wearing a golden crown.[14] The gold they accrued was also used to purchase horses for the cavalry. Using the horsemen and archers that also feature among the Djenné figures, a Sahelian ruler would

enforce the loyalty of surrounding vassal states. He would ensure order was maintained, which benefited traders and local leaders, and for which they paid taxes.[15] Since local customs were spared, Sahelian empires comprised a rich variety of cultures and religions. This also went for Djenné and its surrounding area, where various ethnic groups lived in their own villages and urban districts.[16] This syncretism also allowed Islam to spread across cities and rulers across the Sahel empires, while farmers and local leaders held onto local religion and only converted to Islam in the nineteenth century.[17] The probably religious terracotta sculptures from Djenné and surrounding area could therefore remain in use for many centuries, despite the city becoming a prominent Islamic centre.

Given that the Soninke people possibly founded not only the Wagadou Empire, but Djenné as well, the testimony of eleventh-century author El Bekri is particularly interesting. According to this source, which is thought to describe customs in the Diafulu area inhabited by Soninke people, a big snake resembling a boa constrictor was an object of worship there. The animal would appoint a new leader using its nose. The chosen one was then required to throw himself onto the snake and pull as many scales from the animal's neck and tail as possible. The number of scales he would manage to pull out represented the number of years the new leader would rule. The snake was also the centre of a divination cult, as part of which sacrifices would be made.[18]

As a carrier of the power of prophecy, snakes were thought to be in touch with the forces that bring salvation and doom to the people and the rulers, who enjoy divine endorsement. Although we do not know how the Djenné figures were used, they probably served a ritual purpose and were possibly used as sacrifices as part of the divination cult. These figures do not seem to be grave gifts, because even though they were found buried in the ground, they were rarely found near human remains.[19]

One oral tradition of the Soninke people also seems to provide some information about Djenné snakes, although it remains uncertain whether the Soninke founded Djenné and made the terracotta figures. The mythological history of the Wagadou Empire starts with the leader Dinga, who left the Diaga area and wandered around West Africa with his entourage. Dinga settled in Djenné for 17 (or 27) years, but when his wife remained childless, he took off again. At one point, the wandering Dinga and his entourage stumbled upon a well, where they encountered a spirit. At this encounter, Dinga and the spirit deafened, blinded, and paralysed each other. After Dinga was healed by the 'wizard' in his entourage, the spirit offered him his three daughters, as well as a partnership, providing Dinga would also let him be healed. Dinga accepted the offer, and married the daughters. Dinga fathered six sons with the first woman, including the snake Wagadou Bida, who fled immediately after its birth. The second of the three daughters bore him five sons, among whom was Maghan Diabe, who would go on to found the Wagadou Empire. The third woman bore him four sons. When Dinga reached old age and was ready to hand his power over to his first-born son, Maghan Diabe cunningly pinched his chain. After hearing a prophecy by the 'wizard', Maghan Diabe and forty horsemen headed east to found an empire. Maghan Diabe and his horsemen were initially shown the way by a hyena, and later by a vulture, which led them to a tree marking the site of Koumbi (the capital of the Wagadou Empire). As Maghan Diabe felled the tree, it turned out to stand on a well that was home to a snake. That snake was his own brother, Wagadou Bida, who claimed to be the owner of the land. The brothers then struck a deal under which Maghan Diabe was allowed to found the Wagadou Empire, providing he would sacrifice the most beautiful virgin to Wagadou Bida at every harvest ceremony. After the death of Maghan Diabe, he was succeeded by two of his brothers, who were later succeeded by Kaya Maghan Cisse. Under his reign, the Wagadou Empire crumbled, because the wizard fell in love

with a virgin who was chosen to be sacrificed to the snake, which led the wizard to chop off the snake's head(s) in seven strokes. After the sixth stroke, Wagadou Bida uttered the prophecy that his death would be followed by seven years of drought and that the Soninke people would suffer a famine. This prophecy came true, the Soninke people left Wagadou en masse and founded the city of Djenné.[20]

Like El Bekri, the myth refers to a divine relation between a snake and the ruler of the empire, who share a name. The snake is the owner of the land that the ruler is allowed to use for his empire, providing he sacrifices virgins to the snake. As soon as that agreement is breached, the land falls prey to drought and the empire ceases to exist. This seems to chime with the exchange of sacrifices and prophecies El Bekri describes. What is odd is that the Wagadou Empire had already fallen many centuries ago when most of the sculptures with snake depictions were made in the sixteenth and seventeenth century, and even longer ago when the accompanying myth was recorded in the nineteenth century. Only the large snake's head dates back to the actual era of the Wagadou Empire, i.e. the seventh – ninth century,[21] the period referred to in the myth. Since the sculptures with snake depictions were made long after the downfall of the Wagadou Empire, and the myth was passed on in oral tradition even longer, the culture of the Wagadou Empire must have outlived the actual empire by many centuries, and the myth must have contained a message that, despite the changes of power, retained its relevance in subsequent empires.

The myth chronicles the rise and fall of the Wagadou Empire in terms of antitheses such as settlement and departure, fertility and drought, natives and newcomers, human and spirit, life and death. The departure that kicks off the story is prompted by a childless marriage, and the departure at the end is the result of a violent breach of contract. Fertility and drought appear to hint at a conflict between locals and

strangers, but given that settlement invariably follows the discovery of a well, drought itself also seems an additional problem. Settlement is dependent on reconciliation of newcomers and natives, with the latter presented as a spirit or snake with supernatural powers. Only after that conflict has been settled will women be given in marriage and children born. The conflict itself only leads to disaster; parties are deafened, blinded, and paralysed, or murder is followed by drought. Considering the consequences, clashes of ethnic groups are experienced as fruitless for both parties in the myth, with mutual recognition being the message the myth intends to send out. What is needed for locals and migrants to strike up a fruitful coexistence is mutual respect, culminating in both parties reaching an agreement. The myth highlights the contract between Dinga and the spirit, as well as the one between Maghan Diabe and the serpent. What is special about the contract between the newly-arrived ruler and the already settled serpent is not only that they are brothers, but also that both are in fact migrant and land owner or ruler. This is typical of leadership structures in the Wagadou Empire, where vassal states are subjected to the rule of the empire by the grace of local leaders' and religions' acceptance of that rule: the ruler of the empire is at once a migrant and a native.

Besides through a social contract, the myth also ties fertility to divine consent in both a natural and social sense (well, marriage, child, brotherly bond). Soninke rulers that feature in the myth rely on the support of animal spirits (hyena and vulture) and 'wizards', and the spirit and snake that act as local leaders seem human-like creatures that converge with divine powers. This suggests that social relationships and divine powers need to be reconciled, otherwise any settlement will be inviable. Apart from a local leader with divine powers, the snake can also be considered to purely be a spirit. That would explain why arriving Soninke rulers need to bring 'wizards' to make contact with divine forces, while local leaders converge with these forces. Showing mutual respect and reaching an

agreement then reflects the relationship between humans and spirits. The myth reduces the existence of the Wagadou Empire to a contract between ruler and snake. The empire is born as these strike a deal, and ends when the deal is violated. When considering the snake as a spirit, its murder at the hands of the wizard could be taken as a reference to the islamisation of the Soninke people, with the snake's defeat symbolising the demise of traditional religion. This could be a later addition to the myth, as told during the times when Islam was on the rise. The Soninke people were, however, never fully islamised. There are records of a ritual observed in 1954, which commemorated Bida with a twelve-metre-long snake portraying the history of the Soninke people.[22]

If there is one message that can be ascribed to this myth throughout many centuries, it seems to be mutual respect between old and new parties, where old parties can take the form of both human inhabitants and spirits, and the contract can relate to either other cultures and religions or people's own set of beliefs. To assess those possibilities, the myth will have to be offset against actual history.

The Soninke's Wagadou Empire was preceded by the Dhar Tichitt civilisation in Mauritania, which existed around 1600 BCE. As the desert and nomads invaded their habitat, this civilisation moved south around 300 BCE, down to the then fertile northern part of Mali, where the Wagadou Empire would rise around the year 400. This is reminiscent of the roundabout emigration of Dinga and his entourage. Dinga was from the Diaga region in southern Mauritania, and his fruitless marriage might stand for drought or conflict with nomads; both are realistic factors that can force people to abandon their habitat.[23] The ruler of the Wagadou Empire stayed at Koumbi Saleh, the city of the tree, the well, and the snake in the myth. In actual fact, Koumbi Saleh had a sacred grove with religious specialists, which made the city the spiritual centre for the Soninke people. The ruler too lived

in a walled area that eleventh-century Muslims referred to as 'the grove'. In line with the myth's hypothetical message, the city also had a Muslim area with mosques, traders, and its own wells, and Muslims acted as advisers to the ruler of the empire. There was therefore no shortage of mutual respect between natives and newcomers and their respective cultures and religions. In the eleventh century, new states absorbed the Wagadou Empire, and the empire declined as a result of internal struggles and the jihad of the al-Murabitun (Almoravids) from Morocco. The myth may be alluding to this decline when it describes the drought in the empire following the slaying of the snake. In 1235, the Wagadou Empire became part of the Mali Empire.[24]

As far as the origins of the terracotta figurines are concerned, the myth states that Dinga lived in Djenné, and left that city only to refound it after the Wagadou Empire had literally dried out. This matches reality. The initial city of Djenné-Jeno was founded around 250 BCE, with its trademark walls erected around 850. Around the year 1000, a second Djenné rose next to this Djenné, which may have been the doing of either the Soninke people or the Bozo people. After the fall of the Wagadou Empire, new Djenné developed into the most important centre for trade and Islam in West Africa, while Djenné-Jeno gradually depopulated. When the Mali Empire rerouted the Sahara trade route through Timbuktu, new Djenné weakened, but the city does appear to have continued to pay taxes.[25]

The Mali Empire rose in the tenth century and became a sizeable empire in 1235 when existing Mande states were united in the Mali Empire. This empire too had many religions, but rulers and cities were Muslim, and both Djenné and Timbuktu had a Quranic school. Despite the prominence of Islam, the rulers of the Mali Empire still allowed female servants and slaves to walk round naked, much to the dismay of the Islamic traveller Ibn Battuta in the fourteenth century.[26] This nudity is reflected in the Djenné figurines, and further corroborates that Islam and local customs existed side by side across the Mali Empire. But figurines with snake depictions appear not to have been made during this period.[27]

The eastern Islamic vassal state of Songhay was also part of the Mali Empire, but rebelled and started to gain ground in the north from 1400. When the Songhay took over Timbuktu and Djenné, and gained control of all trade routes through the Sahara desert towards the end of the fifteenth century, people in the southern section of the Mali Empire upped sticks and moved to the coast, where they found new trade partners in the Portuguese. But the Mali Empire failed to stem its territorial losses and finally ceased to exist altogether in the early part of the seventeenth century. Meanwhile, the Songhay Empire had grown to a considerable size by the end of the fifteenth century. Where the myth speaks of a peace treaty based on the exchange of women, Songhay ruler Sonni Ali sealed a peace deal by marrying the widow of the killed Djenné ruler. But the merger of the western Mali Empire and the eastern Songhay Empire did not prove a fertile one. Resistance from within the Mali Empire mainly came from the Mossi people. This development was in itself already not compatible with the mutual respect preached in the past, but that ideal was further undermined by Ali chasing Muslim scholars from Djenné, because he feared losing the support of rural communities if he was seen not to endorse their local religions. After Ali's death in mysterious circumstances, his Soninke successor Askiya Muhammad restored relations with the Muslim population. But this new ruler also failed to build a unified Songhay Empire, although he did recognize all religions and foster peace and trade. This boosted the growth of Djenné and Timbuktu in the sixteenth century, which saw these cities become the main centres of trade and Islam in Africa, although they increasingly had to compete with the Portuguese trading post of Elmina. It seems possible that the Muslims upon their return after having been banned by Ali had to compromise, because in the sixteenth and seventeenth century

Djenné figurines suddenly started featuring snakes. In 1591, the Moroccan sultan Ahmed al-Mansur conquered the Songhay Empire and took over the gold trade through the Sahara desert up to 1630. Figurines depicting snakes continued to be manufactured throughout the seventeenth century, and Djenné retained its standing as a centre of trade and Islam, but fell into decline later as a result of being subjected to the rule of external parties, such as the Bamana and the French.[28]

After outlining the historical context in which the Djenné figurines should be viewed, it becomes clear that some of the characteristics of the various Sahelian empires are reflected in the sculptures themselves, such as in the opposites that are key constituents of the Soninke myth. The message that draws attention to the need for reconciliation of local and migrant rulers and religions, as expressed by the myth, also turns out to be relevant in light of the history of the Wagadou Empire and subsequent empires. The difficulties maintaining a harmonious coexistence of different religions and ethnic groups seem to further confirm the importance of the message, but that is immediately undermined by the fact that objects depicting snakes, the animal that embodies the myth, were made precisely in this period of islamisation, while the snake had been absent throughout the existence of the religiously liberal Mali Empire. Whether or not migrant and local rulers can be made to see eye to eye does not rule out that the myth, at local level, refers to the contract between the serpent as the land owner and the local ruler, who uses that land. Virgins are sacrificed under such a contract, otherwise the land would be arid and the empire would not be able to exist.

The relevance of the second meaning of the contractual relationship emerges from more recent information about ritual worshipping of snakes in the area in question. The reconstructed meaning of the snake for Soninke people is similar to that of the python venerated by the

Bozo people in later times. Both these peoples may stem from the same ethnic group, and both are attributed a role in the foundation of Djenné, with Djenné-Jeno possibly built by the Bozo people. The Bozo believe that the first inhabitants of abandoned or old cities are represented by a python protecting this land. When a stranger wants to settle there, he will first have to form an alliance with the snake. One Bozo myth tells the story of a group of young men who want to settle in a city and hope to conquer the most beautiful women by dancing before them. When they also start snorting tobacco while trying the impress the women, two fighting snakes emerge from their nostrils.[29] Although the meaning of the myth is unclear, the story does chime with the Djenné figurines, many of which also have snakes coming out of their noses, ears, or eyes. Where virgins were sacrificed to Bida to safeguard the fertility of the land, tradition has it that the Bozo put live virgins into the wall around Djenné to guarantee its integrity. They also sacrificed virgins in the building of a dam that was intended to make sure there would be enough fish to catch.[30]

The virgins sacrificed to Bida may also represent the gold nuggets demanded as tax by Sahelian rulers. Fertility of the land was here presented in the form of material wealth. There is one Djenné sculpture of a snake resting its head on seven balls. These seem to be the heads of Bida, which laid bare several gold mines when they fell to the ground after being chopped off.[31] The association of the snake with wealth and gold is reminiscent of the snake spirit Ninkinanka from tribes in Guinea and Senegal, some of which were once part of the Mali Empire. That spirit was thought to be a bringer of rain, children, and fortune. He looks like a boa constrictor, but his head is covered in gold. The rulers of the various Sahelian empires also donned golden adornments.[32]

In the tales about the contractual understanding between ruler and snake, the myth articulates the belief in the possibility of humans and

animals sharing divine powers, with a 'wizard' acting as a go-between. This belief also comes to the fore in the help Maghan Diabe receives from the hyena and the vulture in finding the site for the Wagadou Empire that was revealed to him in a prophecy. If the relationship with the snake were to be a totem relation, the snake would be a taboo. That goes for the wizard going against the taboo by killing the snake and drowning the empire in doom. It also goes for the Soninke people who depicted Bida as a black snake with a red collar in the 1970s. The person who would kill the snake would meet with doom. Honouring the taboo, on the other hand, would mean that the snake in a totem relation could offer protection or healing. That is the case for the Bozo people in the 1960s, when a jug with live snakes was found. Whoever would wash themselves in that jug would be healed of disease or would be immune in war.[33] This custom is reminiscent of the spherical Djenné urns, which sometimes had a human head sticking out of them.

The belief in supernatural powers shared by humans and animals also seems to be reflected in the Djenné figurines that merge man and snake. The serpent's divine powers, which bring fertility when taboos are honoured and sacrifices are made, are expressed in the figurines depicting mothers with children. In several figurines, the protective and healing power the Bozo people attributed to the serpent seems to be represented by the numerous snakes accompanying sick men. These figurines may, however, also warn of divine revenge, because the myth describes disease and infertility as a consequence of not reaching an understanding or not complying with an obligation. Earlier on, the snake's healing significance is also represented in small sculptures of curled-up snakes, which were probably used as amulets. Benefiting from the snake's powers requires compliance with the contract and sacrifices. Perhaps a number of the terracotta figurines were buried as an offering as part of a ritual performed to harness the snake's powers. In the

myth, what is sacrificed is not a sculpture, but a virgin, i.e. the snake's bride-to-be.

Now we have seen *what* it is that the figurines with the depictions of snakes appear to represent, the question remains *who* they represent. The sculpture of a woman giving birth to a snake must represent the birth of Bida. But what is harder to interpret are the male figurines that seem to be completely unfazed by the many snakes crawling all over them. Since snakes are linked to leadership in the tradition of the Soninke people, these men may perhaps be Soninke rulers. The 'wizards', who would invoke divine powers on behalf of Soninke rulers, could be depicted by the often male, but sometimes also female, figures of humans morphing into snakes. The horsemen and archers in some sculptures could represent either soldiers or Sahelian rulers themselves; the fourteenth-century traveller Ibn Battuta noted that rulers of the Mali Empire carried a bow and wore an arrow quiver on their backs.

The serpent's shield

The savannah that stretches out eastward from the southern part of present-day Mali to Burkina Faso and the north of Ivory Coast is home to several ethnic groups that worship the snake as a protective spirit, such as the Dogon, Senufo, Lobi, and Bwa. Apart from a belief in the snake's divine powers, these ethnic groups also share their history. Up to 1500, these ethnic groups lived in small agricultural communities without centralised rule. After that, oral traditions suggest that the Dogon, Senufo, Lobi, and Bwa were repeatedly forced to relocate by intruding horsemen, who came from the Mali Empire, among other areas. When Mossi horsemen founded their new empires in this region, local religions were spared, and local rulers were appointed priests of the land to oversee farming and the worship of earth spirits. Although people from the south west were sold as slaves in Mali or along the Guinea coast, most people were safe

under Mossi rule, as rulers went out of their way to maintain peace so that farming, industry, and trade could thrive. In the eighteenth century and later, the status quo was unsettled by the dominance of the Bamana people, the Fulani people, and French colonial rule. In 1960, the area that used to be known as Upper Volta gained independence, and later renamed itself Burkina Faso.[34]

It is because of this shared history, in which trade and migration fostered the exchange of cultural elements, that ethnic groups all over West Africa have many of the same cultural elements. The snake is one of them. The snake represents protection in the area described above, and is worshipped by many ethnic groups in the wider context of West Africa. Oral traditions link snakes to ancestors and immortality, because they are the interface between the dead, the living, and descendants.[35] As it was believed that ancestors were able to influence everyday life from the domain of invisible powers, the mediating snake could bring either fortune or misfortune. By treating the mediating snake well and tempting him to use his dangerous powers to combat evil, the snake could offer protection. The protection offered by the snake not only safeguards people from supernatural evil, but also from the kind of evil the inhabitants of the region in question suffered due to war, migration, or slavery.

The Dogon in Mali also relate the snake to ancestors and immortality, and derive a sense of protection from that. The Dogon left the Mande area in the fifteenth century to escape Islamic slave hunters, and settled in the nearly inaccessible Bandiagara escarpment, where they still live today. Oral traditions from both ethnic groups claim that the Dogon formed an alliance with the Bozo people in Djenné, which lies west of the escarpment. Like the Soninke people, the Bozo people are thought to be connected to the Djenné figurines and snake worship in that area. Dogon culture appears to have taken elements from both ethnic groups, because the zigzag

pattern on Djenné sculptures of horsemen is also used by the Dogon. In Dogon culture, this pattern represents invisible movements such as words that are sounding, light that is shining, and grain that is growing. This pattern also stands for the sacred serpent and the god of earth Lébé in Dogon culture, with the latter associated with farming and the rejuvenation of the land and vegetation. Their mythology states that the Dogon decided to abandon the Mande region after their ancestor Lébé had already been buried. When they dug up his remains to take these with them, they found that Lébé had transformed into a living snake. This was taken as proof of his powers of rejuvenation. The Dogon therefore took earth from the grave with them, which they sprinkled over every Lébé altar they erected in each new village they founded.[36]

The Dogon people depict Lébé in their Imana Na mask. This mask stands several metres tall and is displayed during the Sigui ceremony that is performed once every 60 years. Since a new version of this mask is used for each ceremony, and the Dogon keep the old copy, there are now nine copies of this mask. The Imana Na mask is also paraded at the burial of men who experienced the Sigui ceremony during their lifetime. The Sigui ceremony portrays the death of Lébé and his transformation into a snake. The mask is then used as the abode of the soul of the deceased. This ritual involves a procession past all Dogon villages, which the last time the ceremony was held took from 1966 to 1974 to complete. Besides during the Sigui ceremony, Lébé is also worshipped by the Hogon, the spiritual leader in each of the regions of the Dogon land. Each year at the start of the agricultural season, the Hogon, together with the priests of the other immortal ancestors, performs a rejuvenation ritual.[37]

The Senufo people, who live further east in the border region between south east Mali, south west Burkina Faso, and northern Ivory Coast, also worship the snake as a protector. For the Senufo people, everyday life is inextricably bound up

with the world of the spirits, who go very far in making their influence felt. Whenever disease, infertility, or death manifest themselves, that means the relationship with the spirits has been disturbed, and needs to be restored. Contacts with the spirits – ancestors, twins, shapeless powers, and wilderness spirits – run through the latter and are instigated by secret societies. The python spirit Fo is the main messenger of the wilderness spirits.[38]

Senufo families have a totem relation with certain animals that protect them, but that can also cause harm when a family member wounds or kills this animal. Hunters in particular must be on their guard against violating this taboo, because animals can take the shape of other animals. Hunters can also be attacked by animals or be exposed to the strength of mind of a slain animal avenging itself. In order to ward off these dangers, hunters wear amulets and power artefacts on their clothes. Ordinary villagers too wear rings, pendants, bracelets and anklets for protection. These objects also serve to restore the relationship with a spirit or enlist their help. Animals are a common feature in protective objects. Bracelets often depict a python representing the snake spirit Fo.[39]

The python spirit Fo is important for the female fortune tellers from the Sandogo society, who are protected by this animal. This society of women passes on moral rules and protective Sandogo powers, which safeguard the purity of the families, and stem from ancestors. Divine approval is particularly important when families assume obligations through marriage. Without moral rules, families' purity would be endangered, and the balance between spouses and their respective families could be disrupted. Illicit sexual relations are a threat and arouse the wrath of the ancestors, who can avenge themselves through disease, death, or other disasters. In case of family problems, the female fortune teller can use her divination skills to find out who is responsible for which problem. The Sandogo society hence exercises social control in the villages, but also advises villagers. Every village has a female fortune teller who can be consulted whenever disease or infertility strike or people feel uncertain about something or have had an odd dream.

Prophecies are issued through mediation by the spirits of the wilderness, who are notoriously unpredictable and can also bring suffering. Only when the female fortune teller adheres to food and clothing requirements dictated by the spirits of the wilderness will they help her make contact with ancestors and twins. Ancestors and twins will provide insight into problems and solutions through the spirits of the wilderness, as well as into the wishes and grievances of other spirits of the wilderness. They also send messages from impersonal forces from the wilderness through spirits of the wilderness, and they reveal the knowledge of the python spirit to the female fortune teller. The female fortune teller has sculptures in which the spirits of the wilderness that assist her live. These often also feature depictions of the python spirit, as he is a source of knowledge and the messenger for the spirits. The python spirit is portrayed on bronze bracelets and as an undulating shape in murals. The bracelets are a homage to Fo, and are often touched during consultations to invoke the snake. These bracelets are heavy and sculpturally wrought. The artistry displayed in the bracelet supposedly appeased the spirits of the wilderness, and increased functionality.[40]

The Senufo people are not the only people in the south western part of Burkina Faso to wear protective artefacts. The Lobi and Bwa wear bracelets, anklets, rings, and pendants for protection against misfortune caused by evil spirits or a disrupted relationship with their own protective spirits. Even after disease or infertility has set in, it is not too late to have a protective artefact made after consulting a ritual specialist. People often wear these artefacts for their entire lives for support throughout the various life stages – birth, marriage, sexuality, pregnancy, death. Since babies and infants are

particularly vulnerable, they wear protective artefacts from very early on. These artefacts are made by smiths, who also make other artefacts for rituals, such as masks. Animals or symbols depicted on those masks appear in smaller versions on protective rings. Like ritual artefacts, musical instruments also serve to attract spirits. Flutes are connected with fertility of both humans and crops, overcoming dangers during the hunt and war, or achieving success.[41] Many musical instruments, amulets, bracelets, and other protective artefacts are emblazoned with a depiction of a python.

The Lobi people and the related Gan people also consider the serpent as an animal that offers protection. The Lobi and the Gan have bracelets, amulets, and pendants, as well as pottery and wooden objects with depictions of snakes. These bracelets are either made of bronze or iron, with the bronze ones also lending themselves for purely embellishing purposes. Iron bracelets for a specific spirit can be ordered from the smith.

Leg band, Lobi/Burkina Faso, copper alloy, 22 cm. Collection: Afrika Museum, Berg en Dal, 492-474

When a bracelet features a depiction of a snake, this piece of jewellery can also offer protection against the snake itself. Hunters in the woods are always on their guard against snakes and therefore rarely bitten, but women and children venturing outside the village to get water can be bitten unexpectedly and sometimes succumb to that snake bite. Power objects are generally worn on the body, but can also be placed on an altar. Lobi and Gan pendants can take unusual shapes, such as that of a horizontally writhing snake, a small flute emblazoned with a snake, or a curled-up snake with a number of snake's heads sticking out of it. Necklaces depicting a flute were often the property of men of distinction. These would generally be worn at celebrations, burials, and markets.[42]

With the Lobi people being the main exception, many ethnic groups in Burkina Faso used masks for initiations, seasonal rites, and burials. Aside from that, masks can also have entertainment value. Some masks depict a snake, once again expressing this animal's protective significance. Many masks are adorned with geometric patterns in red, black, and white. The Bwa people were unique in that they were the only ones using the excrement of the sacred Bwa serpent to create the colour white. This specific serpent is depicted in a board mask several metres tall, but this serpentine mask is an exception in the ritual repertoire of the Bwa people, and only appears in southern regions.[43]

The snake mask is part of a world view that revolves around animal spirits and the life-creating force called Do. The Bwa people believe that God sent his son Do down to earth to act as a mediator after the Creation. Do represents the woods and the force that brings fertility and is depicted in the Binie mask, which is worn throughout the Bwa region, and which is made of leaves to ensure it looks nothing like something humans made. The Bwa also have myths featuring animals, among which is the snake. These myths are family stories that tell of

Mask, Bwa/Burkina
Faso, wood, 4.10 m.
Collection: Morat
Institut für Kunst und
Kunstwissenschaft,
Freiburg im Breisgau,
Germany

meetings ancestors who founded cultures had
with real and spiritual inhabitants of the world.
Southern Bwa people depict these family myths
in masks representing animals, humans or forest
spirits, which go against the Do cult.

Where the Do cult gives the Bwa people who are
spread out over a large geographical area a
common identity, the mask-based ceremonies
performed by families within the southern Bwa
region express the competitive element that
exists between Bwa people. These masks
represent powers other than the powers Do
possesses, and which were copied more recently
from those of neighbouring ethnic groups, such
as the Mossi and the Gurunsi, and are incom-
patible with the old mask made of leaves. Both
wooden masks and masks made of leaves are used
during important events in the village, albeit
never at the same time. Families who worship Do
using masks of leaves consider the wooden masks
an infringement on the authority of the priest of
the earth – the oldest man of the family that was
the first to settle there. Families with wooden
masks are excluded from the Do cult, because
they copied the magic from neighbouring ethnic
groups. Families wearing masks made of leaves
are, in turn, insulted in songs that accompany
ceremonies involving wooden masks. Together
both mask types reflect the balance between
nature and culture, which is central to the Bwa's
world view. Masks made of leaves integrate
farmer and farmland into spring in nature, while
wooden masks reintegrate the people into village
life after the harvest. Masks made of leaves
represent rejuvenation and life, and wooden
masks stand for culture and social control. Masks
made of leaves are used in spring rites, and
during the initiation of boys into the Do cult, but
only very rarely at burials. Wooden masks, on the
other hand, are used for burials and remembrance
rites, as well as in the initiation of boys and girls,
harvest rituals, and on market days.
Wooden masks are the property of families who
give full rein to their rivalry in dance
competitions and songs. The geometric patterns

Mask, *Bansonyi*,
Baga/Guinea, wood,
220 x 50 cm. Collection:
Museum Rietberg,
Zurich, RAF 8

have a moral meaning that people learn when they are initiated. These patterns allude to prominent elders and ancestors within the family, who serve as role models for youngsters. Remembrance rituals see wooden masks visit the homes of the deceased to ensure their spirits have a safe trip to the land of their ancestors. Harvest rituals include expressions of gratitude to spirits and ancestors for the harvest and their watching over the village. These spirits are generally the ones associated with fertility, such as the serpent. On market days, the wooden masks are used to entertain villagers and traders, as well as in a kind of match-making ritual for young men and women. In an attempt to attract marriageable girls to the village, villages would compete by trying to outdo each other in the magnificence of their masks. In doing so, they would copy new types of masks, or try to emulate existing masks. This competition led to the masks becoming ever more impressive. It goes without saying that the huge snake mask can play a key role in the competition between villages. Since new mask types represent new spirits, these new spirits are subsequently also given a role in myths and family histories with retrospective effect. These stories are therefore highly creative ones that frequently change.[44]

Where the several-metres-tall snake mask is concerned, one myth tells of men from the village of Dossi who once attacked a neighbouring village. The village under attack repelled the assault, and the men from Dossi fled. One of the village elders in Dossi hid in a hole that was home to a large snake. He told the snake that he meant no harm, and only wanted to hide. The snake subsequently decided to protect the man. The man hid in the snake's hole for two weeks, while the snake caught animals for him to eat. Upon his return to Dossi, a religious specialist ordered the man who had escaped his attackers to carve a mask in honour of the snake and his protective spirit.
Although the myth articulates the protective power of the snake, the snake mask, and its

enormous height in particular, also adds to the attractiveness of the village and the family that owns it. The snake mask and the spirit depicted by it hence give the family a strong position on the marriage market, as well as in the competition with other families and villages. As well as in the form of a mask, the snake is also depicted in the zigzag pattern on other masks. This pattern refers to the skeleton of the sacred Bwa snake, which was thought to live in faraway mountainous areas.[45]

Migrations of the serpent

The Baga people on the coast of Guinea are known for their huge snake mask, but they are a small ethnic group that suffered heavily in the twentieth century due to French colonisation, Christianisation and decolonisation, forced islamisation by neighbouring Malinke and Sus people, and the Marxist ideas of the Islamic Malinke dictator Sekou Touré. As a result, the Baga people saw their rites banned, their ritual artefacts sold or destroyed, and their sacred groves cut down. Ever since part of the rituals were allowed to be revived from 1984, older people have wanted to return to customs from various decades ago, while youngsters pursued modernisation. [46]

The Baga's famous snake mask was also part of a tradition that was banned and never returned in its original form. Based on testimonies of older Baga people who had seen the snake mask dance during their childhood, and on old reports from outsiders, the significance of this mask could partially be reconstructed. This showed that the snake mask, due to a difference in the migratory backgrounds of the different groups, did not have the same significance to all Baga groups. Oral traditions have it that the Baga people once split up into groups as they fled the Guinea highlands to go down to the coast, with the different groups eventually settling at different places at different times. The Baga sub-group

that arrived on the coast first, the Sitemu, claimed that an avian spirit guided them to the coast, while all other Baga sub-groups credit the snake spirit for showing them the way.[47]

Since the mask of the snake spirit is tied to the migration to the coast, further information is needed here. The Baga people probably used to live in the southern part of the Sahel, and migrated south later. Myths state that the Baga people originate from the Fouta Djallon highlands in Guinea. The first groups of (proto) Baga people may have headed to the coast when Mande farmers, at the start of the first millennium, invaded the Guinean highlands from the interior delta of the Niger River. The Baga people did, however, still adopt some Mande cultural elements. They would, for example, organise themselves as 'older and younger brothers' – sub-groups that settled earlier or later. Many of the major migration flows started when groups of Fulani shepherds infiltrated the Guinean highlands during the rise of the Mali Empire in the fourteenth century and started to sell people who were living there into slavery after 1500. The ensuing exodus to the coast appears to not only involve Mande farmers, but also Baga people and related ethnic groups. When the islamised Fulani invaded the highlands around 1700 to launch their jihad against 'the animals', this triggered another exodus to the coast. Apart from the Mande-speaking Malinke and Susu people, groups of whom had already fled to the coast around 1500, animist Fulani people were now also among the migrants. This group of refugees probably also (or again) included Baga people and related ethnic groups. Islamic Fulani settled in Fouta Djallon as the upper class of an empire that made the slave trade its core business, in the name of Islam. Over a period of various centuries, the Baga people settled on the coast spread across five dialect groups as families and village communities without central government. These five groups are, from west to east, the Mandori, Sitemu, Kakissa, Koba, and Kalum.[48]

The coast proved not to be the safe haven the Baga people sought, and they turned to their snake spirit for protection. The migrants' arrival on the coast around 1500 coincided with the arrival of the Portuguese in coastal areas. Up to that point, coast dwellers, who were limited in number, sold salt and cola nuts to the Sahelian empires in inland areas, but when the Portuguese introduced new products and started buying large numbers of slaves, the coast became an attractive place to settle. After 1500, the Baga people lived right on the coast, with Susu people living slightly further inland, and the Malinke still further inland. Whereas the Susu and Malinke people themselves had fallen prey to the slave trade up in the highlands, they took an active part in this very trade on the coast. The slave trade network included outposts further inland occupied by the Islamic Fulani people in the Fouta Djallon highlands and the Malinke people in Timbuktu. In the eighteenth century, the Susu took over most of the coastal strip where the Baga lived, and started to dominate trade on the coast. The Baga sub-group of the Kakissa also had a stake in trade on the coast, but most Baga groups did not. The Europeans, in turn, avoided the mosquito-infested swamplands where the Baga people lived. However, these swamps were a far from safe place for the Baga; from the moment trade on the coast started to boom, the Susu, Malinke, and Fulani started selling and shipping Baga people as slaves. Also in the twentieth century, Baga enclaves were infiltrated by the Susu, Malinke, and Fulani, and yet the Baga stayed put in the same coastal areas throughout the centuries.[49]

The Baga claim they took their spirits and masks with them on their flight down to the coast, with the highest, most secretive, most feared and ubiquitous spirit showing them the way only to return to the highlands afterwards. Most Baga groups consider the snake spirit a-Mantsho-ña-Tshol to be the highest spirit, but to the Baga Sitemu, who were the first to reach the coast, the highest spirit was the avian spirit a-Mantsho-ño-Pön. More than other Baga groups, the

Sitemu people claim that they were the ones who brought the sacred mask dance with them. During their voyage to the coast, their leaders sometimes transformed into birds to be able to scan the environment. This bird was brought back for initiations, in the form of a several-metres-tall construction with a bird's head, in which the young person who was to be initiated would sit. The frightening figure of this spirit helped the Sitemu keep hostile neighbouring ethnic groups at bay. The Sitemu also excluded other Baga groups by keeping them out of the avian mask ritual on account of them merely being 'late arrivals on the coast'. The other Baga groups reacted by associating themselves with the snake spirit called a-Mantsho-ña-Tshol. Incidentally, the Sitemu did still worship the snake spirit. Snake or bird, all Baga and kindred Pukur and Buluñits people thought that the highest spirit would leave the highlands every 10 – 15 years to attend initiations on the coast, settle family disputes, and promulgate laws.[50]

The Baga people's claim that they introduced the snake spirit and corresponding mask on the coast does require some nuancing. Ritual expressions of the belief in snake spirits occur throughout Guinea, from the Malinke in the interior to the Baga on the coast. Coast-dwelling groups related to the Baga, such as the Nalu, Landuma, Buluñits, and Pukur, were also familiar with the snake mask.[51]

The order in which the various groups settled on the coast is not only reflected in their respective preference for either a bird or a snake as the highest spirit, but also in the way their respective villages were set up. The Baga split their villages up into districts , which were arranged according to their order of settlement. The district with descendants of the first settlers managed the mask dance, with certain authorised villagers following the great spirit (snake or bird) in the order in which the ancestors of their district had reached the coast. The districts themselves were subdivided into clans, also classified according to when they settled on

the coast. The first clan would provide the clan eldest, who would be the leader of the district. Clans, in turn, were split up into masculine and feminine halves. Since people would marry outside their half of the village, the villages would still remain unified.[52]

The Buluñits, a group related to the Baga people, had dances with a male and a female snake to represent the masculine half and the feminine half of the village. Both snakes would engage in a mock fight for supremacy over the village, and try to snatch their opponents' children during initiations. But for most Baga groups, the male snake faced another kind of female spirit. The traditions of the Baga Sitemu lacked snakes altogether, and used the bird mask to play the male role, while the female role was played by a-Bol, the sea spirit that the Sitema had encountered on the coast. In all Baga villages, responsibilities regarding manifestations of masculine and feminine spirits were divided among the masculine and feminine halves of the village. Apart from sex, the juxtaposition of inland and coast could also be the criterion used to split the village in two. The Sitemu people associated the male mask dance (not the corresponding people) with origins in the highlands, while the female dance was tied to coastal origins. The same subdivision is seen in Buluñits villages.

The Baga groups Mandori, Kakissa, Koba, and Kalum consider the snake spirit a-Mantsho-ña-Tshol to be the highest of all spirits. Like the Sitemu's avian spirit, the snake struck fear into outsiders, and protected the population during times of war, but his own people too feared him. The name a-Mantsho-ña-Tshol means 'master of the medicine'. People thought the snake spirit wandered through the villages, killed wizards, had two faces, and was attentive to whether any unlawful acts were performed in the houses he passed. The spirit was depicted in the form of a black, red, and white wooden snake, which towered 2.5 metres above the head of the dancer, who himself was covered with flowery

fabric. The snake's head was adorned with fluttering ribbons and feathers.[53]

While the snake spirit protected the Baga and related ethnic groups against the Fulani, Malinke, and Susu, these latter ethnic groups, as well as many others in Guinea and Senegal, worshipped that same spirit under the name Ninkinanka. This is the spirit that was thought to be a bringer of rain, children, and fortune. His manifestation was that of a boa constrictor, an animal that is often seen in coastal swamplands, but then bigger, more colourful, and with its head covered in gold. In his younger years, Ninkinanka lived in a tree in the woods, but in adulthood he took to the water. Ninkinanka is also the rainbow, descending to earth after having drunk the rain, and subsequently digging himself in and letting the water flow from springs.

Baga oral traditions also use other manifestations for Ninkinanka. He is red, black, and white, dons a crest from head to tail, has a human face, and beautiful eyes. He is an old duck that morphs into a snake, or a rolling stone. The mask depicting a-Mantsho-ña-Tshol was carved at the spot where the Baga had managed to capture Ninkinanka. The snake mask is an incarnation of Ninkinanka, and carved to resemble him, but is not actually Ninkinanka. A-Mantsho-ña-Tshol takes on the powers of Ninkinanka, but also has powers of his own, such as the power to kill spirits and discover secrets. Ninkinanka lives on earth, just like humans, albeit separate from them, near a tree. Its scales are shiny and bring fortune to those who keep them in a box. The boa constrictor lays the egg for Ninkinanka right in the centre of a circle of ordinary snake's eggs. Whoever finds that circle of eggs after they have all hatched, except for the one in the centre, must take that egg with him and keep it in an unlocked box with a lid. If that person then fed Ninkinanka white breadcrumbs and water, he would crawl out of the egg, and return four days later with a lot of money.[54]

In Sitemu traditions, a-Mantsho-ña-Tshol would appear in mask dances that were a form of competition between the various clans. These mask dances could be held at any time, and last from anywhere between a few days to several months. Each district had its own masks and dancers, who would take turns performing their dances. This would see the dancers go from district to district with the whole village coming out to watch the spectacle. In other cases, women and uninitiated boys would not mix with the others. In this competitive culture, the largest clan was held in high esteem, while the smallest was associated with wizardry. The Sitemu people also invoked the snake spirit for initiations of men, where the spirit would feature as a rainbow. Since rainbows were considered both as a spring of rivers and the end of rain, connecting beginning and end, and with that life and death, they represent perpetual family lines.

For the Sitemu people, the mask dances were mainly intended to breathe new life into their villages, whereas the Kakissa performed these dances when something suspicious was going on. The Baga Kakissa paired the snake spirit with a female spirit resembling a small version of the Sitemu's highest spirit; a bird's head with horns. When it was time to round up 'wizards', this female spirit would herald the arrival of the snake spirit. She would then chase around the village, catch the 'wizards', and then make way for the snake spirit to finish the job. Mandori people staged initiations in the sacred grove. The snake spirit would attend such initiations in their entirety, which could last up to four years. Koba and Kalum people had more personal initiations. These were held at a secluded place in the village, where the snake spirit was screened off, and the initiates had to try to grab his beard over the screen.

The rare performances involving the snake spirit that are still held today differ from the ones from the past. The Sitemu people dance while holding a stick upright in their hand, while the Koba hold the stick on their shoulder. Ninkinanka is

sometimes hidden under a costume, and can be recognized by his snake-like movements. All these performances are accompanied by terrifying sounds.[55]

By performing mask dances in honour of the highest spirit, the Baga people not only hoped to keep hostile neighbouring ethnic groups at bay, but they also differentiated their dialect groups, clans, districts, masculine and feminine village halves based on the date on which their ancestors settled on the coast. Each population segment would associate itself with the divine powers of the highest spirit, which to most Baga and related groups was the snake spirit a-Mantsho-ña-Tshol. Although the Baga people's mask dances differentiated Baga people internally and from neighbouring ethnic groups, they also highlighted similarities. All Baga groups shared a common culture, with several sub-groups sharing specific traditions. Training for initiations happened across geographical borders, as initiates from all sub-groups were brought together according to the lines of migration that interconnected their respective villages. Harvest festivals and ceremonial sacrifices were attended by representatives from each Baga region. Mask dances would see rival districts perform in various villages with their masks, after which their own village would be honoured with a return visit. That was how bonds were forged between families and villages. This rivalry led to differentiation and renewal, but also to mutual alignment of masquerades.[56] Although the order in which ancestors had settled on the coast determined the pecking order of the groups that made up the Baga civilisation, with some groups considering themselves superior to others simply because they were there first, the fact of the matter is that all these groups had still sprung from migrants. The spiritual beings of the bird and the snake represented precisely that ambiguity of the Baga groups, which ensued from their dual identity of being both migrant and establishment.

Serpents as messengers and symbols

When you head east from Guinea you will, in
successive order, get to Liberia (formerly known
as Pepper Coast), Ivory Coast, Ghana (formerly
known as Gold Coast), and Togo, Benin, and
Nigeria (which together once formed the Slave
Coast). These countries received their former
names from trade with Europeans, which they
had been involved in since the fifteenth century.
Except for the inhabitants of the former Slave
Coast, part of the population of Liberia, Ivory
Coast, and Ghana were already allied to the
Sahelian empires before the Europeans set foot
on West African soil. To a certain extent, many of
the West African ethnic groups share a common
history, but their respective contributions to
that history range from trading to waging war,
from fleeing to ousting, and from selling slaves
to being enslaved. As a result, West African
ethnic groups show many mutual similarities and
differences. The same goes for the worship and
significance of snakes in Ghana, Togo, Benin, and
Nigeria.

The Ashanti people in Ghana would traditionally
use gold dust as a means of payment. To weigh
that gold, they used bronze counterweights
adorned with various different shapes and
patterns, including snakes. Such snakes could be
depicted curled up or as a fully stretched out and
winding body with a head on either side.
Sometimes the snake would have a prey, a bird or
a lizard, in its mouth. In many cases, a gold
counterweight refers to one or more proverbs,
opening them up to a variety of interpretations.
The goldweight would normally represent a
piece of personal wisdom, with only the owner
aware of the deeper meaning of the object. The
weights would be made to order for prominent
people, who displayed them as status symbols. A
goldrweight can also point at a fable with an
ethical message, as is the case with the snake
with a bird in its mouth, a theme discussed by
Wouter Welling earlier in this book. But in such
stories, the animal is of a different order than the
animal spirits that feature in myths. Besides a

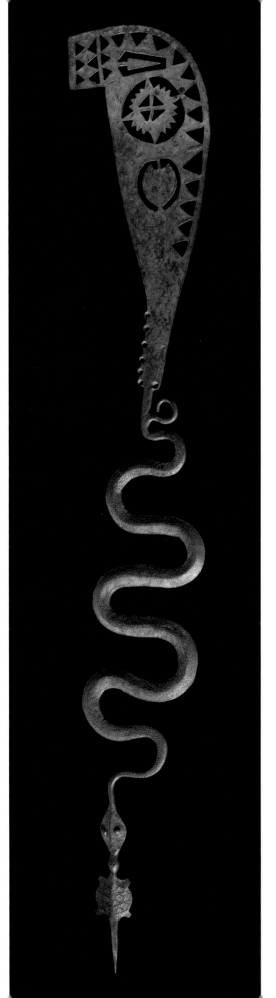

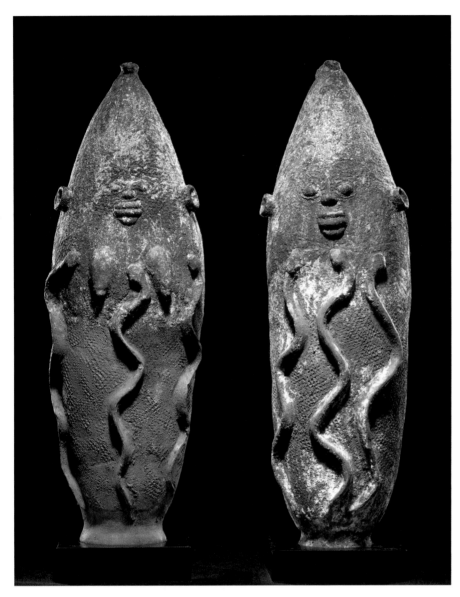

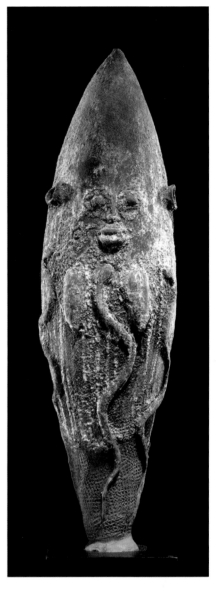

Pots, Ouatchi/Togo, pottery, 71 cm. Collection: Afrika Museum, Berg en Dal, 599-5 and 599-6

Pot, Ouatchi/Togo, pottery, 75 cm. Collection: Afrika Museum, Berg en Dal, 599-4

status symbol, goldweights were sometimes also used as a protective amulet. In that case, the owner does appeal to the divine powers the weight embodies.[57]

Where figurative goldweights were used between 1700 and 1900, when Akan people like the Ashanti traded with Europeans and their goldweights conformed to Portuguese and Dutch measures, trade in previous centuries was with the Mali Empire. That is why different weights were used between 1400 and 1700, weights that were compatible with the Islamic system of

measurement.[58] The relationship Akan groups had with the Sahel was a tight one. Akan groups originate from the Sahel, where they lived before migrating south to settle in Ghana and eastern parts of Ivory Coast. From there they maintained close trade relations with Djenné in particular from the twelfth century. They mainly traded the gold they mined locally. In their search for gold, Akan groups spread out across the region and regularly started new states. This search eventually took the Akan people to the coast. From the fifteenth century to the nineteenth

Pots, Aja/Benin, pottery.
Collection: Afrika
Museum, Berg en Dal,
577-1, 577-2, 577-17

Pots, Aja/Benin, pottery.
Collection: Jan Cocle

century, the Akan people dominated the gold trade in the region.

Besides their origins in and trade with the Sahel, Akan people also shared a love of gold with the traditional population of Djenné and surrounding area, where gold, leadership, and snakes formed a trinity of supernatural powers. Ashanti people also considered gold more than just something with material value; gold is associated with the soul, maturity, kingship, fertility, and eternal life.[59] In West Africa, eternity and fertility are often linked to the snake, and the combination thereof with gold and wealth is seen not only in the old Wagadou Empire, but also in the Ninkinanka snake in Senegal and Guinea. The idea of combining snake and gold in some of the goldweights may have sprung from the divine nature attributed to both. Gold is found all over Ghana, and according to the Ashanti that was based on a divine principle.[60] They also considered snakes carriers of divine powers; they can offer protection, which also makes them taboo. The Ashanti people bury pythons with the same ritual ceremony as they would stage when burying humans.[61]

The various Ewe cultures of the Ouatchi, Aja, Fon, Gun, and Yoruba people in Togo, Benin, and Nigeria are also related. They share a cosmology where the visible world exists alongside an invisible world of all-encompassing forces, which are called Vodun. Vodun forces can bring either salvation or suffering, and must therefore be steered, through rituals, in a direction that benefits the people. Vodun powers are spread across the creator god and many other gods, spirits, and ancestors that make up a complex pantheon. All these powers are kept together by the rainbow serpent, who snakes around the cosmos. This divine serpent connects celestial bodies, atmosphere, and wind to the earth and water. That is how the rainbow serpent maintains the balance between heaven and earth.[62]

The Ouatchi live on the coast in the border region between Togo and Benin. They have cocoon-like altars made up of a masculine and a feminine pot, which are dug into the ground with the opening down. Faces were painted on the upward facing bottoms of the pots, with a snake featuring on the body of the pot. The masculine and feminine manifestation of the pot and the

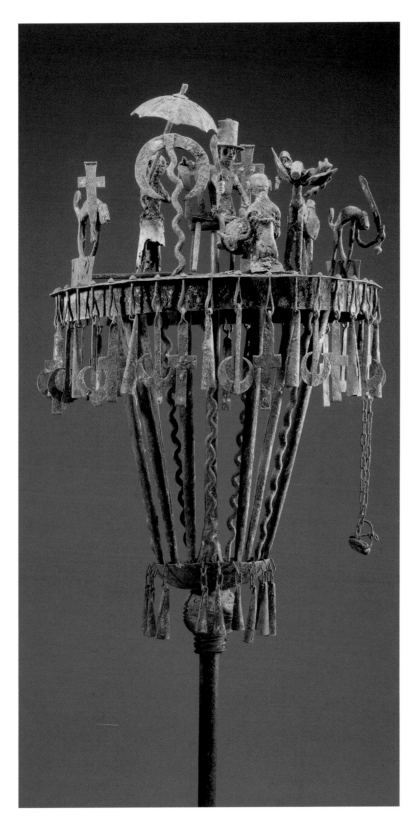

depiction of the snake show that this altar is the product of a cosmology that is related to that of the Fon people, who split heaven up into a masculine and a feminine part, with these parts kept together by the rainbow serpent. In an attempt to balance the cosmic powers, sacrifices are made through the pots.[63]

The Aja people also live in the border region between Togo and Benin. They appeased Vodun gods, spirits, and ancestors by offering blood, alcohol, and beer to pots that sometimes had the rainbow serpent painted on them. These pots serve as a temporary abode for Vodun powers, who feed on the offerings and are hence strengthened. Apart from Vodun powers, pots are also associated with death, because they serve as the home for the spirit of the deceased. They are covered in white colouring, as white is the colour that stands for the domain of the dead, divine force, and purity. Novices who are initiated into the secrets of the Vodun, store water and food in these pots, which are placed on altars after the initiation. An altar would often feature two pots, emblazoned with female and male (horned) snakes.[64]

For Fon people, man is the central element in a cosmos that comprises both a visible domain and an invisible domain, with the latter made up of a creator god and a range of heavenly, earthly, and thunder gods, spirits, and ancestors. Heaven is split up into a masculine half (strength, day, sun, heat) and a feminine half (fertility, night, moon, rest) that complement each other and are inseparable. The god Lissa rules the masculine part, while the goddess Mawu governs the feminine part. The rainbow serpent Dan Aido Hwedo helped this divine couple organise the world. Whenever a rainbow appears in the sky, Fon people take that as Dan appearing to them. Dan furthermore appears in anything that curls, lives, and moves without limbs, such as smoke or the umbilical cord. Together, Lissa and Mawu ensure the alternation of day and night, keeping the world in balance. The children of Mawu and

Ancestor altar, *Asen*,
Fon/Benin, iron, 203 x
36.5 cm. Collection:
Afrika Museum, Berg en
Dal, 535-9

Lissa are earth gods, who are responsible for life on earth. There are also the thunder gods, who connect heaven and earth, and are responsible for storms, rain, and thunder. The thunder gods are feared because lightning can strike and kill people. The main thunder god is Hevioso, whose thunderbolt is equated with a snake.[65]

The rainbow serpent Dan and Hevioso's serpentine thunderbolt are depicted on Fon people's ritual artefacts. They can figure on an asen, a portable iron altar to ancestors or kings, which can be inserted into the ground anywhere, and which is subsequently doused in blood and drink by way of offerings. When the god Dan is depicted, that is often as a male snake with horns. In some of these depictions, Dan bites himself in his tail as a sign of continuity and regeneration. The god Dan is then portrayed with a body in the colours of the rainbow and a black horned head.[66]

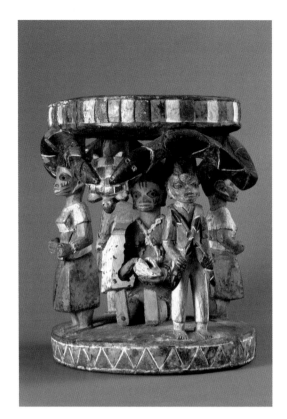

That was also the case for the figurative symbol for king Guezo from the Fon kingdom of Dahomey, which adorned the wall of the royal palace in Abomey. Guezo likened himself to Dan in the form of a snake biting its own tail. This symbolism gave Guezo and his kingdom an aura of eternity. Guezo ascended to the throne in 1818, and turned Dahomey into one of the most powerful empires in Africa during his 50-year reign. He did so by fostering the export of slaves and agricultural products and by liberating the empire from the obligation to pay tax to the powerful and hostile Yoruba city state of Oyo. The Fon people, who had migrated from Niger to southern parts of Togo and Benin in the thirteenth century, were divided over three rival kingdoms in the seventeenth century, but by the eighteenth century only Dahomey was left. This empire dominated the West African slave trade after conquering the port of Ouidah, and using it to exchange slaves for European weapons. That empowered Dahomey to stand up against Oyo and conquer surrounding empires. Guezo therefore opposed attempts by some Europeans to abolish

Stool, Yoruba/Nigeria,
wood, 50.5 x 50 cm.
Collection: Afrika
Museum, Berg en Dal,
160-118

Stool, Yoruba/Nigeria,
wood, 40 x 33 cm.
Collection: Afrika
Museum, Berg en Dal,
160-14

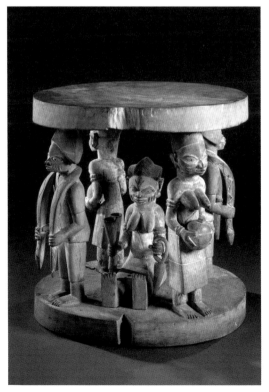

Gelede mask, maker: Dadaolomo, Yoruba/ Nigeria, wood, 38 cm. Collection: Afrika Museum, Berg en Dal, 149-2

Kifouli Dossou, *Kpeto, Gelede* mask, Yoruba/ Nigeria, wood, paint, 69 x 32.5 cm. Collection: Afrika Museum, Berg en Dal, 685-1

Mask with a depiction of *Oshun*, Yoruba/Nigeria, copper alloy, 16.3 cm. Trustees of the British Museum, Af.1897,-529

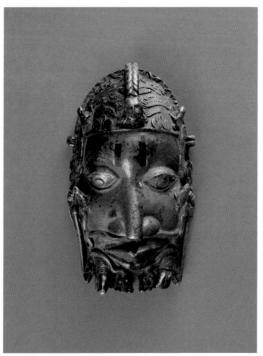

slavery and human sacrifice. Criminals and prisoners of war were sacrificed at annual ceremonies honouring the Dahomey king with Vodun rituals, military parades, and ritual dancing. In order to be able to consult ancestors, people would be sacrificed by sending them to the realm of the dead with a question, after which priests would receive the answer through divination. The sacrifices were also used to sprinkle the graves of deceased members of the ruling dynasty and hence regenerate this dynasty according to the symbolism of the snake biting its own tail.[67] The Gun people in Benin, who are related to the Yoruba people, live in the border region with Nigeria. As they share the Yoruba's faith, they also believe in the divine oracle Ifa. To invoke Ifa, a ritual specialist would sprinkle cola nuts onto an oracle plate covered in flour and subsequently draw lines between the nuts to obtain a pattern from which he could deduce what the future

would bring. The ornate edge of the oracle plate often features a snake, as the snake was considered the messenger of the gods that the divination seeks to consult.[68]

The Yoruba's messenger for the gods was called Eshu, who can take the form of animals, such as a snake. In Yoruba iconography, snakes generally refer to Oshumare, i.e. the snake that wraps its body around the earth and manifests itself as a rainbow. Oshumare is the god that brings prosperity and fortune. Rituals devoted to this god can coincide with those for the god

Shopona, the healer god, who apart from healing can also use disease as a punishment. Oshumare depictions on ritual artefacts tend to come in the form of a python. Cowrie shells can also depict Oshumare, as they resemble the scales of the python. The rainbow serpent can also feature on a ceremonial staff or a mask used to consult ancestors (Egungun ritual) or to make witches use their powers to do good (Gelede ceremony). Ritual earthenware or a ceremonial stool can also include illustrations of the rainbow serpent.

Gelede mask, Yoruba/Nigeria, wood, 37 x 63 x 14 cm. Collection: Afrika Museum, Berg en Dal, 160-105

Group of statuettes,
Nok/Nigeria, terracotta,
29 cm. Collection:
Durand-Dessert, Paris

prehistoric times. Nok culture terracotta figures have unique characteristics in how they depict eyes, which only recurs in masks made by Yoruba people. Nok figurines tend to represent dignitaries and serve a ceremonial purpose. Figurines depicting animals are less common, as are figures merging man and animal. Among the few animal figures that were found, there are also some that depict snakes, although their significance in Nok culture is unknown. The combination of dignitaries and animal figures is one that is also seen in bronze figurines from the city state of Benin. In Benin, the power of the king was expressed by linking his image to an elephant's tusk and painting snake figures on the walls of the palace.[69]

The present-day Benue region is home to ethnic groups such as the Chamba and Mumuye, who both associate snakes with rain and thunderbolts. Although this geographical region bordered Islamic states to the north and west, it was quite isolated for a long time, because it was too far south for Arab traders who crossed the Sahara, and too far north for the kingdoms that were trading with Europeans on the coast. The ethnic groups involved were, however, still connected through ritual and political relations, which led to similarities in religions and ritual artefacts. This changed when the Benue region became involved in the slave trade by the Tiv people in the eighteenth century and the Islamic Fulani in the nineteenth century. The Chamba people were driven west by the Fulani people, where they founded a small kingdom and developed into fearsome slave hunters who dominated their region. The Mumuye and other ethnic groups who lived along the Benue had no centralised rule and fled into the hills. The Europeans also meddled in this region in the nineteenth century, culminating in full-blown British colonial rule in 1900.[70]

Nevertheless, traditional art and religion remained important throughout the nineteenth century, although they did make way for Islam

The similarities between the Yoruba world view and that of the Fon people and other neighbouring ethnic groups ensues from the fact that they have a shared history. From the seventh century onward, the Yoruba started developing powerful city states, such as Ife, and later also Benin and Oya, which would dominate their respective regions for centuries. The Yoruba people possibly originate from the area where the rivers Niger and Benue meet. This is also where the Jos plateau is, where Nok culture existed between 1000 BCE and 1000 CE. Predecessors to the Yoruba people are thought to have migrated south from this area in

and Christianity in the twentieth century. That development continued after Nigeria gained independence in 1960, and even intensified during the Biafra war from 1967 to 1970, when large numbers of ritual artefacts disappeared and were never replaced. Iron artefacts had limited material value, but did trump wooden ones in rituals, and they therefore remained in use for much longer. Due to the widespread and frequent exchange of artefacts and customs over preceding centuries, it is hard to tie these artefacts to specific ethnic groups. Potters and smiths would also make artefacts for ethnic groups other than their own.[71]

Objects that imply snakes are coiling iron rods, which are separate objects or bundled and held together by a piece of string, a piece of iron, or a piece of pottery they have been baked into. They are used by both the Chamba and the Mumuye, and therefore difficult to distinguish. When the dry season draws to a close, and the Mumuye are longing for rain, they turn to the Master of the Rain. If he is unable to summon rain, he will consult the greatest specialists in this area, the Master of the Rain and the Master of Thunder in the high mountains in the east. Nowhere is the rain as abundant as there. Iron thunderbolts are the tools of the trade for every Master of the Rain. These thunderbolts are harbingers of thunder and rain, and are associated with the sudden movements of snakes, because these too forebode rain. After sticking the masculine and the feminine thunderbolt into the ground in the rainhut, the Master of the Rain rubs them with the blood of sacrificed animals. While doing that, he would eat meat, drink beer, and pray to the Master of the Sun. After that, it would start raining, and given that lightning could strike those that had sinned against ancestors/parents, the Master of the Rain and the Master of Thunder were considered the highest authority and feared. After all, exercising control over rain that falls from the sky implies control over all crops and with that over all life.[72]

As the serpent writhes on

The examples of snake-based symbolism in West Africa show that people appealed and continue to appeal to the divine powers of the serpent during transitions in terms of time (life stages and seasons) or space (woods, the domain of the spirits) to support them through such uncertainty-filled transitional stages. Depending on interrelations between the various ethnic groups across West Africa, similarities in the way they worship serpents as though they are spirits can vary, but what unites all these ethnic groups is that they all link their fortune and misfortune to the will of the serpent.

What is also clear is that parts of the serpent's trail take us far back in time and writhe through a widespread geographical area. In reality, the trail goes even further back in time, and has even greater geographical coverage. Sheila Coulson's contribution shows that serpents were worshipped up to tens of thousands of years ago, while Wouter Welling's contribution explains how slaves took their belief in the snake's mysterious power with them as they were shipped to the New World. Once they arrived there, the serpent started blazing a trail that took it into new eras and new lands, and it is still blazing new trails.

The secret of Rhino Cave

SHEILA COULSON

*Reaching your destination has been challenging. After journeying for days, through
seemingly endless sandy scrub, the initial appearance of distant hills was both exciting and
welcome. Yet long periods of time under the hot sun pass but the hills never appear to be
closer. Finally the ground underfoot changes from loose sand to solid rock. Squeezing
between and clambering over massive rocks you travel ever upwards and are rewarded with
uninterrupted views of the open flat land now far below. Narrow pathways between giant
boulders tempt you with many false leads.*

*At last you find the entrance to the dimly lit deep opening in the hill you have been searching
for and peer inside. What meets your eyes is like nothing you have seen before. What is that
jutting out from the hillside? It appears to have a huge elongated body, with a long slit for a
mouth and a single beady eye. Is this a giant snake? The long drop to the cave floor will place
you directly in front of its rearing head – dare you venture in...*

This fanciful account of our ancient ancestor's
journey across the Kalahari to the rocky
outcrops, now known as Tsodilo Hills, is instantly
recognizable to anyone who has visited the
hilltop site of Rhino Cave in Botswana. It is no
longer necessary to approach the hills on foot
and today a guide will lead you directly to the
entrance of this hidden cave. However, once
your eyes are accustomed to the twilight of the
interior you too witness a sight like nothing you
have seen before – a massive carved rock outcrop
that has been interpreted by modern researchers
as a zoomorphic form, such as a thick-bodied
snake (fig. 1). Standing in front of the panel you
are struck by the extent and intricacy of the
carvings. It is evident that some of the carvings
are heavily worn while others appear to be
extremely fresh. How old is this practice? Why
are these carvings so entirely different in form
and number from the other rock carvings found
on Tsodilo Hills? Why was this particular rock
outcrop chosen for such attention when it is so
well hidden from view?

In an attempt to answer the many questions that
surround this remarkable site it is first necessary
to recount how the site was 'discovered', offer
a short description of the carvings and how they
are thought to be made, before entering the
realm of speculation – how this rock panel can
be interpreted.

'Discovery' and setting

Despite the fact that Tsodilo Hills and its
surroundings are some of the most intensively
investigated areas in Botswana, Rhino Cave
escaped the notice of researchers until the mid
1990s. It was only during the course of an audit
of rock art that Xhao Xontae, the headman of the
local Ju/'hoansi San, revealed the existence of
this cave to archaeologists. It is, however, easy
to understand how the site evaded detection, as
it is perched high on a ridge. Gaining entry to the
cave is only slightly less arduous than navigating
the approach to the entrance. On the western
side there is a raised, narrow crawl space that
ends with a considerable drop into the site.
Alternatively, the wider eastern entrance offers
two options: a 2 m jump or a slide down a steep
boulder face, followed by a scramble over a rock-

Fig. 1. Rhino Cave, Tsodilo Hills, Botswana. The interior of this small cave as seen from a large boulder that partially blocks the entrance. Note the cave paintings on the north wall (to the right) and the massive carved panel that dominates the south wall (directly ahead and to the left). Photo: Sheila Coulson

strewn opening near the present day floor. It is worth noting that during earlier times the floor level would have been in excess of a meter lower still and before the build-up of wind-blown sands on the eastern side of the Hills the climb to the top of the ridge would have presumably been even more difficult.

The interior of Rhino Cave is formed by a narrow fissure in the quartzite bedrock that has created an opening which is just under 11 m long, and between 1.25 – 5 m wide, with a resultant floor area of about 22 m. The high ceiling and walls of the cave extend beyond the boulders that dominate the eastern opening, effectively blocking any direct sunlight. The floor covering is flat, powdery and devoid of virtually any vegetation. Clearly this is not an ideal place to live, particularly as the Hills are replete with numerous well-protected rock shelters that are easily accessible. Yet Rhino Cave contains a number of obvious and distinctive features which attest to its use over a considerable period of time. There are paintings on the north wall that are dominated by an animal that has been interpreted to be a white rhinoceros, which gives

the cave its name. Furthermore, initial excavations at the site revealed material dateable to the Early Iron Age, with signs of sporadic use during the Late Stone Age, but quite surprisingly the weight of the evidence for utilization lies with the substantial body of lithic debitage attributable to the Middle Stone Age, a period dated to in excess of 40 000 years ago.

The carved wall

The dominant feature of the south wall is a massive quartzite outcrop that is slightly under 7 m long, 2 m high and approximately 1m thick. As can be seen in figure 2, it appears to be virtually free standing, as only the lower back section rests on the stone beneath it. Access to a chamber behind the outcrop is gained by crawling through the opening created by the upraised section closest to the main entrance of the cave. From this hidden vantage point it is possible to see into the cave through the 20-30 cm gap that runs the full length of the top of the outcrop. By manoeuvring onto the ledge that

runs parallel to this gap a small-bodied person can work their way up to a narrow opening that leads outside the cave, although today this is choked by rocks.

It is the face of this massive outcrop that is the immediate focus of attention upon entering the cave, as it has been ground with over three hundred grooves and depressions, which are also referred to as cupules. These are confined to this single, vertical face and are concentrated on the lower 1.4 m of the 2 m high panel. The forms and condition of these cupules vary: some are long and thin, others oval to tear-drop shaped (fig. 3). They vary between 1-4 cm deep and while some are now heavily weathered, others appear to be relatively fresh. Unlike the other carving types found at Tsodilo, these cupules tend to overlap and truncate each other and many have been obliterated from repeated grinding. It is also the face of this outcrop which is dramatically

illuminated during the midwinter months, when for a few hours in the late afternoon a narrow arc of sunlight enters through a small opening in the ceiling of the cave and flickers directly across the carvings.

There are at least 30 cupule sites on Tsodilo Hills most of which are associated with Late Stone Age material. With a few exceptions these carvings are found in smaller concentrations on horizontal or sloping surfaces that contain a variety of shapes: most are circular while some sites also contain grooves or cigar/canoe-shaped forms. However, the carvings at Rhino Cave are exceptional, not only for the number of cupules but also for the variety of forms. This virtually free-standing rock formation is unique in these Hills and even without the addition of the ground cupules, within such a confined space this outcrop would still be impressive and imposing. Arguably it would have been even

Fig. 2. Rhino Cave, the carved south wall shown in the mid-winter late afternoon light. Photo: Sheila Coulson

Fig. 3. Rhino Cave, a close-up of the carved south wall showing the variation in grooves and depressions or cupules and the differences in overall condition. Note: 10 cm scale

To right, shows natural spalling which occurs on the wall (this spall has not yet been recovered)

Rhino Cave, close-up of cupules on a section of the carved south wall (to the right these are shown in the mid-winter late afternoon light). Photo's: Sheila Coulson

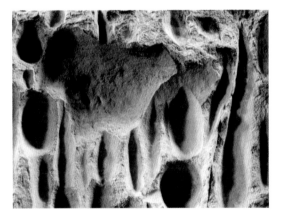

more striking during the Middle Stone Age, when the floor level was substantially lower, as it would then have been positioned at head height or even higher. This would have made grinding the panel more difficult, although it is unlikely this would have presented an insurmountable problem to anyone agile enough to make their way into this hidden cave.

Grinding stones – a potential manufacturing tool

It has been proposed that the cupules may have been ground into the rock face using well-rounded hammer stone/grindstones such as those recovered from both the Late and Middle Stone Age excavated deposits. However, grinding or smoothing stones can serve a multitude of functions and although their presence in direct proximity to the carved wall is suggestive, it cannot automatically be assumed that these artefacts were used on the wall. Fortunately, a small section of the carved

Fig. 4. Rhino Cave, spalled fragment of carved wall retrieved from depth of 140 cm in the Middle Stone Age deposit and ironstone grinding stone from 165-170 cm within the same deposit. Photo: Sheila Coulson

panel spalled from the outcrop and was recovered in the excavation well within the Middle Stone Age deposit (fig. 4). At present it can be stated that this panel was being carved at some point during the Middle Stone Age and even though it is not possible to determine the configuration of ground cupules on this panel at any point in the past, the carved fragment found in the Middle Stone Age deposit did contain the same elongated grooves presently found on sections of the outcrop. Additionally, the grinding stones recovered from this deposit have working edges that fit the dimensions of the present cupules and could potentially have been used to carve this wall. However, questions as to when the grinding of cupules first commenced or when this process stopped remain unanswered.

The carved wall – at night

As burnt artefacts were recovered from the archaeological deposits at Rhino Cave, and the natural light in the cave is restricted, it is highly likely that it at times would have been illuminated by firelight. It has been suggested that natural features of rock surfaces are not only used in depictions, but since the light source in a cave would have been a flickering flame, the depictions also were intended to

serve as animations. Therefore, a series of night-time experiments were carried out using clusters of glass-enclosed smokeless candles to observe the effect of flickering light on the panel (fig. 5). As can be seen the results are dramatic. The 'eye' is not particularly distinct in daylight but is prominent in firelight. Keeping in mind that, in earlier times, the increased depth of the floor surface would have altered the viewing angle, care was taken to assure that both the 'mouth' and 'eye' could be easily seen, even from directly beneath the outcrop. Furthermore, the present configuration of cupules, with their varying shapes and depths, combined with the natural colour variation of the formation, created the effect of movement in the flickering light.

Interpretation – the realm of speculation

Why was this particular rock outcrop chosen for such attention when it is so well hidden from view? As has been noted by rock art experts the choice of one particular rock panel, over an array of other seemingly equally suitable options, is an indication of its importance to those who chose to carve it – it is by no means a neutral support for imagery. It has also been postulated that using a particular rock surface as a prop brings to life a seemingly 'dead' cave wall – it becomes a living entity where the rest of the body is inside the wall. Numerous researchers have interpreted more recent rock art surfaces as points of access to the spirit world – integral parts of ritual. In the case of Rhino Cave, unfortunately, we simply as yet have no suitable framework within which to discuss this Middle Stone Age rock art or to begin to postulate any form of ritual from this distant past. The carved wall from this cave remains unique – and a mystery.

If the spalled section of the carved wall and the grinding stones from this site had been recovered in an archaeological deposit dated to the very recent past ethnographic analogies and historical sources could have been used to

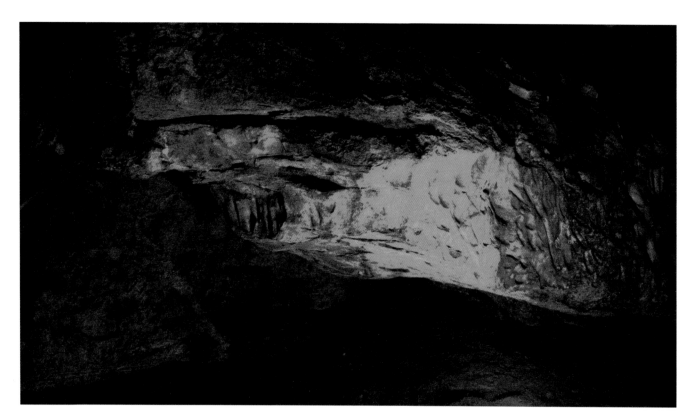

Fig. 5. Rhino Cave, night time experiments with flickering light on the front of the carved panel. Photo: Sheila Coulson

formulate an interpretation. Unfortunately, when the deposits and the finds are a minimum of 40 000 years old this possibility is ruled out. However, certain areas of speculation are still tempting to explore.

Obviously it is impossible to determine how this outcrop was interpreted in the past but it takes little imagination to see it as a zoomorphic form, such as a snake. The 'head' of this figure 'rears up'; there is an elongated crack for a 'mouth' and a natural circular depression for the 'eye'. With full allowance made for the differences in time and geographical setting it is worth noting that in European Upper Palaeolithic examples of rock art it is a well-recognized phenomenon that natural formations or protuberances in a cave wall would be incorporated into the depiction of animals and that shadows from firelight were used to enhance images (see the writings of rock art expert David Lewis-Williams listed below). To modern eyes the effect of firelight on the cupules from Rhino Cave appears to make the carved panel undulate and jut from the cave wall. Was this rock outcrop carved to enhance its resemblance to a snake? Can this carved panel be counted among the numerous painted depictions of snakes appearing from or disappearing into rock walls? Some people immediately see the form of a snake in this carved outcrop, while others see a panel of rock with patterns of cupules. What do you see?

The snake and Satan in Jewish, Christian and Islamic creation stories*

MINEKE SCHIPPER

Worshipped and reviled: the snake

Of all the animals it was the snake that had the finest qualities, and in some respects it resembled humans. Just like them it stood upright on two feet, and it was as large as a camel. Its superior intellect led it to become an unbeliever, whence its envy of humans. It was above all jealous of Adam's relationship with Eve, and in its jealousy it sought ways to kill him.[1]

In many cultures, snakes symbolised both healing and destruction, both life and death. They were often found in mythical gardens. An example was the Greek Garden of the Hesperides, where the apple trees bore golden fruit: the garden – which was Hera's domain before she married Zeus – was guarded by a snake called Ladon. With Zeus's permission, Heracles killed the snake. Goddesses were originally in charge of such gardens, but male gods gradually took over.

In the Sumerian Garden of the Gods, which belonged to Siduri, the Goddess of Wisdom, Gilgamesh was robbed of the plant of life by a snake. And an illustration from Central America showed the god Tlaloc weeping with joy as he entered a Mexican garden, for his sister Chalchiuhtlicue had given him permission to rule over her paradise with her. Rearing up behind the god was a mottled snake – another manifestation of Tlaloc.[2]

In the Middle East, the negative role of the snake in the Jewish Genesis story was an indirect reference to the Canaanite cult of the great goddess Astarte (in Hebrew, Ashtoreth), who promised humans life and fertility. Belief in this mother goddess and the snake, which was worshipped as a deity alongside her, fascinated the Israelites in Canaan. To suppress this attraction to the neighbours' religion, Genesis may well have turned the snake into a diabolical figure bent on inciting disobedience to God's commandments.

The snake symbolised the great temptation that faced the Israelites on arrival in the land of Canaan. Would they serve their own God, or the gods of the conquered land? A never-ending struggle. Temptation by the snake and the sins of the Israelites symbolised the wickedness of a human race inclined to do evil rather than good. The creation story in the bible only mentioned the snake as a 'creature hateful to God'. In the Koran, the snake's place was taken by Satan himself.

The biblical story referred back to an older, rather gory Babylonian creation story in which the mother of the living was slaughtered by a male god who created heaven out of her immense carcase. It was a story of the struggle for power between rival gods, in which the creation of the first humans – a key part of the Genesis story – was not so important.

Before heaven and earth existed, and before gods were created, the salt waters of the sea existed in the form of the female creator Tiamat, and the fresh waters of the springs and rivers in the form of the male creator Abzu. The waters merged, and new generations of deities were born. The young gods' boisterousness angered their ancestral parents, and Abzu resolved to destroy his offspring; but before he could do so he was killed by one of the young gods, Marduk, whereupon Tiamat decided to avenge the loss of her beloved. Originally the personification of the

* This essay is an edited version of a chapter from Mineke Schipper's book *Overal Adam en Eva: verhalen en beelden van de eerste mensen in jodendom, christendom en islam*, Bert Bakker, Amsterdam 2012.

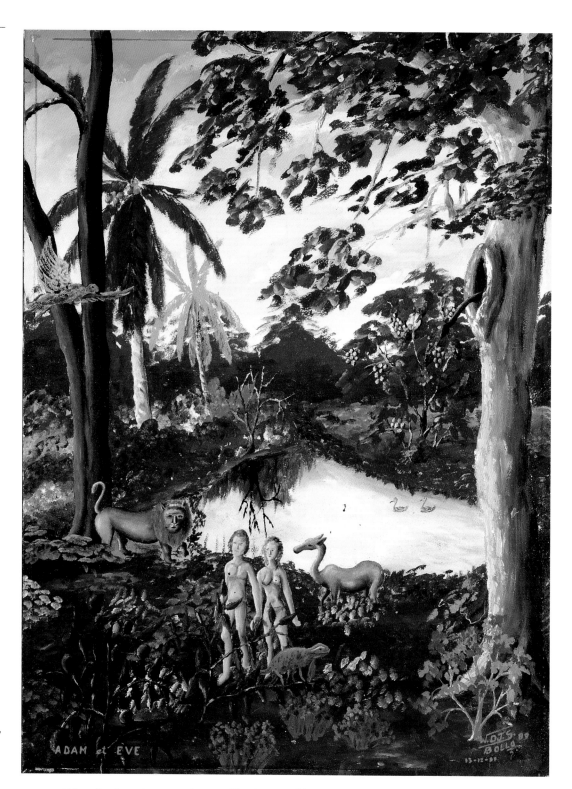

Bollo, Adam & Eve, 1989, work on canvas, 73 x 53 cm. Collection: Afrika Museum, Berg en Dal

oceans, this primal mother was also reptilian in nature. She hatched several monstrous snakes, a wondrous brood of demons with names like Viper, Dragon and Scorpion, and placed her son and new husband, Kingu, at their head. The god Marduk challenged the furious Tiamat, and she lost the fight. Standing triumphantly over her conquered body, Marduk clove it in two like an oyster shell; the upper half became heaven.[3] Abandoning the violent pattern of rivalry

between the Babylonian gods, the God of the early Israelites created the universe by the Word alone. The snake still had a part to play in this story, but its behaviour now ran counter to God's plans. In the Hebrew bible, powers opposed to God were not infrequently portrayed as snakes. Some of the powers created by God rejected his divine world order.[4]

The female creating principle was strikingly absent from the story of the Hebrew God, but before leaving Paradise Adam called his wife Eve, or *Hawwah*, a name often associated with the Hebrew word *haya*, 'living'. The name, 'mother of the living', sounds like a late echo of female grandeur in early civilisations. However, the related Aramaic word *ḥēwjā*, sometimes also rendered as *hawwa*, means 'snake'. The name *Hawwah* may once have meant 'snake-mother' (= mother goddess), but the author of the Genesis story opted for the meaning 'mother of the living'.[5] The snake thus met the first woman on an equal footing, and offered her evil wrapped in fine promises:

'Ye shall not surely die,' said the snake, 'for God doth know that in the day ye eat thereof, then your eyes shall be opened, and ye shall be as gods, knowing good and evil.' (Genesis 3: 4-5).

Stories and illustrations often portray the snake as the embodiment of evil together with Eve, and seem determined to paint a picture of mother Eve, and all her daughters, based on negative sexual connotations of women as sinful temptresses.

The mother of the living has increasingly been identified with the evil role of the snake. One rabbinical interpretation of the bible states that Adam called the first-created woman 'Eve' in order to remind her just how many generations she had consigned to perdition by eating of the forbidden fruit. Eve was given to Adam in order that they might live, but the counsel she gave him was that of a snake. The rabbi who wrote all this addressed Eve directly in the following

terms: 'The snake is your snake, and you are Adam's snake.'[6]

One Talmud story attributed erotic effects to the fruit of the tree of knowledge of good and evil, and in the Christian church the image of the snake as a symbol of cunning was increasingly associated with lust.

Although in the Koran the snake in the Garden of Eden story was replaced by the diabolical character of Iblis, snakes have regularly featured in Islamic tradition. Jewish and Christian stories in the region undoubtedly influenced the figure of Iblis or *al-Shaitan* (Satan). From Egypt to Indonesia, both the snake's appearance and its sinister connection with Satan are described in florid detail; and in Jewish writings and in Christianity the figure of the snake often has diabolical traits.

In the Hebrew bible, according to modern biblical scholars, the snake symbolises 'that which opposes God'.[7] But then why has the Israeli paratroopers' brigade chosen a rearing winged snake with a forked tongue as its insignia and named all its units after snakes – Cobra, Viper, Coluber and so on?

A sexy creature

In those blissful days before the Fall, the snake was still an extraordinarily lovely creature, tall, slim and upright, with brilliant green eyes and long hair like a woman's. It became Eve's best friend. (Arabia)[8]

Like all the other animals created by God, the snake was a denizen of the Garden of Eden, but one of outstanding beauty. Was that why Eve was so fond of it? It is sometimes said that Satan deliberately chose the snake as the instrument for his evil machinations.

Stories about animals make a point of explaining how they acquired their appearance or behaviour. In various stories about Adam and Eve, the snake from the time before the Fall was

portrayed as an animal with legs. Sometimes it even had arms and hands, wings or a human head. It could talk, walk and stand upright, and some say it was as large as a camel. If it stood on tiptoe it could reach Eve's ear, for it was so bold that it dared to come very close to her.
To make the snake's influence even more convincing, some stories noticeably played up its appearance. Especially in the Arabian tradition, it was often depicted as a woman:

'The serpent was the queen of all beasts. Her head was like rubies and her eyes like emeralds. Her form was like a camel, and her skin shone in the loveliest hues. Her hair was soft like that of a young noblewoman. She smelt of musk and amber, she fed on saffron and all her words were songs of praise.'[9]

The sounds that emerge from the throats of earthly camels are hardly mellifluous, and the scent that surrounds them is far from fragrant. But of course this snake was no ordinary camel –

Eve and the snake (*Speculum humanae salvationis*, 1448)

and who could deny that everything in the Garden of Eden was perfect?
The snake's conversation with Eve is crucial to the story. The fact that Eve was not surprised to be addressed by the snake means that, in the time before the Fall, people and animals spoke the same language. In the beginning, according to some stories, even the trees could speak. Only when Adam and Eve were expelled from the Garden of Eden did this self-evident communication come to an end: 'On that day the mouth of all the beasts and cattle and birds and whatever walked or moved was stopped from speaking because all of them used to speak with one another with one speech and one language.'[10] But which heavenly language did Adam and Even speak to each other, and to the snake and the other creatures? According to the fathers of the Christian church such as St Augustine (and many after him) it must have been Hebrew, 'the primitive language of the human race and the mother of all others.'[11] Depending on where they came from, various writers suggested that the language spoken in the Garden of Eden was Hebrew, Aramaic, Arabic, Persian, Amharic – or Syriac, which Ephrem the Syrian chauvinistically called 'the oldest language of humanity' and 'the king of all languages'.
The author's own choice was sometimes followed by the modest words 'but only God can know for certain …' – a prudent addition when we consider that as late as the twentieth century a dispute among Dutch Christians as to whether the snake could talk resulted in a schism.[12] Once Adam and Eve were expelled from the Garden of Eden, all creatures lost their common heavenly language. They could no longer understand each other, but they could still talk to others of their own species. Only the snake lost its voice for good, and, according to a Maltese tale, its lovely legs:

'The snake cried out sadly "But how am I to move?" "On your belly – to your everlasting

shame." But the snake was vain, and did not want to crawl over the earth while people were looking. So what did he do? As soon as people came near, he reared up on his tail and rushed at them so that they would think he still had legs.'[13]

Perfection remained beyond the reach of humans, and even a creature as lovely as the snake. Once Satan entered the blessed garden, the world changed radically. But how did he get there?

How Satan entered Paradise

Taos said 'I know of a creature that can help you to enter Paradise – Hayya the Snake, the servant of Adam, the Caliph of Allah.' Iblis beamed. 'Hayya is my friend. I used to go out riding on her back. Fetch her here. She is our only hope.' (Yemen)[14]

Of course Iblis had often tried to enter Paradise, but Ridwan, the vigilant guardian angel, had always denied him entrance. Yet, being the Lord of Evil, he was patient. After his conversation with Iblis, Taos the peacock pranced away, and as soon as he was back in Paradise he went in search of Hayya.
Taos told the snake about his encounter with Iblis (a cherub from the sixth heaven) outside the gate of the Garden, and about a mysterious tree in Paradise called the Tree of Eternal Life. He cried out excitedly 'Whoever eats of it will live forever. He has promised to point out the tree to us if we can help him to enter Paradise. Can you do this?' Hayya did not have to think for long. She nodded with her 'ruby head, framed in virginal locks' and lisped through her fangs 'I believe I can.'[15]
In this Yemeni tale, the snake was again described as a camel-like quadruped with splendid wings. In stories about Paradise, the peacock and the snake often cooperated with Iblis. An Arabic prophet story described the

peacock as the loveliest bird in Paradise. It had such a sweet, melodious voice that it was allowed to sing God's praises each day in the main streets of heaven. When Iblis saw the peacock parading outside Paradise, he knew that the bird's special status in heaven had made it vain. After flattering the bird, he asked Taos to hide him in his wings. Once they were in Paradise, he said, he would reward him by teaching him three secret words: uttering them would protect him forever against sickness, old age and death. In an Indonesian version of the story, Iblis then entered the peacock's beak, hid inside his body and so got past the gatekeeper with no difficulty. Once he was in Paradise, he slipped out through the peacock's anus. No snake was involved.[16]
In other versions, the peacock wanted to know the three words, but was so afraid of being caught by Ridwan that he said no. Instead he consulted the snake, who was also very interested in the three secret words. Shortly afterwards the snake left Paradise to meet Iblis, who was still hanging around close by.
After flattering the snake, Iblis came to the point. How could Hayya smuggle him into Paradise unnoticed? The various authors provided different answers. Iblis shrank to the size of a baby mouse (Malaysia), changed into two drops of water (Egypt) or dissolved completely into air (Yemen). In each case he was thus able to hide in the snake's mouth:

'I can see a big gap between your front teeth,' said Iblis. 'I know it is big enough for me. Let me in, and I will teach you the three words.' The snake opened its mouth, and Iblis settled in the gap between its two incisors, which he poisoned for the rest of time.[17]

Would Ridwan be suspicious? He was still there outside the entrance to the Garden of Eden. In the Yemeni version, all those that dwelt in Paradise needed a password in order to get through the gate. The password was 'Only Allah,

our Lord, is the one revered Lord.' Hayya carefully recited these words before greeting the guard.

'Peace be with you, Ridwan,' said Hayya airily. 'It is good to be back in Paradise.' 'Peace be with you,' Ridwan replied. He looked at Hayya. Seeing no change in either her appearance or her voice, he said 'Welcome back.' Hayya trotted cheerfully back into Paradise.[18]

In one Egyptian story, just as in the Koran, the snake played no part. Here Iblis entered Paradise under the peacock's wings. Being weak and vain by nature, the beautiful bird fell for Iblis's honeyed words after Iblis saw him showing off his magnificent plumage outside the gate of Paradise.[19]

In all three religions there are stories explaining how the snake and Satan came to cooperate, but Islamic stories go out of their way to answer the question of how Iblis entered Paradise; he could only do so with the help of one or more beasts of the Garden – usually the snake, sometimes the peacock, and sometimes both. The peacock regularly appears in Islamic pictures of Adam and Eve's departure from Paradise, some of which show Adam riding away on a dragon-like snake and Eve on a peacock.

In a fourth-century Christian text originally written in ancient Syriac and attributed to Ephrem the Syrian (c. 306-373 AD), the emphasis was different. Jealous of Adam and Eve, who were living happily in Paradise, Satan was consumed with jealousy and fury. He knew that his own appearance was so foul and abhorrent that Eve would instantly flee if she saw him as he really was, so he assumed the attractive appearance of the snake instead.

He moved into the snake, lifted it up and made it fly through the air towards Mount Eden, where Paradise was located.[20]

According to a German story from Pomerania, the snake did not even live in Paradise. The devil had changed into a snake with a shiny skin, and had crawled up from his underground place of exile via the roots of the tree of knowledge of good and evil to its trunk in the middle of the Garden. There he emerged from the ground, and he immediately wound himself round the trunk. Adam and Eve were lying in the grass not far away ... Eve was fascinated by the strange creature with its shiny skin, glittering eyes and long tongue, and soon let herself be tempted. After she had eaten of the fruit, Adam was angry. He accused her; but Eve, fearful of being expelled from Paradise without him, forced him to swallow the apple as well. [21]

Stories from all three religions thus provide varied descriptions of the snake's appearance and role. They also answer the question of how evil gained access to Paradise in very different ways, even within the same religion. But every single version has a sombre ending, and not one of them concludes with the euphoric message for humanity 'And they lived happily ever after.'

The meaning of the snake in the bible and in gnosticism/hermeticism

Jacob Slavenburg

The Swiss psychiatrist Carl Gustav Jung was fascinated by the figure of Hermes-Mercury. In one of his studies on *The Spirit Mercury*[1] he wrote this about Hermes-Mercury's staff:

Originally in Egypt Hermes was known as the ibis-headed god Thoth, and therefore was conceived as the bird form of the transcendent principle. Again, in the Olympian period of Greek mythology, Hermes recovered attributes of the bird life to add to his chthonic nature as serpent. His staff acquired wings above the serpents, becoming the caduceus or winged staff of Mercury.

The Western ancient world

In antiquity, snakes were generally thought of as chthonic (earthbound, underworld) creatures. They were seen as rulers of the realm of the dead; in the geometric funerary art of ancient Greece, they were the appropriate symbols for the finiteness of life, and were often depicted on funerary jars. Snakes were sometimes shown coiled round the jars or crawling up along the handles. They also played an important part as house snakes, for instance during the Minoan period in Crete, where many homes were protected by house snakes. But snakes were also worshipped as sacred creatures, for instance Python, the serpent of the underworld in the famous Delphic oracle. Animals that were as closely associated with the earth as snakes surely controlled its forces. As chthonic creatures they could use their mantic (divining) gifts – which they again derived from the earth – to indicate the right medicines for the sick, as in the shrines

to Asclepius, the Greek god of medicine. The oracles of antiquity were chthonic oracles, and originally belonged to Gaia, the Earth Mother. Just as snakes shed their old skins annually, the earth was renewed each year. Accordingly, snakes symbolised both dying and life resurrected from death. That is why they were sometimes cursed and sometimes worshipped as divine saviours. In his *Saturnalia*,[2] the late-Roman writer Macrobius (c. 400 CE) said of Asclepius and Salus: 'Figures of serpents are joined to their images, then, because they ensure that their bodies are rejuvenated and regain their original vigour, as though by shedding their old skin of infirmity, just as serpents are rejuvenated from one year to the next by shedding the skin of old age.'

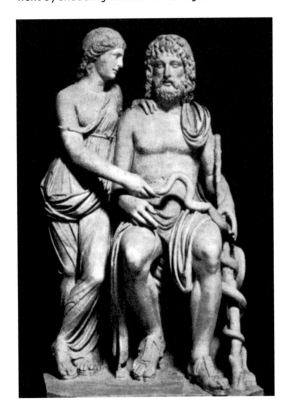

133

The snake in the bible
and in gnosticism/
hermeticism

Snakes were also generally seen as a means of promoting health. Their flesh was especially easy to digest, and was used as a medicine for the sick. Snake meat was also used in the panacea *theriac* to provide immunity against snakebite.

Hermes-Mercury

The snakes round Hermes-Mercury's caduceus most probably originated in the cult of Asclepius. The snake was an important symbol of Asclepius (and survives in the still widely used 'rod of Asclepius' symbol, for example in the logo of the World Health Organisation). In many pictures of Asclepius, the deity was shown leaning on a staff with a snake winding round it; this has become the symbol of medicine and pharmacy. When the sick in the *abatons* (dormitories) of shrines to Asclepius were in a kind of dream state, the god appeared to them, laid his hand on the ailing spot and had a snake lick it clean; this is splendidly illustrated by a

Asclepius and Hygeia

Dream healing, National Archaeological Museum, Athens

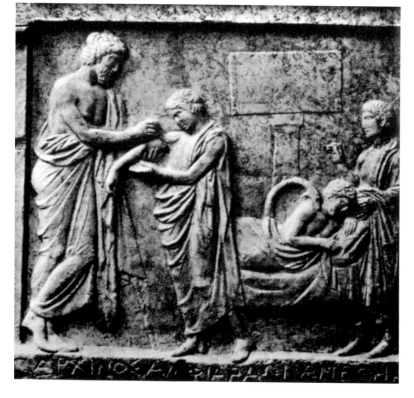

healing scene at the National Archaeological Museum in Athens that shows Amphiaraus, in imitation of Asclepius, curing a patient in a dream state (see illustration). According to the historian Eduard Meyer,[3] Hermes's caduceus was initially a single messenger's staff as well as a sign of peace. Later it also became a symbol of commerce and prosperity. Even later it would assume the form of a winged staff with two snakes winding round it. By then the original magical meaning was apparently no longer understood.

The Homeric *Hymn to Hermes* related that young Hermes was reconciled with his half-brother Apollo on Olympus, the mountain of the gods. In return, the supreme god Zeus gave him a herald's staff with two white ribbons, a round hat to keep the rain off, and winged sandals; the speed these enabled him to achieve was very useful in his task as messenger of the gods. According to Robert Graves,[4] the white ribbons on Hermes's staff were later mistaken for snakes. Jan Schouten[5] also takes the view that Hermes-Mercury's caduceus was not considered a medical symbol in antiquity, and that this meaning was only introduced in the West, during the Renaissance. Hermes was then shown bearing the familiar staff with two snakes winding round it (see illustration). This was used as a medical symbol on the frontispieces of various seventeenth- and eighteenth-century pharmacopoeias (books on the preparation of medicines) instead of the rod of Asclepius. The attribute of Mercury also appeared as medical heraldry in some portraits of physicians.

So was Hermes completely separate from Asclepius? Not at all. In the aforementioned Homeric *Hymn to Hermes*, Hermes, like Asclepius, was seen as the guide to dreams. And then there was the miraculous birth of Asclepius himself, as described by the Greek poet Pindar (522-443 BCE) in his *Pythian Odes*. According to Pindar, the god Apollo impregnated the king's daughter

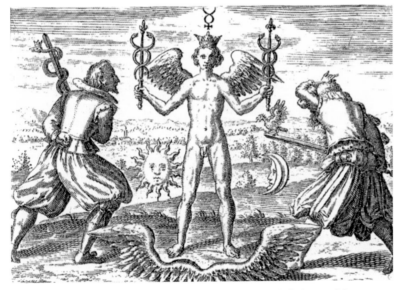

Double Mercury. Michael Maier, *Atalanta Fugiens*, Oppenheim, 1618

Mercury the mediator. D. Stolcius von Stolcenberg, *Vividarium chymicum*, Frankfurt,1624

The snake in the bible

The Genesis story of Eve's temptation is a familiar one:

'Now the serpent was more subtil than any beast of the field which the Lord God had made. And he said unto the woman, Yea, hath God said, Ye shall not eat of every tree of the garden? And the woman said unto the serpent, We may eat of the fruit of the trees of the garden: But of the fruit of the tree which is in the midst of the garden, God hath said, Ye shall not eat of it, neither shall ye touch it, lest ye die. And the serpent said unto the woman, Ye shall not surely die: For God doth know that in the day ye eat thereof, then your eyes shall be opened, and ye shall be as gods, knowing good and evil. And when the woman saw that the tree was good for food, and that it was pleasant to the eyes, and a tree to be desired to make one wise, she took of the fruit thereof, and did eat, and gave also unto her husband with her; and he did eat.'

When God found out, he was angry at the snake and the first human couple:

'And the woman said, The serpent beguiled me, and I did eat. And the Lord God said unto the serpent, Because thou hast done this, thou art cursed above all cattle, and above every beast of the field; upon thy belly shalt thou go, and dust shalt thou eat all the days of thy life: And I will put enmity between thee and the woman, and between thy seed and her seed; it shall bruise thy head, and thou shalt bruise his heel.' (from the King James Version)

Coronis, but she was secretly in love with a mortal called Ischys. In revenge, Apollo had her killed by his sister Artemis's arrows. But when he saw the dead body burning on the funeral pyre, he felt remorse, and motioned to Hermes to rescue the still living child from Coronis's burning womb. The child was Asclepius.

In the Old Testament, the snake has two meanings. The snake from the Garden of Eden was cursed as the arch-enemy of the human race. However, in Numbers 21: 4 we read that the Israelites who were wandering in the Sinai desert complained about their poor food and general circumstances. Thereupon God sent fiery snakes

among them, and many of the Israelites were bitten to death. The people repented, and on God's instructions Moses made a snake out of bronze and placed it on a pole. Anyone who had been bitten by a snake and looked at the bronze snake remained alive. Schouten comments that these conflicting ideas about snakes – as enemies and saviours – corresponded to the ancient notion of terrestrial snakes as chthonic creatures with knowledge of life and death.

In the Middle Ages the bronze snake, as a typification of the Saviour nailed to the cross, became a symbol of healing. In St John 3: 14 we read that 'just as Moses in the desert lifted the serpent on the pole, the Son of Man must be lifted up.' Through his death on the cross, Christ redeemed fallen mankind, and so healed the spiritually afflicted. During the Middle Ages, as a typification of Christ's death on the cross and a symbol of healing, the bronze snake was undoubtedly more familiar and popular than Asclepius. During the Renaissance, in their attempts to revive the classics, humanists rediscovered Asclepius and his rod, and transformed him into Hermes-Mercury, whom

they saw as a contemporary of Moses (see the mosaic of Hermes Trismegistus on the floor of Siena Cathedral).

The snake in gnosticism

What is striking in gnosticism is that the snake has an essentially positive image. The gnostic group known as the Naassenes took their name from the Hebrew word for snake, *nachash*. This group was almost certainly identical to the Ophites (*ophis* is the Ancient Greek word for snake). They associated Ouroboros, the magic snake of wisdom that symbolised the cycle of life by biting its own tail, with the primal snake Leviathan, which they used as a symbol of the boundary between the visible and invisible divine world (see illustration). Gnostics saw the snake from the Garden of Eden as a well-intentioned creature, for it had enabled humans to eat of the tree of knowledge, so that they could acquire gnosis (inner knowing).

Accordingly, one of the gnostic texts found at Nag Hammadi, *The Hypostasis of the Archons* (NHC II, 4), describes the Garden of Eden story in very different terms from the bible:

The Rulers took counsel with one another and said, 'Come, let us cause a deep sleep to fall upon Adam.' And he slept. Now the deep sleep that they 'caused to fall upon him, and he slept' is Ignorance. They opened his side like a living Woman. And they built up his side with some flesh in place of her, and Adam came to be endowed only with soul.
And the spirit-endowed Woman came to him and spoke with him, saying, 'Arise, Adam.' And when he saw her, he said, 'It is you who have given me life; you will be called "Mother of the Living" … Then the Authorities came up to their Adam. And when they saw his female counterpart speaking with him, they became agitated with great agitation; and they became enamoured of her.

Ouroboros. Jacob Böhme, *Theosophische Wercke,* Amsterdam, 1682

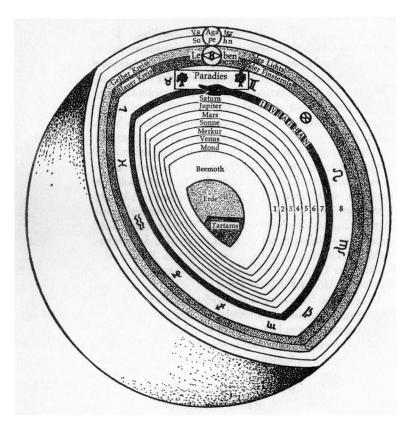

Naassenes. Hans Leisegang, *Die Gnosis*, Stuttgart, 1985

that he said this to you (pl.). Rather your (pl.) eyes shall open and you (pl.) shall come to be like gods, recognising evil and good.' And the Female Instructing Principle was taken away from the Snake, and she left it behind merely a thing of the earth.

And the carnal Woman took from the tree and ate; and she gave to her husband as well as herself; and these beings that possessed only a soul, ate. And their imperfection became apparent in their lack of Acquaintance; and they recognised that they were naked of the Spiritual Element, and took fig leaves and bound them upon their loins.

Then the chief Ruler came; and he said, 'Adam! Where are you?', for he did not understand what had happened.

And Adam said, 'I heard your voice and was afraid because I was naked; and I hid.'

The Ruler said, 'Why did you (sing.) hide, unless it is because you (sing.) have eaten from the tree from which alone I commanded you (sing.) not to eat? And you (sing.) have eaten!'

Adam said, 'The Woman that you gave me, she gave to me and I ate.' And the arrogant Ruler cursed the Woman.

The Woman said, 'It was the Snake that led me astray and I ate.' They turned to the Snake and cursed its shadowy reflection, [gap in the text] powerless, not comprehending that it was a form they themselves had modelled. From that day, the Snake came to be under the curse of the Authorities; until the All-powerful Man was to come, that curse fell upon the Snake.[6]

Even more graphic is the rendering of this myth and the commentary on it in the text entitled *The Testimony of Truth*, which was also found at Nag Hammadi:

They said to one another, 'Come, let us sow our seed in her,' and they pursued her. And she laughed at them for their witlessness and their blindness; and in their clutches, she became a tree, and left before them her shadowy reflection resembling herself; and they defiled it foully. And they defiled the form that she had stamped in her likeness, so that by the form they had modelled, together with their (own) image, they made themselves liable to condemnation.

Then the Female Spiritual Principle came in the Snake, the Instructor; and it taught them, saying, 'What did he say to you (pl.)? Was it, "From every tree in the garden shall you (sing.) eat; yet from the tree of recognising evil and good do not eat"?'

The carnal Woman said, 'Not only did he say "Do not eat", but even "Do not touch it; for the day you (pl.) eat from it, with death you (pl.) are going to die."'

And the Snake, the Instructor, said, 'With death you (pl.) shall not die; for it was out of jealousy

It is written in the Law concerning this, when God gave a command to Adam, 'From every tree you may eat, but from the tree which is in the midst of Paradise do not eat, for on the day that you eat from it you will surely die.' But the serpent was wiser than all the animals that were

in Paradise, and he persuaded Eve, saying, 'On the day when you eat from the tree which is in the midst of Paradise, the eyes of your mind will be opened.' And Eve obeyed, and she stretched forth her hand; she took from the tree; she ate; she also gave to her husband with her. And immediately they knew that they were naked, and they took some fig leaves and put on girdles. But God came at the time of evening walking in the midst of Paradise. When Adam saw him he hid himself. And he said, 'Adam, where are you?' He answered and said, 'I have come under the fig tree.' And at that very moment God knew that he had eaten from the tree of which he had commanded him, 'Do not eat of it.' And he said to him, 'Who is it who has instructed you?' And Adam answered, 'The woman whom you have given me.' And the woman said, 'The serpent is the one who instructed me.' And he cursed the serpent, and he called him 'devil'. And he said, 'Behold, Adam has become like one of us, knowing evil and good.' Then he said, 'Let us cast him out of Paradise, lest he take from the tree of life and eat and live for ever.' But of what sort is this God? First he envied Adam that he should eat from the tree of knowledge. And secondly he said 'Adam, where are you?' And God does not have foreknowledge, that is, since he did not know this from the beginning. And afterwards he said, 'Let us cast him out of this place, lest he eat of the tree of life and live for ever.' Surely he has shown himself to be a malicious envier. And what kind of a God is this? For great is the blindness of those who read, and they did not know it. And he said, 'I am the jealous God; I will bring the sins of the fathers upon the children until three and four generations.' And he said, 'I will make their heart thick, and I will cause their mind to become blind, that they might not know nor comprehend the things that are said.' But these things he has said to those who believe in him and serve him! And in one place Moses writes, 'He made the devil a serpent for those whom he has in his generation.' In the other book which is called 'Exodus', it is written thus: 'He contended

against magicians, when the place was full of serpents according to their wickedness; and the rod which was in the hand of Moses became a serpent, and it swallowed the serpents of the magicians.'

Again it is written (Numbers 21:9), 'He made a serpent of bronze and hung it upon a pole [gap in the text] which [gap in the text] for the one who will gaze upon this bronze serpent, none will destroy him, and the one who will believe in this bronze serpent will be saved.'

For this is Christ; those who believed in him have received life. Those who did not believe will die. What, then, is this faith?[7]

In this commentary on the Garden of Eden story, the snake is referred to as 'wise' and portrayed as the one who encourages gnosis. The snake understands why the demiurge (the jealous undergod) wants to keep humans ignorant of their own divinity; and it is his intention to help humans achieve true self-knowledge and free them from damnation. That is why the demiurge curses the snake and calls him *diabolos*, for the snake has thwarted his plans. Later in the text the bronze snake, which Moses set up on a pole as a means of salvation, is likewise symbolically identified with Christ, who was similarly nailed to a cross in order, so the gnostics claimed, to redeem humanity via the path from self-knowledge to knowledge of God – a complete reversal of the traditional interpretation in Genesis.

The snake and psychotherapy

WOUTER BLEIJENBERG

However unusual the connection between snakes and psychotherapy may be in a country such as the Netherlands, this article will nevertheless look closely at the symbolic and substantive meaning of the snake in relation to the psychotherapeutic process and the structure of the psyche. It will also give the reader a brief introduction to the lives and work of Carl Gustav Jung and Erich Neumann, in whose theoretical writings and therapeutic approach the snake plays a prominent part. A dozen Dutch psychologists and psychotherapists use the snake as part of the psychotherapeutic process in what is known as 'sandplay therapy', a non-verbal form of psychotherapy in which clients use miniature replicas of animals (including various snakes), buildings, vehicles, sculptures and utensils to create pictures in a tabletop sandbox based on their fantasies, impulses and imagination. Sandplay therapists see this as a way of exploring their clients' inner imagery and associations.

In Jungian psychology, the snake is a complex, ubiquitous and powerful archetypical[1] symbol that is found in mythology all over the world. As the ouroboros, the primal snake that bites its own tail, it symbolises wholeness, unity, paradise, resolution of contradictions, symbiosis, the mother goddess. This article will mainly focus on the relevance of the snake to the development of consciousness, formation of the ego, the 'self' and the process that Jung called 'individuation'. According to Jungians, the symbolism of the ouroboros is mainly related to the *unconscious* and the mother-child relationship, and the rearing snake more to the process of ego strength and the power that the *conscious* attempts to exert over the unconscious.

The snake is fascinating and terrifying because of its unpredictable and possibly poisonous bites, as well as its autonomous behaviour and beauty. Many human qualities are projected onto the snake, which in various cultures stands for a wide range of human emotions, behaviour and ambitions. It combines the most hated, diabolical and destructive aspects with the most elevated, 'divine' properties and spiritual goals that humans can aspire to. It is also a prominent symbol in alchemy.

An alchemical print from 1760, with the ouroboros symbolically depicted as a circle made up of two snakes, one of which is wearing a crown and has feet and wings (Adam McLean collection).[2]

According to Jungians, the snake can change from a deadly hazard into the *kundalini* energy that can raise the entire person, mentally, physically and spiritually, to a high state of consciousness. They believe that these many facets automatically reflect the essence of every archetype, in which resolution of contradictions, transformation and permanent development symbolise mental activities and development of consciousness. An archetype cannot function without diversity and duality.

The snake in Jung's analytical psychology

The collected works of Carl Gustav Jung (1875-1961) contain many passages in which the snake plays a part. Since according to Jung the invisible world of the inner psyche is mainly manifested through visual language, it is very important to be open to dreams, fantasies, folk tales, myths and works of art. Nor is it surprising that Jung

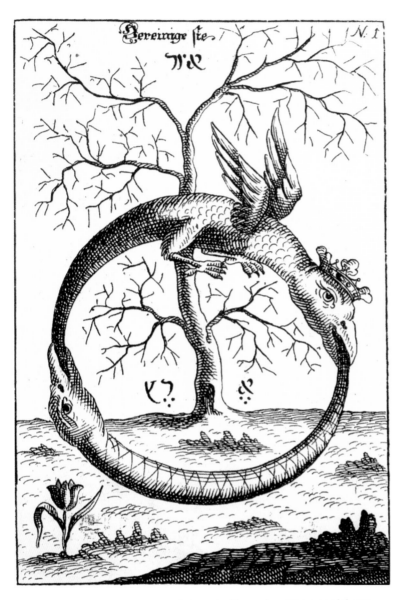

Abraham Eleazar, *Uraltes chymisches Werk,* Leipzig 1760. Alchemical print depicting a double ouroboros, Adam McLean[2]

between the personal and the collective. In this connection, Jung stated that in modern times humans have tended to neglect the natural relationship with their inner selves in favour of material progress and rationalism. They thus deny and repress the irrational side of the psyche, which re-emerges symbolically in dreams, fantasies and sometimes psychoses. Especially owing to the loss of religious faith, the link with the mystical aspects of human consciousness (which Jung calls the transcendent function of the psyche) is also lost.

The analytical psychology propagated by Jung set out to develop a theory with a therapeutic outlook in which the shadow sides and unconscious layers of the psyche were linked to mental problems and their analysis provided ways of achieving mental development, 'self-realisation'. Jung also felt that psychotherapy should be open to existential aspects. In a letter written in 1958, he said 'my *raison d'être* consists in coming to terms with that indefinable Being we call "God".' He saw individuation as the process whereby inner growth is accompanied by integration of one's own blind spots, integration of male and female properties, shadow sides, the personal unconscious and reconnection with the collective and archetypical aspects of human consciousness. The archetypical structure of the snake was, he felt, eminently suitable for understanding the many facets of the psyche.

One case history involved a client who dreamed about a snake guarding a golden bowl in an underground vault.[3] To obtain a full picture of the client's personal associations, Jung looked for similar descriptions in folk tales, myths, fables and religious stories. He also examined the biological features of the snake. 'In such a case we have to go back to mythology, where the combination of snake or dragon with treasure or cave represents an ordeal in the life of the hero.'[4] In this way he attempted to help the client get more closely in touch with his many-faceted

was so interested in such matters as alchemy, cultural anthropology, religious studies and art. He visited many countries and 'primitive' peoples, and learned to observe the relationship between human consciousness and images and what he saw as the symbolic reality behind developments throughout human history. Both in ancient periods, when ideas take shape instinctively and all that is visible is perceived as animate ('animism'), and in the lives of individualistic modern humans there is a link

inner self, in which ancient, instinctive and mythical images become visible in dreams and other images that emerge in the consciousness. If the snake appears in dreams, drawings, active imagination or sandplay therapy, Jungian therapists believe this almost always involves transformative meaning, connection with the earth and unconscious content that tends towards consciousness.

Besides personal associations and assignment of meaning to symbols, Jung believed it was important to make use of 'amplification'. This means taking account of symbolic meanings in folk tales, myths and cultural and religious frameworks. I will mention some aspects of amplification relating to the symbol of the snake.

The author Hans Egli[5] has made a thorough study of the many facets of the symbol of the snake in history, myths and folk tales, and describes the snake as a symbol of *power, life, the underworld, guarding of treasures, healing, initiation, poison* and *knowledge*, and as a symbol of *transformation* (shedding of the skin, action of poisons and medicines) and *consciousness*. The snake has an important meaning in religious myths, and in the bible it is associated with forbidden knowledge, Satan and healing (Moses's rod). Jung[6] describes a passage from the autobiography of the church father Ignatius of Loyola which refers to a shining light that he often saw and that some-times took the *form* of a snake.

In Hinduism we find the following description in the Rigveda (X, 90): 'Thousand-headed was the Purusha, thousand-eyed and thousand-footed. Having encompassed the earth on all sides....' In Egyptian mythology, the primal snake occurs in the form of a divine cosmic force that binds the zodiac together and brings life, with stars as eyes looking down on the earth. The All-Seeing Eye is a Christian remnant of this. According to Jung, such images emerge from the collective layer of the human psyche, and have an archetypical structure that helps form and guide

consciousness. He describes the snake's relationship to Christ by pointing to mediaeval illustrations that show *the snake hanging from the cross in place of Christ*,[7] and also refers to Christ with Moses's snake in the Gospel of John 3:14. In connection with Greek mythology and the Mithraic religion, there is another interesting detail involving Christ and a sacrifice: 'The bull symbolises the living hero ... but the serpent symbolises the dead, buried or chthonic hero ... the Mithraic killing of the bull is a sacrifice to the Terrible Mother, to the unconscious ... so is the act of sacrifice an impregnating of the mother; the chthonic snake demon drinks the blood; that is to say, the libido (sperma) of the hero committing incest. Life is thus immortalised for the hero because, like the sun, he generates himself anew.'[8] The implications for the Christian mystery are interesting: from the human sacrifice, Jesus as both a hero and a snake on the cross to the heroic act of Christ who dies and sacrifices himself but is also resurrected and united with the mother (in biblical books with the father!). Jung associated such mythological descriptions with the psychological level of differentiation and consciousness of unconscious processes which, in the case of the 'hero', take on an archetypical meaning for all men who pass through this 'heroic stage'. In our culture, the mediaeval story of Percival is in this respect again illustrative of the heroic structure and maturity of the man, who 'escapes' from the maternal bond by setting out alone on a journey, overcoming failure and sacrificing himself, and *thereby* being resurrected as a hero, i.e. as an autonomous adult.

The Red Book

Jung's semi-autobiographical book *Memories, dreams, reflections* describes important developments in his life, and makes clear that he often drew inspiration from the visual language of his unconscious. That this was not always a

positive or easy process is apparent from the fact that for years he was overwhelmed, sometimes psychotically, by images that it took him considerable effort to integrate and control. Two very specific and highly creative manifestations of this have survived.

The first is a complex towered structure in Jung's wooded lakeside garden in the Swiss village of Bollingen, where from 1923 to 1956 he frequently worked with stones and the geometric measures and shapes that were so sacred to him. Building and making stones with inscriptions and symbols also helped him express his inner images in material form through physical work.[9] Among these was a stone with a snake and inscriptions in an unknown language on it.[10]

Until well into his old age Jung would often withdraw to these towers, which he saw as a *temenos*, or sacred place of encounter, between the invisible world of inner forces and the reality

of his physical life (his family, his profession, his research and his affinity with nature). Some ten years later this was to be a source of inspiration for Dora Kalff (1904-1990) when she developed sandplay therapy.

The second manifestation is even more mysterious and complex: *The Red Book*. Jung began this extraordinary diary about an inner visual journey and confrontation with his unconscious in 1913. After his break with Freud, Jung was even more convinced of the importance and significance of the visual language of the unconscious for growth and the development of meaning and spirituality. To Freud, the unconscious was a counterpart to the ego that was dominated by sexual and repressed instinctive content. Freud said 'Where id is, ego shall be', reflecting his view that the ego should dominate the unconscious (id). Jung saw things quite differently: the ego should develop in such a way that the unconscious and the growing 'self'[11] would become the main forces for growth, leaving only a modest place for the ego. Such attunement of the ego and the 'self' to unlimited unconscious content was, he felt, the main source of mental integration and self-realisation. Today we might put it this way: one-sided emphasis on cognitive behavioural therapy, with its focus on strengthening of the ego and reduction of dysfunctional patterns of thought and behaviour, overlooks the 'transpersonal' potential for growth that can be fostered by confrontation with the inner self. In Jung's day, his positive focus on the unconscious was a revolutionary innovation, and particularly through his study of alchemy he understood that the language of the unconscious was very different from rational conscious thinking.

While travelling by train in autumn 1913, Jung had a shattering hallucination: a tidal wave full of bodies and other shapes was flooding across Switzerland from western Europe, and the water was changing into blood. He knew from his

Cover of C.G. Jung, *Das Rote Buch*, Copyright 2009 Foundation of the Works of C.G. Jung, Zürich.
First published by
W.W. Norton & Company

Brahmanaspati

The subtitle *Brahmanaspati* means that the text
should be seen as an invocation of the divine
precursor of Brahman, shown here in the form of a
snake. The text at the top reads 'Amen, you are
the lord of the beginning / Amen, you are the star
of the East / Amen, you are the flower that blooms
over everything / Amen, you are the deer that
breaks out of the forest / Amen, you are the song
that sounds far over the water / Amen, you are the
beginning and the end.' (Jaffé, 1977, p. 68)

The snake as the *beginning and the end* refers to
the ouroboros, but in the illustration we see the
snake both as a depiction of the cosmic breath,
the soul of the world, the primal force – the
volcanic character – that pervades all that exists,
and (seemingly) as the regurgitation, or
devouring, of a tree-like shape. Here I cannot help
thinking of the primal tree, the tree of knowledge
of good and evil in the Christian creation myth.
The illustration also clearly includes black
elements, which may refer to shadowy aspects. In
this myth the punishment for the encounter with
the snake is expulsion from the Garden of Eden,
the unconscious situation, the archaic mother.

experience as a psychiatrist that such halluci-
natory visions could presage psychosis. The First
World War began the following summer, and
Jung saw a link with his hallucination. He decided
to write down and draw such experiences, and
over the following decades this resulted in what
has come to be known as *The Red Book*, after the
red cover of this impressive work. For many years
it remained unpublished, but at the beginning of
this century Jung's family finally gave permission
for publication. It is a fascinating book full of
magnificent illustrations and texts in fine
calligraphy.

Towards the end of his life, Jung said in an
interview: 'The years… when I pursued the inner
images, were the most important time of my life.
Everything else is to be derived from this. It
began at that time, and the later details hardly
matter anymore. My entire life consisted in
elaborating what had burst forth from the
unconscious and flooded me like an enigmatic
stream and threatened to break me. That was the
stuff and material for more than only one life …
It took me forty-five years to distil within the
vessel of my scientific work the things I
experienced and wrote down at the time.'[12]

154

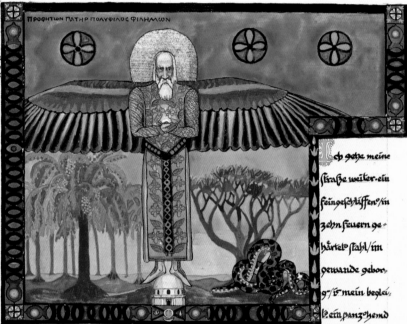

ΠΡΟΦΗΤΩΝ ΠΑΤΗΡ ΠΟΛΥΦΙΛΟΣ ΦΙΛΗΜΩΝ

A huge water snake
or monster from the
unconscious
threatens the boat
of the conscious on a
striking page from
The Red Book.

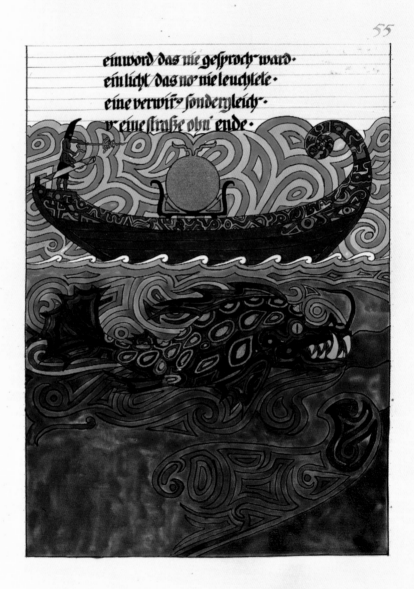

In the years to come, *The Red Book* will undoubtedly be the subject of much study and interpretation. What matters for the purposes of this article is that all the texts and drawings refer to images, visions and messages from 'inner guides'; in particular, Jung attributes many statements to Philemon, a kind of inner master that he drew as a wise old man with a white beard, sometimes with a bull's horns and, in the illustration on p. 143, with a kingfisher's wings (while out walking he came upon the dead body of a rare kingfisher, which struck him as a significant coincidence). In the bottom right-hand corner we can also see a huge snake writhing at Philemon's feet. As Jung said later, 'Philemon said things I had not consciously thought ... there are things in the soul that I do not make but that make themselves and have a life of their own.'[13] One evening in 1916 Jung and his family heard the doorbell ring, but there was no-one at the door. They could see the clapper moving, even though no-one was pulling the bell-pull.[14] 'They all simply stared at one another, and Jung knew that "something had to happen". The whole house seemed crammed full of spirits that were packed deep right up to the door. They cried out in chorus "We have come back from Jerusalem, where we found not what we sought".' Jung gives no explanation for this cabbalistic message, but he does say that immediately afterwards he rapidly wrote the remarkable *Seven Sermons to the Dead*,[15] in which Philemon occurs frequently. It is important to mention that during this period Jung was in the throes of a major inner crisis and feared that he might be going mad. However fine the drawings, and however neat and flawless the calligraphy, it will probably soon be clear to the reader and viewer that Jung was fighting a terrifying battle.

Writing and drawing this book probably helped him cope with these overwhelming unconscious images and avert a total breakdown. We should not forget how therapeutic his physical work in the garden and the meticulous writing and drawing of *The Red Book* were to him. Jung is known for his many other publications, but it was his personal process of coming to terms with periods of crisis that laid the foundations for his psychological insight and productive work.

Origins of consciousness: the ouroboros snake

In 1948, Erich Neumann (1905-1960) wrote a pioneering Jungian work on the development of human consciousness from a historical and above all mythological perspective. In the foreword to this book, *The Origins and History of Consciousness*, Jung writes that Neumann started where he himself would begin if he had a second life to live. This book, as well as *The Great Mother*, on the mother archetype, pursued Jung's use of study of the human psyche to establish links with the entire development of humanity from every source of civilisation, alchemy, myth and religion[16] – seeing human beings as permanently developing, from babies to wise older people, in the light of the mythological story of the whole of humanity. From ontogenesis to phylogenesis, as described by the biologist Ernst Haeckel (ontogenesis recapitulates phylogenesis, i.e. a single individual recapitulates the whole of evolution) – from the development of the individual to that of the group. From 'primitive' to 'civilised' humans: according to Neumann, all the stages of human civilisation could be found in the process of development from baby to adult. In his book on the structure of the mother archetype, he writes at length on the multi-faceted, dynamic nature of the mother archetype and symbol in the mythologies of numerous cultures, religions and folk tales. He is not always clear or consistent about the various stages, and his descriptions are at times chaotic. His aforementioned book on the origins of consciousness describes the hero archetype. He states that the stages begin and end with the symbol of the ouroboros, the snake that bites its

own tail, a symbol of symbiosis, origin, primal unity, the circle that produces life within itself. Neumann mentions several stages of the ouroboros in connection with the development of the ego:
1. the perfection/symbiosis of paradise;
2. differentiation/growing awareness of the ego;
3. separation from the primal parents.

If the hero (the ego) is then capable of overcoming trials, this may lead to a new, more differentiated relationship with the primal mother. The ouroboros then symbolises the perspective of the hero who fits into the totality of life, as Jesus's life and development are described in the biblical stories. Neumann describes the development of the ego with reference to many creation myths that begin with total harmony, which is then disrupted, leading to the human quest for the original harmony. Just as in human babyhood the symbiotic relationship with the parents is disrupted by autonomous development of the psyche, similar to expulsion from the original unity/symbiosis – not just from the paradise we know from the bible and the koran, but also from the heavenly situation described in the myths of almost all ancient civilisations. Expulsion from this ideal situation is followed by separation because a taboo has been violated, duality and conflict and the birth of a 'hero' (in Jungian terms, an ego/'self' link). There is then a heroic stage involving the pursuit and

E. Neumann, *Die Grosse Mutter*, 1956

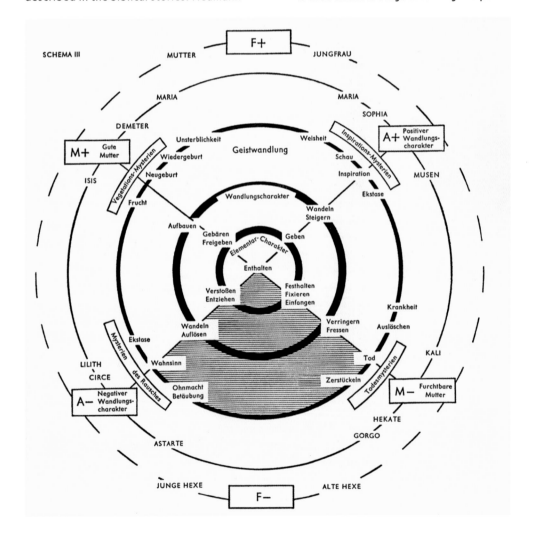

overcoming of dangers (vanquishing the dragon – the primal snake – which represents the symbiotic-incestuous primal state of *un*consciousness, primal chaos). The hero survives and civilisation evolves, as does the growing consciousness of the ego. As can be seen in many myths (and folk tales), dangers and shadowy forces must be overcome (in Jungian terms this is described as a parallel process of intrapsychic growth) in order to achieve transformation and seek and find a higher form of harmony and unity. Once the 'ego' is sufficiently well developed, it comes to serve the 'self' during adulthood, when maturing insight, autonomous action and individuation take place as a matter of course in those who are open to them. However, say Jungians, if these are ignored or repressed this leads to mental tension, and inner conflicts may be manifested as mental disorders or psychoses. Jung's own one-sided attitude to consciousness was disrupted from within by crises and a flood of images from his unconscious. This later led to remarkable personal growth and insight, and he wrote numerous books that were largely based on his own experience.

Neumann analysed the structures of myths, linked them to the growth of consciousness and hence created a new field of research. The challenge today is to extend this to new insights into the neurobiology of the brain and the development of consciousness. Even an author such as Van Lommel (2010), with his description and analysis of 'near-death experiences', finally arrives at a description of consciousness that goes well beyond individual thinking or the physical brain. He postulates a cosmic consciousness in which everything is vibration, energy and information that links everything to everything else, independently of time and space, and fundamentally transcends the individual – a total cosmic unity that, in Neumann's terms, can be symbolised by an ouroboros snake as the highest transformed

unity that consciousness can achieve and comprehend. This too is in line with the symbolism of alchemy, the finding of the Philosophers' Stone or comprehensive wisdom in the form of a cosmic snake. The primal snake in the ouroboros image is thus the beginning, the development process and the transformed totality all at once.

The ouroboros and the aurora

MARINUS ANTHONY VAN DER SLUIJS

The image of the mythical serpent or dragon is as enduring as it is elusive. Although based on reptilian biology, the creature's anatomy and antics incorporate many puzzling traits. And although cultures worldwide adopted the snake as a symbol, they did so for a wide variety of reasons. Psychoanalysts, sociologists and anthropologists have espoused a vast number of theories seeking the origins of the archetype in recesses of the human mind; salient examples are Jung's 'collective unconscious', Erich Neumann's stages of evolving consciousness in individuals, the structuralist paradigms of Durkheim and Lévi-Strauss, David Jones' resort to racial memory, and Jeremy Narby's concept of psychotropic drugs 'magnifying' DNA. Yet, for all their ingenuity, none of these ideas met with unanimous acclaim. Could it be that the mythology of the serpent was ultimately rooted not in the internal world of the mind, but in the external world of nature? Did human imagination weave its elaborate 'dragon lore' around a sensory template supplied by prototypes in the natural world around us?

In recent years, geomythologists have pointed out that many cultures interpreted local fossils as the ossified or petrified remains of mythical beings, including dragons. Perhaps it can further be surmised that these people or their ancestors identified the living forms of such entities with other natural phenomena, notably in the sky. Across the globe, people have recognised snakes or dragons in certain bright phenomena in the sky, typically arched or elongated in form and transient in nature. In particular, the Milky Way, rainbows, comets, lightning flashes and polar lights have often attracted ophidian metaphors. This will now be illustrated with reference to one specific manifestation of the mythical serpent – the *ouroboros*.

Historical overview

The generic term *ouroboros*, sometimes Latinised as *uroborus*, is Greek for 'tail-eater'[1] and refers to the image of a snake, usually circular, whose head touches its tail, as if to consume it. The *ouroboros* appears in many different contexts. Combined evidence from anthropology, archaeology and the history of literature, art and religion shows that the image was once known on all inhabited continents, enjoying particular popularity at latitudes between the equator and 30° north. The ancient Egyptians incorporated it into their mortuary literature as an aspect of the sun. Magicians engraved it on amulets during the Roman Empire. The Chinese carved it into jade discs; people in Amazonia, New Mexico and Arizona painted it on pots; and indigenous Australians painted it on bark. To the Maya and the Aztec it was the feathered serpent Cuculcán or Quetzalcóatl, to Vikings the malignant Miđgarđsormr, to Hindūs the Nāga or Ananta, and to Jews the sea monster Leviathan. Alchemists saw it in their vessels, astrologers in the zodiac, and sailors in the ocean. A Greek biographer regarded Alexander the Great as its embodiment. The Irish Saint Brendan encountered it during his legendary sea voyage. The German Romantic Goethe put it to allegorical use. And the French archaeologist Champollion discovered it engraved in the ruins of Philae, in Upper Egypt.

On current knowledge, the earliest attestations of the term *ouroboros* are in the *Greek Magical Papyri* (second century BCE to fifth century CE).[2] Yet the theme of a tail-biting serpent itself boasts a hoarier antiquity. Perhaps the earliest example concerns a terracotta amphora of the Neolithic Yǎngsháo culture (5000-3000 BCE),

Illustration in pseudo-Cleopatra, *Chrysopoeia* (MS. *Marcianus*, 299 = 584 in Greek, 11th century, Biblioteca Nazionale Marciana, Venice, Italy, fol. 188 verso) ed. Berthelot 1885: 61 and print I, 1888: 132, 134, 196

discovered at Gāngǔ (in China's Gānsù province).[3] This depicts a snake-like creature with its head approaching its tail, that is suggestive of 'the incipience of the dragon motif'.[4] Early artistic examples on bowls and rings have also been found in south-western Iran and Egypt.[5]

The oldest textual attestation of a tail-biting snake is an imprecation in the Egyptian *Pyramid Texts* (c. 2300 BCE): 'Your tail be on your mouth, O *šnṯ*-snake!'[6] The descriptive term *sd m r₃* or 'tail in mouth' dates from the New Kingdom period.[7] Going by a variety of other names, including *Meḥen*, the tail-biter remained popular throughout Egyptian history.[8] It was primarily a cosmological symbol, closely associated with the sun, darkness, the 'underworld' and a circular 'ocean'. The sun god, Atum or Ra, is portrayed inside the dragon's coil, which was either the physical manifestation of the god himself or his antagonist – a gloomy and watery underworld from which the sun must liberate itself in order to produce the light of day and of creation as a whole.

During the Imperial Age, the tail-biting dragon was imported into the classical world from Egypt and Phoenicia as a magical icon. Magical spells composed between the third and fifth centuries CE and written on papyrus repeatedly prescribed charms presenting the *ouroboros* in a protective – perhaps subdued – attitude forming a ring around the sun god. For example: 'Helios is to be engraved on a heliotrope stone as follows: a thick-bodied snake in the shape of a wreath should be [shown] having its tail in its mouth. Inside [the circle formed by] the snake let there be a sacred scarab ...'[9] In the same tradition, magic gems were inscribed with the round snake enfolding the name of the tutelary genius, such as Abraxas, Anubis, Osiris, Horus, Iao, Khnum, Harpocrates or Serapis.[10]

The underworld connotations of the original *ouroboros* were preserved in Christian tradition.

John of Lydia observed that to the Egyptians the tail-biting dragon 'means the abyss and the serpent in it, whence according to them the material gods and all that can be known have issued forth.'[11] The Coptic text *Pistis Sophia* contained an eschatological scene in which 'the *disc* of the sun was a great *dragon* whose tail was in its mouth.'[12] The *ouroboros* is here a manifestation of the sun god, but in the same text Jesus is made to say 'The outer darkness is a great *dragon* whose tail is in its mouth, and it is outside the *whole* world, and it surrounds the whole *world*.'[13]

Traditional cosmologies situated the *ouroboros* as frequently in the underworld as in a circular ocean surrounding the earth, sometimes defining its boundary or supporting the earth and causing occasional earthquakes. The *Pyramid Texts* appear to invoke Osiris in this capacity.[14] In the *Acts of Thomas*, the apostle encounters the son of 'the serpent ... who encircles the globe ... who is outside the ocean, whose tail lies in his mouth ...'[15] In Jewish tradition, Leviathan 'grips his tail between his teeth and forms a ring around the Ocean.'[16] In Iceland it was held that the snake Miðgarðsormr 'lies in the midst of the ocean encircling all lands and bites on its own tail.'[17] The *Mahābhārata* tells how Brahmā instructed the snake Ananta to be 'encompassing all around the felly of the ocean.'[18] And the Kogi (Colombia) relate that Gaulčováng was the primordial ocean, 'the Great Mother, the origin of all things' or 'a huge black serpent that encircled the sea'.[19]

Mythical traditions just as frequently project the *ouroboros* in the sky as in the ocean, perhaps because to coast-dwellers the horizon seems to mark the boundary between the ocean and the sky. Thus the Shipibo-Conibo (Peruvian Amazonia) contend that Ronín, the 'great world boa', 'with its spiral body encircles the cosmos', yet surrounding the disc of the earth it dwells in the sea, 'at the aquatic edge of the world'.[20]

150

Illustration of the feathered snake on the interior of a yellow food dish, a culture from Tusayan, possibly the Kokop clan of the Hopi, Sikyátki, Navajo County, Arizona, US, 14th – 16th century, Collection: Smithsonian Museum, 155482. Fewkes 1898: 672-673, 672, figure 266, print CXXXIIa

Traditions touching on the colour pattern of the circular serpent often link the creature to the rainbow and lightning. For instance, in Australia's Northern Territory the famous rainbow serpent, called Borlung by the Ngalgbon people, could be represented in a circular form, with the head almost touching the tail;[21] and in Benin the snake Dã Ayidohwɛ do was compared to the rainbow, with echoes of a solar aspect.[22]

As for lightning, the luminosity of Leviathan was a commonplace in Judaism: 'The reflection of the Leviathan's fins makes the disk of the sun dim by comparison ...'[23] And the Toba Batak (Sumatra) defined Panē na Bolon as a mythical snake enclosing the earth, sometimes depicted in a head-to-tail position; he was 'the god of the underworld, of the sea and the lightning ...'[24] Specifically, Panē na Bolon presided over sheet lightning observed at twilight that was oriented towards one point of the compass and shifted with the seasons.[25]

As an engirdling band in the sky, the snake was often identified with the Milky Way. The Tewa (New Mexico) account for the origin of the Milky Way with the belief that Avanyu, a tail-biter issuing lightning from its mouth, 'threw himself across the sky';[26] and in Indonesia, the Buginese reported that the Nāga, seen as a buffalo, once ascended to the sky and turned into the galaxy.[27]

In the Graeco-Roman world, the ouroboros's function in marking the perimeter of the universe received a more sophisticated definition as a reference to a band along the surrounding sphere of the cosmos, such as the celestial equator, the zodiac or the ecliptic. Horapollo ascribed the interpretation of the ouroboros as the surrounding 'soul of the universe' to the Egyptians.[28] Macrobius attributed a similar interpretation to the Phoenicians, 'as a visible image of the universe which feeds on itself and returns to itself again.'[29]

From Late Antiquity onwards, the ouroboros's association with the outer shell of the cosmos was extended to the notion of time, especially the year, clearly because of the apparent diurnal revolution of the fixed stars and, perhaps, the role of the sun. Servius referred the linkage of the ouroboros and the year back to the Egyptians: 'For according to the Egyptians, the year was indicated before the invention of letters by the image of a dragon biting its own tail, because it returns to itself.'[30]

The ouroboros was further associated with the planet Saturn,[31] presumably because the Greek word for time, chronos, was strikingly similar to Kronos, the name of the god associated with Saturn since the Hellenistic period. Saturn's sphere was held to be the highest of all planetary spheres and the closest to that of the fixed stars. During the Middle Ages, the ouroboros emerged as an emblem in the right hand of Saturn, identified with the year. It was Martianus Capella who first described Saturn in this way.[32] The ouroboros retained its link with Saturn even

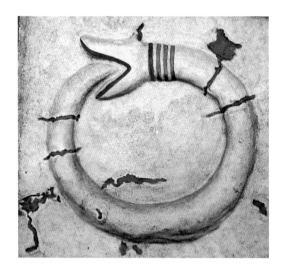

Bas-relief adorning King
Gezo's palace, Abomey,
Benin, 19th century.
Waterlot 1926: print IX.A

in its common application as a book printer's icon during the sixteenth and seventeenth centuries.[33]

The dictionary definition of the *ouroboros* as a symbol of physical and temporal unity, expressing such abstract concepts as union, completion, continuity, stability, cyclicity, eternity, immortality and infinity,[34] seems to be rooted in the alchemical connection of the circular snake with a union of the 'beginning' and the 'end'. For example: 'Agathodaemon, having placed the original principle in the end, and the end in the original principle, affirmed it to be that serpent Ouroboros …'[35] The circularity of the snake also conveyed the cyclicity of the alchemical 'Work'.[36]

In a way, the alchemical *ouroboros* even appears to have opened the door to the modern science of organic chemistry. In 1865, the German scientist August Kekulé discovered the molecular structure of benzene (C_6H_6) – a closed ring of six carbon atoms, with alternating single and double bonds. The circular structure first occurred to Kekulé during a daydream: 'But look! What was that? One of the snakes had seized hold of its own tail, and the form whirled mockingly before my eyes.'[37] As Kekulé had been thoroughly familiar with alchemical imagery, his vision is

best explained as a case of phosphene-induced cryptomnesia – a 'forgotten memory' resurfacing in the form of floating particles seen on the retina.[38]

Explaining the *ouroboros*

To make head or tail of this extraordinary diversity of expressions is a vexing task indeed. None of the phenomena associated with the *ouroboros* can explain the motif on their own; the image does not spontaneously impress itself upon anyone viewing the horizon, the perimeter of land and water, the Milky Way, the ecliptic, rainbows or lightning. Yet these associations do suggest that the theme was inspired by some sort of remarkable natural phenomenon.

Transient optical meteorological phenomena, such as haloes and diffraction discs, provide a compelling explanation for 'historical' observations of the tail-biter when it is wrapped around the sun. For example, on 26 June 1873 two citizens of Fort Scott, Kansas, recorded this unusual appearance of the rising sun: 'The sky was clear, and the sun rose entirely unobscured. When the disk of the sun was about half way above the horizon, the form of a huge serpent, apparently perfect in form, was plainly seen encircling it, and was visible for some moments.'[39] If this referred to a halo at sunrise, the impression of a 'serpent' may have been reinforced by a 'sun dog', common in low-altitude haloes, serving as a head. Moreover, as the Laki volcano in Iceland had begun to erupt on 8 June that year, releasing large amounts of gases, the halo may well have been enhanced by aerosols. Such Bishop's Rings differ from ordinary haloes in their sizes and their diffuse forms, producing a wavy outline that resembles the coils of a snake.

When observed at night, the *ouroboros* may be traced to observations of the aurora. Again, historical sightings can be distinguished from

A homogeneous double band aurora, as seen in Churchill, Manitoba, Canada (before 1963). Petrie 1963: print XXVI, likely to be based on a photo by the Defence Research Board, Canada

more purely mythological ones. The former are illustrated by a vision experienced by Isaiah, assistant to the Syrian bishop Theodoretus of Cyrrhus (d. 457 CE): 'As soon as the singing of the psalms began, I saw over where those villages stand a serpent of fire gliding through the air from West to East. After praying three times, I saw it once again, coiled in a circle, so that its head was joined to its tail. I recited more prayers and saw that it had divided into two parts and dissolved into smoke.'[40] In keeping with the spirit of the time, Theodoretus interpreted the snake as the dragon from the *Apocalypse of John* and its eventual evaporation as a portent foreboding the downfall of the heretical Marcionite sect, against which he was campaigning. Nevertheless, the account reads like a straightforward report of an auroral curl. As a parallel, the Norwegian Arctic explorer Fridtjof Nansen witnessed a display on 18 October 1894, in which the aurora 'wound itself like a fiery serpent in a double coil across the sky': 'Thence it turned off with many windings in an easterly direction, then round again, and westwards in the form of an arch … the phenomenon lost something of its brilliancy, dispersing little by little, leaving merely a faint indication of an aurora in the southern sky.'[41]

Circular or not, the aurora has often been compared to a snake. An auroral hypothesis

would readily explain a large number of properties ascribed to the *ouroboros*. The dazzling, lightning-like radiance attributed to the creature matches the luminosity of the aurora; the aurora is frequently portrayed as a 'nocturnal rainbow', owing to both its array of colours and its common appearance as an arc suspended over the horizon; the *ouroboros*'s function as a delimiter of the underworld explains the 'dark segment' often noted between an auroral arc and the horizon, and dovetails with the widespread Arctic belief that the aurora consists of spirits; and the intimate link between the *ouroboros* and the sun in Egypt recalls the frequent description of the aurora as a 'night sun', especially apposite with respect to a corona, when countless rays converge towards the magnetic zenith.

The commonly held idea that a typically polar phenomenon such as the aurora could not possibly account for a global theme such as the tail-biting snake is based on a popular misunderstanding. The aurora *does* occur worldwide, but its frequency decreases with latitude. On exceptional occasions, extreme disturbances of the earth's magnetic field spawn low-latitude aurorae, the so-called *aurora tropicalis*.[42] The aurora has appeared within 30° of the equator at least ten times since the famous Carrington Event of 1859 alone.[43] Even the most

spectacular form, the corona, has at times appeared a long way from the poles. The Sterno-Etrussia geomagnetic excursion was an especially active episode that occurred between c. 800 and c. 600 BCE.[44] During this time, the geomagnetic dipole inclined more than 10° towards the east and increased more than 40% in strength, suggesting a higher incidence of the aurora in the Near East. If anything, the rarity of the aurora at lower latitudes would have enhanced its ominous and magico-religious significance.

The mythology of the *ouroboros* is embedded in a wider framework of archaic cosmology and creation mythology. Aside from its intricate connection with a surrounding ocean and a disc-shaped earth, some traditions situate the entity at the foot of the *axis mundi* or around four pillars at the cardinal points. The creation of the world repeatedly serves as the narrative backdrop to the animal's defeat in combat and its 'banishment' to the nether regions of the cosmos. Surprisingly, this interlocking of motifs can be preserved on the assumption of an enhanced aurora. Just as each century brings one or two instances of extreme aurorae, unusual geomagnetic storms may be scaled up to an order of millennia. The intensity of a geomagnetic storm is modulated by the output of plasma – or ionised gases – from the sun. What would happen in the case of an extreme solar outburst?

Whirls of an electron beam of 90 kilo ampere on a carbon witness plate, etched, Los Anamos National Laboratory. Thanks to H. Davis

The American plasma physicist Anthony Peratt found that an increase in electrical current between the sun and the earth would cause the plasma in the earth's magnetosphere to organise itself in the form of a 'diocotron instability': a rotating hollow sheath separating into filaments like ribbons suspended from a ring. The *ouroboros* materialises as a cross-section of the revolving rim of the plasma sheath when observed bottom-up.[45] This model also accommodates a large number of other motifs familiar from traditional cosmologies.

Scientists continuously refine techniques to identify extreme geomagnetic storms in the past. Nitrates trapped in ice cores are reliable – and datable – indicators of solar energetic-particle (SEP) events, which accompany coronal mass ejections and trigger auroral storms.[46] Based on this and other evidence, the American physicist Paul LaViolette concludes that 'a super-sized solar proton event' signalled the end of the Pleistocene era, exterminating the megafauna of that time.[47] If correct, the event would undoubtedly have entailed a series of auroral displays dwarfing anything seen today. Was the *ouroboros*, or any other form of the mythical dragon, a part of the displays? Until interdisciplinary science can provide a definitive answer, it remains a mystery – but one that will continue to rear its ugly head.

Real snakes

FRANS ELLENBROEK

Snakes are highly interesting from the point of view not only of anthropology, mythology and history of art but also evolutionary biology, for a remarkable number of evolutionary principles and mechanisms can be seen in their structure and variety of forms. This, together with the malevolent characteristics that have always – unfairly – been ascribed to them by humans, makes them an extremely fascinating group of creatures.

Few animals have such a bad press as snakes. People have never been fond of crawlers. The more vertical animals look, and the more they match the image we see in the mirror, the more we tend to like them. Our aversion to creatures that do not resemble us is universal, and probably due to a combination of upbringing and genetically implanted preferences. Animals with too few legs (snakes), too many legs (spiders, centipedes) or too low a forehead (camels) strike us as weird or creepy. Two legs – just like us – is best, as is an appealingly high forehead, if necessary simulated by a crest of hair or feathers (parakeets, parrots). We also have a weakness for penguins, meerkats and quadrupeds that can stand on their hind legs – and if they cannot do so of their own accord, we can always train them with the help of dressage (horses) or circuses (bears).

This is not an area snakes can score points in. They may occasionally be encouraged to rear up more or less vertically by a snake charmer's rhythmical movements – but not by his flute-playing, for snakes are as deaf as dormice (actually, dormice aren't deaf at all, but that's another story). And their unprepossessing foreheads and slippery movements – features identified in the iconography of crime as typical

of robbers and other lawbreakers – do nothing to help.

Kindly gestures, friendly winks and modestly lowered eyes are all alien to snakes, for they lack both limbs and eyelids. And even though only about a third of the 2,500 known species of snake are in any way poisonous, this is the first thing that comes to mind when we think of snakes. Their venom helps them kill and digest their prey, and keep enemies at bay. In the fierce ritual struggle between two male rattlesnakes, however, this vicious weapon is not used.

The first snake to be mentioned in a biblical context, seriously damaging the reptile's image, is a familiar one. The idea that the cunning creature tempted Eve to eat of the forbidden fruit is highly implausible, and was surely made up by the first and most famous of sinners. Fruit means nothing to snakes – they are all carnivorous. Eve was simply putting the blame on the creature that humans hate the most.

Amusingly, palaeontologists have traced the first snakes back to approximately the same region, the Middle East – but 140 million years ago, at the start of the geological period known as the Cretaceous. Finds from Lebanon and Israel point in this direction. Although we can see from the anatomy of certain groups (such as the giant snakes) that they are descended from lizards, there is still disagreement among biologists as to the origin of snakes. This shows – once again – that palaeontologists find it just as hard as archaeologists to interpret finds, for they never have more than a few pieces of the jigsaw puzzle. Since both sea-dwelling mammals (such as whales) and reptiles (ichthyosaurs and mosasaurs) had a tendency to lose their

superfluous legs, it was still thought in the nineteenth century that snakes first developed in the sea. Although fossil snakes with vestigial hind legs seemed to suggest that snakes were descended from terrestrial lizards, the most recent find again indicates that they first appeared in water, for it displays features of the swimming mosasaur, a creature from the Cretaceous resembling a monitor lizard.

Not every snake-like animal is in fact a snake. Well-known examples are the slowworm (a lizard), the earthworm (a worm) and the eel (a fish). This jumble of names makes clear just how grateful we should be to Linnaeus, who brought order to chaos by devising the nomenclature we

use to this day (although not in this article). Resemblance due to very similar ways of life rather than genetic proximity is the result of 'convergent evolution': the creature adapts its form to similar circumstances through natural selection. Convergence is the opposite of radiation, a phenomenon that ensures species richness and diversity through a process of adaptation to differing circumstances. As we will see in a moment, this is something snakes know all about.

Wherever people have a need for unrestricted flow along a flexible path, they make use of snake-like devices known as hoses: air hoses, garden hoses, fire hoses and so on;[1] and flexible

Mounted Python molurus bivittatus. c. 340 cm. Collection: C.N. Klijn

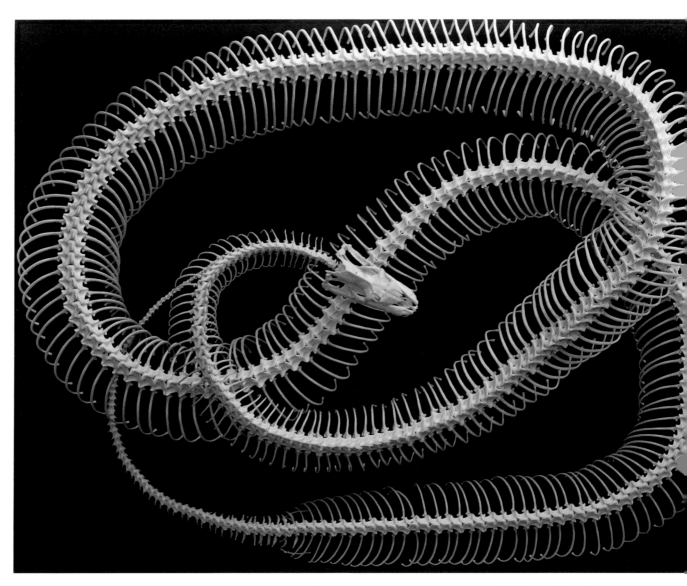

Python molurus
bivittatus. Collection:
C.N. Klijn

flow has always been at the top of the
evolutionary agenda for the creatures belonging
to the group (sub-order) of reptiles. Snakes are a
perfect example of how evolution causes animals
to get rid of any parts of their bodies that have
become superfluous, or indeed inconvenient, in a
new or altered environment (a process known as
reduction). Legs, a pectoral girdle and a rigid
ribcage would merely get in the way, so they
have all gone. Unlike us and most other
creatures, snakes evidently perceive no
advantage in being able to store their urine,

for they have no bladders either. Many snakes
have just one very long, thin lung and so are
unable to expand their chests, something that
can lend other predators an aura of nobility.
They also have no eyelids, which explains their
frighteningly unwavering stare.

Are there any parts of their bodies that snakes
have more of, rather than fewer? Certainly. Their
number of vertebrae ranges from 180 to 435
(humans have just 33 or 34); and, like lizards, the
males have two penises (although they only use

one at a time). They are thus free to choose whether to enter a squirming female from the left or the right (from the rear is more awkward, for the tail gets in the way). And their most notorious extra features, of course, are the venomous fangs found in some families of snake.

Snakes swallow their prey whole, without choking. They can do this because the various segments of their skulls – which in humans have completely fused – are mobile, allowing them to open their throats very wide. Also, because their prey can temporarily interfere with their air supply (by compressing the windpipe), they have an extra air sac behind the lung. Whereas in other vertebrates food is propelled through the digestive tract by the muscles in the intestinal wall, in snakes this is mainly done by the muscles in the body wall.

Snakes that crush rather than bite their prey to death, such as various types of giant snake (pythons, boas and so on), have also – partly because of our need for heroic tales and horror films – done considerable harm to the snake's reputation. Only a handful of the many kinds of giant snake – some pythons, and the notorious anaconda – are really able to crush a human being to death, and there is little documentary evidence of such incidents. However, one place they do occur is the Orinoco delta, where adult humans have been attacked and eaten by anacondas.

The great species richness that is still found in snakes is, geologically speaking, fairly recent. The Miocene ('less recent period'), which extended from 23 to 5 million years ago, was a time of great radiation (growth in the number of species). In the case of snakes this was associated with the spread of small mammals and amphibians, which are most snakes' favourite prey. The result was specialisation and immense species richness.

Snakes are thus, in evolutionary terms, a very successful group of creatures, whose cultural image has made them sympathetic or unsympathetic, but in any case immortal.

The snake and the sun: elements of ancient Egyptian magic

MAARTEN J. RAVEN

We will begin with a story. Preserved on an approximately 3000-year-old papyrus scroll at the Egyptian Museum in Turin, it tells how the goddess Isis became so powerful.
All the gods feared the creator of the cosmos, the sun god Ra. But Isis cunningly discovered his secret name – and thus gained power over him.

The goddess had resolved in her heart to find out the exalted god's name. Each day he appeared at the head of the crew [of the sun ship], seated on the throne of the horizon. The old god's mouth was slack, and his spittle dribbled onto the ground. Isis kneaded it together with the earth that was clinging to it, and shaped it into a sacred snake, which she gave the appearance of a pointed object. It did not move, even though it had come to life in her presence. She left it at a crossroads which the god always passed so that his heart might dwell in his Two Lands [Egypt]. The exalted god came outside with the palace gods following behind him, and set forth just as he did each day. Then he was bitten by the sacred snake; the living fire burst out from him, even wreaking devastation among the trees. The exalted god cried out, and the sound of His Majesty's voice carried up to heaven. The Ennead [the nine primal gods] said 'What is this? What is this?' And his gods said 'What ails you?' But he could longer use his mouth to reply. His lips were

quivering and all his limbs were shaking. The poison had seized his body, just as the flooding Nile seizes everything in its path ... Then Isis said to Ra 'Divine father, tell me your name. If you are to live, you must be invoked by your name!'

Even the creator of the world, Ra, was defenceless against the snake, for it had been kneaded from his own spittle and so contained something of his own magic power. The end of the story was that Isis got her way: she learned Ra's secret name – in which all his magic power was concentrated – and could use it to counter-act the snake's poison. And now that she knew his name she could also perform many other kinds of magic.

This story contains many elements of ancient Egyptian ideas about the snake, the mysterious creature that could spring forth spontaneously from earth and moisture. The Egyptians believed that the creator god appeared as a snake in the primal water – the source of all life. He was then usually known as Atum, another manifestation of Ra. Live snakes were therefore worshipped and mummified snakes were buried at temples to Atum. Snakes were clearly primitive creatures, and must therefore be a primal form of life. According to another Egyptian creation story, the sun was created by four snakes and four frogs, and only then did creation begin. But snakes also lived in holes in the ground; a common ancient Egyptian name for certain kinds of snake was 'son of the earth'. So snakes had knowledge of the underworld beneath them. This meant they were messengers from the afterlife and could guide human souls on their journey there. Snakes also guarded the realm of

Stele Isis, Osiris, Canopus and serpent, Egypt, limestone, 46 x 37 x 10.5 cm. Collection: Dutch National Museum of Antiquities, Leiden, F1960/9.1

Snake mummy, Egypt, linen, 22 x 8.4 x 5.8 cm. Collection: Dutch National Museum of Antiquities, Leiden, AMM 16p

Statuette of
Hermanubis, Egypt.
Collection: Allard
Pierson Museum,
Amsterdam, 7972

Amduat vignettes,
Egypt, papyrus, 23 x 38
cm. Collection: Dutch
National Museum of
Antiquities, Leiden, L.I.1
sheet 5

Book of the Dead, Ra,
Egypt, papyrus, 22 x 45.5
cm. Collection: Dutch
National Museum of
Antiquities, Leiden, AMS
15 sheet 1

Book of the Dead,
Qenna, Egypt, papyrus,
36.5 x 45.7 cm.
Collection: Dutch
National Museum of
Antiquities, Leiden, SR
sheet 14

the dead, which not everyone could enter
without permission.

Snakes were the perfect symbol of eternal life.
In shedding their skins, they seemed to abandon
their old living form and be reborn. One of the
snake gods that could grant humans eternity was
called 'the lord of life', and another snake-like
creature that looked after the dead and provided
them with food was 'he who enhances the life
force' (*Nehebkau*). It is surely no accident that
the hieroglyph for 'eternity' (*djet*) was a snake.
The sun god, whose power was restored in the
underworld at night, was protected while he was
there by 'the coiled one' (*Mehen*), and just
before sunrise he passed through a snake's body
in order to be rejuvenated. And the whole
cosmos was encircled by the snake Ouroboros,
who bit his own tail and therefore had no
beginning or end.

At the same time, the story points to some
sinister aspects of snakes. Since they lived on or
even under the ground, they were the natural
counterparts of the sun god, who was associated
with light and heaven. Every night a huge snake
called Apep (known in Greek as Apophis)
threatened to devour the sun, and this malign
power was sometimes manifested even by day,

in the form of a raincloud that concealed the sun
from view – a very rare occurrence in Egypt. Each
day, to assist the sun god, Egyptian priests stood
on the roofs of the temples spitting on, piercing,
trampling and burning 'snakes' made of
beeswax. Apep was also dreaded because he had
the 'evil eye': snakes did not blink, and people
were instinctively afraid of their unwavering
gaze. In fact, to withstand Apep you needed an
equally searing gaze – which Ra luckily had, for
on top of his head was the radiant solar disc, the
celestial god's Eye of the Sun. In Egyptian
mythology, this combination of disc and eye was
often thought of as Ra's daughter, and many
goddesses (including Isis) were associated with
it. These goddesses could all be depicted as
snakes, and even the generic word for 'goddess'
could be written in the form of a snake.

The goddess was therefore also shown as a
rearing snake on Ra's forehead, or else coiled
round the solar disc. This was the *uraeus* (in
Egyptian *iaret*, 'the rearing one'), the cobra with
its head raised and its hood spread menacingly.
A cobra could spit poison and thus (just like the
sun) blind its adversary – a truly dangerous
ability possessed by some kinds of cobra that
still live in Egypt. The *uraeus* also appeared on

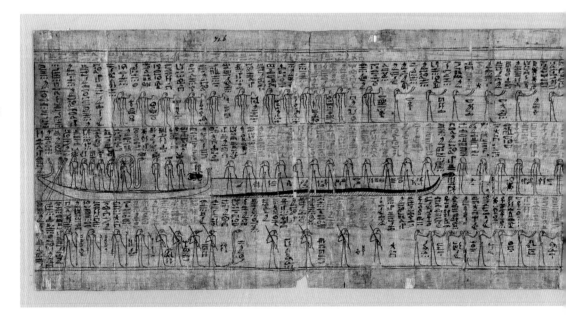

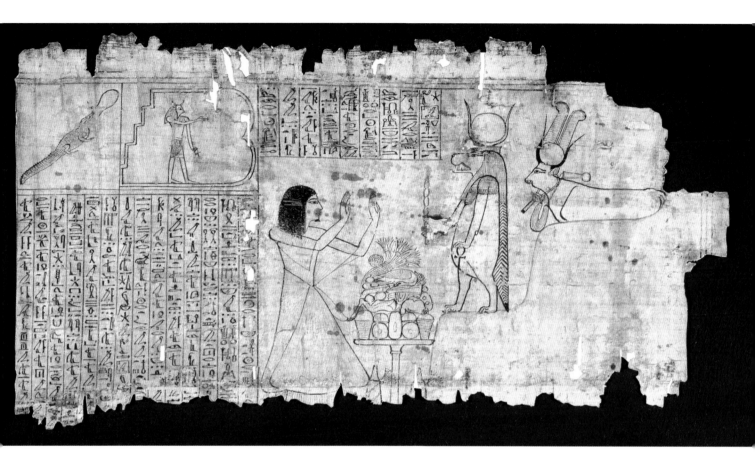

the foreheads of other Egyptian gods, as well as that of the pharaoh, who – as the 'Son of Ra' – was allowed to wear this emblem. It was therefore a feature of all Egyptian crowns, usually made of gold and inlaid with coloured stones, symbolising the snake's glistening skin and the splendour of the sun.

Ordinary Egyptians lack such protective power, and snakes are a great threat to them. There are no fewer than 34 kinds of snakes now living in Egypt, and in ancient times there were even more. Some of these were highly poisonous, and they must have claimed many victims each year, especially as they felt at home in the fields and even in people's houses. It was not only Ra that was powerless against them; the ancient Egyptians had no real cures for the extremely painful, paralysing bites. Medical texts often mentioned them, but mainly sought the remedy in magic spells. These were often written on miniature sculptures of the youthful god Harpocrates (Horus the Child), who had supposedly been attacked by snakes and scorpions and survived to tell the tale: Greetings, o Horus, son of Osiris, born of the goddess Isis! I utter your name, I recite your magic spells, I speak with your powerful words … Now that you are steering the ship of the gods, come swiftly to protect me from the lions of the

desert, the crocodiles of the river and the snakes in their lairs. Make them as motionless for me as the stones in the desert and the potsherds in the alleyway. Remove for me the fierce poison that has penetrated the body of X, son of Y. May he be rescued from evil by the power of your words.

A more effective remedy was to have the venomous creature tracked down by a professional snake charmer. Such experts are still employed in Egypt; in ancient times they were known as 'charmers of Serket', after the scorpion goddess (also known as Selkis) with whom they were particularly associated. The Egyptians also believed they could perform magic, like doctors and purveyors of magic texts and other amulets. And there was yet another remedy: rather than think of snakes as enemies

Statuette, Egypt, copper alloy, 7.6 x 3.2 x 3.7 cm. Collection: Dutch National Museum of Antiquities, Leiden, AB 70a

Votive statuette of snake, Egypt, clay, 9 cm. Collection: Dutch National Museum of Antiquities, AT 103c

Votive statuette of Isis, Egypt, terracotta, 19 cm. Collection: Dutch National Museum of Antiquities, Leiden, AED 123

Stele Agathodaimon, Egypt, material, 54.5 x 30 cm. Collection: Allard Pierson Museum, Amsterdam, 7795

Bes with snake, Egypt, material, 45.5 x 33 cm. Collection: Allard Pierson Museum, Amsterdam, 7762

and hence, as it were, provoke their attacks, it made more sense to worship them as protectors of the home. Snakes were thus often considered *agathodaimones* (Greek for 'benevolent spirits') and depicted as such on household altars. Harvests and fertile fields were seen as gifts of the snake goddess Renenutet, who in turn was closely linked to one of the manifestations of Isis (Thermuthis) – clear proof of the Egyptians' ambivalence towards snakes. It is hence not surprising that magicians often had wands in the form of a coiled snake, which gave them power over life and death.

Snakes: South-East Asia

DAVID VAN DUUREN

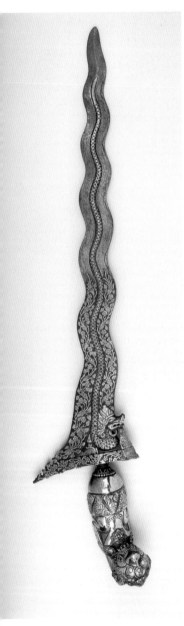

Kris, Java/Indonesia, iron, nickel, silver, gold, 50 x 10 x 4 cm. Collection: Dutch National Museum of Ethnology, Leiden, 031863

Some years ago an Indonesian man came to the reception desk at the Tropical Museum in Amsterdam wanting to find out more about his *kris* knife. The man, who spoke flawless Dutch and looked like a cosmopolitan businessman, introduced himself as a European representative of the Indonesian airline Garuda. He said he was more often to be found at his employer's European branches than at the company headquarters in his home city of Jakarta; and he added that he was even starting to lose touch with Indonesia. Over a cup of coffee he cautiously produced a rather ordinary-looking *kris*. The model and the detailing were typical of Central Java, and the blade had seven 'waves' from base to tip. Nothing special, by the look of it – there were several almost identical knives in the Tropical Museum's storeroom. As the museum employee was counting the waves in order to identify the type of *kris*, the visitor remarked that Dutch scholars who had studied Indonesian *kris* knives in the past had often described such blades as *geslangeld* ('serpentine'). He turned out to be very familiar with the most famous publications on these weapons, and he kept mentioning their *geslangeld* character. When asked how long he had owned this particular specimen and where he had got it from, he told a brief story in more or less the following words:

'When I was about ten years old and still living with my parents in my native village, I kept pestering my father for a *kris*. He told me I was much too young for one and would have to wait till I was a *really* big boy. But I kept on at him, for I was determined to have my very own *kris*. Eventually he got tired of my constant nagging, and one day he took me to a *dukun* and told him how desperately I wanted a *kris*. The *dukun*

listened, then decided that I was evidently ready for one, even though I was so young. He used a divining device to choose the right night for us to go to the cemetery outside the village. Go to that scary cemetery in the dead of night? I was terrified, and my father wasn't keen either, but the *dukun* said we had to go. When my father and I arrived at the silent, lonely cemetery later that week, we had no idea what we were supposed to do; we simply followed the *dukun*, who was walking round slowly in the darkness as if looking for something. It was really creepy, and I stayed very close to my father. Suddenly the *dukun* stood stock still and peered at a grave. And there, right beside the grave, was a snake winding its way out of a hole and slithering towards us. "Quick," the *dukun* whispered to me, "grab it behind the head." But I was terribly scared and didn't dare to. "Hurry," said the *dukun* again, "grab it quickly or it'll be gone. Don't be scared! I thought you wanted to be a big boy...." So I stepped forward quickly, suddenly noticing that this was my grandfather's grave, and grabbed the snake behind its head. But it wasn't a snake at all. It was a *kris* – the one you are holding right now. I always have it with me, I sacrifice to it each day, and it protects me day and night.'

At that point the museum learned more from this man – who had not lost touch with Indonesia after all – than he learned from the museum. The incredible story of his *kris* includes nearly all the features that are associated with snakes. In Indonesia, and especially on the islands of Java and Bali, where this symbolism is richest, the *kris* is the classic symbol of the snake. The now outdated term *geslangeld* as a description of a wavy blade refers to the local belief that a *kris* with such a blade symbolises a moving snake

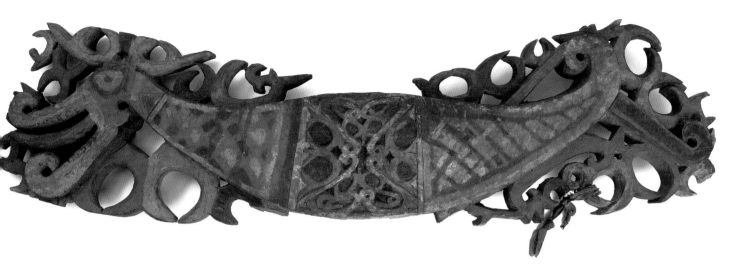

Statue, *Pragden*, Alor,
Nusa Tenggara
Timur/Indonesia, wood,
22 x 80 cm. Collection:
Tropenmuseum,
Amsterdam, 1772-2246

Shadow figure, *Wayang
purwa*, Bali, parchment,
54 x 23.5 cm. Collection:
Tropenmuseum,
Amsterdam, 15-954-72

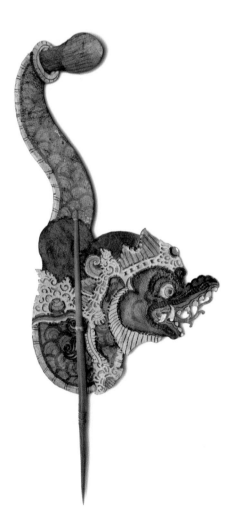

(whereas a straight blade indicates a snake in a state of meditative repose). The distinguished serpentine *kris* worn by prominent men actually includes a figurative depiction of a snake; its head is clearly forged on the front of the blade, and its scaly body, often decorated with gold, winds in elegant curves towards the tip of the knife, which is its tail. On this *kris naga sasra* the snake is depicted as a *naga*, just as it came to Indonesia from India along with Hinduism many centuries ago: a semi-divine dragon-like creature adorned with a crown and jewels like a prince. It has a diamond in its gaping mouth, for in ancient Indian mythology *nagas* live in underground palaces and guard the riches that are stored in the earth.

This brings us to the notion of the snake as a chthonic creature, an 'earthly' animal that hugs the ground and lives in holes. As the classic earthly creature, it symbolises the ground and the depths, and in the Indian mythical system it is the opposite of the eagle, the king of the birds and the classic dominant creature of the air. The eagle is the arch-enemy of poisonous snakes, but together, as each other's antithesis symbolising heaven and earth (which are interdependent), they form the entire cosmos. The Indonesian *kris*

Horn, *Naga* Padoha, Toba, Sumatra/ Indonesia, horn, wood, 50 x 63 cm. Collection: Tropenmuseum, Amsterdam, A-3931

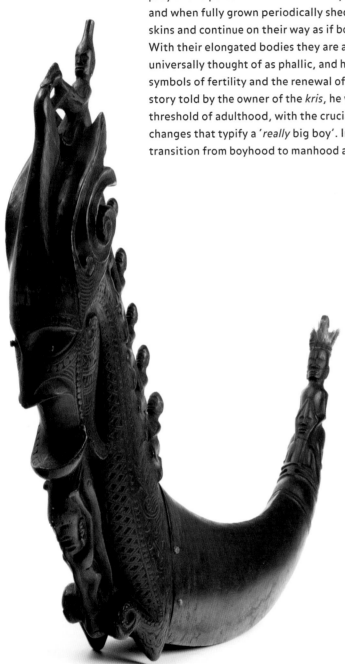

with its snake-like blade not infrequently has a handle in the form of an eagle: Naga the snake and Garuda the eagle.

Snakes are remarkable creatures. They have no legs, hatch from eggs just like birds, kill their prey with a poisonous bite or a deadly embrace, and when fully grown periodically shed their skins and continue on their way as if born anew. With their elongated bodies they are almost universally thought of as phallic, and hence are symbols of fertility and the renewal of life. In the story told by the owner of the *kris*, he was on the threshold of adulthood, with the crucial physical changes that typify a '*really* big boy'. In their transition from boyhood to manhood all Javanese

boys are circumcised, and in the past they were also given a *kris*, which could be seen as a phallic symbol, especially if the handle was a stylised figure halfway between a standing man and an erect penis. In becoming a man, the boy had shed his skin like a snake and was embarking on a new stage of his life. The boy was also the next link in the chain of the generations, as symbolised by the snake crawling out of the grandfather's grave.

Throughout Indonesia the snake plays a major role as a creature associated with the organisation of the cosmos. This is partly a legacy of the snake tradition imported earlier from India, and partly a reflection of local popular belief. Among the Batak of Northern Sumatra, the all-powerful supreme being *Mula Jadi na Bolon* has various manifestations, one of which is *Pane na Bolon*, a giant snake that is believed to live in the womb of the earth (the underworld) and to support the world of humans (the middle world) with its body. When this god of darkness stirs in anger, he causes storms with thunderclaps and bolts of lightning, earthquakes and floods. But the snake also has a friendlier manifestation called *singa naga*, a dragon snake with a kind of lion's head that is frequently displayed in architecture and the visual arts. The great *adat* houses of the Batak, like other traditional Indonesian family houses with their threefold structure, are often thought of as models of the entire cosmos. The two *singa* heads flank the veranda of the dwelling area in the cosmic house, the 'middle world', and guard and protect the occupants. The wooden covers of priests' medicine books (*pustaha*) often have a dragon-like snake guarding the secret contents, as do the large wooden boxes (*hombung*) in which precious family possessions such as jewels and fabrics are kept. Here the snake performs the same task as the classic *nagas* that guard the treasures of the earth.

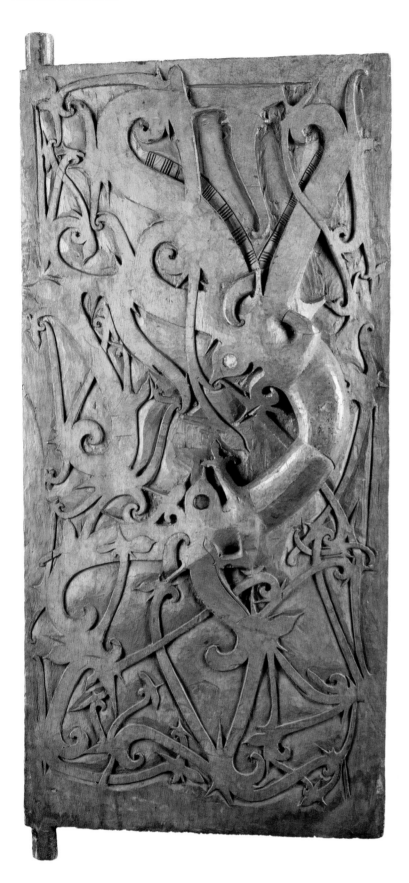

As the creature symbolising fertility and periodic renewal, the snake remains associated with the underworld. Among the Dayak of Borneo and elsewhere in Indonesia, it appears on cloths used to cover coffins, and as a water snake it becomes a vessel that conveys the dead to the 'other side'. It is depicted in this fashion on fabrics from Southern Sumatra and in drawings from Borneo. Its association with the progression of the stages of life is shown by the tree of life that forms the mast on the ship of the dead. In other Indonesian illustrations of the snake's body, the creature is overgrown with branches and leaves. Sometimes it is completely covered by them, for instance on the small Moluccan island of Alor, where in some cases it has almost ceased to be recognisable as a snake. It has been taken over by the fertile, vegetative aspect.

Door, *Betamen,* Kayan, Kalimantan Barat/ Indonesia, wood, 100 x 46 cm. Collection: Dutch National Museum of Ethnology, Leiden, 1219- 209

Snakes: Oceania

DAVID VAN DUUREN

In Oceania, and above all Melanesia, the snake is again a mythological creature with a dual nature. On the one hand it is a symbol of fertility, and hence continuity of life; on the other its actions can be extremely destructive, and it is associated with violence and transience. In various places, as a renewer of life, it plays a part in the initiation of boys as they are ritually guided to a new stage in their lives. Along the coasts of Cenderawasih (Bird of Paradise) Bay in north-western New Guinea, which were strongly influenced by the cultures of the eastern Indonesian archipelago, a large braided snake with a gaping mouth used to appear during the ceremony – the initiation demon that 'devoured' the boys and so brought their childhood to an

end. Men danced in a line that made sinuous movements like the body of a snake, symbolising the mythical time in which the primal snake swallowed all but two people. The creature was eventually killed by a surviving old woman, and then became a canoe in which the second survivor, a young child, was able to paddle its way to land. Human life thus began anew.

In many mythological tales, from New Guinea to Fiji, snakes are conquered and destroyed by humans, and humans, animals and plants come forth from their bodies. Their heads also emanate power. According to tradition in various parts of Melanesia, coconuts (an important local foodstuff) grow out of a buried snake's head. In all these stories, snakes play a leading part: a symbolic death that always generates new life.

In Melanesia, snakes are associated with fertility. In the mythical time they roamed around giving people unfamiliar new crops, methods of cultivation and magic techniques that encouraged growth. However, they are still unpredictable creatures that have to be treated with caution. The fertile rains that they send, and that are crucial if garden crops are to thrive, can change into devastating floods that wash away all the plants. The existence of local cults to prevent this shows just how precarious life can be when it is dependent on the whims of nature. The Arapesh, a people living in the basin of the River Sepik in Papua New Guinea and made famous in studies by the American anthropo-logist Margaret Mead, are convinced that spirits dwelling among rocks and in swamps sometimes appear as striped, two-headed snakes. These are somehow connected with the origin of the landscape and people's living habits, and hence have the status of mythical creators and

Divination statuette, Bird's head culture/Ayu islands, wood, 39.5 x 21 x 21.5 cm. Collection: Wereldmuseum, Rotterdam, 28294

Suspension hook, Sawos, around 1940, wood, 116.5 x 38 x 20 cm. Collection: Wereldmuseum, Rotterdam, 52425, photo: Erik Hesmerg

Suspension hook, Latmul, Sepik/Papua New Guinea, wood, 89 x 25 cm. Collection: Tropenmuseum, Amsterdam, 2670-34

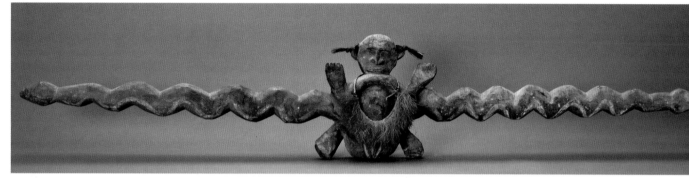

Statue, Maprik, wood,
207 x 38 cm. Collection:
Wereldmuseum,
Rotterdam, 51720

Ancestor figure, *Korwar*,
Doreh bay, Papua Barat/
Indonesia, wood,
35.5 cm. Private
collection, Netherlands

benefactors, but they fanatically guard their own specific hunting grounds and the domains that belong to them. They are aggressive towards intruders and are especially dangerous to pregnant women, in whom they can cause miscarriage or stillbirth. But women have magic of their own to fight them with – menstrual blood, which the snakes are powerless to withstand. They can still cause quakes, landslides and floods; but there is a story that an old Arapesh woman survived a tidal wave because she refused to eat part of a water snake that had been killed by her fellow villagers. She was amply rewarded, for her fertility was restored in the sense that her body henceforth produced yams, a great boon to the group of people which whom she took refuge. Here again, fertility and food followed in the wake of death and disaster – the snakes were not all bad.

But in New Guinea snakes are also associated with actual death. Round Cenderawasih Bay, a dead person's soul or spirit was believed to descend into a *korwar* – a carved sculpture of the person – during certain rituals. In this way the dead could be consulted or asked for help if this was necessary to avert war, disease or natural disasters that threatened the survival of the community. One striking feature of these figures (which were depicted either standing or sitting) was the openwork ornament that some standing sculptures held before them, as if they were behind a balustrade. This ornament did not seem to serve any purpose, especially not as a shield

(though it has often been described as one), since the open arabesques offered no protection to the person depicted behind them; moreover, the person was often a woman, and women do not carry shields. In some cases the figures were shown holding a single snake, or a pair of them, behind the head. The snakes were quite clearly depicted; but in other sculptures they dissolved into symmetrical curls with a reptile's mouth, or sometimes with no mouth at all. Just one step further in this direction and there was no longer any discernible trace of a snake. Yet it may be assumed that a depiction of the snake was the starting point for this type of carving, which throughout western New Guinea displays elaborately carved and painted curvilinear patterns whose original meaning is obscure, but which were undoubtedly once inspired by snakes and vegetation. Snakes and death are a combination found throughout the western Pacific. The small wooden snakes that are made along the River Sepik are said to symbolise the ancestors and in some cases house their spirits. They do good things for the whole community and are therefore looked after carefully in the men's houses, lest they become angry.

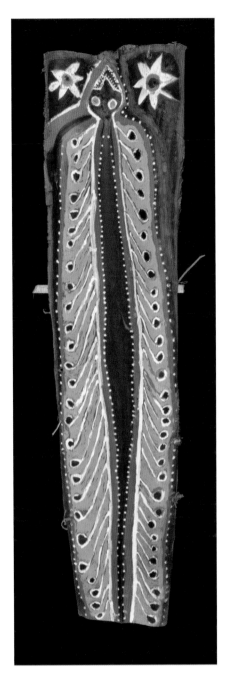

Panel, Abelam, East
Sepik/Papua New
Guinea, sago palm leaf
stalk, 22 x 50 x 143 cm.
Collection: Dutch
National Museum of
Ethnology, Leiden, 5526-
385-24

Panel, Abelam, East
Sepik/Papua New
Guinea, Sago Palm Leaf
Stalk, 20 x 32 x 165 cm.
Collection: Dutch
National Museum of
Ethnology, Leiden, 5526-
385-22

Panel, Abelam, East
Sepik/Papua New
Guinea, sago palm leaf
stalk, 142 x 50 x 8 cm.
Collection: Dutch
National Museum of
Ethnology, Leiden, 5526-
385-33

'Casting ahead serpent-fashion'[1] – the Rainbow Serpent in Australia

GEORGES PETITJEAN

The Rainbow Serpent is one of the commonest ancestral beings in Australia. This mythical serpent can be found throughout the Australian continent, and there are many stories about it in the Aboriginal culture. It is associated and sometimes even identified with the rainbow, but is also connected with water in the form of rain, rivers and water holes. As a symbol of fertility it is both the father and mother of all life, and as such is a link between humans and nature. As a supreme creator being, the Rainbow Serpent can also be manifested in destructive ways – especially when humans violate the laws or the land, of which snakes are often considered the guardians. Rainbow Serpents are therefore frequently found in art.

The Rainbow Serpent as the supreme being

The term 'Rainbow Serpent' was coined by the British anthropologist and founder of modern social anthropology, Alfred Radcliffe-Brown.[2] During his field work in Australia in the 1920s and 1930s, he came to the conclusion that, despite regional variations, Aboriginal language groups throughout Australia seemed to have one particular mythical creature in common. Various myths – usually referred to as 'Dreamings' – tell of a serpent of sometimes gigantic proportions, with exceptional powers and both creative and destructive abilities. The serpent is sometimes manifested as a rainbow, and is responsible for creating the landscape, for the naming and singing of places, and for swallowing, devouring or in some cases drowning people. In general, the Rainbow Serpent is identified with fertility.

The Rainbow Serpent occurs in various forms, and interpretations of it, as well as its name, vary from area to area and people to people.[3] It is impossible to define the Rainbow Serpent, let alone provide a clear visual image of it. Sometimes it is described as single, sometimes as multiple, sometimes as male, sometimes as female and sometimes as both, as a snake, another animal or a human being, and sometimes as a fusion of various creatures. Besides various kinds of snake, crocodiles, lizards and amalgams of these and other kinds of animal can be referred to as Rainbow Serpents. The roles and powers of these creatures, whose common feature is that they can be manifested as rainbows, also vary considerably. A rainbow is evidence that the mighty Rainbow Serpent is present and is rearing up from the water holes where it dwells.

Strikingly, the Rainbow Serpent is able to transfer magic powers to certain individuals, who can then act as healers in the group or cause rain to fall. One place where this is so is the Cape York peninsula in northern Queensland, where traditional healers among the Wik-mungkan receive their healing powers from the Rainbow Serpent, known locally as Nganwi.[4] In other cases, however, the serpent will punish people. Among the Kunwinjku of eastern Arnhem Land, the *marrkidjbu* or 'clever men' (ritual specialists) derive their powers from Ngalyod, the Rainbow Serpent. Ngalyod, who is then described as a great sea monster with the strength of a hurricane, sends cyclones as punishment.[5]

The Murinbata, who live some 485 kilometres west of Port Keats on the north coast of

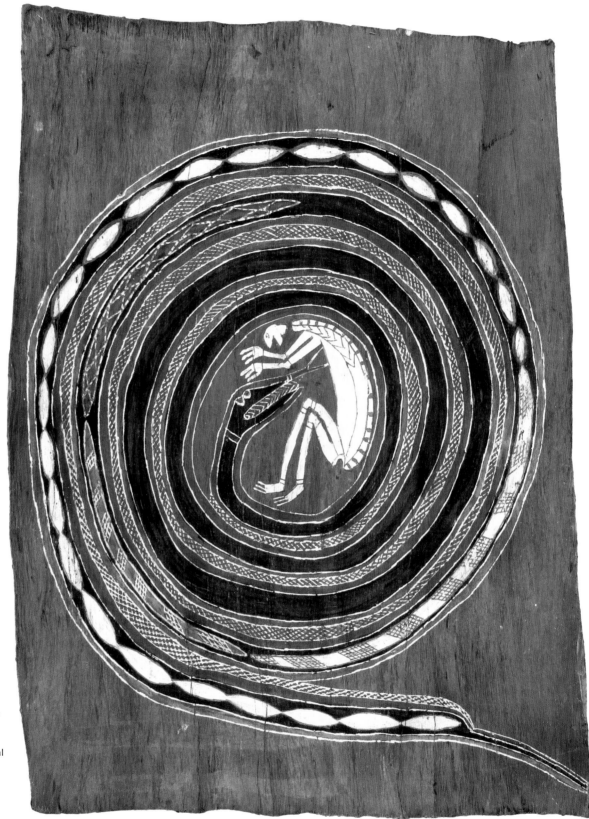

Bark painting,
probably produced
by Yirawala,
depicting the giant
snake Nowyran
biting a child that
has misbehaved.
Northern Territory,
Australia, 76 x 55
cm. Before 1966.
Collection: National
Museum of
Ethnology Leiden.
4138-1

Australia, know the Rainbow Serpent as Kunmanggur. It is thought of as a huge man with superhuman powers, and is described as the 'First Man' who created all human beings. His spit was the rainbow – an image found in ancient rock paintings.[6]

In north-eastern Arnhem Land the Rainbow Serpent is known as Yurlunggur, or 'Great Father'. Yurlunggur is associated with one of the most important myths or Dreamings in the area, particularly the creation story of the Wawilak sisters (as they are called by the Kunwinjku of western Arnhem land – in the Yolgnu languages of eastern Arnhem Land they are known as the Wagilag sisters). The Wawilak sisters are among the main artistic themes in Arnhem Land.[7] During the creation time, two women camped with their sons near Yurlunggur's water hole. One of the women accidentally polluted the water with her menstrual blood. An infuriated Yurlunggur rose up from the depths and drew the water with him, causing a tidal wave across the earth. He devoured the women and their two children, and regurgitated them. This process was repeated several times until only the boys were left. Eventually the mothers were regurgitated and turned into stone. The spirits of the Wawilak sisters would later pass the songs and dances on to the men, who performed them in their rituals.

Yurlunggur's voice was thunder, his tongue was lightning and the rainbow was his body. Every year this meta-totemic creature sent the monsoon from the north-west to flood the earth again and again. In various parts of Australia, the Rainbow Serpent is seen as a transcendent symbol or ruler of nature, and hence directly or indirectly forms the basis for the law and religious customs.[8]

The Kunapipi cult of northern Arnhem Land (where Kunapipi is another name for the Rainbow Serpent) is the most powerful and dramatic of the four major initiation rites associated with Yurlunggur. In this ceremony the Rainbow Serpent supposedly swallows and then regurgitates the newly initiated. The image of swallowing and reviving is used to describe both ancestral creation and the main rites of passage in the human life cycle.

In southern Arnhem Land, however, Kunapipi is associated with the concept of a primal mother, a kind of mother goddess or 'mother of everything', also known as Karwadi.[9] This shows that the Rainbow Serpent possesses the generative powers and even the organs of both sexes.

The Rainbow Serpent as an androgynous creature

The Rainbow Serpent can be said to possess properties that combine the main activities of the male and female reproductive organs in a single creature. In many stories the serpent devours things and people, but in some cases regurgitates them as a metaphor for rebirth.

In the western part of Arnhem Land the Rainbow Serpent is known as Ngalyod. In an essay entitled *The Rainbow Serpent as a Visual Metaphor in Western Arnhem Land* (1990), Luke Taylor comments that the Kunwinjku people of western Arnhem Land use the word 'rainbow' to describe two different creatures. Yingarna is the original creating creature, and has androgynous qualities. Sometimes the Kunwinjku refer to it as 'Mother One', but sometimes it is claimed to be a man. Yingarna has given birth to all the totemic ancestral beings and placed them in their respective clan lands.[10] Ngalyod is Yingarna's son, but both creatures are described as bisexual or androgynous. They are both typically represented as a combination of elements from various animals or plants. Yingarna's chest is sometimes said to be filled with water, so that it can produce water. Ngalyod, on the other hand,

is the creator of the seasons. If the weather is good, this is because he is satisfied and content.

Various local myths tell of the creation of a particular place by an ancestral being that was swallowed at that place by a Rainbow Serpent. The idea of devouring and regurgitating is associated with the idea of rebirth, and refers to an act of transformation and creation of the place in question.[11] The ancestral nature of such places is thus synonymous with the Rainbow Serpent and its power.

To the Unambal of western Australia, the Rainbow Serpent is also a bisexual creature, called Ungud, who is assisted in creating the world by the Milky Way galaxy.[12] Ungud is an archetype of life itself and is directly responsible for the existence of all life, including that of humans. All natural species arose because Ungud dreamed himself into their various forms.

A connection between human sexuality and the bisexuality of the Rainbow Serpent can also be seen in ritual practices. In ritual subincision of the male penis, the urethra assumes the form of the vulva, so that the male genitals symbolically assume the bisexuality of the Rainbow Serpent and thus, as it were, themselves become a Rainbow Serpent.[13]

In one particular Dreaming among the Warlpiri language group of central Australia (the Lajamanu community), the serpent quite clearly symbolises maleness. The story tells of a battle between two snakes which assume male traits during the Dreaming, and the Rainbow Serpent emerges victorious. This specific story is sometimes told in connection with another very important Dreaming that is associated with women. In this story, an older man's penis penetrates the earth, continues growing underground and then rises up through the ground in a place where women happen to be dancing or digging.[14]

Given these androgynous qualities and the bisexuality of the Rainbow Serpent, it is striking that the rainbow flag is nowadays used as a symbol by lesbian, gay and bisexual communities the world over.

Recent manifestations of the Rainbow Serpent: the Rainbow Serpent as the universal reconciler

Ever since Radcliffe-Brown, a very extensive and detailed literature on the Rainbow Serpent has developed in Australia, from the scientific to the popular. Roland Robinson's *The Feathered Serpent* (1956) was probably the first to introduce the subject to a wider general readership.[15] It is scarcely surprising that, as a creature that appeals strongly to the imagination, the Rainbow Serpent has also made its appearance in European popular literature, including children's books. However, this has led to vulgarisation and generalisation of the concept of the mythical serpent.

Recently the Rainbow Serpent has also been the subject of exchanges between Aboriginal religions and Christianity, which was introduced among the Aboriginal population during the colonisation of Australia. The Rainbow Serpent remains a popular choice for Aboriginal authors seeking universal indigenous religious symbols. This is notably the case with a group of Aboriginal leaders known as the Rainbow Spirit Elders. Their text *Rainbow Spirit Theology: towards an Australian Aboriginal Theology* attempts to integrate Aboriginal cultural traditions into Christianity.[16] This implies that the Rainbow Spirit, as they call the Rainbow Serpent, prevails throughout Australia as a single well-defined mythological entity, as often described by Radcliffe-Brown. However, recent authors have dismissed this notion of a uniform Rainbow Serpent that occurs in all Aboriginal cultures as an anthropological fiction.[17]

All this attention has brought the Rainbow Serpent into the public eye, and it is used by Aboriginal organisations to draw attention to the unity and shared ideas of all Aboriginal people in Australia (whether they come from cities or remote areas). For example, the Australian pavilion at the Brisbane World Expo 88 included a Rainbow Serpent Theatre with Aboriginal performers from the cities. The scenery was a painting of the ubiquitous Rainbow Serpent by Kunwinjku artist Ivan Namirrki.

A Rainbow Serpent Festival has even been held in the south-east Australian state of Victoria, starting in 1997. This is mainly known as an open-air psychedelic trance music and minimal techno festival, but it also includes an 'art and lifestyle village' with 'spiritual education' and relaxation and healing workshops. The explicit use of the name 'Rainbow Serpent' is a direct and deliberate – but not always justified – reference to Australia's Aboriginal population. According to the festival website, 'the name Rainbow Serpent is distinctly Australian, coming from the Dreamtime creation story told by the traditional owners of the land.'[18]

As a reconciling symbol of unity, the Rainbow Serpent regularly makes it into the media. In the Upper Yule River area of north-western Australia, for example, it was mentioned by opponents (Aboriginal and non-Aboriginal alike) of local uranium mining. The Aboriginal people of Arnhem Land believe that the power of uranium is itself derived from the Rainbow Serpent.[19] Any attempt to mine underground material could disturb the serpent's sleep and cause it to take devastating revenge.

Yet the Rainbow Serpent is not always acknowledged as a universal Aboriginal symbol. There is a notable instance of an Aboriginal artist specifically choosing *not* to use it. Apart from his firm Christian belief in God as the sole creator, his reason for doing so was that the serpent had been co-opted by New Agers and other groups as a creating creature for the whole of Aboriginal Australia.[20] However, even such ostentatious rejection of the serpent's iconography may still be a kind of acknowledgement.

The Rainbow Serpent as the creator and source of inspiration of art

The rainbow was, and still is, frequently depicted in art. Rock paintings, which are the oldest surviving art form in Australia, go back at least eighteen thousand years. About ten thousand years ago the sea level rose and the coast shifted inland. Marine fauna and flora made their appearance in the iconography of the rock paintings of Arnhem Land in north-eastern Australia, and Rainbow Serpents and other ancestral beings associated with water also appeared for the first time. Such depictions of Rainbow Serpents are often found near water or caves in which they supposedly dwell.[21]

In the eastern Kimberley region of north-western Australia, the Rainbow Serpent represents a fascinating combination of destructive power and initiation of artistic output. In fact, this area was the scene of a dramatic event that indirectly led to the Rainbow Serpent becoming the basis for contemporary local art.

On Christmas Eve 1974, Australia's tropical northern city of Darwin was devastated by Cyclone Tracy. This was interpreted by Aboriginal people in the area as a warning to stop neglecting their traditional law and associated rituals. As the guardian of local customs, the Rainbow Serpent had sent a cyclone during the rainy season to destroy this local bastion of European civilisation. 'Lawless' city life, with high rates of alcohol consumption and other temptations, had prevented many Aboriginal people from fulfilling their duties. This episode in the recent history of Aboriginal

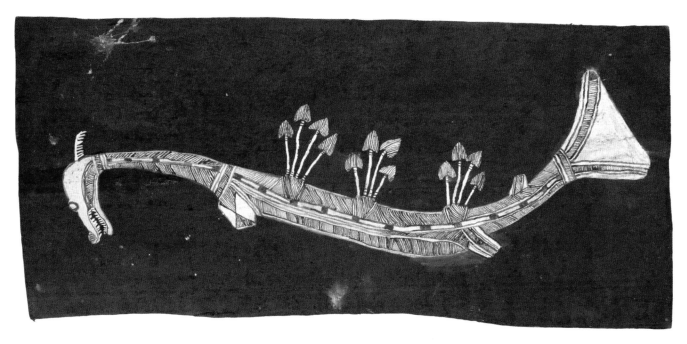

Lofty Bardayal
Nadjamerrek, *Ngalyod II*,
2005, ochre pigments on
bark, 52 x 114 cm.
Laverty Collection,
Sydney

art shows that the Rainbow Serpent is still very much present and plays an active part in current events.

Some time before, as a premonition of what was to come, there was a car crash hundreds of kilometres west of Darwin. An elderly woman who had been injured during the accident, which was supposedly caused by the Rainbow Serpent, died in the plane that was taking her to hospital in Perth, and her spirit travelled back through the Kimberley to her place of origin in the Dreamtime (*Ngarranggarni* in the Gija language).

These events, and the visit by the dead woman's spirit, led a Kukatja-Wangkanjunga man called Rover Thomas (1926-1998) to compose a new public dancing ceremony called the 'Gurirr Gurirr' cycle. This was a reconfirmation of the law, and hence could ward off the Rainbow Serpent's anger. When the ceremony took place, large painted panels were carried round on the dancers' shoulders. The visual idiom on the panels became a key element in contemporary painting in the Kimberley.

In 1990, Rover Thomas and Trevor Nickolls were the first Aboriginal artists to represent Australia at the Venice Biennale. Innovation in tradition and art, for which the Rainbow Serpent was ultimately responsible, drew the international art world's attention to contemporary Aboriginal art.

The coloured landscapes painted by Ginger Riley Munduwalawala (c. 1937-2002) from Ngukurr, a settlement to the south of Arnhem Land, often include a manifestation of the great serpent Garimala in the land. Garimala, often depicted in a flamboyant red colour, is usually shown creating water holes. As well as the creator of the land, Garimala is the guardian of customs.

Garimala, a taipan snake, is often described as two creatures and depicted as two mirror-image or paired snakes. According to Riley, Garimala travelled from a spectacular range of hills called the Four Archers to the Nyamiyukanji site in the Limmen Bight river.[22] There the snake disappeared under water, only to re-emerge from the water as a rainbow. As a rainbow, Garimala is associated with the life-giving properties of freshwater and the rainy season.

In another metamorphosis, Garimala turns into Bulukbun, an evil fire-breathing dragon snake with a mane of protruding scales.[23] In some paintings Riley shows the snake pursuing a group of young initiates that had disregarded the prohibitions and restrictions imposed on them. The youths were eventually consumed by the monstrous dragon snake's fiery breath.

The Rainbow Serpent in the art of Arnhem Land

However, it is in Arnhem Land that the Rainbow Serpent is most evident. This area of Australia's tropical north extends across large, open rocky plateaus to the west, as well as tropical rainforest. This area, where the earth is flooded by the monsoon year after year, is a particularly suitable dwelling place for the Rainbow Serpent, which is ubiquitous and stands at the beginning of all creation in the area. The Rainbow Serpent therefore occurs frequently in the art of Arnhem Land.

In this area, particularly the western part of it, the Rainbow Serpent first appeared in rock paintings some three to six thousand years ago. Ngalyod, as the serpent is known in the local Kunwinjku language, has various manifestations in local art. This is because Ngalyod is sometimes described as the mother of all ancestral beings,[24] known as djang. The Rainbow Serpent contains the creative energy of all creatures, and hence is associated with almost every place in the landscape. Remarkably, the elongated figure of the giant python also includes features of other animals.

The iconography of the ancient rock paintings can still be seen in contemporary bark paintings. There are numerous scenes in which the Rainbow Serpent has a crocodile's teeth, a kangaroo's head, an emu's chest, a snake's body, a barramundi's tail (a barramundi is a tropical fish)

and even water lilies on its back. Strikingly, there are also features of the recently introduced water buffalo, such as horns. These depictions emphasise Ngalyod's changeable nature and great potential for transformation. Some depictions actually show a blend of features of the landscape, especially water holes, and features of the Rainbow Serpent. The message is clear: there is a causal link between the topography of the landscape and the Rainbow Serpent's creative power. According to Taylor, works of art containing the Rainbow Serpent express the notion that, despite many differences, all life is ultimately interrelated.[25]

The task of painting the most powerful ancestral beings, such as the Rainbow Serpent, is mainly left to older, more experienced artists who have attained a high degree of initiation. The depiction may vary according to the artist's ritual clanship. Carefully executed cross-hatchings are designed to produce more than just a powerful optical effect reflecting the presence of ancestral powers – they also lend the object spiritual value.[26] In some depictions of the Rainbow Serpent, the subtly applied cross-hatching, which fills up the figures to create a powerful optical effect of shimmering brilliance, emphasises the vital presence of the serpent.[27]

The large canvas by the artist and film actor Charlie Djurritjini (Ganalbingu language, b. 1952) depicts Badayalamirri, the freshwater land which Karritjarr, the Rainbow Serpent, travelled through after devouring two brothers, their canoe and their fish in Burralkungarri. Karritjarr emerged from a water hole and exhaled a mist, creating a rainbow. Then he regurgitated the two brothers. The large water hole from which Karritjarr emerged, and where the regurgitated men awoke, was in another country called Gapu Nangutji. This country was full of long-necked turtles and water lilies (depicted in the right-hand half of the painting). Water lilies on the surface of the water point to the presence of the

Rainbow Serpent. The shoots that appear with the first rains indicate that the Rainbow Serpent is rising up from the water to heaven to make rain. The blooming of the water lily is associated with the way in which the Rainbow Serpent maintains the cycle of the seasons. Depicted in the left-hand half of the painting are Warrnyu, flying foxes, which are associated with the artist's clan (Gurrumba Gurrumba).

This painting, which is entirely filled up with figures and cross-hatching, is typical of the style of central Arnhem Land, where Yolgnu is a general name for the languages in the area.[28] All over the painting we see the serpent, which clearly takes up much of the composition. Rather than the action of the story, it is the land, the place where the action occurs, that is depicted. The land is saturated with the ubiquity and presence of its creator, the Rainbow Serpent. This powerful presence is emphasised by the water lilies and the rainbow, although these have the traditional palette of red, white and yellow rather than the usual colours.

The rainbow, as the personification of the serpent, is also found in the bark painting by

Mithinarri Gurruwiwi (Galpu, 1929-1976). The painting shows the Rainbow Serpent flanked by digging sticks that are used to till the earth and create water holes. It is associated with Wititj, the large serpent from the Dhuwa 'moiety' (half) of the Yolgnu people, which devoured the Wawilak sisters. Wititj, the Rainbow Serpent, is often depicted as an olive python. The background pattern belongs to the artist's Galpu clan and represents reflections on the surface of the water. Wititj brings the storms of the rainy season, with thunder and lightning. In the curve of the rainbow we can see *djaykung*, a file snake, with a swollen body full of eggs. The two digging sticks on either side of the rainbow refer to the Wawilak sisters, who were devoured by the Rainbow Serpent Wititj.

The cross-hatchings in Djambawa Marawili's visually very powerful and dynamic bark painting *Baraltja* are the sacred motifs of the artist's Madarrpa clan, and symbolise saltwater and fire. Baraltja is the dwelling place of Mundukul (also known as Burrut'tji), the lightning serpent. It is an area with extensive floodplains in the northern part of Blue Mud Bay on the north coast of Australia.

Charlie Djurritjina,
Basayalamirri, paint on canvas, 305 x 145 cm. Collection: Aboriginal Art Museum, Utrecht

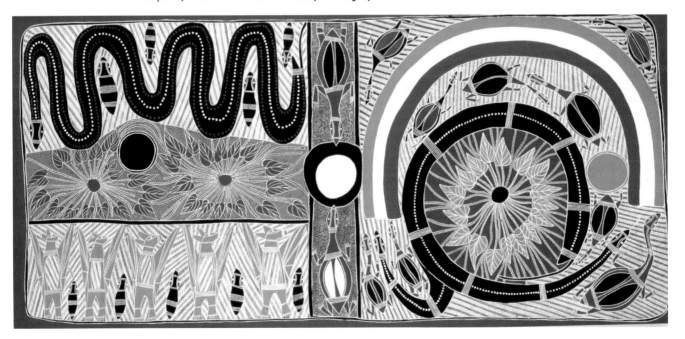

The ancestral lightning serpent Mundukul is often depicted near a water hole called Lorr. At the very start of the rainy season, Mundukul tastes freshwater. This excites the serpent so much that it stands on the tip of its tail to herald the new season by spitting lightning into the sky.

This painting primarily depicts the waters of Yathikpa, which flow from the floodplains across the land and past the sacred manifestations of

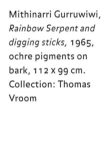

Mithinarri Gurruwiwi, *Rainbow Serpent and digging sticks,* 1965, ochre pigments on bark, 112 x 99 cm. Collection: Thomas Vroom

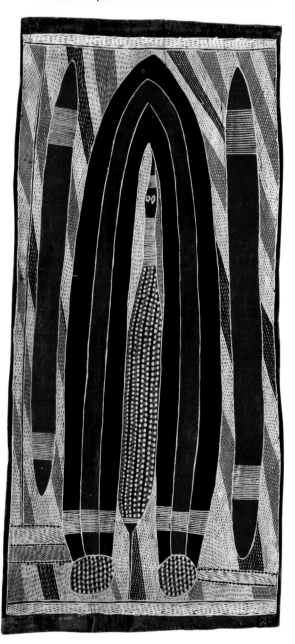

the serpent Mundukul to the sea. Next to Mundukul, who is shooting bolts of lightning into the sky, we can see another serpent on the horizon – Wanupini, who sings. Wanupini is responsible for the bolts of lightning and the fertile storm clouds of the rainy season. Water is said to be permeated with fire, and finally returns to the coast of Baraltja as saltwater at high tide, or as freshwater brought by the rain that Wanupini has caused to fall.

The Rainbow Serpent, in all its many forms, is a bringer of water. The meeting of various waters, or kinds of water, is a common theme among the Yolgnu of north-eastern Arnhem Land. This meeting symbolises fertility. The tidal movements of seawater and the flow of the rivers – in short, all the various 'states of being' of water – are an integral part of the Yolgnu philosophy and are depicted in dancing ceremonies. A profound knowledge of the country includes knowledge of the behaviour of rivers, floodplains and the sea.

While spitting lightning into the sky in the painting, Mundukul uses this 'electric' language to communicate with other serpent ancestors that occupy similar positions throughout the area. The various areas and clans, and hence all human beings, are thus connected with one another.

Djambawa Marawili,
Baraltja, pigment on bark,
141 x 43 cm. Collection:
Aboriginal Art Museum,
Utrecht. 3662 R

Snakes and snake gods in Hindu India and Nepal

BEN MEULENBELD

The worship of snakes in the Indian subcontinent – both ordinary snakes and gods in part-animal, part-anthropomorphic form – goes back at least 3000 years. The Sanskrit word for snake is *naga* (male) or *nagi(ni)* (female). In present-day Hindi the word for snake is *nag*.

The most prominent of the snakes that are both feared and worshipped is the cobra. The characteristic feature of snakes belonging to the cobra group (such as the Egyptian cobra, the spectacled cobra and the king cobra) is their 'hood' – widening of the head caused by expansion of the cervical ribs when the snake rears up.

A divine *naga* is usually depicted with a snake's body and three, five or seven cobra hoods.

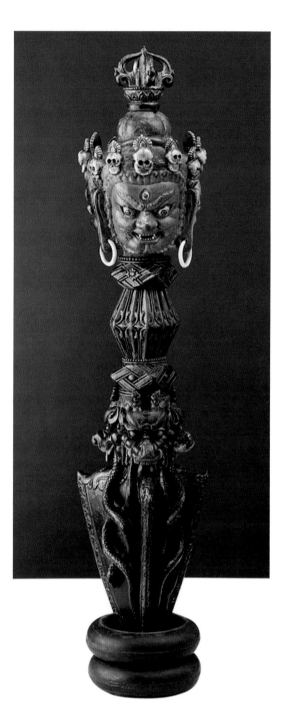

Mask, *Naga Rassaya*, Sri Lanka, wood, 61 x 28 cm. Collection: Tropenmuseum, Amsterdam, 2563-9a

Dagger, *Phurbu*, Tibet, 15th – 16th century, polychromed wood, bone, ivory 42 x 10 cm. Collection: Wereldmuseum, Rotterdam, on loan from Bodhidharma Foundation, V 315. Photo: Saskia Kars-Carel Cools

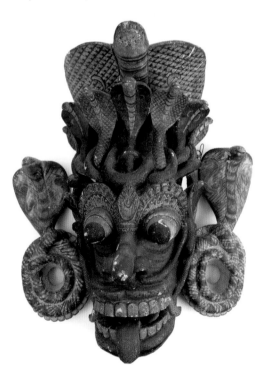

Greeting card,
Bihar/India, paper, 22.5 x
12 cm. Collection:
Tropenmuseum,
Amsterdam, 4877-1

Snakes live near water and in holes in the ground. They are seen as guardians of the waters. In Nepal, snakes are worshipped in the Kathmandu valley, where there was once a large lake with water snakes living in it. People ask them to ensure a good monsoon, with plenty of rain. In India and Nepal, snakes are associated with water and fertility. They also denote regeneration and reincarnation, since they die symbolically by shedding their skins, yet continue to live. This mysterious ability puts people in awe of them. They are believed to have supernatural powers, and are expected to provide protection or healing.

The association of snakes with water and rain, and hence with fertility, is apparent from the Hindu *Naga Panchami* festival, which is celebrated during the monsoon season, in July or August. People living in the Kathmandu valley paste pictures of *nagas* above their doors, and put small bowls of milk, rice and honey out in the fields as sacrifices to the snakes. If they did not do so, the snakes could become angry and use their powerful influence to stop the monsoon too early; the rice harvest would then fail, causing a famine. The festival is also an annual peace offering to compensate the snakes for the fact that their lake was drained long ago.

The snake has a number of ambivalent aspects. Anyone confronted with a poisonous snake will first try to drive it away; only in extreme cases will the snake be killed. Hindus living in houses with a poisonous cobra in the garden are often pleased about this, because the reptile brings good luck. They often put out food for it. A place where snakes are found sometimes develops into a temple, for instance near a long-venerated sacred tree with snakes living among the roots. Sacrifices of milk and eggs are made there.

In some parts of India, dead snakes are cremated just like human beings.

In the town of Shirala, in the Indian state of Maharashtra, many people set out a few days before the start of Naga Panchami to find and catch snakes, which are then put into terracotta pots. On the day of the festival, the pots, containing hundreds of snakes, are taken to the fields and overturned so that the snakes can crawl out and return to their lairs. The symbolism is obvious: terracotta pots are used to fetch and store water, and the overturned pots 'spill' their contents across the fields, with the escaping snakes as bringers of rain.

The dangerous aspect of snakes is particularly evident during the monsoon. The chances of

snakebite are greater then because the reptiles leave their flooded lairs. Farmers in the fields therefore run more risk of being bitten, especially at harvest time, for the snakes are harder to see among the dense crops than when the fields are bare. That is why the snake goddess *Manasa* is so widely worshipped in eastern India (including Bengal, Bihar and Orissa), where there has always been a great deal of agricultural land.

Manasa is worshipped because she is expected to provide protection again the dangers of snakes. She is depicted either in human form as a goddess protected by a multiple cobra hood or surrounded by snakes, or else abstractly in the form of a water pot decorated with snakes. Her depiction as a water pot associates her with fertility and life, and hence also with marriage and the desired result of Hindu marriage, which is childbirth. Her worship reaches its peak during the monsoon.

As with snakes, there are two sides to Manasa. She protects people against snake bites, but can also cause them. Given her association with snakes, it is understandable that people worship her by asking her to ensure fertility and prosperity. In addition, she affords protection

Poster of Nagas on the occasion of Naga Panchami, Kathmandu, Nepal. Photo: Ben Meulenbeld

Nagakals in Karnataka, Southern India. Photo: Ben Meulenbeld

against diseases such as smallpox and chicken-pox; but she can also cure them, something she has in common with many mother goddesses and with snakes, which can heal people, but can also cause diseases if their worshippers neglect them. The connection with healing is not confined to India. In ancient Greece, snakes played an important part in the cult of Asclepius, the god of medicine (from whom the physicians' emblem the rod of Asclepius is derived).

As already mentioned, snakes often live in holes and shafts in the earth, such as mineshafts – especially ones where precious stones are mined. Snakes that live there are seen as the guardians of hidden treasures. This explains why they are sometimes depicted with pearls in their mouths, or with crowns of precious stones on their heads.

Hindus worship many kinds of trees. Trees are the link between heaven and earth. They provide shade, freshen the local atmosphere, are often medicinal, produce nutritious fruits, are a source of fuel and building materials, are associated with fertility and symbolise growth and continuity of life. Tree spirits and snakes live in and around them. Particularly in southern India, *nagakals* – 'snake stones' – are placed beneath sacred trees. There are *nagakals* with single

snakes or two intertwined ones. Childless married women immerse the stones in water for a while so that they become impregnated with this life-giving element, and then place them round a tree.

Fertility and children are very important in India. Termite mounds also play a role in this. Termites only make their homes where there is water in the soil. They dig passages, creating mounds out of the excavated clayey earth. Snakes, with their predilection for cool cavities and damp places, move into these deep underground systems of passages. Through their connection with water and the 'womb' of the earth, snakes are again associated with fertility. In southern India, childless women sometimes sleep beside termite mounds at night, and chew clay that supposedly has medicinal and pregnancy-inducing properties. A *nagakal* may be placed next to the mound, and sacrifices of milk are made to the snakes living there. Some of the milk, fortified with the beneficial power of the *nagas*, may be taken home afterwards to be consumed there.

The Hindu god *Shiva* often wears a cobra as an ornament round his neck, wrist or belly. Just like snakes, Shiva is ambivalent. He is the god of destruction and death, but this also gives him the

Statuette, *Nagakal*, Madurai, Tamil Nadu/India, stone, 40.7 x 13.2 x 13.6 cm. Collection: Tropenmuseum, Amsterdam, 6226-58

Statuette, *Nagakal*, Madurai, Tamil Nadu/India, stone, 43.5 x 19.3 x 11.5 cm. Collection: Tropenmuseum, Amsterdam, 6226-59

Statuette, *Nagakal*, Madurai, Tamil Nadu/Indonesia, stone, 22.3 x 7.8 x 8.7 cm. Collection: Tropenmuseum, Amsterdam, 6205-31

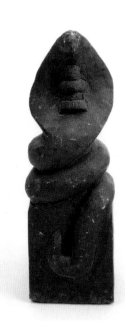

Print, 2003, India, paper, 29.7 x 43.6 cm. Collection: Tropenmuseum, Amsterdam, 6226-17

Colour litho depicting newly born Krishna being carried across the Yamuna river, India, 36.3 x 25 cm. Collection: Tropenmuseum, Amsterdam, 5752-14

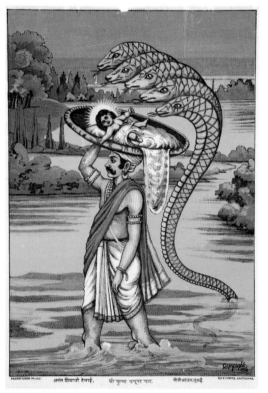

power of rebirth and life. He is mostly worshipped in the form of a *linga*, a phallic and fertility symbol. The *linga* may be protected by a *naga* spreading its hood above it, but may also be encircled by a snake

A similar duality is found in the other great Hindu god, *Vishnu*. Sun and water are both necessary for farming, for neither sun nor water on their own are enough to make crops germinate and grow.

Vishnu, the god of constancy and continuity, may be depicted either seated or reclining on the snake *Ananta*, who floats in the cosmic ocean. Ananta is the primal snake, the infinite one who was there at the beginning of creation and will also be there when a new cycle of time commences. Vishnu rides on the back of the sun eagle *Garuda*, who is often shown gripping his arch-enemies – snakes – in his talons or beak.

Painting, Orissa/ India, fabric, paint, 60 x 48.5 cm. Collection: Tropenmuseum, Amsterdam, 4816-139

Statuette, 1100-1200, Cambodia, stone, 36 x 30 cm. Collection: Tropenmuseum, Amsterdam, 1772-2378

Most *nagas* are found in Hindu iconography and mythology, but some also occur in Buddhism, which is derived from Hinduism. The most famous of these is the snake prince *Mucalinda*, who protected *Siddhartha* – the later Buddha – when he was caught in a persistent, devastating rainstorm during his meditation, which would lead to his enlightenment. Mucalinda reared up behind Siddhartha, spreading his cobra's hood above him like a protective umbrella.

The snake as the symbol of transition and transformation in Peruvian art

EDWARD K. DE BOCK

The Andes mountains on the west coast of South America were the birthplace of a completely independent civilisation. The Incas (1250-1532 CE), who lived in what is now Peru, were the final representatives of that cultural tradition, until their vast empire was so dramatically conquered in the sixteenth century by a handful of audacious Spaniards who brought the pre-Columbian period to a close.

Despite their high degree of sophistication, not one of the Andean cultures developed a formal system of handwriting. However, there was a registration system for the bureaucracy, in the form of *quipus* – bunches of knotted cords that were used to keep records of harvests and products. They also served as calendars, and to register the population's annual social activities. The Andean cultures can therefore be described as prehistoric in the sense that they themselves left no written sources. The Spaniards, in contrast, did write a good deal about their customs and the native religion – all the better to wipe out the old traditions and beliefs. Once the Inca nobility had learned the Latin script, they in turn wrote chronicles about the Inca civilisation at its height. In their view, only barbarians had lived in the days before the Incas.

Twentieth-century archaeologists identified many different cultures in the Andes, all of them unusually prosperous and intellectually developed. The Incas turned out to have inherited traditions that went back several thousands of years. Architectural finds and works of art point clearly to a single uninterrupted cultural development from 5000 BCE up to the time of the Incas. We find depictions of the same gods among Andean peoples from different periods. We also know for certain that their social organisation had the same main structure everywhere – one that survives in villages and small towns to this day. Their social organisation was recorded – perhaps covertly – in the religious art left in temples or in the goods that were buried along with the dead. The illustrations were codifications of society. Animals played a part in this – particularly the puma, the jaguar, the eagle and the snake.

In Inca society the snake was the symbol of transition and transformation. It was known as *amaru*, which the Spaniards translated as 'snake' and 'dragon'. The snake shared this transition symbolism with the puma and the jaguar. When the mythical king Pachacuti Inca Yupanqui came to power, his father the sun emerged from a spring clad in puma skins and snakes. Springs were places of transition, and furthermore it was a time of change. Pachacuti would overthrow the old hierarchy. He boastingly compared himself to powerful wild animals. These were revealed to initiates during rites of passage. As part of their initiation, the sons of the nobility had to compete in a race. The fastest runners were called eagles and pumas, and the slower ones foxes, snakes and toads. The same contrasts applied in the organisation of the empire. One example is Guaman Poma de Ayala, a prominent chronicler of noble Inca birth, who illustrated his work on the Inca state with hundreds of drawings. His European style was mainly borrowed from in-memoriam cards designed in Antwerp and sent out to Peru.

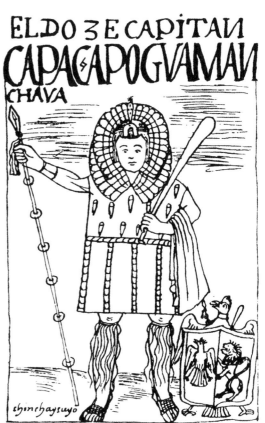

Drawing by Guaman Poma de Ayala (1615, 1616)

The Inca empire was divided into four sections called *suyus*. For the north-eastern section, Antisuyu (which included the Amazonian lowlands), Poma de Ayala drew a coat of arms with a horizontally positioned jaguar and snake, in contrast to a vertically positioned eagle and puma, drawn as a lion, for the north-western section, Chinchaysuyu (which included the Andes).[1]

In the Amazon region the snake had numerous meanings. It was a phallic symbol of fertility, as well as a cosmic creature that was depicted vertically as the link between the world above and below us. It was then the *axis mundi*, the cosmic axis. The Warao Indians believed that at the moment of the nadir or anti-zenith passage – the moment when the sun passed through the zenith on the other side of the world – the *axis mundi* was encircled by a huge four-headed snake with stag's antlers. This all-seeing monster's

heads looked towards all four points of the compass, and its writhing body supported the floating surface of the earth. Like many other peoples, the Warao believed in the notion of a three-layered world, with a sun bird at the top of a central tree and a snake at the foot of it. During the nadir and zenith passages, the *axis mundi* was a path linking humans and the supernatural creatures that lived in the space above, below and all round us. The cosmic snake could also rise up from the underworld through the central hole in the earth. It could likewise appear in the form of a woman sitting astride a fallen tree.[2]

The fact that the antlered snake still plays an important part in the lives of the Amazonian Indians is interesting in view of its ancient iconography, which dates back to the Moche culture (100-800 CE). The Moche culture flourished on the north coast of Peru. It is world-famous for the golden treasures of the Lord of

Sipán. This culture has left a legacy of finely painted pottery which documents its view of the cosmos and is our only source of information on this people's religion and rituals, with illustrations of gods, animals, plants and rites. Snakes are painted separately, and as parts of the clothing of gods and humans. The most striking feature is that they are always depicted with ears. Their heads are usually more like those of foxes, but with a forked tongue. Sometimes the ears are stag's rather than fox's ears, especially if the head is adorned with stag's antlers. This hybrid form is also found in the modelled pottery of the much earlier Cupisnique culture (1000-5000 BCE), which also flourished on the north coast of Peru. The figure below shows the flat snake's head with lidless eyes, a wide mouth with fangs that are more reminiscent of a puma, and two small ears protruding at the sides. To this day the puma and the fox are seen

Strombus monster figure

as related. They are often observed together by the carcase of an animal. In the local mythology of the north coast, the fox calls the puma 'uncle' (Spanish *tío*).[3] This indicates a hierarchical difference suggesting that the fox and the snake were lower in rank than the puma, and hence might be combined (e.g. a snake with fox's ears). This is in keeping with the Inca situation described above. There is no other information about combinations of other animals with the stag, or any basis for speculation on the subject.

In depictions of Moche gods, snakes appear in three interesting places: as hair, earrings and belts.Not only among the Moche but also in the Huari culture (600-1000 CE), gods or ancestors are depicted with snakes in place of hair. This does not mean the same as Medusa's hair in Greek mythology, but is a metaphor for water and fertility. The flowing hair symbolises streaming water. Furthermore, hair is 'dead' matter that grows back after it is cut off. This is similar to the regenerative powers of the snake, which appears immortal because it can shed its old skin. When the human body or the human-like body of a god is seen as a microcosm of the macrocosm, hair is a metaphor for the water that flows down from the mountain peaks (the head). This is a seasonal phenomenon, and so can easily account for the association with the snake shedding its old skin.

The snake-head earrings can really only be recognised as such by the forked tongues and lidless eyes. Only gods wear such earrings, never humans. This may mean that they serve to guard one of the most important body orifices: the ears. Ears are the point of transition for sound, and snakes are related to transition and connection. The gods also wear belts that end in two snakes' bodies. The belts clearly mark the boundary between the upper and lower body. As already mentioned, a god's body can be seen as a microcosm of the macrocosm. Defecation, symbolising a different world that stands in

Two boats with snakes' heads, Moche culture

Pot, Moche/Peru, pottery, 19.3 x 12.9 x 14.8 cm. Collection: Wereldmuseum, Rotterdam, 75658

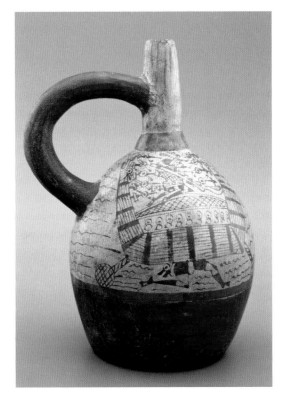

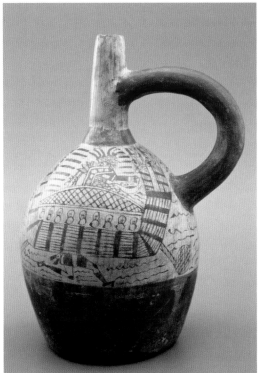

contrast to life and growth, and to the food that we put in our mouths above and that reappears below as death and foul odour, takes place below the belt. Yet this is also the location of the source of new life – the genitals. In the Andes the 'underworld', the world of the ancestors, is the source of fertility. Perhaps the two-headed snake belt should be seen as a symbol of this connotation: a clear boundary between two worlds, but at the same time a clear link between the source of fertility and the upper world.

The figure above shows a boat made of reeds, whose tips end in snakes' heads. These are in keeping with the symbolism of the boats that form a link between this world and that of the ancestors. The boat is like the crescent of the moon. The moon moves from east to west, but also from west to east, for it rises a little further east each day. On the boat are sacrifices of blood in jugs. Painted underneath the boats are legs in a running position.

Bowl, 250-400 CE, Nasca/
Peru, pottery, 7 x 10.4
cm. Collection:
Wereldmuseum,
Rotterdam, 30130

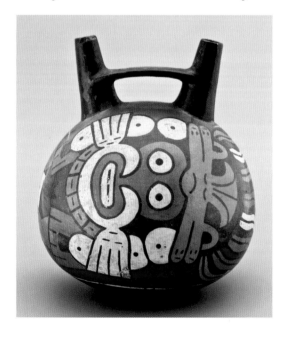

Another important culture that has left a legacy of richly painted pottery is the Nasca culture. This was contemporary to the Moche culture, between about 100 and 600 CE, but flourished on the south coast of Peru. It is famous for its huge geoglyphs in the desert pampas, consisting of depictions of animals and plants, as well as straight lines up to ten kilometres in length. Here, unlike in the northern tradition, snakes are depicted without ears. The characteristic forked tongues are also absent – here the snakes have undivided tongues. Snakes are shown as a knot of writhing white snakes, or else as neatly

parallel individual snakes. This may be an expression of fertility. Famous features are the interlocking snake friezes, a pattern borrowed from textiles. The interlocking snakes have two colours, probably expressing the male-female duality that forms the basis of creation. Snakes mainly occur in depictions of gods. The puma god is the main deity in the Nasca culture. It usually wears a diadem whose horizontal parts are snakes. The Nasca gods also have snakes for hair, and sometimes two very long braids ending in snakes' heads. The interesting thing is that in the most complex depiction of the puma god one long braid also becomes its tail, and then ends in a young puma's head. There is a clear contrast between the large red adult puma's head on one side of a jug and the small orange or yellow head on the other side. The fact that these are adult and young puma heads respectively is apparent from such things as the large and small whiskers, the large and small headdresses and the large ear

Jug, 100-250 CE, Nasca/
Peru, pottery,
15.9 x 13.4 cm.
Collection:
Wereldmuseum,
Rotterdam, 30132

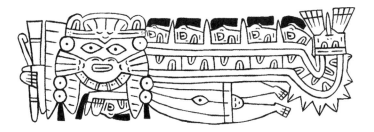

Cup, 6th century CE,
Nasca/ Peru, pottery,
13.7 x 12.7 cm.
Collection:
Wereldmuseum,
Rotterdam, 73248

Bowl with 'snake tears',
Nasca-Huari/Peru, c. 800 CE,
terracotta, 11 x 15 cm.
Private collection,
Netherlands

discs on the adult head and the lack of them on the smaller head. This depiction of the puma god probably represents the solar cycle. The large adult head represents the time of the December solstice, when the sun is strong and close, and it is the start of the rainy season in the mountains, which will fill the river beds on the desert coast with water. The small head represents the time of the June solstice, when the sun is weak and low on the horizon, and nature hardly stirs. The association of the young puma as the sun low on the horizon with a snake moving close to the ground, in contrast to the puma dwelling high in the mountains, is a possible interpretation. It is in keeping with the situation described earlier with regard to the Incas. The snake is associated with the lowlands, and the puma with the highlands.

Notes

Snake Art Studies: representations of the snake worldwide, and World Art Studies

1 Whitney Davis, 'World Without Art', *Art History* 33 (4), 2010, pp. 711-16.
2 Kitty Zijlmans & Wilfried van Damme (eds), *World Art Studies: Exploring Concepts and Approaches*. Amsterdam: Valiz, 2008. The book includes an article by the British art historian John Onians, who coined the term 'World Art Studies' and introduced it to other researchers in an article published in 1996 ('World Art Studies and the Need for a New Natural History of Art,' *Art Bulletin* 78 (2), pp. 206-209).
3 See, in particular, various articles in James Elkins (ed.), *Is Art History Global?* New York: Routledge, 2007. Criticism was also voiced at the conference entitled *In the Wake of the 'Global Turn': Propositions for an 'Exploded' Art History Without Borders*, Clark Art Institute, Williamstown, Massachusetts, November 2011.

The Secret of the serpent

1 Ovid 2010: 425
2 Timmer 2001: 761
3 Timmer 2001: 76
4 Pagels 1989: 133. Quotation from *Testimony of Truth, The Nag Hammadi Library*
5 Jung 1953-79
6 Timmer 2001: 546
7 Jung 1953-79: Vol. 9, Part 1, 3-4.
8 *Ibid.* p. 5.
9 *Ibid.*, §7.
10 Klossowski de Rola 1973.
11 Quoted in Mundkur 1983: 264
12 Mundkur 1983: 275
13 *Ibid.*, p. 263
14 Van der Heijden 2011: 8
15 Derksen 2011
16 Baring and Cashford 1993: 143
17 Jacobi 1999 (1942): 59
18 McTaggart 2003
19 In 2007 the Staatliches Naturhistorisches Museum and the Herzog Anton Ulrich Museum in Braunschweig jointly organised an exhibition entitled *Schlangen und Drachen: Kunst und Natur* ('Snakes and Dragons: Art and Nature'), focusing on ancient Western art. In 2008 an exhibition entitled *L'aventure d'une exposition: sur les traces du serpent* ('The Adventure of an Exhibition: on the Trail of the Snake'), focusing on non-Western art, was organised by students of art history and museology directed by Marie Gautheron and Claire Merleau-Ponty in collaboration with the Musée du Quai Branly for Le Muséum / Musée des Confluences in Lyon. *Dangerous and Divine: the Secret of the Serpent* covers not only Western and non-Western but also ancient and modern art.
20 Jung 1959-73, Vol. 9, Part 1, 4.
21 Lewis-Williams and Pearce 2009: 9
22 *Ibid.*, p. 10
23 *Ibid.*, pp. 48 ff.
24 Van Lommel 2007: 300
25 Narby 1999: 24
26 Jacobi 1999 (1942): 60
27 Narby 1999: 31
28 *Ibid.*, p. 34
29 *Ibid.*, p. 7
30 *Ibid.*, p. 112
31 *Ibid.*, p. 52
32 *Ibid.*, p. 116
33 Gardiner and Osborn 2006
34 Le Quellec 2004: 166
35 *Ibid.*, p. 158
36 Jacobi 1999 (1942): 63
37 Baring and Cashford 1993: 479
38 Eliade 1965.
39 Baring and Cashford 1993: 480
40 Foubister 2011: 8
41 *The Epic of Gilgamesh*, 1989: 107
42 Egli 1982: 131 ff.
43 Lash 1993: 40
44 Welling 2009: 96
45 Hübner 2009: 44
46 Welling 2009: 94
47 Lautwein 2009: 59
48 *Ibid.*, p. 62
49 Merkelbach 1998: 234-235
50 Timmer 2001: 173
51 Hemenway 2008
52 Lautwein 2009: 70
53 *Ibid.*, p. 73
54 *Ibid.*, p. 75
55 Edouard Duval Carrié sent me the following e-mail on the subject: 'You asked if Delft was on my mind. I've been to some temples in the Gonaives region where very fine porcelain pieces adorned the altar! So only the best for the Goddess!' (24 November 2011).
56 *Ibid.*
57 E-mail from Duval Carrié (18 October 2011)
58 In 1993 Marilyn Houlberg photographed an altar to Bawon Samdi in a temple otherwise dedicated to Dambala (whence Avedon's photograph). See Houlberg 2008: 153
59 Jung 2009: 231
60 *Ibid.*, p. 204
61 Schulz 2006: 51
62 *Ibid.*, pp. 58-59
63 Hoffmann 1969: 67

64 Jung 2009: 233
65 Hesse 1992: 174
66 In classical antiquity, the cockerel was a
common sacrificial animal. '[It] was said to
be the herald of the dawn and Asklepios
was the divine physician who enabled man
to see daylight. The belief that cocks are
apotropaic birds may have contributed to
their popularity as sacrificial animals.'
(Schouten, 1963: 43)
67 Joger and Luckhardt 2007: 76
68 Jung 1957: 403
69 Jung 2009: 347
70 Timmer 2001: 91
71 Lawrence 1950: 147-148
72 De Gruyter 1942: 164 ff.
73 Ibid., p. 167
74 Lawrence 1950: 261
75 From the libretto of *The Magic Flute*, first
performed in Vienna in 1791
76 Joger and Luckhardt 2007:148
77 For an exact Jungian-alchemical
interpretation, I refer to Van den Berk 1994
(for the quote from the libretto and the
nigredo phase, see p. 201).
78 Timmer 2001: 115
79 Ovid 2010: 109
80 Saint Phalle 2011: 21
81 Welling 1991: 20
82 Ibid., p. 19
83 Tiemersma 1995: 41
84 Van der Voort
85 Ibid.
86 Baring and Cashford 1993: 510
87 Ibid.
88 Ibid., p. 512
89 Sütö 2009: 7
90 Bronwasser 2009: 14
91 Ibid.
92 Sütö, 2009: 8
93 Bronwasser 2009: 16
94 Kraijer 1998
95 Van Beek 1999: 133
96 Welling 1993: 17
97 sangeetasandrasegar.blogspot.com
98 Meyer 1994: 193
99 Ibid., p. 185
100 Ibid.
101 Mundkur 1983: 43
102 Ibid., p. 51
103 Ibid., p. 44
104 Information from *Eos* magazine, 28 October
2011
105 Blandin 1992: 122-123
106 Ibid., p. 120
107 Blandin 1988: 100-101
108 Garrard 1980: 202-207
109 Egli, 1982: 51-52
110 Schouten 1963: 182
111 Docters van Leeuwen 1997: 112

112 Boeke 1969: 97-98
113 Schouten 1963: 39
114 Sibeth 1990: 133-136
115 Ibid., p. 126
116 Ibid., p. 138
117 Ibid., p. 136
118 Ibid., p. 138
119 Thomson 2010: 135
120 Timmer 2001: 461
121 Roob 1996
122 Joger and Luckhardt 2007: 148
123 Orenstein 2003
124 Ibid.
125 The breasts of Artemis of Ephesus, replicas
of which were found throughout the Roman
Empire, were sometimes said to be bull's
testicles.
126 The horns are referred to as signs of the
male god Dan in Piqué and Rainer 1999. The
artist Gérard Quenum has pointed out to
me that the horns are ears.
127 Sinha 2000: 15 and 110 ff.
128 Ibid., p. 109
129 Ibid.
130 Hefting and Van Tuyl 1977: 49
131 Van Munster 1997
132 Merkelbach 1998: 97
133 Ibid., p. 193
134 Ibid., p. 203
135 Ibid., p. 224
136 Ibid., p. 225
137 Timmer 2001: 486
138 Saint-Exupéry 1995: 68-70

Roundabout ways: serpent symbolism in West Africa

1 Information about snakes in Dan culture
was taken from fieldwork by Vandenhoute
in Ivory Coast in 1939, who complemented
his data with information from
Himmelheber, among others.
Vandenhoute's research sometimes covers
related ethnic groups such as Mano,
Diomande, or Kran, while also highlighting
differences between highly diverse
habitats of the Dan. This chapter does not
go into the same level of detail. The part of
Vandenhoute's report that focuses on Ivory
Coast has been complemented by Fischer
and Himmelheber, who did research in
Liberia between 1949 and 1976. Due to the
fact that these studies were conducted at
different times and in different places,
information about traditional Dan culture is
less clear-cut than can be reflected here. Cf
Vandenhoute, P.J., *De tweeling en de slang
bij de Dan van Ivoorkust* [Twins and the
serpent in Dan culture in Ivory Coast], in
Africana Gandensia, no. I, Ghent 1976, pp.
13 – 62; Fischer, E. & Himmelheber, H., *The
Arts of the Dan in West Africa. Fieldwork in
collaboration with George Wowoa W.
Tahmen, Saniquellie, Liberia; and Tiemoko
Gba, Man, Ivory Coast*, Museum Rietberg
Zurich 1984.
2 Vandenhoute, *Tweeling en Slang* [Twins and
Serpent], op. cit., pp. 14 – 19, 39.
3 Vandenhoute, *Tweeling en Slang* [Twins and
Serpent], op. cit., pp. 21 – 23, 25 – 27, 39,
50.
4 Although totemism is not widely accepted
as a theoretical concept in the
interpretation of African cultures,
Vandenhoute and the authors he cites do
use it. The author fails to further define the
concept or explain how he uses it, but
seeing as it does help to clarify Dan
customs, a decision was made to use the
concept here.
5 Vandenhoute, *Tweeling en Slang* [Twins and
Serpent], op. cit., pp. 16 – 17, 31, 46; Lévi-
Strauss, C., *Totemism Today*, Boston 1963,
passim. It should be noted that Lévi-
Strauss views totem relations as a symbolic
kinship, while Vandenhoute is of the
opinion that the Dan really consider it an
actual relation between human and animal.
6 The three strategies as described in
Douglas, M., *Purity and Danger. An analysis
of the concepts of pollution and taboo*.
London 1966, passim.
7 Vandenhoute, *Tweeling en Slang* [Twins and
Serpent], op. cit., pp. 29 – 34; Johnson,
B.C., *Four Dan Sculptors. Continuity and
Change*. San Francisco 1986, p. 2.
8 Vandenhoute, *Tweeling en Slang* [Twins and
Serpent], op. cit., pp. 34 – 39, 42.
9 Fischer, E. & Himmelheber, H., *Arts of the
Dan*, op. cit. pp. 3, 6 – 7; Johnson, B.C.,
Four Dan Sculptors, op. cit. pp. 2 – 3.
10 Fischer, E. & Himmelheber, H., *Arts of the
Dan*, op. cit. pp. 4 – 5; Johnson, B.C., *Four
Dan Sculptors*, op. cit. p. 2.
11 Grunne, B. de, *Terres Cuites Anciennes de
l'Ouest Africain – Ancient Terracottas from
West Africa*, Louvain-La-Neuve 1980, pp. 1,
10, 13.
12 Grunne, B. de, *Ancient Terracottas from West
Africa*, op. cit., pp. 4, 26 – 27, 30, 104 –
105.
13 Collins, R.O., *Western African History. Vol. I
of African Readings: Text and Readings*, New
York 1990, pp. 2 – 11.
14 Ibn Battuta in Collins, R.O., *Western African
History*, op. cit., pp. 22 – 23; Grunne, B. de,
Ancient Terracottas from West Africa, op.
cit., pp. 1 – 4.

15 Ibn Battuta, ibid.; Grunne, B. de, *Ancient Terracottas from West Africa*, op. cit., pp. 4 – 5.

16 Grunne, B. de, *Ancient Terracottas from West Africa*, op. cit., pp. 5 – 6, 37.

17 Izard, M. and Ki-Zerbo, J., *From the Niger to the Volta*, in Ogot, B.A. (ed.), *General History of Africa V; Africa from the sixteenth to the eighteenth century*, Oxford 1992, p. 363; Grunne, B. de, *Ancient Terracottas from West Africa*, op. cit., p. 7.

18 El Bekri in Grunne, B. de, *Ancient Terracottas from West Africa*, op. cit., pp. 31 – 32.

19 Grunne, B. de, *Ancient Terracottas from West Africa*, op. cit., pp. 34 – 35.

20 Grunne, B. de, *Ancient Terracottas from West Africa*, op. cit., pp. 9, 27 – 29. The combination of well, snake, and founding a city/empire is reminiscent of the story or Cadmus, who founded Thebes, which features in Wouter Welling's contribution elsewhere in this catalogue.

21 Grunne, B. de, *Ancient Terracottas from West Africa*, op. cit., p. 30.

22 Grunne, B. de, *Ancient Terracottas from West Africa*, op. cit., p. 29.

23 Levtzion, N., *Ancient Ghana and Mali*, London 1973, pp. 16 – 17; Grunne, B. de, *Ancient Terracottas from West Africa*, op. cit., pp. 3, 6 – 7.

24 Collins, R.O., *Western African History*, op. cit., pp. 5 – 8; Al-Bakri in Levtzion, N., Hopkins, J.F.P. (eds. and trans.), *Corpus of Early Arabic Sources for West Africa*, New York 2000, pp. 77 – 83; Grunne, B. de, *Ancient Terracottas from West Africa*, op. cit., p. 4.

25 Leloup, H., *Chefs-d'oeuvre de la statuaire Dogon*, in Schmidt, J.K., *Dogon – Meisterwerke der Skulptur – Chefs-d'oeuvre de la statuaire Dogon*, Stuttgart 1889, p. 41; Grunne, B. de, *Ancient Terracottas from West Africa*, op. cit., pp. 7 – 11

26 Ibn Battuta, ibid.; Collins, R.O., *Western African History*, op. cit., pp. 2 – 6.

27 Grunne, B. de, *Ancient Terracottas from West Africa*, op. cit., pp. 27, 30.

28 Collins, R.O., *Western African History*, op. cit., pp. 9 – 11; Leloup, H., *Chefs-d'oeuvre de la statuaire Dogon*, op. cit., p. 42.

29 Grunne, B. de, *Ancient Terracottas from West Africa*, op. cit., pp. 6 – 7, 32.

30 Grunne, B. de, *Ancient Terracottas from West Africa*, op. cit., pp. 35 – 36.

31 Grunne, B. de, *Ancient Terracottas from West Africa*, op. cit., pp. 30 – 31.

32 Lamp, F., *Art of the Baga. A Drama of Cultural Reinvention*, New York 1996, p. 77.

33 Grunne, B. de, *Ancient Terracottas from West Africa*, op. cit., pp. 29 – 30, 33.

34 Roy, Christopher D., *Art of the Upper Volta Rivers*, Paris 1987, pp. 30, 35 – 38, 41 – 50, 160 – 162.

35 Grunne, B. de, *Ancient Terracottas from West Africa*, op. cit., p. 29.

36 Ezra, K., *Art of the Dogon. Selections from the Lester Wunderman Collection*, New York 1988, pp. 18 – 19; Grunne, B. de, *Ancient Terracottas from West Africa*, op. cit., pp. 33 – 34; Beek, W.E.A. van, *Dogon, Africa's People of the Cliffs*, New York 2001, p. 104.

37 Davis, S.R., *Dogon Funerals*, in *African Art*, 2002, Vol. 35, No. 2, pp. 68 – 74; Beek, *Dogon, Africa's People of the Cliffs*, op. cit., p. 133; .

38 Veirman, A., *De kunst van het leven*. [The art of living] *Enkele aspecten van de kunst en de cultuur van de Senufo* [Some aspects of Senufo art and culture], in Grootaers, J.L. en Eisenburger, I. (ed.) *Vormen van verwondering*. [Forms of Wonderment] *De geschiedenis en collecties van het Afrika Museum, Berg en Dal*. [The history and collections of the Afrika Museum] Berg en Dal 2002, pp. 110 – 111, 114, 116, 118, 122 – 125; Krieg, K.H. & Lohse, W., *Kunst und Religion bei den Gbato – Senufo, Elfenbeinküste, Wegweiser zur Völkerkunde*, Heft 26, Hamburg 1981, pp. 118 – 121; Roberts, A.F., *Animals in African Art. From the Familiar to the Marvellous*, New York 1995, pp. 120 – 121.

39 Veirman, *Kunst en cultuur van de Senufo* [Senufo Art and Culture], op. cit., pp. 113, 115, 117. In her description of the relationship between man and animal, the author does not actually use the concept of totemism.

40 Veirman, *Kunst en cultuur van de Senufo* [Senufo Art and Culture], op. cit., pp. 111 – 112.

41 Doehring, E., Ehrich, J., Ehrich, J.H.H., *Child Health Reflections in African Art*, Hannover 2011, pp. 7, 9, 17, 19, 43 – 46, 62 – 69, 73; Roy, Christopher D., *Art of the Upper Volta Rivers*, Paris 1987, pp. 72 – 89; Roberts, A.F., *Animals in African Art*, ibid.

42 Doehring, E., Ehrich, J., Ehrich, J.H.H., *Child Health Reflections in African Art*, Hannover 2011, pp. 69, 72 – 73; Roy, Christopher D., Wheelock, Thomas G.B., *Land of the Flying Masks. Art and Culture in Burkina Faso. The Thomas G.B. Wheelock Collection*, Munich (Prestel) 2007, p. 435; Scanzi, G. F., *L'Art traditionnel Lobi. Lobi Traditional Art*, Bergamo 1993, pp. 355, 372 – 373 ; Blandin, A., *Bronzes et Autres Alliages. Afrique de l'ouest*, Marignane 1988, pp. 100 – 102; Meyer, P., *Kunst und Religion der Lobi*, Zürich 1981, pp. 173 – 174.

43 Roy, Christopher D., *Art of the Upper Volta Rivers*, Paris 1987, pp. 38 – 41.

44 Roy, Christopher D., *Art of the Upper Volta Rivers*, op. cit, pp. 262, 264, 269 – 288, 290 – 296.

45 Roy, Christopher D., *Art of the Upper Volta Rivers*, op. cit., pp. 268, 298.

46 Information about the significance of the snake mask to Baga people was taken from fieldwork interviews and observations by Lamp in 1985, 1986 - 1987, 1990, and 1992. Due to the fact that Lamp was not allowed to reveal informants' secret knowledge, but could still quote public sources, his essay is partly made up of quotes from archives and literature that was published earlier, which replaced or complemented his fieldwork data. As a result, there are barely any publications that provide additional information, and this section is a reflection of Lamp's work, complemented with general historical data. Lamp, F., *Art of the Baga. A Drama of Cultural Reinvention*, New York 1996, pp. 12 – 16.

47 Lamp, F., *Art of the Baga*, op. cit., pp. 12, 19 – 22, 25 – 28, 33, 44, 57; Niane, D.T., *What the Oral Traditions Say*, in Lamp, F., *Art of the Baga*, op. cit., p. 52.

48 Barry, B., *Senegambia from the sixteenth to the eighteenth century; evolution of the Wolof, Sereer and 'Tukuloor'*, in Ogot, B.A. (ed.), *General History of Africa V; Africa from the sixteenth to the eighteenth century*, Oxford 1992, pp. 266, 291 – 293; Wondji, C., *The states and cultures of the Upper Guinean coast*, in Ogot, B.A. (ed.), *General History of Africa V*, op. cit., pp. 373 – 374, 379; Thornton, J.K., *Warfare in Atlantic Africa, 1500 - 1800*, London 1999, p. 43; Lamp, F., *Art of the Baga*, op. cit., pp. 19, 42 – 44, 49 – 52, 56; Niane, D.T., *What the Oral Traditions Say*, in Lamp, F., *Art of the Baga*, op. cit., p. 52; Hair, P.E.H., *Early Written Sources: A Question of "Origins"*, in Lamp, F., *Art of the Baga*, op. cit., p. 55 – 56.

49 Barry, B., *Senegambia from the sixteenth to the eighteenth century*, op. cit., 267; Wondji, C., *The states and cultures of the Upper Guinean coast*, op. cit., p. 379; Barry, B., *Senegambia and the Atlantic slave trade*, Cambridge 1998, pp. 121 – 123; Lamp, F., *Art of the Baga*, op. cit., pp. 19, 27, 33 – 39, 45, 49 – 50, 54.

50 Lamp, F., *Art of the Baga*, op. cit., pp. 52, 54, 57 – 63; Niane, D.T., *What the Oral Traditions Say*, in Lamp, F., *Art of the Baga*, op. cit., p. 52.

51 Lamp, F., *Art of the Baga*, op. cit., pp. 53.

52 Lamp, F., *Art of the Baga*, op. cit., pp. 65 – 66, 70. Lamp uses the concept of moieties, which has not been used here as it would require too much further explanation.

53 Lamp, F., *Art of the Baga*, op. cit., pp. 54, 65 – 67, 69 – 70, 76 – 77.

54 Lamp, F., *Art of the Baga*, op. cit., pp. 77 – 80.

55 Lamp, F., *Art of the Baga*, op. cit., pp. 80 – 85.

56 Lamp, F., *Art of the Baga*, op. cit., pp. 45 – 46.

57 Garrard, Timothy F., *Akan Weights and the Gold Trade*, London 1980, pp. 202 – 207.

58 Grootaers, J.L., *Goudgewichten, gewikt en gewogen* [Goldweights, a comprehensive study], in Grootaers, J.L. en Eisenburger, I., (red.), *Vormen van verwondering* [Forms of Wonderment], op. cit., pp. 103 – 107; Phillips, T (ed.), *Africa. The Art of a Continent*. Munich, London, New York 1999, pp. 440 – 446; Blandin, A., *Bronzes et autres alliages*, Marignane 1988, pp. 183 – 254.

59 Grootaers, J.L., *Goudgewichten, gewikt en gewogen* [Goldweights, a comprehensive study], in Grootaers, J.L. en Eisenburger, I., (red.), *Vormen van verwondering* [Forms of Wonderment], ibid.

60 Doehring, E., Ehrich, J., Ehrich, J.H.H., *Child Health Reflections in African Art*, op. cit., p. 54.

61 Grunne, B. de, *Ancient Terracottas from West Africa*, op. cit., p. 32.

62 Hübner, I., *Geest en kracht* [Spirit Power]. *Vodun uit West-Afrika* [West Africa Vodun], Berg en Dal 1996, pp. 15 – 16.

63 Grootaers, J.L., *Voorwerpen uit West-Afrika: een keuze uit de collectie* [Artefacts from West Africa: a selection from the collection], in: Grootaers, J.L. en Eisenburger, I., (red.), *Vormen van verwondering* [Forms of Wonderment], op. cit., p. 262; Hübner, I., *Geest en kracht* [Spirit Power], op. cit., pp. 19 – 20.

64 Hübner, I., *Geest en kracht* [Spirit Power], op. cit., pp. 19 – 20, 35.

65 Hübner, I., *Geest en Kracht* [Spirit Power], op. cit., pp. 16 – 17; Herskovits, M.J., *Dahomey; An Ancient West African Kingdom*, 2 volumes, vol. II, New York 1938, p. 248.

66 Grootaers, J.L., *Voorwerpen uit West-Afrika: een keuze uit de collectie* [Artefacts from West Africa: a selection from the collection], in: Grootaers, J.L. en Eisenburger, I., (red.), *Vormen van verwondering* [Forms of Wonderment], op. cit., p. 268; Perani, J. en Smith, F.T., *The visual arts of Africa. Gender, Power and Life Cycle Rituals*, New Jersey 1998, pp. 161 – 162.

67 Piqué, F. and Rainer, L.H., *Wall Sculptures of Abomey*, London 1999, p. 8 – 15, 75.

68 Witte, H., *Wereldbeeld en iconografie van de Yoruba* [World view and iconography of the Yoruba], in: Grootaers, J.L. en Eisenburger, I., (red.), *Vormen van verwondering* [Forms of Wonderment], op. cit., pp. 75 – 76; Witte, H., *A Closer Look. Local Styles in the Yoruba Art Collection of the Afrika Museum*, Berg en Dal 2004, pp. 46 – 47.

69 Witte, H., *Wereldbeeld en iconografie van de Yoruba* [World view and iconography of the Yoruba], op. cit., p. 73; Grunne, B. de., *The Birth of Art in Africa. Nok Statuary in Nigeria*, Paris 1998, pp. 15 – 30.

70 Berns, M.C. and Fardon, F., *Introduction: Central Nigeria Unmasked*, in Berns, M.C., Fardon, F., Kasfir, S.L. (eds.), *Central Nigeria Unmasked: Arts of the Benue River Valley*, Los Angeles 2011, p. 26; Fardon, R., *Introduction: The Middle Benue*, in op. cit, pp. 215, 217 – 221.

71 Berns, M.C. and Fardon, F., *Introduction: Central Nigeria Unmasked*, in Berns, M.C., Fardon, F., Kasfir, S.L. (eds.), *Central Nigeria Unmasked: Arts of the Benue River Valley*, Los Angeles 2011, p. 27; Fardon, R., *Introduction: The Middle Benue*, in op. cit, p. 219, 221 – 223, 226 – 9.

72 Bovin, M., *Seen or Heard? Masquerades That Cry and Figures That Talk among the Mumuye*, in Berns, M.C., Fardon, F., Kasfir, S.L. (eds.), *Central Nigeria Unmasked*, op. cit., pp. 377 – 379, 390 – 391.

The snake and Satan in Jewish, Christian and Islamic creation stories

1 Ginzberg 1909, pp. 71-72.

2 In later versions, Siduri was reduced to a kind of maidservant in a nearby tavern. Graves and Patai 1964, pp. 80-81; Heim and Gordon Wasson Heim 1958-1959, pp. 123-204.

3 The Hebrew borrowing *tehom*, 'the deep' ('the celestial ocean of chaos that the firmament prevents from destroying the whole of creation'), is related to *Tiamat*, 'the formless, dark feminine' described in the Babylonian creation story. See Loretz 1968, p. 119, Phillips 1984, pp. 5 ff. and 40-41, Norris 1998, pp. 22 ff., and Lambert in Geller and Schipper 2007, Ch. 2. Some researchers have explained this story as a good example of the mythical shift that took place as an emerging male society stifled the previously dominant female principle embodied in the early mother goddesses that controlled the crucial cycle of birth, death and new life; the idea that everything was the result of procreation was gradually replaced by the notion of divine creation.

4 Among other things, the snake is used as a figurative reference to the Assyrians (in the biblical book of Isaiah 14: 29), other enemies of the Israelites (Deuteronomy, 32: 33) and the wicked (Psalm 58: 4); see Martinek 1996, p. 68.

5 It has also been suggested that the name Eve comes from Kheba, a Hurrian goddess, or else the wife of the Hittite god of storms, the goddess Heba, who rode naked on the back of a lion. Graves and Patai 1964., p. 12; Martinek 1996, pp. 48-49.

6 Yalkut Shimoni, translated by August Wünsche, 1906, p. 65. See also Wünsche's article on the comparison of Jewish and Babylonian creation stories, *ibid.*, Ch. V.

7 Graves and Patai 1964.

8 Knappert 1985, p. 37.

9 Dähnhardt 1907-1912, pp. 206-207.

10 *Book of Jubilees* 3: 28, quoted in Kvam *et al.* 1999, pp. 53 ff.

11 The scholar Joseph Justus Scaliger also asserted that it must have been Hebrew, for 'the holy books were written in that language'. Others claimed that Adam and Eve spoke Flemish, or Swedish. See Delumeau 1992, pp. 262-263.

12 Budge 1927; Dros 2010.

13 Ginzberg 1909, p. 71; Dähnhardt 1907-1912, p. 216.

14 Al-Udhari 1997, p. 177.

15 *Ibid*.

16 Steenbrink 1998, p. 118.

17 Weil 1841, pp. 20 ff.; Thackston 1978, pp. 36-38; Al-Udhari 1997 pp. 179-180; Knappert 1980, p. 31.

18 Al-Udhari 1997, p. 180; Thackston 1978, p. 38.

19 Knappert 1985, p. 37; Steenbrink 1998, pp. 118-119.

20 Budge, 1927, pp. 63-64.

21 Dähnhardt 1907-1912, pp. 208-209.

The meaning of the snake in the bible and in gnosticism/hermeticism

1 C. G. Jung, 'Symbolism of the Spirit', *Collected works of C. G. Jung*, Princeton, Princeton University Press.

2 Macrobius, *Saturnalia*, I.20.1-4.

3 E. Meyer, *Geschichte des Altertums*, II, Essen, Phaidon, 1952-1958.
4 R. Graves, *The Greek Myths*, London, Penguin Books, 1955.
5 J. Schouten, *The Rod and Serpent of Asklepios*, Elsevier Publishing Co., Amsterdam, London and New York, 1967.
6 'The Hypostasis of the Archons' (translated by Bentley Layton), in *The Nag Hammadi Library*, E. J. Brill, Leiden, 1984.
7 'The Testimony of Truth' (translated by Birger A. Pearson and Søren Giversen), in *The Nag Hammadi Library*, E. J. Brill, Leiden, 1984.

The snake and psychotherapy

1 An archetype in the Jungian sense can be described as a pattern (deemed to be innate) of thoughts and images which – like instincts – form dynamic force fields in the human psyche out of the collective unconscious and contribute to the development of the total personality.
2 Illustration by Adam McLean, published on www.alchemywebsite.com
3 Jung, 1953-79.
4 *Ibid.*
5 Egli, 1982.
6 Jung, 1953-79.
7 Illustration by Adam McLean on www.alchemywebsite.com.
8 Jung, 1953-79.
9 Jung, 1965.
10 Photograph taken by psychotherapist O. R. van Embden-Wolff in 2011.
11 The 'self' is the *teleios anthropos*, the whole individual, symbolised by the divine child or its synonyms. Elsewhere Jung describes the 'self' as a combination of the centre and totality of the whole psyche.
12 Jaffé, 1979.
13 *Ibid.*
14 Brome, 1978.
15 Jung, 1916, *Seven Sermons to the Dead*.
16 E. Neumann, 1963, p. 83.

The ouroboros and the aurora

1 Liddell & Scott 1996: 1274 s. v. 'οὐροβόρος', cf. 1273 s. v. 'οὐρη-βόρος'.
2 *Greek Magical Papyri*, 1. 146; 7. 586; 36. 184, ed. Preisendanz 1973: 10; 1974: 26, 169; cf. 13. 50.
3 Elisseeff & Bobot 1973: 40 s. v. #30

4 Mundkur 1983: 75
5 See for example Amiet 1966: 37; Toscanne 1911: 191 figure 351; Petrie 1914: 25 s. v. #96d and plate XII
6 *Pyramid Texts*, 689 (393), tr. Faulkner 1969: 129. Cf. Hannig 2009: 898 s. v. ' n '.
7 Hannig 2009: 853 s. v. '**sd (sd)**'; Erman & Grapow 1930: 364 s. v. 'śd-m-r3'
8 Kákosy (1986) offers a useful summary. See also Ritner 1984; Piankoff 1945; Piankoff & Rambova 1957b: 181 Plate 24, 189 Plate 26, trs 1957a: 56, 182, 189; Hornung 1963; Stricker 1953; Piccione 1990; Uphill 2003.
9 *Greek Magical Papyrus*, 12. 274-276, tr. M. Smith, in Betz 1986: 163
10 Plenty of examples can be found in Bonner 1950; Chabouillet 1858; Mastrocinque 2005: 150 note 676, 173, 175; Michel 2002.
11 Lydus, *De Mensibus*, 3. 4, ed. Wuensch 1898: 39
12 Valentinus (?), *Pistis Sophia*, 4. 136, trs Schmidt & MacDermot 1978: 354 / 708-709
13 Valentinus (?), *Pistis Sophia*, 3. 126, trs Schmidt & MacDermot 1978: 317 / 634-635; cf. also 3. 102, 105-107, 119, 127-128.
14 *Pyramid Texts*, 628-629 (366); 847 (454); 1631 (593)
15 *The Acts of Thomas*, 32, tr. Elliott 1993: 460
16 Rabbi 'Ēli'ęzęr haQalir (seventh century CE), apud *Piyyuṭ Wəyikkōn 'Ōl m*, apud *Maḥzōr* of the Romans, in Graves & Patai 1964: 48; cf. Ginzberg 1947: 43-46.
17 Snorri Sturluson, *Edda: Gylfaginning*, 34, tr. Faulkes 1987: 26-27
18 Vyasa, *Mahābhārata*, 1 (*Astika Parva*) (5) 32. 17-19, tr. Van Buitenen 1973: 93
19 Reichel-Dolmatoff 1987: 83-84
20 Gebhart-Sayer 1984: 10, 13
21 Brandl 1973: 201 #157; see also 37; cf. 144 Plate XXXIV, 74 figure 157.
22 Maupoil 1943: 74; Mercier 1954: 221; Métraux 1958: 92; Merlo & Vidaud 1966: 301; Burton 1966: 298; Ellis 1966: 47-49
23 Rabbi Pin as ben ama (fourth century CE) and Rabbi Šəmu'ēl bar Yiṣḥaq, apud Rabbi Yirmeyahu, apud *Pəsīqtā də-Rab Kāhānā* (fifth century CE), supplement 2. 4, trs Braude & Kapstein 1975: 467
24 Tobing 1956: 27; Hasibuan 1985: 79 #15, 123 #45
25 Joustra 1917: 331
26 Calvin 1934: 201
27 Adriani 1928: 448 s. v. 'naga'
28 Horapollo Niliacus, *Hieroglyphica*, 1. 59, 64, tr. Boas 1993: 69, 70-71; compare 1. 60, 61, 63.
29 Macrobius, *Saturnalia Convivia*, 1. 9. 12, tr.

Davies 1969: 67
30 Servius, *In Vergilii Aeneidos Commentarius*, 5. 85, eds Thilo & Hagen 1923: 603
31 Deonna 1955; Lancellotti 2002: 82
32 Martianus Capella, *The Marriage of Philology and Mercury*, 1. 70
33 Preisendanz 1935
34 See for example Howey 1955: 2; Mahdihassan 1963: 23; Lindsay 1970: 261
35 Olympiodorus of Thebes, *De Arte Sacra* (II. iv. 18), ed. Berthelot 1888: 79-80 (Greek), tr. Needham 1980: 375; cf. Leisegang 1955: 38.
36 Abraham 2001: 207 s. v. '**uroboros**'; Needham 1980: 374; Berthelot 1885: 58-59, 61, 63
37 Kekulé 1890: 1306, tr. Benfey 1958: 21
38 Contra Boden 2004 and Shermer 2001: 273, who seem to be clutching at straws about Kekulé's 'dream'. Jung 1964: 38 seems to have suggested cryptomnesia.
39 Anonymous 1873a
40 Isaiah, apud Theodoretus of Cyrrhus, *Religiosa Historia* or *Ascetica Vivendi Ratio* (c. 440 CE), 22 (1244), ed. Schulze 1864: 1441-1442, tr. Mastrocinque 2005: 8
41 Nansen 1897: 483-484
42 The term was coined by Chapman (1957: 7).
43 See Silverman & Cliver 2001; Cliver & Svalgaard 2004; Townsend *et al.* 2006; Green *et al.* 2006; Silverman 2006; Eather 1980: 79.
44 Raspopov, Dergachev & Goos'kova 2003; cf. Ohno & Hamano 1992: 1717; Silverman 2006: 205.
45 Van der Sluijs & Peratt 2009; see also Peratt 2003; Peratt *et al.* 2007
46 McCracken *et al.* 2001; Reames 2004
47 LaViolette 2011

Real snakes

1 In fact, in some languages (including Dutch) the words for 'hose' and 'snake' are the same.

'Casting ahead serpent-fashion' – the Rainbow Serpent in Australia

1 'Casting ahead serpent-fashion' is a translation of the German *schlängelnd vorauswerfen*, which in turn is the Lutheran missionary Carl Strehlow's translation of the first part of a line from a song poem of the Arrernte and Luritja language groups in

central Australia. The story describes the movement of the Rainbow Serpent. Such songs (in German translation) formed the basis for Tristan Tzara's Dadaist poem *Chanson du serpent*. See Ann Stephen, 'Blackfellows and Modernists: Not Just Black and White', in Mary Ann Gilles, Helen Sword, Steven Yao (eds), *Pacific Rim Modernists*, University of Toronto Press, Toronto, 2010, p. 157.

2 Radcliffe-Brown, Alfred R., The Rainbow-Serpent Myth of Australia, *The Journal of the Royal Anthropological Institute of Great Britain and Ireland, Vol. 56*, 1926, pp. 19-25; Radcliffe-Brown, Alfred R., The Rainbow-Serpent Myth in South-East Australia, *Oceania,* Vol. 1, No. 3, 1930, pp. 342-347.

3 Radcliffe-Brown recorded the following names: Kanmare, Tulloun, Andrenjinyi, Takkan or Targan for areas in the State of Queensland, Myndie (Victoria), Bunyip (western Victoria), Kurreah, Wawi, Neitee and Yeutta for areas in the State of New South Wales, Wogal, Wanamangura and Kajura in the State of Western Australia, and Numereji in the Northern Territory. There are many other names for the Rainbow Serpent throughout the continent, including Ngalyod (Arnhem Land, in the Kunwinjku language) and Warnayarra (Lajamanu, in the Warlpiri language).

4 McKnight, David, Conflict, Healing, and Singing in an Australian Aboriginal Community, *Anthropos,* Vol. 77, Ch. 3/4, 1982, pp. 491-508.

5 Taylor, Luke, *Seeing the Inside: Bark Painting in Western Arnhem Land*, Oxford University Press, Oxford, 1996, p. 152.

6 Hiatt, L. R., *High Gods*, in Charlesworth, Max, Dussart, Françoise and Morphy, Howard (eds), *Aboriginal Religions in Australia: an Anthology of Recent Writings*, Ashgate, Farnham and Burlington, 2005, p. 53.

7 Caruana, Wally and Lendon, Nigel (eds), *The Painters of the Wagilag Sisters Story 1937-1997; exhibition catalogue, National Gallery of Australia, Canberra, 13 September – 23 November 1997*, National Gallery of Australia, Canberra, 1997, p. 9.

8 Hiatt, L. R., *High Gods*, p. 52.

9 Hiatt, L. R., *ibid.*, p. 52.

10 Taylor, Luke, *Seeing the inside*, p. 210.

11 Taylor, Luke, *ibid.*, p. 55.

12 Study conducted by the German anthropologist Andreas Lommel. Hiatt, L. R., *High Gods*, p. 54. See also Maddock, Kenneth, 'Introduction', in Buchler, Ira and Maddock, Kenneth (eds), *The Rainbow Serpent: A Chromatic Piece*, Mouton, The Hague, 1978, pp. 15-16.

13 Hiatt, L. R., *ibid.*, p. 54. See also Berndt, Ronald, *Kunapipi: A Study of an Australian Religious Cult*, Cheshire, Melbourne, 1951, p. 36.

14 Japaljarri, Tiger, 'Warnajarrakurlu: the Two Snakes', in Rockman Napaltjarri, Peggy, and Cataldi, Lee (eds), *Warlpiri Dreamings and Histories (Yimikirli)*, Harper Collins, San Francisco, London and Sydney, 1994, pp. 139-147.

15 Robinson, Roland, *The Feathered Serpent*, Edwards & Shaw, Sydney, 1956.

16 Rainbow Spirit Elders, *Rainbow Spirit Theology: towards an Australian Aboriginal Theology*, HarperCollins Religious, Melbourne, 1997, subsequently reprinted as Rainbow Spirit Elders, *Rainbow Spirit Theology: towards an Australian Aboriginal Theology*, ATF Press, Adelaide, 2008.

17 Hiatt, L. R., *High Gods*, p. 55.

18 See www.rainbowserpent.net (visited on 22 December 2011).

19 At least among the Kunwinjku of eastern Arnhem Land. See Taylor, Luke, *Seeing the inside*, p. 158.

20 Anderson, Suzanne, 'Rejecting the Rainbow Serpent: an Aboriginal Artist's Choice of the Christian God as Creator', in *The Australian Journal of Anthropology,* Vol. 12, 2001, pp. 291-301.

21 Taçon, Paul S. C., Chippindale, Christopher and Wilson, Meredith, 'Birth of the Rainbow Serpent in Arnhem Land Rock Art and Oral History', *Archaeology in Oceania,* Vol. 31, No. 3, Oceania Publications, University of Sydney, Sydney, 1996, pp. 103-124.

22 In 2011 the land round the Limmen Bight river was threatened by large-scale iron-ore mining.

23 Ryan, Judith, *Ginger Riley; exhibition catalogue, National Gallery of Victoria, Melbourne, 17 July-22 September 1997*, National Gallery of Victoria, Melbourne, 1997, p. 30;

24 See in particular Morphy, Howard, *Aboriginal art*, Phaidon, London, 1998, p. 174.

25 Taylor, Luke, 'The Rainbow Serpent as Visual Metaphor in Western Arnhem Land', in *Oceania*, Vol. 60, No. 4, Special 60th Anniversary Issue (June 1990), 1990, p. 342.

26 In western Arnhem Land, the ritual elements (artefacts, songs, sounds, dances, drawing motifs and sculptures) that are used during major ceremonies connecting the Rainbow Serpent with the rainy season are seen as transformations of this mythical creature. The Lorrkkon or hollow grave post in which the bones of the dead are kept likewise symbolises the Rainbow Serpent. Other topics involved in the ceremonies are sexual reproduction and fertility. See Taylor, Luke, *Seeing the inside*, pp. 85-86.

27 In eastern and central Arnhem Land, the act of painting is seen as a process of transformation of the surface from a state of dullness to a state of shimmering brilliance. The Aboriginal people believe that this brilliance, known in the local Yolgnu language groups as *bir'yunhamirri*, comes from the *djang*, the ancestral beings. It symbolises the ancestors' presence in art and the land. The brilliance of the bark paintings is evidence of the presence of ancestral powers in these works of art. This *bir'yunhamirri* is achieved by filling up the figures on the sheet of bark with cross-hatching.

28 Yolgnu, which can be translated as 'human being', is a general term that the Aboriginal people of central and eastern Arnhem Land use to refer to themselves. The social organisation of the Yolgnu is based on two 'moieties' (halves) known as Dhuwa and Yirritja. All living things, including human beings, ancestral beings, motionless things and natural phenomena, belong to one of these moieties. See Morphy, Howard, 'From Dull to Brilliant: The Aesthetics of Spiritual Power among the Yolngu', in Coote, Jeremy and Shelton, Anthony (eds), *Anthropology, Art, and Aesthetics*, Clarendon Press, Oxford, 1992, pp. 181-208.

The snake as the symbol of transition and transformation in Peruvian art

1 Zuidema 1985

2 Wilbert 1985

3 De Bock fieldwork 1983

Bibliography

The secret of the serpent

Baring, Anne and Cashford, Jules: *The Myth of the Goddess: Evolution of an Image*, 1993. London: Arkana, Penguin Books

Blandin, André: *Bronzes et autres alliages*, 1988. Marignane, France: private publication

Blandin, André: *'Fer Noir' d'Afrique de l'Ouest*, 1992. Marignane, France: private publication

Boeke, Enno: *Hoogte en diepte: bijbelse symboliek van dualisme en kringloop*, 1969. Wassenaar: Servire

Bronwasser, Sacha: 'A torch in the darkness', in Sütö, Wilma and Bronwasser, Sacha: *Iris van Dongen: Suspicious, 2009*. Nijmegen: BnM Uitgevers

De Gruyter, Jos: *Quetzalcoatl: De mythe van den gevederden slangengod*, 1942. 's-Graveland: De Driehoek

Derksen, Jan: 'Red de psychologie uit de klauwen van hersenonderzoekers.' 12 February 2011, Opinie en Debat, pp. 1-2, *NRC Handelsblad*

Docters van Leeuwen, Onno and Rob: *De Tarot in de herstelde orde*, 1997. Utrecht: Servire

Egli, Hans: *Das Schlangensymbol*, 1982. Olten and Freiburg im Breisgau: Walter-Verlag

Eliade, Mircea: *The Myth of the Eternal Return*, 1965. Princeton: Princeton University Press

Foubister, Linda: *Goddess in the Grass: Serpentine Mythology and the Great Goddess*, 2003, Eccenova Editions. Quoted from the e-book publication, 2011, Smashwords edition

Gardiner, Philip and Osborn, Gary: *The Serpent Grail*, 2006. London: Watkins Publishing

Garrard, Timothy F. *Akan Weights and the Gold Trade*, 1980. London and New York: Longman

Hefting, Paul and Van Tuyl, Gijs: *Paper for Space*, 1977. Amsterdam: Stedelijk Museum

Hemenway, Priya: *The Secret Code*, 2008. Cologne: Taschen

Hesse, Hermann: *Siddhartha, Demian and Other Writings*, 1992. New York: The Continuum Publishing Company

Hoffmann, E. T. A.: 'The Golden Pot', in *Tales of E. T. A. Hoffman*, translated by Leonard J. Kent and Elisabeth C. Knight, 1969. Chicago: University of Chicago Press

Houlberg, Marilyn: 'Water Spirits of Haitian Vodou', in Drewal, Henry John et al.: *Mami Wata: Arts for Water Spirits in Africa and Its Diasporas*, 2008. Los Angeles: Fowler Museum

Hübner, Irene: 'Always on the move, never on the run: the journey of African spirits', in Hübner, Irene and Welling, Wouter: *Roots & More: the Journey of the Spirits*, 2009. Berg en Dal: Afrika Museum

Jacobi, Jolande: *Psychology of C. G. Jung*, translated by K. W. Bash, 1999 (1942). London: Routledge

Joger, Ulrich, Luckhardt, Jochen et al.: *Schlangen und Drachen: Kunst und Natur*, 2007. Darmstadt: Primus Verlag

Jung, C. G.: *Collected Works of C. G. Jung*, various translators, 1953-79. Princeton: Princeton University Press

Jung, C. G.: *Psychology of the Unconscious*, 1957: New York: Dodd, Mead and Company

Jung, C. G.: *The Red Book*, translated by Mark Kyburz, John Peck and Sonu Shamdasani, 2009. New York: W. W. Norton

Klossowski de Rola, Stanislas: *Alchemy: the Secret Art*, 1973. New York: Avon Books

Kraijer, Juul: *De Hydra*, 1998. Rotterdam: private publication

Lapatin, Kenneth: *Mysteries of the snake goddess: art, desire, and the forging of history*, 2002. Boston and New York: Houghton Mifflin Company

Lash, John: *Twins and the Double*, 1993. London: Thames and Hudson

Lautwein, Thomas: *Hekate: die dunkle Göttin*, 2009. Rudolstadt: Roter Drache

Lawrence, D. H.: *The Plumed Serpent*, 1950. Harmondsworth: Penguin Books

Le Quellec, Jean-Loïc: *Rock Art in Africa, Mythology and Legend*, translated by Paul Bahn, 2004. Paris: Flammarion

Lewis-Williams, David and Pearce, David: *Inside the Neolithic Mind*, 2009. London: Thames & Hudson

McTaggart, Lynne: *The Field: the Quest for the Secret Force of the Universe*, 2003. New York: Harper Paperbacks

Merkelbach, Reinhold: *Mithras: ein persisch-römischer Mysterienkult*, 1998. Wiesbaden: Albus im VMA-Verlag

Meyer, Birgit: 'Satan, slangen en geld: bekentenissen over duivelse rijkdom in christelijk Ghana', in Driessen, Henk, De Jonge, Huub (eds), *In de ban van betekenis: proeven van symbolische antropologie*, 1994. Nijmegen: SUN

Mundkur, Balaji: *The Cult of the Serpent: an Interdisciplinary Survey of its Manifestations and Origins*, 1983. Albany: State University of New York Press

Narby, Jeremy: *The Cosmic Serpent: DNA and the Origins of Knowledge*, 1999. New York: Tarcher/Putnam

Orenstein, Nadine M.: 'Finally Spranger: prints and print designs 1586-1590', in Leeflang, Huigen, Luijten, Ger et al. (eds): *Hendrick Goltzius (1558-1617): Drawings, Prints and Paintings*, 2003. Zwolle: Waanders

Ovid: *Metamorphoses*, translated by Stanley Lombardo, 2010. Indianapolis: Hackett Publishing Company

Pagels, Elaine: *Adam, Eve and the Serpent*, 1989. New York: Vintage Books

Piqué, Francesca and Rainer, Leslie H.: *Wall Sculptures of Abomey*, 1999. London: Thames & Hudson

Roob, Alexander: *Alchemy and Mysticism: the Hermetic Museum*, 1996. Cologne: Taschen Verlag

Saint-Exupéry, Antoine de: *The Little Prince*, 1995. Ware: Wordsworth Editions

Saint Phalle, Niki de: "De zomer van de slangen", in Huijts, Stijn, *et al.*: *Niki de Saint Phalle – Outside-In*, 2011. Heerlen: Schunck*

Schouten, Jan: *De slangestaf van Asklepios, symbool der geneeskunde*, 1963. Dissertation. Amsterdam-Meppel: Brocades-Stheeman & Pharmacia (translated into English as *The Rod and Serpent of Asklepios: Symbol of Medicine*, 1967. Amsterdam: Elsevier)

Schulz, Isabel: 'The "Omnipotence of Dream": Dream and the Unconscious in the Oeuvre of Meret Oppenheim', in Bhattacharya-Settler, Therese and Frehner, Matthias: *Meret Oppenheim: Retrospective, 'an enormously tiny bit of a lot'*, 2006. Ostfildern: Hatje Cantz Verlag

Sibeth, Achim *et al.*: *Batak: mit den Ahnen leben*, 1990. Stuttgart and London: Edition Hansjörg Mayer

Sinha, Indra: *Tantra: the cult of ecstasy*, 2000. London: Hamlyn

Sütö, Wilma: 'Mistress of herself, nature and the beast in mankind', in Sütö, Wilma and Bronwasser, Sacha: *Iris van Dongen: Suspicious, 2009*. Nijmegen: BnM Uitgevers

The Epic of Gilgamesh, translated by Maureen Gallery Kovacs, 1989. Stanford: Stanford University Press

Thomson, Belinda *et al.*: *Gauguin: Maker of Myth*, 2010. London: Tate Modern

Tiemersma, Enno Willem: *De geboorte van Alexander de Grote*, 1995. Dissertation, Groningen University

Timmer, Maarten: *Van Anima tot Zeus*, 2001. Rotterdam: Lemniscaat

Van Beek, Marius: 'Man with a hundred glueing clamps', in Scholten, Theo *et al.*: *Gerhard Lentink: sculptures, projects*, 1999. Scheveningen: Museum BeeldenaanZee

Van den Berk, M. F. M.: *Die Zauberflöte: een alchemistische allegorie*, 1994. Tilburg: Tilburg University Press

Van der Heijden, Margriet: 'Een goede tegenwerping heb ik nog niet gehoord', interview with Dick Swaab. 5 November 2011, Wetenschap, pp. 8-9, *NRC Handelsblad*

Van der Voort, Marcel: 'Die mannen zijn bang om hun vrouw te ontmaagden', Marcel van der Voort's website

Van Lommel, Pim: *Eindeloos bewustzijn: een wetenschappelijke visie op de bijna-dood ervaring*, 2007. Kampen: Ten Have (translated into English as *Consciousness beyond Life: the Science of the Near-Death Experience*, 2010. New York: HarperCollins)

Van Munster, Jan: *The Energy of the Sculptor*, 1997. Tokyo: Gallery Yamaguchi

Welling, Wouter: 'Niki de Saint Phalle: "In mijn atelier ben ik god",' in *Beelding*, Vol. 5, No. 1, February 1991, pp. 18-21. The Hague: Stichting Beeldspraak

Welling, Wouter: *Gerhard Lentink: sculptures, environmental projects with Reinout van den Bergh*, 1993. Dordrecht: private publication

Welling, Wouter: 'Encounters at the crossroads', in Hübner, Irene and Welling, Wouter: *Roots & More: the Journey of the Spirits*, 2009. Berg en Dal: Afrika Museum

Wickler, Wolfgang and Seibt, Uta: *Kalenderwurm und Perlenpost: Biologen entschlüsseln ungeschriebene Botschaften*, 1998. Heidelberg and Berlin, Spektrum Akademischer Verlag

The secret of Rhino Cave

Campbell, A., Robbins, L. & Taylor, M. (Eds.) 2010. *Tsodilo Hills. Copper Bracelet of the Kalahari*, East Lansing and Gaborone, Michigan State University Press and The Botswana Society.

Chalmers, A. 2002a Firelight: Graphics & Archaeology. University of Bristol Computer Graphics and Archaeology Group homepage

Chalmers, A. 2002b Very Realistic Graphics for Visualising Archaeological Site Reconstructions. *Proceedings of the 18th spring conference on Computer graphics*. New York, ACM Press.

Coulson, S. & Staurset, S. 2011 Middle Stone Age ritual at Rhino Cave, Botswana. *Radical Anthropology*, (5):12-17.

Coulson, S., Staurset, S. & Walker, N. J. 2011 Ritualized Behavior in the Middle Stone Age: evidence from Rhino Cave, Tsodilo Hills, Botswana *PalaeoAnthropology*, 18-61.

Lewis-Williams, D. 1997 Harnessing the Brain: Vision and Shamanism in Upper Paleolithic Western Europe. In Conkey, M. W., Soffer, O., Stratmann, D. & Jablonski, N. G. (Eds.) *Beyond Art: Pleistocene Image and Symbol*. 321-342. San Francisco, University of California Press.

Lewis-Williams, D. 2002 *The Mind in the Cave: Consciousness and the Origins of Art*, London, Thames and Hudson.

Robbins, L. H., Brook, G. A., Murphy, M. L., Campbell, A. C., Melear, N. & Downey, W. S. 2000 Late Quaternary archaeological and palaeoenvironmental data from sediments at Rhino Cave, Tsodilo Hills, Botswana. *Southern African Field Archaeology*, 9 17-31.

Robbins, L. H., Murphy, M. L., Campbell, A. C. & Brook, G. A. 1996 Excavations at the Tsodilo Hills Rhino Cave. *Botswana Notes and Records*, 28 23-45.

Taçon, P. S. C. & Ouzman, S. 2004 Worlds within stone: the inner and outer rock-art landscapes of northern Australia and southern Africa. In Chippindale, C. & Nash, G. (Eds.) *The Figured Landscapes of Rock-Art: Looking at Pictures in Place*. 39-68. Cambridge, Cambridge University Press.

The snake and Satan in Jewish, Christian and Islamic creation stories

Al-Udhari, Abdullah. *The Arab Creation Myth*. Prague, Archangel, 1997.

Budge: see *The Book of the Cave of Treasures*.

Dähnhardt: see *Natursagen*.

Delumeau. Jean. *Une histoire du Paradis*. Paris, Fayard, 1992.

Dros, Nico. *De sprekende slang: een kleine geschiedenis van laaglands fundamentalisme*. Amsterdam, G. A. van Oorschot, 2010.

Geller, Markham J. and Mineke Schipper (eds): *Imagining Creation* (with an introduction by Mary Douglas). Leiden and Boston, Brill, 2007.

Ginzberg: see *The Legends of the Jews*.

Graves, Robert and Raphael Patai. *Hebrew Myths: the Book of Genesis*. New York, Anchor Books/Doubleday, 1964.

Heim, Roger and R. Gordon Wasson Heim, 'Les champignons hallucinogènes du Mexique', offprint, *Archives du Muséum National d'Histoire Naturelle*, series 7, vol. 6. 1958-1959: 123-204.

Knappert, Jan. *Myths and legends of the Swahili*. Nairobi, Heinemann Educational Books, 1970.

Knappert, Jan. *Malay myths and legends*. Kuala Lumpur, Heinemann Educational Books, 1980.

Knappert, Jan. *Islamic legends: histories of the heroes, saints and prophets of Islam*. Leiden, Brill, 1985.

Kvam, Kirsten E., Linda S. Schearing and Valarie H. Ziegler (eds), *Eve & Adam: Jewish, Christian and Muslim Readings on Genesis and Gender.* Bloomington, Indiana University Press, 1999.

Lambert, W. G. 'Mesopotamian Creation Stories', in Markham J. Geller and Mineke Schipper (eds). Leiden and Boston, Brill, 2008, pp. 15-60.

Loretz, Oswald. *Schöpfung und Mythos: Mensch und Welt nach den Anfangskapiteln der Genesis.* Stuttgart, Verlag Katholisches Bibelwerk, 1968.

Martinek, Manuela. *Wie die Schlange zum Teufel wurde: die Symbolik in der Paradiesgeschichte von der hebräischen Bibel bis zum Koran.* Wiesbaden, Harrassowitz, 1996.

Midrasch der Bereschit Rabba, das ist: die haggadische Auslegung der Genesis. Zum ersten Male ins Deutsche übertragen von August Wünsche. Leipzig, Verlag von Eduard Pfeiffer, 1881.

Natursagen: eine Sammlung naturdeutender Sagen, Märchen, Fabeln und Legenden, with contributions by V. Armhaus *et al.*; edited by Oskar Dähnhardt; Leipzig [etc.], Teubner, 1907-1912.

Norris, Pamela. *The Story of Eve.* London, Macmillan, 1998.

Phillips, John A. *Eve: the History of an Idea.* San Francisco, Harper & Row, 1984.

Speculum humanae salvationis, 1448.

Steenbrink, Karel. *Adam redivivus: Muslim Elaborations of the Adam Saga with Special Reference to the Indonesian Literary Traditions.* Zoetermeer, Meinema, 1998.

Talmud, der Babylonische, in seinen haggadischen Bestandteilen, translated by August Wünsche. 2 parts. Leipzig, Verlag von Eduard Pfeiffer, 1881.

Thackston: see *The Tales of the Prophets of al-Kisa'i.*

The Book of the Cave of Treasures: a History of the Patriarchs and the Kings; their Successors from the Creation to the Crucifixion of Christ, transl. from the Syriac text of the British Museum Ms. Add. 25875 by E. A. Wallis Budge. London, The Religious Tract Society, 1927.

The Legends of the Jews, translated from the German manuscript by Louis Ginzberg. Vol. 1. Philadelphia, The Jewish Publication Society of America, 1909.

The Tales of the Prophets of al-Kisa'i (translated from the Arabic, with notes, by W. M. Thackston, Jr.). Boston, Twayne Publishers, 1978.

Wünsche, August. *Schöpfung und Sündenfall des ersten Menschenpaares im jüdischen und moslemischen Sagenkreise.* Vol. II, Ex Oriente Lux (Hugo Winkler ed.), Leipzig, Verlag von Eduard Pfeiffer, 1906.

The snake and psychotherapy

Ammann, R. (1989). *Heilende Bilder der Seele: das Sandspiel, der schöpferische Weg der Persönlichkeitsentwicklung.* Munich, Kösel-Verlag

Bradway, K. (1997). *Sandplay – Silent workshop of the Psyche.* New York, Routledge

Brome, V. (1978). *Jung: Man and Myth.* New York, Atheneum

Egli, H. (1982). *Das Schlangensymbol.* Freiburg, Walter-Verlag

Henderson, J. L. (1963). *The Wisdom of the Serpent. The Myths of Death, Rebirth and Resurrection.* New York, G. Braziler

Jaffé, A. (1979). *C. G. Jung: Word and Image.* Princeton, Princeton University Press

Jung, C. G. (1953-79). *Collected Works of C. G. Jung.* Princeton, Princeton University Press

Jung, C.G. (1965). *Memories, Dreams, Reflections.* New York, Random House

Kalff, D. (1983), *Sandplay: a Psychotherapeutic Approach to the Psyche,* Boston, Sigo Press

McLean, A. (1998). *Alchemical Images.* Published on http://www.alchemywebsite.com

Neumann, E. (1948). *Ursprungsgeschichte des Bewusstseins,* Munich, Kindler Taschenbücher

Neumann, E. (1963). *The Great Mother,* Princeton: Princeton University Press

Pattis Zoja, E. *et al.* (2004). *Sandplay Therapy. Treatment of Psychopathologies.* New York, Daimon Verlag

Ryce-Menuhin, J. (1992). *Jungian Sandplay, the wonderful Therapy.* London, Routledge

Stevens, A. (1998). *Ariadne's clue,* Princeton: Princeton University Press

Van Lommel, P. (2010). *Consciousness beyond Life: the Science of the Near-Death Experience.* New York: HarperCollins

For more information on sandplay (in Dutch only), see www.sandplaynederland.org and www.bleijenbergderks.nl

The ouroboros and the aurora

Abraham, L. (ed.), *A Dictionary of Alchemical Imagery* (Cambridge: Cambridge University Press, 2001)

Adriani, N., *Bare'e-Nederlandsch Woordenboek met Nederlandsch-Bare'e Register* (Leiden: E. J. Brill, 1928)

Amiet, P., *Elam* (Auvers-sur-Oise: Archée, 1966)

Benfey, O. T. (tr.), 'August Kekulé and the Birth of the Structural Theory of Organic Chemistry in 1858', in *Journal of Chemical Education,* 35 (1958), 21-23

Berthelot, M., *Les Origines de l'alchimie* (Paris: Georges Steinheil, 1885)

Berthelot, M., *Collection des anciens alchimistes grecs* (Paris: Georges Steinheil, 1888)

Betz, H. D. (tr.), *The Greek Magical Papyri in Translation; Including the Demotic Spells* (Chicago: University of Chicago Press, 1986)

Boas, G. (tr.), *The Hieroglyphics of Horapollo* (Bollingen Series, 23; Princeton, New Jersey: Princeton University Press, 1993)

Boden, M. A., *The Creative Mind; Myths and Mechanisms* (London: Routledge, 2004[2])

Bonner, C., *Studies in Magical Amulets Chiefly Graeco-Egyptian* (Ann Arbor: The University of Michigan Press, 1950)

Brandl, E. J., *Australian Aboriginal Paintings in Western and Central Arnhem Land; Temporal Sequences and Elements of Style in Cadell River and Deaf Adder Creek Art* ('Australian Aboriginal Studies', 52; 'Prehistory and Material Culture Series', 9; Canberra: Australian Institute of Aboriginal Studies, 1973)

Braude, W. G. & I. J. Kapstein (trs), *Pěsi̱kta dě-Ra̱b Kahăna* ('The Littman Library of Jewish Civilization'; London: Routledge & Kegan Paul, 1975)

Burton, Sir R., *A Mission to Gelele King of Dahome* (London: Routledge & Kegan Paul, 1966)

Calvin, R., *Sky Determines; An Interpretation of the Southwest* (New York: The MacMillan Company, 1934)

Chabouillet, M., *Catalogue général et raisonné des camées et pierres gravées de la Bibliothèque Impériale* (Paris: Claye & Rollin, 1858?)

Chapman, S., 'The Aurora in Middle and Low Latitudes', *Nature,* 4549 (5 January 1957), 7-11

Cliver, E. W. & L. Svalgaard, 'The 1859 Solar-Terrestrial Disturbance and the Current Limits of Extreme Space Weather Activity', *Solar Physics,* 224 (2004), 407-422

Davies, P. V. (tr.), *Macrobius: The Saturnalia* ('Records of Civilization: Sources and Studies'; New York: Columbia University Press, 1969)

Deonna, W., 'La Descendance du Saturne à l'ouroboros de Martianus Capella', *Symbolae Osloenses*, 31 (1955), 170-189

Eather, R. H., *Majestic Lights; The Aurora in Science, History, and the Arts* (Washington, D. C.: American Geophysical Union, 1980)

Elisseeff, V. & M. T. Bobot, *Trésors d'art Chinois récentes découvertes archéologiques de la République Populaire de Chine* (Paris: Petit Palais, 1973)

Elliott, J. K. (tr.), *The Apocryphal New Testament; A Collection of Apocryphal Christian Literature in an English Translation* (Oxford: Clarendon Press, 1993)

Ellis, A. B., *The Ewe-Speaking Peoples of the Slave Coast of West Africa; Their Religion, Manners, Customs, Laws, Languages, &c.* (Oosterhout, Netherlands: Anthropological Publications, 1966)

Erman, A. & H. Grapow (eds), *Wörterbuch der aegyptischen Sprache im Auftrage der deutschen Akademien* (4; Leipzig: J. C. Hinrich'sche Buchhandlung, 1930)

Faulkes, A. (tr.), *Snorri Sturluson: Edda* (Everyman's Library; London: Dent, 1987)

Faulkner, R. O. (tr.), *The Ancient Egyptian Pyramid Texts* (Oxford: Oxford University Press, 1969)

Fewkes, J. W., 'Archeological Expedition to Arizona in 1895', *Annual Report of the Bureau of American Ethnology to the Secretary of the Smithsonian Institution* for 1895-1896, 17 (1898), 527-744

Gebhart-Sayer, A., *The Cosmos Encoiled: Indian Art of the Peruvian Amazon* (New York: Center for Inter-American Relations, 1984)

Ginzberg, L., *The Legends of the Jews* (5; Philadelphia: The Jewish Publication Society of America, 1947)

Graves, R. & R. Patai, *Hebrew Myths; The Book of Genesis* (London: Cassell, 1964)

Green, J. L., S. Boardsen, S. Odenwald, J. Humble & K. A. Pazamickas, 'Eyewitness Reports of the Great Auroral Storm of 1859', *Advances in Space Research*, 38 (2006), 145-154

Hannig, R. (ed.), *Die Sprache der Pharaonen; Großes Handwörterbuch Ägyptisch-Deutsch (2800-950 v. Chr.)* (Kulturgeschichte der antiken Welt, 64; Mainz: Philipp von Zabern, 2009[5])

Hasibuan, J. S., *Art et culture Batak* (Jakarta: P. T. Jayakarta Agung Offset, 1985)

Hornung, E. (ed.), *Das Amduat; die Schrift des verborgenen Raumes* (2; Ägyptologische Abhandlungen, 7; Wiesbaden: Otto Harrassowitz, 1963)

Howey, M. O., *The Encircled Serpent; A Study of Serpent Symbolism in All Countries and Ages* (New York: Arthur Richmond, 1955)

Joustra, M., 'Verschillende Verbodsbepalingen, Eertijds bij de Heidensche Bataks der Tobasche Landen van Kracht; Uit het Tobaasch Vertaald', *Bijdragen tot de Taal-, Land- en Volkenkunde van Nederlandsch-Indië*, 73 (1917), 311-343

Jung, C. G., *Man and his Symbols* (London: Aldus Books, 1964)

Kákosy, L., 'Uroboros', *Lexikon der Ägyptologie*, 6 (1986), 886-893

Kekulé, A., 'Rede', *Berichte der deutschen chemischen Gesellschaft*, 23 (1890), 1302-1311

Lancellotti, M. G., 'Il Serpente *Ouroboros* nelle Gemme Magiche', in A. Mastrocinque (ed.), *Atti dell'Incontro di Studio Gemme Gnostiche e Cultura Ellenistica Verona, 22-23 Ottobre 1999* (Bologna: Pàtron Editore, 2002), 71-85

LaViolette, P. A., 'Evidence for a Solar Flare Cause of the Pleistocene Mass Extinction', *Radiocarbon*, 53. 2 (2011), 303-323

Leisegang, H., 'The Mystery of the Serpent', in J. Campbell (ed.), *Pagan and Christian Mysteries; Papers from the Eranos Yearbooks* (New York: Harper Torchbooks, 1955), 3-69

Liddell, H. G. & R. Scott (eds), *A Greek-English Lexicon* (Oxford: Clarendon Press, 1996)

Lindsay, J., *The Origins of Alchemy in Graeco-Roman Egypt* (London: Frederick Muller, 1970)

Mahdihassan, S., 'The Significance of Ouroboros in Alchemy and in Primitive Symbolism', *Iqbal* (1963), 18-47

Mastrocinque, A., *From Jewish Magic to Gnosticism* (Studien und Texte zu Antike und Christentum, 24; Tübingen: Mohr Siebeck, 2005)

Maupoil, B., *La Géomancie à l'ancienne Côte des Esclaves* (Travaux et Mémoires de l'Institut d'Ethnologie, 42; Paris: Institut d'Ethnologie, 1943)

McCracken, K. G., G. A. M. Dreschhoff, E. J. Zeller, D. F. Smart & M. A. Shea, 'Solar Cosmic Ray Events for the Period 1561-1994; 1. Identification in Polar Ice, 1561-1950', in *Journal of Geophysical Research*, 106. A10 (2001), 21585-21598

Mercier, P., 'The Fon of Dahomey', in D. Forde (ed.), *African Worlds; Studies in the Cosmological Ideas and Social Values of African Peoples* (Oxford: Oxford University Press, 1954), 210-234

Merlo, C. & P. Vidaud, 'Le Symbole Dahoméen du serpent queue-en-Gueule', *Objets et Mondes; La Revue du Musée de l'Homme*, 6. 1 (1966), 301-328

Métraux, A., *Le Vaudou Haïtien* (Bibliothèque des Sciences Humaines; Paris: Gallimard, 1958)

Michel, S., 'Der NYXEYA BOΛBAX-Logos zu einer neuen magischen Formel und ihrer Bedeutung', in A. Mastrocinque (ed.), *Atti dell'Incontro di Studio Gemme Gnostiche e Cultura Ellenistica Verona, 22-23 Ottobre 1999* (Bologna: Pàtron Editore, 2002), 86-134

Mundkur, B., *The Cult of the Serpent; An Interdisciplinary Survey of its Manifestations and Origins* (Albany: State University of New York Press, 1983)

Nansen, F., *Fridtjof Nansen's 'Farthest North' Being the Record of a Voyage of Exploration of the Ship Fram 1893-96 and of a Fifteen Months' Sleigh Journey by Dr. Nansen and Lieut. Johansen with an Appendix by Otto Sverdrup Captain of the Fram* (1; Westminster: Archibald Constable and Company, 1897)

Needham, J., *Science and Civilisation in China; Volume 5: Chemistry and Chemical Technology; Part IV: Spagyrical Discovery and Invention: Apparatus, Theories and Gifts* (Cambridge: Cambridge University Press, 1980)

Ohno, M. & Y. Hamano, 'Geomagnetic Poles over the Past 10,000 Years', *Geophysical Research Letters*, 19. 16 (1992), 1715-1718

Peratt, A. L., 'Characteristics for the Occurrence of a High-current, Z-pinch Aurora as Recorded in Antiquity', *IEEE Transactions on Plasma Science*, 31. 6 (2003), 1192-1214

Peratt, A. L., J. McGovern, A. H. Qöyawayma, M. A. van der Sluijs & M. G. Peratt, 'Characteristics for the Occurrence of a High-Current Z-Pinch Aurora as Recorded in Antiquity Part II: Directionality and Source', *IEEE Transactions on Plasma Science*, 35. 4 (2007), 778-807

Petrie, W., *Keoeeit; The Story of the Aurora Borealis* (Oxford: Pergamon Press, 1963)

Petrie, W. M. Flinders, *Amulets Illustrated by the Egyptian Collection in University College, London* (London: Constable & Company, 1914)

Piankoff, A. (tr.), *The Tomb of Ramesses VI: Texts* (ed. N. Rambova; Egyptian Religious Texts and Representations, 1; Bollingen Series, 40. 1; New York: Pantheon Books, 1945)

Piankoff, A. (tr.) & N. Rambova (ed.), *Mythological Papyri: Texts* (Bollingen Series, 40; Egyptian Religious Texts and Representations, 3; New York: Pantheon Books, 1957a)

Piankoff, A. (tr.) & N. Rambova (ed.), *Mythological Papyri: Plates* (Bollingen Series, 40; Egyptian Religious Texts and Representations, 3; New York: Pantheon Books, 1957b)

Piccione, P. A., 'Mehen, Mysteries, and Resurrection from the Coiled Serpent', in *Journal of the American Research Center in Egypt*, 27 (1990), 43-52

Preisendanz, K., 'Ein altes Ewigkeitssymbol als Signet und Druckermarke', *Gutenberg-Jahrbuch* (1935), 143-149

Preisendanz, K., *Papyri Graecae Magicae: die Griechischen Zauberpapyri* (1-2; Sammlung wissenschaftlicher Commentare; Stuttgart: B. G. Teubner, 1973² and 1974²)

Raspopov, O. M., V. A. Dergachev & E. G. Goos'kova, 'Ezekiel's Vision: Visual Evidence of Sterno-Etrussia Geomagnetic Excursion?', *Eos; Transactions of the American Geophysical Union*, 84. 9 (2003), 77, 83

Reames, D. V., 'Solar Energetic Particle Variations', *Advances in Space Research*, 34 (2004), 381-390

Reichel-Dolmatoff, G., 'The Great Mother and the Kogi Universe: A Concise Overview', *Journal of Latin American Lore*, 13. 1 (1987), 73-113

Ritner, R. K., 'A Uterine Amulet in the Oriental Institute Collection', *Journal of Near Eastern Studies*, 43. 3 (1984), 209-221

Schmidt, C. (ed.) & V. MacDermot (tr.), *Pistis Sophia* (Nag Hammadi Studies, 9; The Coptic Gnostic Library; Leiden: E. J. Brill, 1978)

Schulze, J. L. (ed.), *Theodoreti Cyrensis Episcopi Opera Omnia* (Patrologiæ Cursus Completus ..., Græca Prior series, 82. 3; Paris: Petit-Montrouge, 1864)

Shermer, M., *The Borderlands of Science; Where Sense Meets Nonsense* (Oxford: Oxford University Press, 2001)

Silverman, S. M., 'Low Latitude Auroras Prior to 1200 C. E. and Ezekiel's Vision', *Advances in Space Research*, 38 (2006), 200-208

Silverman, S. M. & E. W. Cliver, 'Low-Latitude Auroras: The Magnetic Storm of 14-15 May 1921', *Journal of Atmospheric and Solar-Terrestrial Physics*, 63. 5 (2001), 523-535

Stricker, B. H., *De Grote Zeeslang* (Mededelingen en Verhandelingen van het Vooraziatisch-Egyptisch Genootschap 'Ex Oriente Lux', 10; Leiden: E. J. Brill, 1953)

Thilo, G. & H. Hagen (eds), *Servii Grammatici qui Feruntur in Vergilii Carmina Commentarii* (1; Leipzig: B. G. Teubner, 1923)

Tobing, P. Lumban, *The Structure of the Toba-Batak Belief in the High God* (Amsterdam: Jacob van Campen, 1956)

Toscanne, P., 'Études sur le Serpent; Figure et Symbole dans l'Antiquité Élamite', in anonymous (ed.), *Mémoires de la Délégation en Perse* (12. 4; Paris: E. Leroux, 1911), 153-228

Townsend, L. W., D. L. Stephens Jr., J. L. Hoff, E. N. Zapp, H. M. Moussa, T. M. Miller, C. E. Campbell & T. F. Nichols, 'The Carrington Event: Possible Doses to Crews in Space from a Comparable Event', *Advances in Space Research*, 38 (2006), 226-231

Uphill, E. P., 'The Ancient Egyptian View of World History', in J. Tait (ed.), *'Never Had the Like Occurred': Egypt's View of its Past* (Encounters with Ancient Egypt; London: University College of London Press, 2003), 15-29

Van Buitenen, J. A. B. (tr.), *The Mahābhārata: I: The Book of the Beginning* (Chicago: The University of Chicago Press, 1973)

Van der Sluijs, M. A. & A. L. Peratt, 'The *Ouoboros* as an Auroral Phenomenon', *Journal of Folklore Research*, 46. 1 (2009), 3-41

Waterlot, E. G. (ed.), *Les Bas-Reliefs des bâtiments royaux d'Abomey (Dahomey)* (Travaux et Mémoires de l'Institut d'Ethnologie, 1; Paris: Institut d'Ethnologie, 1926)

Wuensch, R. (ed.), *Ioannis Laurentii Lydi Liber de Mensibus* (Leipzig: B. G. Teubner, 1898)

The snake as the symbol of transition and transformation in Peruvian art

Bock, Edward K. de, *Human sacrifices for Cosmic Order and Regeneration. Structure and meaning in Moche iconography. Peru, 100 – 800 CE,* BAR International Series 1429, Oxford 2005

Donnan, Christopher B., Donna McClelland, *Moche Fineline Paiting. Its Evolution and Its artists.* UCLA Fowler Museum of Cultural History, Los Angeles 1999

Guaman Guaman Poma de Ayala, Felipe, *El Primer Corónica y Buen Gobierno (1583 – 1615).* Ed. by John V. Murra, Rolena Adorno and Jorge L. Urioste. Madrid: Historia 16. 1986

Hocquenghem, Annemarie, *Iconografía Mochica.* Pontificia Unversidad Católica del Perú. Lima 1987

Wilbert, Johannes, The House of the Swallo-Tailded Kite: Warao Myth and Art of Thinking in Images, *Animal Myths and Metaphors,* ed. by Gary Urton, 145-182. Salt Lake City, University of Utah Press. 1985

Zuidema, R. Tom, The Lion in the City, *Animal Myths and Metaphors,* edited by Gary Urton, 183-250. Salt Lake City, University of Utah Press. 1985

About the authors

Irene Hübner is a cultural anthropologist and director and chief curator of the Afrika Museum in Berg en Dal. She has specialised in the African vodun religion and the related religions of the African diaspora.

Wilfried van Damme is an art historian and cultural anthropologist, and teaches intercultural comparative art studies at Leiden University, where World Art Studies developed as a discipline. He is professor of ethno-aesthetics at Tilburg University, and works for the Afrika Museum as a research consultant.

Wouter Welling is curator of contemporary art at the Afrika Museum in Berg en Dal, and publishes on interculturality and globalisation in the visual arts. Exhibitions he has organised for the Afrika Museum include *Ad Fontes! an intercultural search for hidden sources* (2001), *Kijken zonder grenzen* (2006) and *Roots & More: the Journey of the Spirits* (2009).

Siebe Rossel is a historian and cultural anthropologist. He was curator of ethnographics at the Africa Museum in Berg en Dal (2010-2012. He organised the *Van verre volken thuis: kunst in de kamer (Tribal treasures in Dutch private collections)* exhibition for the Afrika Museum. As head of museum affairs he supervised the permanent presentation of musical instruments at the Tropical Museum in Amsterdam. He was previously project manager at the Netherlands Open Air Museum, and also helped launch the TwentseWelle event in Enschede.

Sheila Coulson has a Bachelors degree in Archaeology from Simon Fraser University in Canada, a Masters in Anthropology from Bryn Mawr College in the US and a Doctorate in Lithic Technology from the Institute of Archaeology, University of London. She is a specialist in the Palaeolithic and Mesolithic and has conducted field work in Canada, England, France, Norway and Greenland. Since 1999 she has participated in the University of Botswana/Tromsø San Research Project as co-Director of the Archaeology Section. Presently she is pursuing research into the Middle Stone Age of Botswana and is about to begin a new collaborative project with the University of Brighton to determine the sources of silcrete, an important raw material source for all periods of the Stone Age in Southern Africa. She has lived and worked in Norway as an Archaeologist with the University of Oslo, since the early 1980s. She is presently an Associate Professor and Head of Department for Archaeology.

Mineke Schipper is emeritus Professor of Intercultural Literary Studies at Leiden University. She has written three novels and numerous books in her specialist field, including *Trouw nooit een vrouw met grote voeten: wereldwijsheid over vrouwen,* Uitgeverij Spectrum, new edition in Scala series, 2010) and *In het begin was er niemand: hoe het komt dat er mensen zijn.* Uitgeverij Bert Bakker, 2010).

Jacob Slavenburg studied history in Utrecht, specialising in gnosticism. He has written a number of articles and books on gnosis and early Christianity, as well as Hermes Trismegistus and the hermeticist currents of thought. He and Willem Glaudemans have jointly translated the Nag Hammadi texts into Dutch.

Wouter Bleijenberg studied clinical psychology and cultural and religious psychology at the Radboud University in Nijmegen, Netherlands, from 1978 to 1985. For the past twenty-five years he has been co-director of a large group practice specialising in primary-care psychology and psychotherapy. He provides practical training for health-care psychologists and is a teaching therapist and supervisor for the Dutch Association for Client-Oriented Psychotherapy. He is the co-founder and a committee member of the Dutch Sandplay Therapy Association, and a certified member of the International Society for Sandplay Therapy. Since 1997 he has also run an ecological ginkgo biloba nursery.

Marinus Anthony van der Sluijs holds a Master's Degree in Comparative and Historical Linguistics from Leiden University, The Netherlands, specialising in the Indo-European and Semitic language families. He is a Consulting Scholar at the University of Pennsylvania Museum of Archaeology and Anthropology, Philadelphia. He has published in journals on such diverse subjects as the history of religions and of science, archaeology, mythology, the ancient Near East, mediaeval literature, near-death studies and Forteana.

F. J. M. Ellenbroek studied biology at Leiden University, specialising in evolutionary biology and ecology. In 1990 he received a doctorate for his research into competition among shrews. Since 1979 he has been director of the Brabant

Nature Museum in Tilburg. He currently chairs the jury that selects the annual winners of the European Museum of the Year Award and the Council of Europe Museum Prize. He is also an artist, and his paintings are regularly exhibited.

Maarten J. Raven studied Egyptian language and literature, history of art and archaeology at Leiden University. In 1984 he was awarded a doctorate for a dissertation on symbolism and iconography in Ancient Egypt. Since 1978 he has been curator of the Egyptian Department at the Dutch National Museum of Antiquities in Leiden. In this capacity he has organised numerous exhibitions, the most recent being *Egyptian magic* in 2010-2011. Since 1975 he has also been involved in the Leiden excavations at the New Kingdom burial ground in Saqqara, Egypt, where he has been field manager since 1999.

David van Duuren is a cultural anthropologist, and recently retired as curator for Oceania and Historical Collections at the Tropical Museum in Amsterdam. He specialises in the art and material culture of Oceania and South-East Asia, and among other things has published on the history and meaning of museum collections, the Indonesian kris knife and the art of Oceania. His publications include 125 Jaar verzamelen: Tropenmuseum, Koninklijk Instituut voor de Tropen, Amsterdam (Amsterdam, 1990), The Kris: An Earthly Approach to a Cosmic Symbol (Wijk en Aalburg, 1998), Krisses: A Critical Bibliography (Wijk en Aalburg, 2002), Physical Anthropology Reconsidered: Human Remains at the Tropenmuseum (Amsterdam, 2007) and (with other authors) Oceania at the Tropenmuseum (Amsterdam, 2011).

Georges Petitjean is an art historian who studied at the Vrije Universiteit Brussel (Brussels) and wrote his PhD at La Trobe University, Melbourne. This PhD explored the transition of Indigenous Australian painting from its sites of origin in the deserts of west and central Australia to the wider art world. He has lived and worked in Australia for many years and since 1992 has closely followed the work of a number of artists in Central Australia and in the Kimberley. He was appointed curator at AAMU, Museum for Contemporary Aboriginal Art, in the Netherlands in 2005. One of his main fields of interest is the peripheral position of Indigenous Australian art – and non-Western art in general – in a wider contemporary art context. Georges Petitjean was curator of numerous exhibitions and wrote several articles for Australian and

European art magazines on the subject. Recent exhibitions include Brook Andrew: *Theme Park and Nomads in Arts* in which work by Marcel Broodthaers is presented alongside that of four Aboriginal artists. He is the author of *Contemporary Aboriginal art: the AAMU and Dutch collections* (Snoeck, 2010).

Ben Meulenbeld studied classical archaeology and the history of art and culture in South and South-East Asia. He has published various works on Asian art, and is curator of South-East Asian culture and history at the Tropical Museum in Amsterdam.

Edward K. de Bock is an art historian. He is currently on the staff of the Wereldmuseum in Rotterdam, as head of research and curator of the Americas section. He has worked for various museums in the Netherlands and abroad, and has been a reader at the University of East Anglia in Norwich, England. He publishes material on the iconography of pre-Columbian Andean cultures, especially the Moche (100-750 CE) and Nasca (100-700 CE) cultures of Peru.

Dangerous and Divine – The Secret of the Serpent
Exhibition catalogue accompanying the
Dangerous and Divine exhibition at the Afrika
Museum, Berg en Dal, the Netherlands. The
exhibition is on display April – November 2012.
This is a joint publication of Afrika Museum,
Berg en Dal and KIT Publishers, Amsterdam.

KIT Publishers
Mauritskade 63
Postbus 95001
1090 HA Amsterdam
E-mail: publishers@kit.nl
www.kitpublishers.nl

©2012 Afrika Museum – Berg en Dal/
KIT Publishers – Amsterdam

Concept and coordination: Wouter Welling
Editing: Irene Hübner, Wilfried van Damme,
Wouter Welling
Translation: Kevin Cook
Translation essay Siebe Rossel: HHCE, Nijmegen

Photography: photographers are mentioned in
the captions. Photo´s without captions are by
the hand of Ferry Herreburgh
Coverphoto front: see p. 77
Coverphoto back: Zephyr (Andrew Witten, New
York), *Venom*, 1981, spray paint on metal, 240 x
240 cm. Private collection of Henk and Leonie
Pijnenburg
Every effort has been made to contact copyright
holders for permission. Please contact the
publisher in case of oversight

Design: Nel Punt, Weesp
Production: High Trade BV, Zwolle

ISBN 978 94 6022 2047

This publication has been produced with
the support of:
Mondriaan Fonds
Turing Foundation
Prins Bernhard Cultuurfonds
VSB Fonds
SNS Reaal Fonds
Janivo Stiching